Introduction to Women's Studies

Edited by
Ana Isla
Brock University

KENDALL/HUNT PUBLISHING COMPANY
4050 Westmark Drive Dubuque, Iowa 52002

Cover image courtesy of Artville.
Back cover photo provided by Ana Isla

Copyright © 2004 by Kendall/Hunt Publishing Company

ISBN 0-7575-1355-7

Printed in the United States of America
10 9 8 7 6 5 4 3 2 1

Contents

Introduction to Women's Studies

Instructor: Ana Isla
phone: 3466
E-mail: *aisla@brocku.ca*

Course Objective:

The main goal for this course is to familiarize the students with women's studies and its achievements in different disciplines and fields. Women think of another's reality as well as their own, in doing so they develop a rich and more complex consciousness of reality. The second semester will be divided into three sections: the first will present feminist challenges to academic disciplines. The second will introduce women's theoretical transformations. The third will redefine the spaces of women and society in which women, nature and other peoples are not colonized and exploited for the sake of others.

Approach to Teaching and Learning

The course will consist of lectures, audio-visual material and seminars. Students are expected to prepare for each class and seminar by reading the assigned material, which will be the basis for discussion.

Evaluation

- Paper 30%
 - *Many topics can be chosen from the course syllabus:* The topics are designed so that they can be addressed on the basis of evidence from the course readings.
 - *Writing the Essay: Outline*

 Create an outline of the themes and evidence you will address.

 Your outline should look like this:

 I. Introduction: includes brief historical background for your topic, your thesis statement, and a few sentences in which you discuss and clarify your thesis statement.

 II. Supporting paragraphs: in these paragraphs, which form the body of your essay, lay out your main points of evidence for your thesis, supported by concrete examples and background information. A well-developed essay must address the issues on both sides of the argument. State why you believe your argument is the correct one. Cite direct quotes with a purpose in mind. All facts that are not common knowledge must be referenced with footnotes, endnotes or other.

 III. Conclusion: Restate your thesis and summarize your main arguments briefly.
 - *Formatting*

 Turn in your paper with a cover sheet that includes: essay title, your name, the course number, your tutorial time and the date. Your paper must be typed, double-spaced, with one-inch margins, numbered pages and should run between 8 to 10 pages in length. Title page and bibliography are separated.
- Seminar Attendance and Participation 15%
- Research Journal and Poster 30%
 - *Writing a Journal.* Each group will have four members. You will rotate the following roles: a facilitator (runs meeting); record keeper (keeps minutes); time keeper (sets agenda) and a mood mender (watches emotions). A collective journal of your research with recorded assistance and activities described above will be handed in.

 Your group may choose any issue that either you support or criticize.
 - *Issues to Choose From:*
 - *Classism and Poverty:*

 - Poverty: welfare levels, poverty rates for single women with children. Jobs which give less entitlement to pensions and lower pensions because these are related to earning. Use *Poverty Profiles* published every year by the National Council on Welfare.

- Housewifization of women's work: workload—unequal number of hours women work compared to men, minimum wage (sweat shops and micro-enterprises).

○ *Male Violence: Sexism*

- Wife abuse - women murders by their partners, sexual assault, rape.

○ *Crime and Mutilation:*

- Beaten to death, dowry murder, female circumcision, sterilization abuse.

○ *Sex-Industry:*

- Trafficking in women, prostitution, pornography, bride industry, sex-tourism.

○ *Racism and harassment:*

-Racism in schools and universities, racial harassment at work

○ *New Feminist Frameworks:*

Ecofeminism, gift-giving, subsistence perspective, gay and lesbian marriage.

● Final Exam 25%

Section Outline

Section I: Feminism Challenges to Academic Disciplines

Feminism in academia has been developing new analyses. How do politics, economics and development theoretical models explain women's oppression?

Class 1. Introductory Class

● The perspective, outline, and requirements of the course will be discussed.

● Make a list of feminist principles as you currently understand them. Keep this until the end of the course so we can compare your early lists with your understanding as it has developed through the course.

No seminar this week.

Class 2. Economics

Video: Who's Counting
Discussion
Seminar
Cohen, Marjorie (1989). "The Problem of Studying 'Economic Man' " in Miles, Angela and Geraldine Finn (Eds.) *From Pressure to Politics*, Black Rose Books. Montreal, New York. Pp147–159.

Class 3. Politics

Video: Beijing
Discussion and journal writing

Seminar

Lorde, Audre (1984). "The Master's Tools Will Never Dismantle the Master's House" in *Sister Outsider*. The Crossing Press. Pp 110–113.

Class 4. Environment

Shiva, Vandana (1993). "The Impoverishment of the Environment: Women and Children Last" in *Ecofeminism* authored by Mies, Maria and Vandana Shiva. Fernwood publications, Halifax, Nova Scotia and Zed Books, London and New Jersey. Pp. 70–90.
Video: Women, love and flowers
Discussion and journal writing
Seminar
Isla, Ana (2000). "Land Management and Ecotourism: A Flawed Approach to Conservation in Costa Rica" Paper presented at the Natural Capital, Poverty and Development Conference 5–8 September 2001. Munk Centre for International Studies, University of Toronto.

Class 5. Development

Isla, Ana (1993). "Women, Development and the Market Economy," *Canadian Woman Studies*. Vol. 13, number 3.
Video: Not for Sale
Discussion and journal writing
Seminar:
Isla Ana, Angela Miles and Sheila Molloy (1996), "Stabilization/Structural Adjustment/: Canadian Feminist Issues in a Global Framework". *Canadian Woman Studies*. Volume 16, Number 3.

Section II: Theoretical Transformations

This section will discus how systems of power, such as class, race and colonialism, create commonalities and differences among women.

Class 6. Class

Video: The Vienna Tribunal
Discussion and journal writing
Seminar

Class 7. Racism

Video: Cultural Criticism and Transformation
Discussion and journal writing
Seminar
bell hooks (1984). "Black Women: Shaping Feminist Theory" in *Feminist Theory from Margin to Centre*. South End Press. Pp 1–15.

Class 8. Colonialism

Mies, Maria (1986). "Colonization and Housewifization" Patriarchy and Capital Accumulation on a World Scale. Women in the International Division of Labour. London: Zed Books Ltd. Pp 74-111.
Video: Beyond Malthus
Discussion and poster project
Seminar:
Mohanty Chandra, Ann Russo and Lourdes Torres (1991)." Under Western Eyes" in Feminist Scholarship and Colonial Discourses. Bloomington, Indiana: Indiana University Press. Pp 51–80.

Section III: Redefining the Spaces of Women and Society

What perspectives are more holistic and connect gender, class, race, colonialism and destruction of the environment? The feminist perspectives seek a society in which nature, women and the other people are not colonized and exploited for the sake of a few. Their understanding of progress is based on other values and on the recognition that our world is finite.

Class 9. Alternatives Visions

Sen, Gita and Caren Grown (1987). "Alternative Visions, Strategies and Methods" in *Development, crises, and alternative visions: Third world women's perspectives.* Monthly Review Press. New York Pp.78–96.
Video: Life and Debt
Discussion and journal presentation
Seminar
Mies Maria and Vandana Shiva. "People or population: Towards a New Ecology of Reproduction" in *Ecofeminism.* Fernwood Publication, Halifax, Nova Scotia.

Class 10. Ecofeminism as Politics

Salleh, Ariel (1994). "Nature, Woman, Labour, Capital: Living the deepest contradiction' in *Is capitalism sustainable? Political economy and the politics of ecology.* Edited Martin O'Connor. The Guilford Press, New York, London. Pp 106–124.
Journal presentation
Seminar

Class 11. Ecofeminism—The Subsistence Perspective

Bennholdt-Thomsen, Veronika and Maria Mies (1999). *The Subsistence Economy.* Zed Books and Spinifex Press. Pp9–64.
Journal presentation
Seminar
Isla, Ana, "Women and Biodiversity as Capital Accumulation on Ecofeminist in *Socialist Studies Bulletin* No. 69. pp 21–34.

Class 12. The Gift Economy

Journal presentation
Seminar
36 Steps Toward a Gift Economy

Class 13. Review for Exam

Journal presentation

Course Package for WISE 1F90: Introduction to Women's Studies

Dr. Ana Isla

Cohen, Marjorie (1989) "The Problem of Studying 'Economic Man'" in Miles, Angela and Geraldine Finn (Eds) *From pressure to politics*, Black Rose Books. Montreal, New York. Pp 145-159.

Lorde, Audre (1984). "The Master's Tools Will Never Dismantle the Master's House" in *Sister outsider*. The Crossing Press. Pp 110-113.

Shiva, Vandana (1993). "The Impoverishment of the Environment: Women and Children Last" in *Ecofeminism* authored by Mies, Maria and Vandana Shiva. Fernwood publications, Halifax, Nova Scotia and Zed Books, London and New Jersey. Pp. 70-90.

Isla, Ana (2000). "Land Management and Ecotourism: A Flawed Approach to Conservation in Costa Rica" Paper presented at the Natural Capital, Poverty and Development Conference 5-8 September 2001. Munk Centre for International Studies, University of Toronto.

Isla, Ana (1993). "Women, Development and the Market Economy," *Canadian Woman Studies.* Vol. 13, # 3.

Isla Ana, Angela Miles and Sheila Molloy (1996). "Stabilization/Structural. Adjustment/Restructuring: Canadian Feminist Issues in a Global Framework". *Canadian Woman Studies.* Volume 16, Number 3.

Harman, Lesley (1992). "The Feminization of Poverty: An Old problem with a New Name" in *Canadian Woman Studies.* Volume 12, No.4.

Moraga Cherrie and Gloria Alzaldua editors (2002). "Entering the Lives of Others;" "La Güera;"and "I walk in the History of My People" in *This bridge called my back: Writings by radical women's of colour.* Women of Color Series. Third Woman Press. Berkeley

bell hooks (1984) "Black Women: Shaping Feminist theory" in *Feminist Theory from Margin to Centre.* South End Press. Pp 1-15.

Mies, Maria (1986) Patriarchy and Capital Accumulation on a World Scale. Women in the International Division of Labour. London: Zed Books Ltd. Pp.74-111.

Mohanty Chandra, Ann Russo and Lourdes Torres (1991)" Under Western Eyes" in Feminist Scholarship and Colonial Discourses. Bloomington, Indiana: Indiana University Press. Pp 51-80.

Sen, Gita and Caren Grown (1987) "Alternative Visions, Strategies and Methods" in *Development, crises, and alternative visions. Third world women's perspectives.* Monthly Review Press. New York Pp78-96.

Mies Maria and Vandana Shiva "People or population: Towards a New Ecology of Reproduction" in *Ecofeminism.* Fernwood Publication, Halifax, Nova Scotia.

Bennholdt-Thomsen, Veronika and Maria Mies (1999) *The subsistence economy.* Zed Books and Spinifex Press. Pp9-64.

Isla, Ana "Women and Biodiversity as Capital Accumulation: an ecofeminist view" in *Socialist Studies Bulletin* No.69. Pp 21-34.

36 Steps Toward a Gift Economy.

Preface

This reader is intended for first-year university students. The main goal of this package, which covers two terms, is to familiarize students with women's conditions and achievements in different disciplines and fields.

Women's studies arise from the practical concerns of women's movements combined with the development of feminist theory. Feminists' starting point is that differentiation by sex or gender is universal and pervasive across societies. As a result of feminism, women have developed a rich and complex collective consciousness of reality that takes into account the diverse experiences of the women who theorize, practice and live their day-to-day lives. Two concepts are central to the way feminists have theorized the world and to this reading package—*patriarchy* and *capitalism.*

Patriarchy is a masculine system of social, political and economic domination in which women are controlled. Patriarchy arose prior to the formation of Western civilization, and gradually institutionalized the rights of men to control and appropriate the sexual and reproductive services of women. Once established as a functioning system of complex hierarchical relationships, patriarchy transformed sexual, social, and economic relations and dominated all systems of ideas (Lerner, 1993).

Capitalism is a system of production in which labour creates value and surplus value. Individuals and countries are separated by force from the surplus goods and services they may produce. This force leads to a concentration of wealth in the hands of a few, because wealth is capable of being transformed into force. At this point we see that the motivation for the acquisition of surplus wealth is the power and control that wealth offers. As a result of both patriarchy and capitalism, women and the "other" were transformed into creatures whose needs could never be fulfilled.

Section I focuses on the patriarchal capitalist structuring of 1) international economics, 2) international relations, and 3) relations to the environment, with attention to the ways women can resist and transform these arrangements:

1. *International Economics.* Marilyn Waring (1988), in *If Women counted: A new feminist economics*, argues that economics is sexist. Only what is produced for the market is considered productive. In discussing the United Nations System of National Accounts (UNSNA), the author is able to detail the mechanisms by which the major part of women's work is rendered invisible and goes uncounted as productive work.
 - the work of middle-class women in the household is not recognized as productive; and
 - the agricultural work of rural women where the separation between enterprise and household is not clear may be recognized as productive, but their primary role is still defined as housework, and they are excluded from the definition of primary producer.

 Both groups of women are considered unproductive, economically inactive, and economists record them as unoccupied. Goods produced by these two groups of women count for nothing in economic accounting and policy making. The invisibility of their work allows their appalling work conditions and exploitation to remain invisible as well, as wages and profits go only to the visible male workers and owners, managers, enterprises—the male face of industry.

2. *International Relations.* Cynthia Enloe (1989), in *Bananas, beaches and bases: Making feminist sense of international politics*, argues that at the centre of international politics are elite men with power, linked to money, guns and personalities. How does their power maintain the international political system in its present form? By creating presumptions about certain cultures and reinforcing global hierarchies between countries. Enloe introduces gender into the picture to explain how power shapes and is sustained by notions of masculinity and femininity. These gendered political arrangements exclude women from decision-making.

3. *Environment/Nature.* Vandana Shiva (1993), in *The impoverishment of the environment: Women and children last*, argues that from women's perspectives, sustainability without environmental justice is impossible, and environmental justice is impossible without justice between sexes and generations. The author criticizes the dominant understanding of poverty as the absence of Western consumption patterns and cash incomes. In fact, subsistence economies do not necessarily involve a low material quality of life. The culturally biased definition of subsistence as poverty is, in fact, used to justify processes of 'development' which actually destroy sustainable ways of living, thus creating real material poverty, or misery, by denying the means of survival. In this process, water, soil

fertility, and genetic wealth are considerably diminished. The scarcity of these natural resources, which form the basis of women's survival economy, impoverishes women and all marginalized people. The source of their impoverishment is the market economy, which has absorbed these resources in the pursuit of commodity production.

Ana Isla (2003), in *Women, Development and the Market Economy*, starts from the premise that capitalism is based on exploitation and accumulation, determined by the demands of profit for a few privileged individuals. The author challenges the discourse of economic development, which promised the elimination of poverty in the Third World through different kinds of investments alleged to promote economic growth (Rostow, 1960). Using the case of debt for nature swaps, the author explains the most recent mechanism the industrial world has set up to exploit the non-industrial world. Since 1982, foreign debt has facilitated a net transfer of wealth, from the periphery to the core, in the form of money, national industries, banks, and other assets, which are taken over in payment of interest on this debt. This has brought countries into submission, perpetuating a process of impoverishment and environmental destruction.

Section II more closely examines class, race, ethnicity, and colonialism, and how these divide women from each other:

Johanna Brenner and Maria Rama (2000) are Marxist feminists who incorporate male power into class analysis in *Rethinking women's oppression*. Their domestic labor theory analyses women's exploitation by capital and their relationship of dependence and powerlessness vis-a-vis husbands and fathers. The authors explore the oppression of women in the 19th and 20th centuries. They argue that both the sexual division of labor and the family-household system are shaped by the exigencies of biology and class structure.

bell hooks (2001), in *Black women: Shaping feminist theory*, argues that a central tenet of modern feminist thought has been the understanding that 'all women are oppressed'. This implies that women share a common lot, that factors like class, race, sexual preference, religion etc., do not create a diversity of experience that determines the extent to which sexism will be an oppressive force in the lives of individual women. It is true that sexism is institutionalized, but it has never determined the fate of all women equally in society. The author sees feminist thought as *a theory in the making*, which we must necessarily criticize, question, re-examine, and explore, because there is much evidence substantiating the reality that race and class identity create differences in quality of life, social status and lifestyles that take precedence over the common experience women share.

Gloria Alzaldua, in "Entering the Lives of Others," "La Güera," and "I Walk in the History of My People" in *This bridge called my back: Writings by radical women of color* [Cherrie Moraga and Gloria Anzaldua editors 2002 (1981)] warns of the danger of women denying racism and failing to acknowledge the specificity of oppression. She

develops a *theory in the flesh*, meaning one where the physical realities of our lives—our skin colour, the land we grew up on, our sexual longings—all blend to create a politics born out of necessity.

Maria Mies (1986), in the chapter "Colonization and Housewifization" in *Patriarchy and capital accumulation on a world scale: Women in the international division of labour*, argues that the historical development of the division of labour in general, and the sexual division of labour in particular, was/is not an evolutionary and peaceful process, based on an ever-progressing development of productive forces (mainly technology) and specialization, but a violent one by which first certain categories of men, later certain peoples, were able mainly by virtue of arms and warfare to establish an exploitative relationship between themselves and women, and other peoples and classes. The author proposes the concept of *housewifization* to explain women's situation in the globalization era. *Housewifization* is a process by which women's work under capitalism is universally made invisible and can for that reason be exploited limitlessly. *Housewifization* of women's labor means:

- the wageless reproduction of labor power, justified by the argument that women's earnings are only a supplement to the male breadwinner's wage; and
- the cheapest kind of production work, mainly done by women who do home work and farm labor, who are peasants, small traders, and factory workers in the non-industrial countries.

Section III presents feminists definitions/visions in which women, nature and other peoples are not colonized and exploited for the sake of others.

SECTION I

Feminism Challenges
to Academic Disciplines

The Problem of Studying "Economic Man"

Marjorie Cohen

*F*eminists are familiar with the androcentric biases of the disciplines which have something to say about women's condition. The power which these disciplines have, in simply defining what they see as the problem and then explaining the issues with a male concept of society and social relationships, is well known. Feminist criticism has put us on our guard against accepting the well established viewpoints of literature, history, medicine, psychology, and even politics. But no one has written about the biases of one of the most thoroughly male of all disciplines—economics. Of course, women, like most men, tend to distrust economists and economic analysis; nevertheless the discipline itself has had extraordinary power, both to shape social institutions according to its own objectives, and to instill in the subconscious of individuals an analytical approach which inevitably leads to conclusions based on apocryphal notions about human behaviour.

The point to be developed is that economics has evolved a methodology which for the most part cannot "see" women's economic behaviour. However, when women's economic behaviour does conform to that which theory can say something about, the assumptions on which the theory is based are false. In short, economic theory has little that is useful to say either about what is happening to women in the economy or why it is happening. My criticism will focus on the theories of neoclassical economies because of their dominant position in economic literature, economic departments in universities, and in social policy. Neoclassical methodology is studied by all students who enter the discipline, and even if they do question its assumptions in later life, a certain amount of mental baggage is retained so that its notions pervade even new fields of economic consideration such as the problem of discrimination, an issue which will be discussed later.

Economists have defined their area of study very widely. One of the most famous definitions is that of Alfred Marshall, the father-figure of neoclassical thought: "Political Economy or Economics is a study of mankind in the ordinary business of life: it examines that part of individual and social action which is most closely connected with the attainment and with the use of the material requisites of well being."[1] The ordinary business of life takes in quite a bit of territory, and with such an inclusive definition one would be tempted to think that "mankind" is used in the generic sense—it is not. The real range of the subject is clarified by Marshall when he says it is concerned "chiefly with those motives which affect, most powerfully and most steadily, man's conduct in the business part of his life."[2] Economists can deal with "facts which can be measured and recorded" and problems which "relate specially to man's conduct under the influence of motives that are measured by a money price."[3] However, there is a great deal of the ordinary business of life which does not lend itself to being measured by a money price. The way economists have coped with this fact has been to assume that although a facet of life does not have a money value established directly on the market, it can nevertheless be determined indirectly by the market value of what one must forego in order to pursue or realize a non-monetary objective.

Some economists have felt that a definition of economics which sees the discipline as dealing with the material requisites of well-being is too restrictive. In an attempt to make the subject include choices between the economic and the non-economic, Lionel Robbins introduced the notion of scarcity as the distinctive feature of the discipline. He defined economics as being "concerned with that aspect of behaviour which arises from the scarcity of means to achieve given ends."[4] With this definition, presumably, the discipline was interested in the economic problems both of the individual and of social economic behaviour on markets.

Paul Samuelson, in his textbook for first year students, restricts Robbins' definition by adding the materialist definition. But he claims it is a definition of the subject on which economists basically agree: "Economics is the study of how people and society end up choosing, with or without the use of money, to employ scarce productive resources that could have alternative uses, to produce various commodities and distribute them for consumption, now or in the future, among various persons and groups in society."[5] It is necessary to pursue the way economists define their field since they claim to study society in a way which would include the economic activities of everyone in the society, including women.[6] There is a tendency for economists to see their analysis as having the widest application to human behaviour and to include activities which do not at first glance appear to be economic.[7] While most of the nitty-gritty of economic analysis deals with the market mechanism, the economists, by defining the scope of the profession widely, use the tools they have developed to explain the market to deal with non-market areas. There are two significant issues here to be discussed: first, that economists are relatively uninterested in non-market behaviour, although they believe that their methodology is sufficient to analyze it should they wish to do so; and second, that the tools which have been developed to explain market behaviour are exceedingly blunt instruments for an analysis of non-market behaviour.

By now, people interested in the study of women are attuned to the fact that the productive nature of most women's work is not counted by economists. Women's economic behaviour as consumers within the "household" generates some interest, but basically the household is viewed as a unit of consumption, not production. Having noticed that excluding women's housework from economic accounting (GNP) creates some problems, economists usually express their regret with a little exclamation point after having repeated A. C. Pigou's puzzled observation that if a man married his housekeeper the GNP goes down! "Or if a wife arranges with her neighbour for each to clean the other's house in return for $5,000 a year, then the GNP would go up by $10,000."[8] But the problems of trying to count non-market work, while not insurmountable, are clearly not considered worth the effort; as Samuelson explains, "So long as the number of women working at home does not change much in relative importance, the ups and downs of GNP will be about the same whether or not we count in this or similar items such as home-grown vegetables and other do-it-yourself activities."[9] Unfortunately, he doesn't discuss how one knows whether the relative importance of what is going on in the household changes if no one measures its productive activity. The implication here, too, is that women's housework is roughly of the same proportions as work involved in hoeing the carrot patch or messing around on the tool bench. In fact, housework is the single largest "industry" in terms of the number of people working at it, and estimates of its *value* range from one-quarter to one-half of the gross national product.[10]

But what are the consequences of excluding housework from the GNP? Would including the value of this work be anything more than a symbolic gesture in recognizing women's work as productive activity? Its juridicial significance *is* often recognized,

particularly for evaluating matrimonial property settlements, pension benefits, entitlement to family wealth, and even as a measure of value should the issue of wages for housework become a reality.[11] But women's work has economic significance as well: excluding such a huge part of economic activity from economic accounting imposes serious limitations on the validity of what is counted. It also raises questions as to what we know about how effectively the system allocates resources. If a productive activity is not counted, then neither is the cost of that production. Efficiency is an important issue for economists, and it can be determined only if total production and total costs are known. For example, if total production increases even though there has been no change in the number of the factors of production used, then the economy has become more efficient, and presumably welfare increases. Both the total amount of production and the efficiency of production are critical indications of an improvement or worsening of the economy. If economics is really concerned with notions of efficiency and employing scarce productive resources to alternative ends, it cannot confine its analysis only to those alternative ends which can be given a value through the market.

By not counting the nature of production in the household, society does not know the cost or benefits of that production, and is thus not able to make rational decisions about alternative uses of resources. For example, because all economic activity within the household is treated as consumption, items like washing machines and stoves are not considered factors of production, hence are not costs of production. There are huge capital costs involved in having kitchens, laundries and playrooms in each individual household, just as there are huge expenditures of labour involved in raising children one at a time by one adult. However, by simply labelling this activity as consumption, the economist is able to say that activity within the household is rational because the household is maximizing its own total utility. But clearly, if this activity were considered as part of the production process, its rationality would be examined in a different way. The fact is that economists have no way of dealing with efficiency outside the market mechanism unless they look at an economic unit in isolation.[12] The whole significance of a market equilibrium (i.e., the optimum use of resources in the economy) becomes quite meaningless if a huge portion of economic activity is not part of the calculation. The policy implications of not seeing activity in the household as production are significant for women because alternatives to production in the home (for example, day-care centres) will be considered only in terms of the cost and benefits of their impact on the market; not in consideration of the total use of resources.

While women's economic behaviour in the household has not been integrated into mainstream economic analysis, this does not mean that neoclassical theory is felt to be inadequate to deal with the issue. When the household is examined, the same methodology which is used to explain market behaviour is applied. My contention is that there are serious difficulties in using an analysis which was designed to explain market behaviour to explain non-market activity as well. Economic theory is based on a notion of human behaviour which in the early days of neoclassical theory building was given

the label "economic man." Economic man is a fantastic creature whose wants are insatiable and whose capacity for calculation is perfect. His motivition for action is gain, so he will be consistent in his choices and will "maximize" everything. Over the years, economic man acquired a rather nasty reputation as a money-grubbing individual whose whole system of values is directed by the profit motive. So economists for some time, mostly for publicity reasons, have avoided the term "economic man": they try to emphasize that they do not believe that a money profit is the sole motive for anyone's behaviour. Nevertheless, the idea of maximizing utility remains fundamental to neoclassical economic theory: on the market the central assumption is that producers will be profit maximizers and consumers will be pleasure maximizers.

This discipline of maximizing gain, which is so critical to a market analysis, is assumed to apply to all behaviour whether or not the ultimate objective is measured in terms of psychic happiness or monetary rewards. In order to maximize behaviour, individuals must be able to determine the relative utility of all possible courses of action and make choices so that total utility is maximized. If this can be done (and economists have no doubt that it can), then the economist feels that emotional needs can be compared with material needs and decision-marking in the market can be compared with decision-marking in the household. So the most basic assumption on which a neoclassical analysis of the household rests is that decision-making is not markedly different within the household than it is on the market. This is a heroic assumption about the nature of human motivation which is treated as constant through time, but which became true even of market behaviour only after a considerable period of discipline. It is likely that the motivation necessary for the successful functioning of the market system was learned behaviour: that is, the economic calculations of individuals are not governed by an immutable natural law but are culturally determined. Karl Polanyi maintains that the great transformation in society brought about by the domination of the market was the change in the motive of action from one of subsistence to one of gain.[13] Other economic historians have shown that this change was not a natural process and that participants on the market, particularly workers, resisted being motivated by gain.[14] If the motive of gain is an economic law peculiar to market behaviour, then any theory which bases its analysis on this assumption but applies it to a non-market situation is beginning with a very questionable premise. Yet any analysis of economic behaviour in the household has this premise as its underpinning. Understanding the assumptions used to explain household behaviour becomes particularly important now as economists are more interested in determining how time is allocated between market and non-market activities. When it is assumed, for example, that the allocation of time within the household or between the household and the market is based on maximizing total utility, then it is fairly easy for the economist to show that the division of labour by sex within the household is the result of a purely rational economic calculation.[15] The social implications are significant: if behaviour is based on some economic law, then what exists is rational and becomes a powerful argument for justifying the *status quo*.

The analysis of household behaviour, particularly with regard to problems of production, is not an issue with which an economist would normally deal. However, in those few cases when the household is examined, it is approached with premises assumed valid for market behaviour. I maintain that these do not necessarily apply to behaviour within the household—behaviour which has not been made to conform to the requirements of the market. But the examination of economic behaviour within the household does not rely simply on the assumption of gain as the motive to explain the relationship between the household and the market. It is also dependent on other tools which neoclassical economics has developed to explain the market mechanism. The most important of these is the explanation of the distribution of income.

When women work for money, their activity comes under the scrutiny of mainstream economic analysis. One issue we might expect an economist to clarify is why women are paid less than men. Neoclassical analysis tells us that except in unusual circumstances we are paid exactly what we are worth. The notion that the wage paid is really indicative of the worth of labour is a belief of our society which has been "proven" by economic science. The theory of wages rests on the economic proof that in normal circumstances, when the market is in equilibrium, workers will be paid a wage equal to their marginal productivity.[16] So if a woman is paid less than a man, it is basically because she is less productive. This conclusion also involves an important assumption about the nature of the market itself—that it is perfectly competitive. Now, no economist today would actually claim that perfect competition exists, rather it is seen as an abstraction where all kinds of inconvenient, distracting complications like unemployment are removed so that the basic mechanism of the market can be explained. A perfectly competitive economy is one where all economic units are small enough so that no one individual or group of individuals can have an effect on the price. It is a market where, among other things, there is total freedom of contract, labour is perfectly mobile, and full employment is the rule. Everyone gets a wage exactly equal to the value of his labour because any wage less than that would force the individual to seek out another employer—one who was behaving more rationally. In a perfectly competitive market, an employer who tried to pay some workers a wage less than the marginal productivity of their labour would have to accept a lower profit because he would be forced to operate with a smaller labour force at a scale of production which was less than optimal. To the neoclassical economist, discrimination is an irrational economic action for which the discriminator pays by receiving a lower profit.

Much of the prejudice regarding the worth of female labour stems from the notion of neoclassical economists, based on the assumption of perfect competition, that labour will be paid a wage equal to its marginal productivity. This idea has so permeated the thinking of society over such a long period of time that it has become a difficult mental hurdle to dissociate women's wage from the true value of women's work. Economists who are interested in the problem of discrimination (it is still considered a fringe field) are still firmly in the grip of the neoclassical model and cannot quite com-

prehend why competition does not eliminate discrimination in the long run.[17] In the short run, prejudice (which the economist tactfully labels "taste") might permit discrimination, but in the long run, prejudice would constitute extremely irrational economic behaviour.

Neoclassical economic analysis, then, explains wage differences between men and women as arising either from differences in the productivity of labour or from economic man not behaving true to form. Of course this analysis flies in the face of reason and (to echo Galbraith) is the sort of thing one can believe only after very careful training. We would suspect that someone must be profiting from paying lower wages to women, but neoclassical analysis will not let us come to that conclusion. The neoclassical explanation of wage differences has had ramifications both for an analysis of women's condition and for political action. If wage differences are a result of differences in productivity, then a great deal of effort must be expended to discover what causes these differences in productivity. This gives rise to the whole supply-side analysis of female labour which explains female labour force participation rates and wages according to characteristics of their labour supply. The explanation for women's lower wages is that women's labour is not invested with as much human capital as is men's labour. So improving the quality of female labour and making women more attractive as workers will eliminate the problem. Practically, this leads to all sorts of policy initiatives of questionable efficacy,[18] but particularly important is the notion that it is the individual woman all by herself who can determine her employment fate.

Feminists tend to be skeptical of an analysis which explains total wage differences between men and women on differences in productivity. With the neoclassical model this leaves only one other conclusion: that discrimination is simply an irrational, anachronistic practice: a matter of prejudice, and not a structural feature of the system. This is comforting to some because it implies that, in fact, equality between men and women is perfectly compatible with the economic system: it is just that some people are not behaving rationally, so it is necessary to point out to them that discrimination is bad business; when everyone understands this, there will be no problem.

The conclusions of neoclassical analysis are perfectly correct *if* the assumptions on which the analysis originates are true. I maintain that the theory takes as "given" precisely those conditions which most affect female labour. For example, theory states that the total number of labourers is given. J. R. Hicks explains this by saying that any question of changes in the total numbers of workers available "is one which modern economists are content to treat as lying outside the theory of wages. It may be regarded as belonging to the theory of population."[19] The best neoclassical theory can do is to tell us that with a given labour force the number employed will vary directly in response to changes in the real wage (which is equal to the marginal product). If people are unemployed, then it means they are unwilling to accept the wage they are worth. Of course the validity of the theory of the direct relationship between the level of employment and the real wage in all instances was disproven by Keynes some time ago,

but it still remains a basic assumption of all neoclassical explanation of wage differences. For women, one of the most important issues is why the size of the labour force changes; this is an issue which economics feels is beyond its purview. If the size of the labour force varies and unemployment does exist, which we know it does, then the whole framework of assuming that employers are competing against each other for scarce workers simply is not true: the result is that the whole neoclassical analysis falls. While the most serious problem with neoclassical analysis is the assumption that the size of the labour force is given and that full employment will be the normal condition of the economy, there are other assumptions of the model which are specifically unrelated to the conditions of female employment. These are the assumptions of freedom of contract and mobility of labour. Women, for most of the history of industrialized countries, have been restricted from access to all but a handful of jobs, so freedom of contract cannot be seen as ever having applied to the condition of female labour. Female labour, particularly for married women, is also severely restricted in its mobility, so the notion that labour is free to move from place to place in search of the wage equal to its marginal productivity is ludicrous when applied to women in general.

That pure competition has been an approximation of any real condition is doubtful; but as an approximation of the female condition of the market, it is surely false. Women simply have not had access to the market under the same conditions as men, yet this fact is not recognized by economic analysis. For example, Alfred Marshall, that pioneer of neoclassical thought, was one of the most ardent defenders of a free unfettered market, yet he clearly did not understand that his view of women was a contradiction of this notion. Beatrice Webb describes a conversation with him in which he expressed his views.

> It opened with chaff about men and women: he holding that woman was a subordinate being, and that, if she ceased to be subordinate, there would be not object for a man to marry. That marriage was a sacrifice of masculine freedom, and would only be tolerated by male creatures so long as it meant the devotion, body and soul, of the female to the male. Hence the woman must not develop her faculties in a way unpleasant to the man: that strength, courage and independence were not attractive in women: that rivalry in men's pursuits was positively unpleasant. Hence masculine strength and masculine ability in women must be firmly trampled on and boycotted by men. *Contrast* was the essence of the matrimonial relation: feminine weakness contrasted with masculine strength: masculine egoism with feminine self-devotion. If you compete with us we shan't marry you, he summed up with a laugh.

(Webb 1971:350)

There is a real danger when neoclassical ideas are used by economists who appear to be sympathetic to women and who seem to want to truly understand the economic condition of women. Ultimately, they merely reinforce the androcentric view of female behaviour. All of the economic theories of discrimination use the neoclassical method-

ology without questioning its assumptions.[20] In addition, the neoclassical theories about how individuals in the household allocate time between the market and the home, and between the sexes, is predicated on the market as being perfectly competitive.

The neoclassical model was developed with a blind eye toward women. Women's economic activity was not a part of the original conception of the model, and fitting them in the existing analysis now does not work. The methods are simply misleading when they try to explain why women earn less than men, why more woman are working for pay, why women do some jobs and men others, and why women do housework.

Footnotes

1. Alfred Marshall, *Principles of Economics* (London: Macmillan, 1927), 8th edition, p. 1.
2. *Ibid*, p. 14.
3. *Ibid*, p. 27.
4. Lionel Robbins, *An Essay on the Nature & Significance of Economic Science* (London: Macmillan, 1935), 2nd edition, p. 24.
5. Paul Samuelson, *Economics* (Montréal: McGraw-Hill, 1976), 10th edition, p. 3.
6. Jacob Viner is a notable exception to this. For him, "economics is what economists do," quoted in Kenneth Boulding, *Economic Analysis* (New York: Harper & Brothers, 1948), p. 3.
7. Gary Becker, for example, states most explicitly that economic theory is well on its way "to providing a unified framework for *all* behaviour involving scarce resources, nonmarket as well as market, nonmonetary as well as monetary, small group as well as competitive." "A Theory of Marriage: Part I" in *Journal of Political Economy.* July/August 1973, p. 814.
8. Samuelson, *op. cit.*, p. 199: also Richard G. Lipsey and Peter O. Steiner, *Economies* (New York: Harper & Row-1966), note 4, p. 151.
9. Samuelson, *op. cit.*, p. 199. This is a point of view which is echoed even by women who are sympathetic to the inclusion of housework in the GNP. Gail Cook and Mary Eberts say "since activity within the household does not change markedly over the period of business cycles, its inclusion has not been essential to appropriate policy decisions." Cook and Eberts, "Policies Affecting Work" in Cook 1976:146.
10. A. B. Atkinson, *The Economics of Inequality* (Oxford: Claredon, 1975), p. 164.: John Kenneth Galbraith, *Economics and the Public Purpose* (Boston: Houghton Mifflin, 1973), p. 33. In Canada, the estimates of the value of housework range from 34–40% of GNP, depending on the method of calculation used. See Hawrylyshyn 1971:33.

11. Judith Alexander, "Women and Unpaid Work: The Economic Consequences" in *Atlantis*, Spring 1979, pp. 204-5; Cook & Eberts *op. cit.*, p. 147; Hawrylyshyn 1971:10.

12. This is not a problem which is peculiar to capitalism. Market analysis is so central a part of economic thought that even socialist economic theory does not escape it. In socialist economic theory there is no *theoretical* basis for rational economic decision-making without a market mechanism, and so far the only solution to this is to treat non-market economies as if their activity were governed by a "shadow" market. See Oskar Lange and Fred Taylor, *On the Economic Theory of Socialism* (New York: McGraw-Hill, 1964); also J. G. Zielinki, *On the Theory of Socialist Planning* (Ibadan: Oxford University Press, 1968).

13. Karl Polanyi, *The Great Transformation* (Boston: Beacon Press, 1957), p. 158.

14. Sidney Pollard, *The Genesis of Modern Management* (London: Edward Arnold, 1965), Chapter 5; E. P. Thompson, *The Making of the English Working Class* (Harmondsworth: Penguin Books, 1963), especially Chapter 6; Harold Perkin, *The Origins of Modern English Society 1780–1880* (London: Routledge & Kegan Paul, 1969), especially Chapter VIII.

15. See Gary Becker, "A Theory of Marriage: Part I" and "A Theory of the Allocation of Time" in *The Economic Journal*, September 1965, pp. 512–516.

16. For those who have managed to avoid all economic courses, or who have suppressed the experience, the term means that workers will be paid a wage equal to the value of the increase in total production as a result of their labour.

17. Francine D. Blau and Carol L. Jusenius, "Economists' Approaches to Sex Segregation in the Labor Market: An Appraisal" in Blaxall & Reagan 1976:185. For an explanation of the economists' difficulty, see Kenneth Arrow, "Economic Dimensions of Occupational Segregation: Comment I" in Blaxall & Reagan 1976.

18. Isabel V. Sawhill, for example, feels that special programmes should be designed for inexperienced workers. What she has in mind are "special apprenticeships at below-market wage rates" so that employers would have an incentive to hire workers they normally discriminate against. "On the Way to Full Equality" in Cohn 1979:46.

19. J. R. Hicks, *The Theory of Wages* (London: Macmillan, 1963), 2nd edition, p. 2.

20. Specifically I am referring to the following approaches to discrimination: the crowding hypothesis explained by Barbara R. Bergman. "The Effect on White Incomes of Discrimination in Employment" in *Journal of Political Economy*, March/April 1971; the human capital approach found in the work of Gary Becker and Jacob Mincer; the statistical theory of sexism of Edmund Phelps; and the internal labour market approach of Blau and Jusenius.

The Master's Tools Will Never Dismantle the Master's House

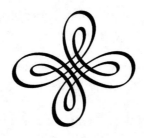

Audre Lorde

I agreed to take part in a New York University Institute for the Humanities conference a year ago, with the understanding that I would be commenting upon papers dealing with the role of difference within the lives of American women: difference of race, sexuality, class and age. The absence of these considerations weakens any feminist discussion of the personal and the political.

It is a particular academic arrogance to assume any discussion of feminist theory without examining our many differences,

and without a significant input from poor women, Black and Third World women and lesbians. And yet, I stand here as a Black lesbian feminist, having been invited to comment within the only panel at this conference where the input of Black feminists and lesbians is represented. What this says about the vision of this conference is sad, in a country where racism, sexism and homophobia are inseparable. To read this program is to assume that lesbian and Black women have nothing to say about existentialism, the erotic, women's culture and silence, developing feminist theory, or heterosexuality and power. And what does it mean in personal and political terms when even the two Black women who did present here were literally found at the last hour? What does it mean when the tools of a racist patriarchy are used to examine the fruits of that same patriarchy? It means that only the most narrow perimeters of change are possible and allowable.

The absence of any consideration of lesbian consciousness or the consciousness of Third World women leaves a serious gap within this conference and within the papers presented here. For example, in a paper on material relationships between women, I was conscious of an either/or model of nurturing which totally dismissed my knowledge as a Black lesbian. In this paper there was no examination of mutuality between women, no systems of shared support, no interdependence as exists between lesbians and women-identified women. Yet it is only in the patriarchal model of nurturance that women 'who attempt to emancipate themselves pay perhaps too high a price for the results', as this paper states.

For women, the need and desire to nurture each other is not pathological but redemptive, and it is within that knowledge that our real power is rediscovered. It is this real connection which is so feared by a patriarchal world. Only within a patriarchal structure is maternity the only social power open to women.

Interdependency between women is the way to a freedom which allows the *I* to *be*, not in order to be used, but in order to be creative. This is a difference between the passive *be* and the active *being*.

Advocating the mere tolerance of difference between women is the grossest reformism. It is a total denial of the creative function of difference in our lives. Difference must be not merely tolerated, but seen as a fund of necessary polarities between which our creativity can spark like a dialectic. Only then does the necessity for interdependency become unthreatening. Only within that interdependency of different strengths, acknowledged and equal, can the power to seek new ways of being in the world generate, as well as the courage and sustenance to act where there are no charters.

Within the interdependence of mutual (nondominant) differences lies that security which enables us to descend into the chaos of knowledge and return with true visions of our future, along with the concomitant power to effect those changes which can bring that future into being. Difference is that raw and powerful connection from which our personal power is forged.

As women, we have been taught either to ignore our differences, or to view them as causes for separation and suspicion rather than as forces for change. Without community there is no liberation, only the most vulnerable and temporary armistice between an individual and her oppression. But community must not mean a shedding of our differences, not the pathetic pretense that these differences do not exist.

Those of us who stand outside the circle of this society's definition of acceptable women; those of us who have been forged in the crucibles of difference—those of us who are poor, who are lesbians, who are Black, who are older—know that *survival is not an academic skill.* It is learning how to stand alone, unpopular and sometimes reviled, and how to make common cause with those others identified as outside the structures in order to define and seek a world in which we can all flourish. It is learning how to take our differences and make them strengths. *For the master's tools will never dismantle the master's house.* They may allow us temporarily to beat him at his own game, but they will never enable us to bring about genuine change. And this fact is only threatening to those women who still define the master's house as their only source of support.

Poor women and women of color know there is a difference between the daily manifestations of marital slavery and prostitution because it is our daughters who line 42nd Street. If white American feminist theory need not deal with the differences between us, and the resulting difference in our oppressions, then how do you deal with the fact that the women who clean your houses and tend your children while you attend conferences on feminist theory are, for the most part, poor women and women of color? What is the theory behind racist feminism?

In a world of possibility for us all, our personal visions help lay the groundwork for political action. The failure of academic feminists to recognize difference as a crucial strength is a failure to reach beyond the first patriarchal lesson. In our world, divide and conquer must become define and empower.

Why weren't other women of color found to participate in this conference? Why were two phone calls to me considered a consultation? Am I the only possible source of names of Black feminists? And although the Black panelist's paper ends on an important and powerful connection of love between women, what about interracial cooperation between feminists who don't love each other?

In academic feminist circles, the answer to these questions is often, 'We did not know who to ask.' But that is the same evasion of responsibility, the same cop-out, that keeps Black women's art out of women's exhibitions, Black women's work out of most feminist publications except for the occasional 'Special Third World Women's Issue', and Black women's texts off your reading lists. But as Adrienne Rich pointed out in a recent talk, white feminists have educated themselves about such an enormous amount over the past ten years, how come you haven't also educated yourselves about Black women and the differences between us—white and Black—when it is key to our survival as a movement?

Women of today are still being called upon to stretch across the gap of male ignorance and to educate men as to our existence and our needs. This is an old and primary tool of all oppressors to keep the oppressed occupied with the master's concerns. Now we hear that it is the task of women of color to educate white women—in the face of tremendous resistance—as to our existence, our differences, our relative roles in our joint survival. This is a diversion of energies and a tragic repetition of racist patriarchal thought.

Simone de Beauvoir once said: 'It is in the knowledge of the genuine conditions of our lives that we must draw our strength to live and our reasons for acting.'[1]

Racism and homophobia are real conditions of all our lives in this place and time. I urge each one of us here to reach down into that deep place of knowledge inside herself and touch that terror and loathing of any difference that lives there. See whose face it wears. Then the personal as the political can begin to illuminate all our choices.

Footnote

1. Simone de Beauvoir, *The Second Sex*, transl. ed. H. M. Parshley (New York: Bantam, 1961).

The Impoverishment of the Environment: Women and Children Last*

Vandana Shiva

\mathcal{R}uth Sidel's book, *Women and Children Last*[1] opens with an account of the sinking of the unsinkable *Titanic*. Women and children were, indeed, the first to be saved on that dreadful night—that is, those in the first and second class. But the majority of women and children did not survive—they were in the third class.

The state of the global economy is in many ways comparable to the *Titanic:* glittering and affluent and considered unsinkable. But as Ruth Sidel observed, despite our side-walk cafes, our saunas, our luxury boutiques, we, too, lack lifeboats for everyone when disaster strikes. Like the *Titanic,* the global economy has too many locked gates, segregated decks and policies ensuring that women and children will be first—not to be saved, but to fall into the abyss of poverty.

Environmental Degradation and Poverty Creation

Development was to have created well-being and affluence for all in the Third World. For some regions, and some people, it has delivered that promise, but for most regions and people, it has instead brought environmental degradation and poverty. Where did the development paradigm go wrong?

Firstly, it focused exclusively on a model of progress derived from Western industrialized economies, on the assumption that Western style progress was possible for all. Development, as the improved well-being of all, was thus equated with the Westernization of economic categories—of human needs, productivity, and growth. Concepts and categories relating to economic development and natural resource utilization that had emerged in the specific context of industrialization and capitalist growth in a centre of colonial power, were raised to the level of universal assumptions and thought to be successfully applicable in the entirely different context of basic-needs satisfaction for the people of the erstwhile colonies—newly independent Third World countries. Yet, as Rosa Luxemburg[2] has pointed out, early industrial development in Western Europe necessitated permanent occupation of the colonies by the colonial powers, and the destruction of the local 'natural economy'. According to Luxemburg, colonialism is a constant, necessary condition for capitalist growth: without colonies, capital accumulation would grind to a halt. 'Development' as capital accumulation and the commercialization of the economy for the generation of 'surplus' and profits thus involved the reproduction of not only a particular form of wealth creation, but also of the associated creation of poverty and dispossession. A replication of economic development based on commercialization of resource-use for commodity production in the newly independent countries created internal colonies and perpetuated old colonial linkages. Development thus became a continuation of the colonization process; it became an extension of the project of wealth creation in modern, Western patriarchy's economic vision.

Secondly, development focused exclusively on such financial indicators as GNP (gross national product). What these indicators could not demonstrate was the environmental destruction and the creation of poverty associated with the development process. The problem with measuring economic growth in GNP is that it measures some costs as benefits (for example, pollution control) but fails to fully measure other costs. In GNP calculations clear-felling a natural forest adds to economic growth, even

though it leaves behind impoverished ecosystems which can no longer produce biomass or water, and thus also leaves impoverished forest and farming communities.

Thirdly, such indicators as GNP can measure only those activities that take place through the market mechanism, regardless of whether or not such activities are productive, unproductive or destructive.

In the market economy, the organizing principle for natural resource use is maximization of profits and capital accumulation. Nature and human needs are managed through market mechanisms. Natural resources demands are restricted to those registering on the market; the ideology of development is largely based on a notion of bringing all natural resources into the market economy for commodity production. When these resources are already being used by nature to maintain production of renewable resources, and by women for sustenance and livelihood, their diversion to the market economy generates a scarcity condition for ecological stability and creates new forms of poverty for all, especially women and children.

Finally, the conventional paradigm of development perceives poverty only in terms of an absence of Western consumption patterns, or in terms of cash incomes and therefore is unable to grapple with self-provisioning economies, or to include the poverty created by their destruction through development. In a book entitled *Poverty: the Wealth of the People*,[3] an African writer draws a distinction between poverty as subsistence, and poverty as deprivation. It is useful to separate a cultural conception of subsistence living as poverty from the material experience of poverty resulting from dispossession and deprivation. Culturally perceived poverty is not necessarily real material poverty: subsistence economies that satisfy basic needs through self-provisioning are not poor in the sense of deprivation. Yet the ideology of development declares them to be so because they neither participate overwhelmingly in the market economy nor consume commodities produced for and distributed through the market, even though they might be satisfying those basic needs through self-provisioning mechanisms. People are perceived as poor if they eat millets (grown by women) rather than commercially produced and distributed processed foods sold by global agribusiness. They are seen as poor if they live in houses self-built with natural materials like bamboo and mud rather than concrete. They are seen as poor if they wear home-made garments of natural fibre rather than synthetics. Subsistence, as culturally perceived poverty, does not necessarily imply a low material quality of life. On the contrary, millets, for example, are nutritionally superior to processed foods, houses built with local materials rather than concrete are better adapted to the local climate and ecology, natural fibres are generally preferable to synthetic ones—and often more affordable. The cultural perception of prudent subsistence living as poverty has provided legitimization for the development process as a 'poverty-removal' project. 'Development', as a culturally biased process destroys wholesome and sustainable lifestyles and instead creates real material poverty, or misery, by denying the means of survival through the diversion of resources to resource-intensive commodity production. Cash crop production and food processing, by diverting land and water resources away from sustenance needs deprive increasingly large numbers of people from the means of satisfying their entitlements to food.

The resource base for survival is being increasingly eroded by the demand for resources by the market economy, dominated by global forces. The creation of inequality through ecologically disruptive economic activity arises in two ways: first, inequalities in the distribution of privileges and power make for unequal access to natural resources—these include privileges of both a political and economic nature. Second, government policy enables resource intensive production processes to gain access to the raw material that many people, especially from the less privileged economic groups, depend upon for their survival. Consumption of this raw material is determined solely by market forces, unimpeded by any consideration of the social or ecological impact. The costs of resource destruction are externalized and divided unequally among various economic groups in society, but these costs are borne largely by women and those who, lacking the purchasing power to register their demands on the modern production system's goods and services, provide for their basic material needs directly from nature.

The paradox and crisis of development results from mistakenly identifying culturally perceived poverty with real material poverty, and of mistaking the growth of commodity production as better satisfying basic needs. In fact, however water, soil fertility, and genetic wealth are considerably diminished as a result of the development process. The scarcity of these natural resources, which form the basis of nature's economy and especially women's survival economy, is impoverishing women, and all marginalized peoples to an unprecedented extent. The source of this impoverishment is the market economy, which has absorbed these resources in the pursuit of commodity production.

Impoverishment of Women, Children and the Environment

The UN Decade for Women was based on the assumption that the improvement of women's economic position would automatically flow from an expansion and diffusion of the development process. By the end of the Decade, however, it was becoming clear that development itself was the problem. Women's increasing underdevelopment was not due to insufficient and inadequate 'participation' in 'development' rather, it was due to their enforced but asymmetric participation whereby they bore the costs but were excluded from the benefits. Development and dispossession augmented the colonial processes of ecological degradation and the loss of political control over nature's sustenance base. Economic growth was a new colonialism, draining resources away from those who most needed them. But now, it was not the old colonial powers but the new national elites that masterminded the exploitation on grounds of 'national interest' and growing GNPs, and it was accomplished by more powerful technologies of appropriation and destruction.

Ester Boserup[4] has documented how women's impoverishment increased during colonial rule; those rulers who had for centuries subjugated and reduced their own women to the status of de-skilled, de-intellectualized appendages, discriminated

against the women of the colonies on access to land, technology and employment. The economic and political processes of colonial underdevelopment were clear manifestations of modern Western patriarchy, and while large numbers of men as well as women were impoverished by these processes, women tended to be the greater losers. The privatization of land for revenue generation affected women more seriously, eroding their traditional land-use rights. The expansion of cash crops undermined food production, and when men migrated or were conscripted into forced labour by the colonizers women were often left with meagre resources to feed and care for their families. As a collective document by women activists, organizers and researchers stated at the end of the UN Decade for Women:

> The almost uniform conclusion of the Decade's research is that with a few exceptions, women's relative access to economic resources, incomes and employment has worsened, their burden of work has increased, and their relative and even absolute health, nutritional and educational status has declined.[5]

Women's role in the regeneration of human life and the provisioning of sustenance has meant that the destructive impact on women and the environment extends into a negative impact on the status of children.

The exclusive focus on incomes and cash-flows as measured in GNP has meant that the web of life around women, children and the environment is excluded from central concern. The status of women and children and the state of the environment have never functioned as 'indicators' of development. This exclusion is achieved by rendering invisible two kinds of processes. Firstly, nature's, women's and children's contribution to the growth of the market economy is neglected and denied. Dominant economic theories assign no value to tasks carried out at subsistence and domestic levels. These theories are unable to encompass the majority in the world—women and children—who are statistically 'invisible'. Secondly the negative impact of economic development and growth on women, children and environment goes largely unrecognized and unrecorded. Both these factors lead to impoverishment.

Among the hidden costs generated by destructive development are the new burdens created by ecological devastation, costs that are invariably heavier for women, in both the North and South. It is hardly surprising, therefore, that a rising GNP does not necessarily mean that either wealth or welfare increase proportionately. I would argue that GNP is becoming increasingly a measure of how real wealth—the wealth of nature and the life sustaining wealth produced by women—is rapidly decreasing. When commodity production as the prime economic activity is introduced as development, it destroys the potential of nature and women to produce life and goods and services for basic needs. More commodities and more cash mean less life—in nature through ecological destruction and in society through denial of basic needs. Women are devalued, first, because their work co-operates with nature's processes, and second, because work that satisfies needs and ensures sustenance is devalued in general. More growth in what is maldevelopment has meant less nurturing of life and life support systems.

Nature's economy—through which environmental regeneration takes place—and the people's subsistence economy—within which women produce the sustenance for society through 'invisible' unpaid work called non-work—are being systematically destroyed to create growth in the market economy. Closely reflecting what I have called the three economies, of nature, people and the market in the Third World context, is Hilkka Pietila's[6] categorization of industrialized economies as: the free economy; the protected sector; and the fettered economy.

The free economy: the non-monetary core of the economy and society, unpaid work for one's own and family needs, community activities, mutual help and co-operation within the neighbourhood and so on.

The protected sector: production, protected and guided by official means for domestic markets; food, constructions, services, administration, health, schools and culture, and so on.

The fettered economy: large-scale production for export and to compete with imports. The terms dictated by the world market, dependency, vulnerability, compulsive competitiveness and so forth.

For example, in 1980, the proportions of time and money value that went into running each category of the Finnish economy were as follows!

Table 5.1

	Time	Money
A. The free economy, informal economy	54%	35%
B. Protected sector	36%	46%
C. The fettered economy	10%	19%

In patriarchal economics, B and C are perceived as the primary economy, and A as the secondary economy. In fact as Marilyn Waring[7] has documented, national accounts and GNP actually exclude the free economy as lying outside the production boundary. What most economists and politicians call the 'free' or 'open' economy is seen by women as the 'fettered' economy. When the fettered economy becomes 'poor'—that is, runs into deficit—it is the free economy that pays to restore it to health. In times of structural adjustment and austerity programmes, cuts in public expenditure generally fall most heavily on the poor. In many cases reduction of the fiscal deficit has been effected by making substantial cuts in social and economic development expenditure, and real wages and consumption decrease considerably.

The poverty trap, created through the vicious cycle of 'development', debt, environmental destruction and structural adjustment is most significantly experienced by women and children. Capital flows North to South have been reversed. Ten years ago, a net $40 billion flowed from the Northern hemisphere to the countries of the South. Today in terms of loans, aid, repayment of interest and capital, the South transfers $20

billion a year to the North. If the effective transfer of resources implied in the reduced prices industrialized nations pay for the developing world's raw materials is taken into account, the annual flow from the poor to the rich countries could amount to $60 billion annually. This economic drain implies a deepening of the crisis of impoverishment of women, children and the environment.

According to UNICEF estimates, in 1988[8] half-a-million children died as a direct result of debt-related adjustment policies that sustain the North's economic growth. Poverty, of course, needs to be redefined in the emerging context of the feminization of poverty on the one hand, and the link to environmental impoverishment on the other.

Poverty is not confined to the so-called poor countries; it exists in the world's wealthiest society. Today, the vast majority of poor people in the US are women and children. According to the Census Bureau, in 1984, 14.4 percent of all Americans (33.7 million) lived below the poverty line. From 1980 to 1984 the number of poor people increased by four-and-a-half million. For female-headed households in 1984, the poverty rate was 34.5 percent—five times that for married couples. The poverty rate for white, female-headed families was 27.1 percent; for black, woman-headed families, 51.7 percent; and for woman-headed Hispanic families, 53.4 percent. The impact of women's poverty on the economic status of children is even more shocking: in 1984, the poverty rate for children under six was 24 percent, and in the same year, for children living in women-headed households it was 53.9 percent. Among black children the poverty rate was 46.3 percent; and for those living in female-headed families, 66.6 percent. Among Hispanic children 39 percent were poor, and for those living in female-headed families, the poverty rate was 70.5 percent.[9]

Theresa Funiciello, a welfare rights organizer in the US, writes that 'By almost any honest measure, poverty is the number one killer of children in the U.S.' (Waring, 1988).

In New York City, 40 percent of the children (700,000) are living in families that the government classifies deprived as 7,000 children are born addicted to drugs each year, and 12,000 removed to foster homes because of abuse or neglect (Waring 1988).

The first right mentioned in the Convention of the Rights of the Child is the inherent right to life. Denial of this right should be the point of departure for evolving a definition of poverty. It should be based on denial of access to food, water and shelter in the quality and quantity that makes a healthy life possible.

Pure income indicators often do not capture the poverty of life to which the future generations are being condemned, with threats to survival from environmental hazards even in conditions otherwise characterized by 'affluence'. Poverty has so far been culturally perceived in terms of life styles that do not fit into the categories of Western industrial society. We need to move away from these restricted and biased perceptions to grapple with poverty in terms of threats to a safe and healthy life either due to denial of access to food, water and shelter, or due to lack of protection from hazards in the form of toxic and nuclear threats.

Human scale development can be a beginning of an operational definition of poverty as a denial of vital human needs. At the highest level, the basic needs have been identified

as subsistence, protection, affection, understanding, participation, leisure, creation, identity, freedom. These needs are most clearly manifest in a child, and the child can thus become our guide to a humane, just and sustainable social organization, and to a shift away from the destructiveness of what has been construed as 'development.'[10]

While producing higher cash flows, patriarchal development has led to deprivation at the level of real human needs. For the child, these deprivations can become life threatening, as the following illustrates.

The Food and Nutrition Crisis

Both traditionally, and in the context of the new poverty, women and children have been treated as marginal to food systems. In terms of nutrition the girl-child is doubly discriminated against in such countries as India (see Table 5.2)[11].

Table 5.2

Foods received by male and female children 3–4 and 7–9 years (India)

Food items in grams				Age in years		
		3–4			*7–9*	
	RDA	*Male*	*Female*	*RDA*	*Male*	*Female*
Cereals	173	118	90	250	252	240
Pulses	55	22	18	70	49	25
Green leafy vegetables	62	3	0	75	0	0
Roots and tubers	40	15	13	50	42	0
Fruits	50	30	17	50	17	6
Milk	225	188	173	250	122	10
Sugar and jaggery	22	13	16	30	30	12
Fats and oils	30	5	2	50	23	8

Source: Devadas, R. and G. Kamalanathan, 'A Women's First Decade', Paper presented at the Women's NGO Consultation on Equality, Development and Peace, New Delhi, 1985.

The effects of inadequate nourishment of young girls continue into their adulthood and are passed on to the next generation. Complications during pregnancy, premature births and low birth weight babies with little chance of survival result when a mother is undernourished; and a high percentage of deaths during pregnancy and childbirth are directly due to anaemia, and childhood undernourishment is probably an underly-

ing cause.[12] Denial of nutritional rights to women and children is the biggest threat to their lives.

Programmes of agricultural 'development' often become programmes of hunger generation because fertile land is diverted to grow export crops, small peasants are displaced, and the biological diversity, which provided much of the poor's food entitlements, is eliminated and replaced by cash crop monocultures, or land-use systems ill-suited to the ecology or to the provision of people's food entitlements. A permanent food crisis affects more than a 100 million people in Africa; famine is just the tip of a much bigger underlying crisis. Even when Ethiopia is not suffering from famine, 1,000 children are thought to die each day of malnutrition and related illnesses.[13]

Everywhere in the South, the economic crisis rooted in maldevelopment is leading to an impoverishment of the environment and a threat to the survival of children. It is even possible to quantify the debt mortality effect: over the decade of 1970 to 1980, each additional $10 a year interest payments per capita reflected 0.39 of a year less in life expectancy improvement. This is an average of 387 days of life foregone by every inhabitant of the 73 countries studied in Latin America.[14] Nutritional studies carried out in Peru show that in the poorest neighbourhoods of Ijma and surrounding shanty towns, the percentage of undernourished children increased from 24 percent in 1972 to 28 percent in 1978 and to 36 percent in 1983.

In Argentina, according to official sources, in 1986 685,000 children in greater Buenos Aires and a further 385,000 in the province of Buenos Aires did not eat enough to stay alive; together constituting one-third of all children under 14.[15]

Starvation is endemic in the ultra-poor north-east of Brazil, where it is producing what IBASE (a public interest research group in Brazil) calls a 'sub-race' and nutritionists call an epidemic of dwarfism. The children in this area are 16 percent shorter and weigh 20 percent less than those of the same age elsewhere in Brazil—who, themselves, are not exactly well-nourished.

In Jamaica, too, food consumption has decreased as is shown:

Table 5.3

Item	No. of calories August 1984	No. of calories November 1985	Change %
Flour	2,232	1,443	−35
Cornmeal	3,669	2,013	−45
Rice	1,646	905	−45
Chicken	220	174	−20
Condensed milk	1,037	508	−51
Oil	1,003	823	−18
Dark sugar	1,727	1,253	−27

Source: Susan George, *A Fate Worse than Debt*, 1988, p. 188.

As the price of food rose beyond people's ability to pay, children's health demonstratively declined. In 1978, fewer than two percent of children admitted to the Bustamente Children's Hospital were suffering from malnutrition, and 1.6 percent from malnutrition-related gastro-enteritis. By 1986, when the full effects of the adjustment policies were being felt, the figures for malnutrition-related admissions had doubled, to almost 4 percent; gastro-enteritis admissions were almost 5 percent.[16]

Numerical malnutrition is the most serious health hazard for children, particularly in the developing countries. Surveys in different regions of the world indicate that at any moment an estimated ten million children are suffering from severe malnutrition and a further 200 million are inadequately nourished.[17]

The increase in nutritional deprivation of children is one result of the same policies that lead to the nutritional deprivation of soils. Agriculture policies which extract surplus to meet export targets and enhance foreign exchange earnings generate that surplus by creating new levels of nutritional impoverishment for women, children and the environment. As Maria Mies has pointed out,[18] this concept of surplus has a patriarchal bias because, from the point of view of nature, women and children, it is based not on material surplus produced *over and above* the requirements of the environment or of the community, it is violently stolen and appropriated from nature (which needs a share of her produce to reproduce herself) and from women (who need a share of nature's produce to sustain and to ensure the survival of themselves and their children). Malnutrition and deficiency diseases are also caused by the destruction of biodiversity which forms the nutritional base in subsistence communities. For example, *bathua* is an important green leafy vegetable with very high nutritive value which grows in association with wheat, and when women weed the wheat field they not only contribute to the productivity of wheat but also harvest a rich nutritional source for their families. With the intensive use of chemical fertilizer, however, *bathua* becomes a major competitor of wheat and has been declared a 'weed' to be eliminated by herbicides. Thus, the food cycle is broken; women are deprived of work; children are deprived of a free source of nutrition.

The Water Crisis

The water crisis contributes to 34.6 percent of all child deaths in the Third World. Each year, 5,000,000 children die of diarrhoeal diseases.[19] The declining availability of water resources, due to their diversion for industry and industrial agriculture and to complex factors related to deforestation, desertification and drought, is a severe threat to children's health and survival. As access to water decreases, polluted water sources and related health hazards, increase. 'Development' in the conventional paradigm implies a more intensive and wasteful use of water—dams and intensive irrigation for green revolution agriculture, water for air-conditioning mushrooming hotels and urban-industrial complexes, water for coolants, as well as pollution due to the dump-

ing of industrial wastes. And as development creates more water demands, the survival needs of children—and adults—for pure and safe water are sacrificed.

Antonia Alcantara, a vendor from a slum outside Mexico City, complains that her tap water is 'yellow and full of worms'. Even dirty water is in short supply. The demands of Mexico City's 20 million people have caused the level of the main aquifer to drop as much as 3.4 metres annually.[20] Those with access to Mexico City's water system are usually the wealthy and middle classes. They are, in fact, almost encouraged to be wasteful by subsidies that allow consumers to pay as little as one-tenth the actual cost of water. The poor, on the other hand, are often forced to buy from *piperas*, entrepreneurs, who fix prices according to demand.

In Delhi, in 1988, 2,000 people (mainly children) died as a result of a cholera epidemic in slum colonies. These colonies had been 'resettled' when slums were removed from Delhi to beautify India's capital. This dispensable population was provided with neither safe drinking water, nor adequate sewage facilities; it was only the children of the poor communities who died of cholera. Across the Yamuna river, the swimming pools had enough chlorinated water to protect the tourists, the diplomats, the elite.[21]

Toxic Hazards

In the late twentieth century it is becoming clear that our scientific systems are totally inadequate to counteract or eliminate the hazards—actual and potential—to which children, in particular, are subjected. Each disaster seems like an experiment, with children as guinea pigs, to teach us more about the effects of deadly substances that are brought into daily production and use. The patriarchal systems would like to maintain silence about these poisonous substances, but as mothers women cannot ignore the threats posed to their children. Children are the most highly sensitive to chemical contamination, the chemical pollution of the environment is therefore most clearly manifested in their ill-health.

In the Love Canal and the Bhopal disasters, children were the worst affected victims. And in both places it is the women who have continued to resist and have refused to be silenced as corporations and state agencies would wish.

Love Canal was a site where, for decades, Hooker Chemical Company had dumped their chemical wastes, over which houses were later built. By the 1970s it was a peaceful middle-class residential area but its residents were unaware of the toxic dumps beneath their houses. Headaches, dizziness, nausea and epilepsy were only a few of the problems afflicting those near the Canal. Liver, kidney, or recurrent urinary strictures abounded. There was also an alarmingly high rate of 56 percent risk of birth defects, including childhood deafness, and children suffered an unusually high rate of leukemia and other cancers.[22] There was a 75 percent above normal rate of miscarriage, and among 15 pregnancies of Love Canal women, only two resulted in healthy babies.

It was the mothers of children threatened by death and disease who first raised the alarm and who kept the issue alive.

In Japan, the dependence of Minamata Bay's fishermen and their families on a fish diet had disastrous results as the fish were heavily contaminated with methylmercury, which had been discharged into the Bay over a period of 30 years by the Chissio chemical factory.

In Bhopal, in 1984, the leak from Union Carbide's pesticide plant led to instant death for thousands. A host of ailments still afflicts many more thousands of those who escaped death. In addition women also suffer from gynaecological complications and menstrual disorders. Damage to the respiratory, reproductive, nervous, musculo-skeletal and immune systems of the gas victims has been documented in epidemiological studies carried out so far. The 1990 report of the Indian Council of Medical Research[23] states that the death rate among the affected population is more than double that of the unexposed population. Significantly higher incidences of spontaneous abortions, still-births and infant mortality among the gas victims have also been documented.

> A few months after the gas disaster, I had a son. He was alright. After that I had another child in the hospital. But it was not fully formed. It had no legs and no eyes and was born dead. Then another child was born but it died soon after. I had another child just one and a half months back. Its skin looked scalded and only half its head was formed. The other half was filled with water. It was born dead and was white all over. I had a lot of pain two months before I delivered. My legs hurt so much that I couldn't sit or walk around. I got rashes all over my body. The doctors said that I will be okay after the childbirth, but I still have these problems.[24]

Nuclear Hazards

Hiroshima, Three Mile Island, the Pacific Islands, Chernobyl—each of these nuclear disasters reminds us that the nuclear threat is greater for future generations than for us.

Lijon Eknilang was seven years old at the time of the Bravo test on Bikini Island. She remembers her eyes itching, nausea and being covered by burns. Two days after the test, Lijon and her people were evacuated to the US base on Kwajalein Atoll. For three years they were kept away because Rongelap was too dangerous for life. Lijon's grandmother died in the 1960s due to thyroid and stomach cancer. Her father died during the nuclear test. Lijon reports that:

> I have had seven miscarriages and still-births. Altogether there are eight other women on the island who have given birth to babies that look like blobs of jelly. Some of these things we carry for eight months, nine months, there are no legs, no arms, no head, no nothing. Other children are born who will never recognise this world or their own parents. They just lie there with crooked arms and legs and never speak.[25]

Every aspect of environmental destruction translates into a severe threat to the life of future generations. Much has been written on the issue of sustainability, as 'inter-generational equity', but what is often overlooked is that the issue of justice between generations can only be realized through justice between sexes. Children cannot be put at the centre for concern if their mothers are meantime pushed beyond the margins of care and concern.

Over the past decades, women's coalitions have been developing survival strate-gies and fighting against the threat to their children that results from threats to the environment.

Survival Strategies of Women and Children

As survival is more and more threatened by negative development trends, environ-mental degradation and poverty, women and children develop new ways to cope with the threat.

Today, more than one-third of the households in Africa, Latin America and the de-veloped world are female headed; in Norway the figure is 38 percent, and in Asia 14 per-cent.[26] Even where women are not the sole family supporters they are primary supporters in terms of work and energy spent on providing sustenance to the family. For example, in rural areas women and children must walk further to collect the di-minishing supplies of firewood and water, in urban areas they must take on more paid outside work. Usually, more time thus spent on working to sustain the family conflicts with the time and energy needed for child care. At times girl children take on part of the mother's burden: in India, the percentage of female workers below 14 years in-creased from four to eight percent. In the 15–19 year age group, the labour force par-ticipation rate increased by 17 percent for females, but declined by eight percent for males.[27] This suggests that more girls are being drawn into the labour force, and more boys are sent to school. This sizeable proportion perhaps explains high female school dropout rates, a conclusion that is supported by the higher levels of illiteracy among female workers, compared with 50 percent for males. It has been projected that by the year 2001 work participation among 0–14 year old girls will increase by a further 20 per-cent and among 15–19 year olds by 30 percent.[28]

The International Labour Organization (ILO) has estimated that at the beginning of the 1980s the overall number of children under 15 who were 'economically active' was around 50 million; the World Health Organization (WHO) estimates put it at 100 million. There are another 100 million 'street' children, without families or homes. These are victims of poverty, underdevelopment, and poor environmental conditions—society's disposable people—surviving entirely on their own, without any rights, without any voice.

Chipko women of Himalaya have organized to resist the environmental destruction caused by logging.

The Love Canal home owner's association is another wellknown example of young housewives' persistent action to ensure health security for their families; this has now resulted in the Citizens' Clearinghouse for Hazardous Waste.

The Bhopal Gas Peedit Mahila Udyog Sangathan, a group of women victims of the Bhopal disaster, has continued to struggle for seven years to obtain justice from Union Carbide Corporation.

Across different contexts, in the North and in the South, in ecologically eroded zones and polluted places, women identify with the interest of the earth and their children in finding solutions to the crisis of survival. Against all odds they attempt to reweave the web which connects their life to the life of their children and the life of the planet. From women's perspective, sustainability without environmental justice is impossible, and environmental justice is impossible without justice between sexes and generations.

To whom will the future belong? to the women and children who struggle for survival and for environmental security? or to those who treat women, children and the environment as dispensable and disposable? Gandhi proposed a simple test for making decisions in a moment of doubt. 'Recall the face of the least privileged person you know', he said, 'and ask if your action will harm or benefit him/her.'[29] This criterion of the 'last person' must be extended to the 'last child' if we are serious about evolving a code of environmental justice which protects future generations.

Dispensability of the Last Child: The Dominant Paradigm

From the viewpoint of governments, intergovernmental agencies, and power elites, the 'last child' needs no lifeboat. This view has been explicitly developed by Garrett Hardin in his 'life-boat ethics'[30]: the poor, the weak are a 'surplus' population, putting an unnecessary burden on the planet's resources. This view, and the responses and strategies that emerge from it totally ignore the fact that the greatest pressure on the earth's resources is not from large numbers of poor people but from a small number of the world's ever-consuming elite.

Ignoring these resource pressures of consumption and destructive technologies, 'conservation' plans increasingly push the last child further to the margins of existence. Official strategies, reflecting elite interests, strongly imply that the world would be better off if it could shed its 'non-productive' poor through the life-boat strategy. Environmentalism is increasingly used in the rhetoric of manager-technocrats, who see the ecological crises as an opportunity for new investments and profits. The World Bank's Tropical Action Plan, the Climate Convention, the Montreal Protocol are often viewed as new means of dispossessing the poor to 'save' the forests and atmosphere and bio-

logical commons for exploitation by the rich and powerful. The victims are transformed into villains in these ecological plans—and women, who have struggled most to protect their children in the face of ecological threats, become the elements who have to be policed to protect the planet.[31]

'Population explosions' have always emerged as images created by modern patriarchy in periods of increasing social and economic polarizations. Malthus[32] saw populations exploding at the dawn of the industrial era; between World War I and II certain groups were seen as threatening deterioration of the human genetic stock; post World War II, countries where unrest threatened US access to resources and markets, became known as the 'population powderkegs'. Today, concern for the survival of the planet has made pollution control appear acceptable and even imperative, in the face of the popularized pictures of the world's hungry hordes.

What this focus on numbers hides is people's unequal access to resources and the unequal environmental burden they put on the earth. In global terms, the impact of a drastic decrease of population in the poorest areas of Asia, Africa and Latin America would be immeasurably smaller than a decrease of only five percent in the ten richest countries at present consumption levels.[33]

Through population control programmes, women's bodies are brutally invaded to protect the earth from the threat of over-population. Where women's fertility itself is threatened due to industrial pollution, their interest is put in opposition to the interests of their children. This divide and rule policy seems essential for managing the eco-crisis to the advantage of those who control power and privilege.

The emerging language of manager-technocrats describes women either as the passive 'environment' of the child, or the dangerous 'bomb' threatening a 'population explosion'. In either case, women whose lives are inextricably a part of children's lives have to be managed to protect children and the environment.

The mother's womb has been called the child's 'environment'. Even in the relatively sheltered environment of the mother's uterus the developing baby is far from completely protected. The mother's health, so intimately linked to the child's well-being is reduced to a 'factor within the foetus's environment'.

Similar decontextualized views of the womn-child relationship are presented as solutions to managing environmental hazards in the workplace. 'Foetal protection policies' are the means by which employers take the focus off their own hazardous production by offering to 'protect the unborn' by removing pregnant (or wanting-to-be pregnant) women from hazardous zones.[34] In extreme cases, women have consented to sterilization in order to keep their jobs and keep food on the table. More typically, practices include surveillance of women's menstrual cycles, of waiting for a woman to abort her pregnancy before employing her. As Lin Nelson has stated: 'It is all too easy to "assume pollution" and accept industrial relocation and obstetrical intervention, but they are responses to the symptoms, not the disease.'[35]

Grassroots Response

Community groups, NGOs, ecology movements and women's movements begin the reversal of environmental degradation by reversing the trends that push women and children beyond the edge of survival. As mentioned earlier, the Chipko movement in India has been one such response. In Kenya, the Green Belt movement has fostered 1,000 Community Green Belts. In Malaysia, the Sahabal Alain Malaysia (SAM) and Consumer Association of Penang have worked with tribal, peasant, and fishing communities to reverse environmental decline. Tribals' blockades against logging in Sarawak are another important action in which these organizations have been involved. In Brazil the Acao Democratica Feminina Gaucha (ADFG) has been working on sustainable agriculture, indigenous rights, debt and structural adjustment.

What is distinctive about these popular responses is that they put the last child at the centre of concern, and work out strategies that simultaneously empower women and protect nature. Emerging work on women, health and ecology, such as the dialogue organized by the Research Foundation of India and the Dag Hammarskjold Foundation of Sweden,[36] the Planeta Femea at the Global Forum in Rio 1992[37] are pointing to new directions in which children's, women's and nature's integrity are perceived in wholeness, not fragmentation.

Putting Women and Children First

In 1987, at the Wilderness Congress, Oren Lyons of the Onondaga Nation said: 'Take care how you place your moccasins upon the earth, step with care, for the faces of the future generations are looking up from the earth waiting for their turn for life.'[38]

In the achievements of growing GNPs, increasing capital accumulation, it was the faces of children and future generations that receded from the minds of policy makers in centres of international power. The child had been excluded from concern, and cultures which were child-centred have been destroyed and marginalized. The challenge to the world's policy makers is to learn from mothers, from tribals and other communities, how to focus decisions on the well-being of children.

Putting women and children first needs above all, a reversal of the logic which has treated women as subordinate because they create life, and men as superior because they destroy it. All past achievements of patriarchy have been based on alienation from life, and have led to the impoverishment of women, children and the environment. If we want to reverse that decline, the creation, not the destruction of life must be seen as the truly human task, and the essence of being human has to be seen in our capacity to recognize, respect and protect the right to life of all the world's multifarious species.

Footnotes

1. Sidel, Ruth, *Women and Children Last*. Penguin, New York, 1987.
2. Luxemburg, Rosa, *The Accumulation of Capital*. Routledge and Kegan Paul, London, 1951.
3. Quoted in R. Bahro, *From Red to Green*. Verso, London, 1984, p. 211.
4. Boserup, Ester, *Women's Role in Economic Development*. Allen and Unwin, London, 1960.
5. DAWN, 1985, *Development Crisis and Alternative Visions: Third World Women's Perspectives*. Christian Michelsen Institute, Bergen.
6. Pietila, Hilkka, *Tomorrow Begins Today*. ICDA/ISIS Workshop, Nairobi, 1985.
7. Waring, Marilyn *If Women Counted*. Harper & Row, San Francisco, 1988.
8. UNICEF, *State of the World's Children*, 1988.
9. Quoted in Marilyn Waring, op. cit. p. 180; and Ruth Sidel, op. cit.
10. Max-Neef, Manfred, *Human Scale Development, Development Dialogue*. Dag Hammarskjold Foundation, 1989.
11. Chatterjee, Meera, *A Report on Indian Women from Birth to Twenty*. National Institute of Public Cooperation and Child Development, New Delhi, 1990.
12. Timberlake, Lloyd, *Africa in Crisis*, Earthscan, London, 1987.
13. Susan George, *A Fate Worse than Debt*. Food First, San Francisco, 1988.
14. Ibid.
15. Ibid.
16. Ibid.
17. UNICEF, *Children and the Environment*, 1990.
18. Maria Mies, *Patriarchy and Accumulation on a World Scale*. Zed Books, London, 1987.
19. UNICEF, op. cit., 1990.
20. Moser, Caroline, Contribution on OECD Workshop on Women and Development. Paris, 1989.
21. Shiva, Mira 'Environmental Degradation and Subversion of Health' in Vandana Shiva (ed.) *Minding Our Lives: Women from the South and North Reconnect Ecology and Health*, Kali for Women, Delhi, 1993.
22. Gibbs, Lois, *Love Canal, My Story*. State University of New York, Albany, 1982.
23. Bhopal Information and Action Group, Voices of Bhopal. Bhopal, 1990.
24. Ibid.
25. *Pacific Women Speak*, Women Working for a Nuclear Free and Independent Pacific, 1987.
26. United Nations, *World's Women*, 1970–1990.
27. Chatterjee, Meera op. cit.
28. UNICEF, op. cit., 1990.

29. Kothari, Rajni, Vandana Shiva, 'The Last Child', Manuscript for United Nations University Programme on Peace and Global Transformation.
30. Hardin, Garrett, in *Bioscience*, Vol. 24, (1974) p. 561.
31. Shiva, Vandana 'Forestry Crisis and Forestry Myths: A Critical Review of Tropical Forests: A Call for Action,' World Rainforest Movement, Penang, 1987.
32. Malthus, in Barbara Duden, 'Population', in Wolfgang Sachs (ed) *Development Dictionary*. Zed Books, London, 1990.
33. UNICEF, op. cit., 1990.
34. Nelson, Lin, 'The Place of Women in Polluted Places' in *Reweaving the World: The Emergence of Ecofeminism*, Irene Diamond and Gloria Orenstein (eds). Sierra Club Books, 1990.
35. Ibid.
36. 'Women, Health and Ecology,' proceedings of a Seminar organized by Research Foundation for Science, Technology and Natural Resource Policy, and Dag Hammarskjold Foundation, in *Development Dialogue* 1992.
37. 'Planeta Fernea' was the women's tent in the Global Forum during the UN Conference on Environment and Development, 1992.
38. Lyons, Oren 4th World Wilderness Conference, 11 September 1987, Eugene, Oregon.

Land Management and Ecotourism: A Flawed Approach to Conservation in Costa Rica

Ana Isla

Abstract

One of the major social tensions today is between the demands of private capital and national governments for economic growth and globalization, and the demands of local communities for security and livelihoods. Sustainable development is commonly believed to resolve these tensions by reconciling global and local economic and ecological interests.

The paper assesses the implementation of sustainable development in Costa Rica's rain forest, through Canada/Costa Rica debt-for-nature investment. Debt-for-nature policy designers forbid governments to receive debt titles directly - debt titles must be donated to Non-government Organizations (NGOs). In the Canada/Costa Rica case, funds were channeled to the World Wildlife Fund-Canada (WWF-C) and the National Institute for Biodiversity (INBio) of Costa Rica. This paper uses this case study to connect the interaction between land management and ecotourism, and its socioeconomic effects on communities.

The paper argues that the concept of sustainable development articulated as a new framework for international donor and NGO practices, creates new poverty among local people; because commodification for sustainable development redefines biodiversity as natural capital. As natural capital, land is enclosed to harvest genetic material; community members are made intruders and criminals; local knowledge is devalued; and agriculture workers become eco-tourism service workers. The author concludes that the unstated aim of restructuring accumulation on a world scale underlies the stated concern for debt-reduction and environmental conservation.

Introduction

This paper looks at a case study of the interactive socio-economic-ecological impact of land management and eco-tourism on local communities resulting from commodification for sustainable development. Commodification for sustainable development proposes to address the debt and the environmental crises by expanding natural and human capital through marketing tropical nature and its people's work for capital accumulation. It argues that the concept of sustainable development, articulated as a new framework for international donor and NGO practices, increases poverty among communities in these areas as a means to restructure capital accumulation.

Since the late 1980s, the commercial banks and the multilateral institutions (IMF-WB), who previously made loans, have been replaced by an inflow of private portfolio funds and debt swaps. Debt swaps are financial mechanisms to repay debt by handing over ownership of national industries, public enterprises, bank assets, and nature.

Particularly since 1988, capital accumulation relies on debt-for-nature investments[1]. Debt-for-nature investments are the core sustainable development mechanisms of choice for the World Bank, the International Monetary Fund, UNESCO and large environmental corporations. Further development of debt-for-nature investments was one of the major outcomes of the United Nations Conference on Environment and Development (UNCED), held in 1992. Since then, the Global Environmental Facility (GEF) under World Bank management has established funding of numerous NGOs involved in debt-for-nature swaps to 'protect' the global environment.

This paper documents the Canada/Costa Rica debt-for-nature investment as a process of sustainable development. What is the Canada/Costa Rica debt-for-nature investment? It is a bilateral debt-for-nature investment, signed on May 1995, that implements the Latin America Official Development Assistance (ODA) program, following three development loan agreements that took place between 1984 and 1985. Since Costa Rica's debt was priced very low in the secondary market, Canada took steps to obtain Parliamentary approval to reduce the portion of the debt owed to Canada by 50 percent. A Costa Rica/Canada Trust Fund for Biodiversity (FIDEICOMMISSA) was created to receive Costa Rica's payment in local currency (*colones*) the equivalent of eleven million, three hundred and fifty-five thousand, eight hundred and nine Canadian dollars and fifty cents (CDN$11,355,809.50) (MOU 1995). The Canadian and Costa Rican governments are not allowed by the designers of the policy to receive the debt titles directly - they must be donated to NGOs, which become the government's creditor. The FIDEICOMMISSA funds created by the Canada-Costa Rica debt-for-nature investment, issued under the Memorandum of Understanding (MOU 1995), were channelled to to the Arenal Conservation Area (ACA-MINAE) directed by the Canadian World Wildlife Fund (WWF-C) and to the Costa Rican National Institute for Biodiversity (INBio).

> Article No. 9 of the MOU specifies funds for the ACA-MINAE as follows: Half of the resources [CAD$ 5.6 million] will be dedicated to specific activities leading to the strengthening and consolidation of the National System of Conservation Areas (SINAC), and specifically to the Arenal Conservation Area (ACA), in the areas of human resource training, scientific research, and the management of areas for their sustainable use, in accordance with appropriate technical and scientific criteria. Resources for the second phase of the ongoing CANADA- COSTA RICA bilateral project, the Arenal Conservation and Development Project, will be allocated from the SINAC portion of the funds. (MOU, 1995:8/19).

The WWF-C is the *creditor* NGO using the debt-for-nature investments. Since 1991, the WWF-C has established, in one of the eleven designated conservation areas of Costa Rica, the Arenal Conservation Area-Tilaran (ACA-Tilaran) a Model of Environmental Management - The Arenal Conservation and Development Project (*the Arenal Project*). *The Arenal Project* is also a Canadian International Development Agency (CIDA) project. *The Arenal Project*, carried out by the World Wildlife Fund-Canada (WWF-C) and the Ministry of Environment and Energy of Costa Rica (MINAE), is based on a covenant between the MINAE, CIDA and the WWF—C The CAD$5.6 million of debt-for-nature funds controlled by the WWF-C has been disbursed as follows: $2.7 million for the *Arenal Project* in ACA (*Propuesta*, 1995) to support the Arenal-Tilaran Conservation Area (ACA) model of management, and to assist in the dissemination of the model to other conservation areas; and, almost $3 million for Investment in Strategic Projects (*Proyectos de Estrategia de Colocacion de los Fondos de Canje de Deuda*) to finance projects, particularly micro-enterprises, in the whole country.

Article No. 10 of the MOU allocates the remaining half of the resources [CAD$ 5.6 million] to projects of the National Institute of Biodiversity (INBio), leading to the knowledge and use in a sustainable manner of the biodiversity in the Conservation Areas. Particular emphasis will be given to those aspects that contribute to the sustainable development of these sectors. Similar attention will be given to social programmes that transfer the knowledge of biodiversity in an easy and accessible way in the different sectors of society. (MOU, 1995:8/19).

INBio is the *debtor* NGO using debt-for-nature funds. The funds went into INBio's Biodiversity Prospecting Division. The main objective of this division is the systematic research of new sources of chemical compounds, genes, proteins, micro-and macro-organisms, and other commercial products of interest. The division identifies opportunities to obtain profits from products and services of added value which originate from biodiversity resources.

This paper focusses on the use of debt-for-nature investment by the two corporate environmental NGOs involved, the WWF-C and INBio, and the role of the Ministry of Environment and Energy - MINAE -of Costa Rica. On the one hand, corporate environmental NGOs are engaged in genetic and species research; in addition, they have become the administrators of the IMF and the WB project of integrating local governments and communities into the global economy. On the other hand, 'national states" involvement in sustainable development requires a more complex intervention in the affairs of local communities. To fit their economic aspirations and activities into the world-system, states are adopting policies which are responsible for destitution as well as oppression of their citizens.

Both NGOs and 'national states' have created the conditions for material expansion and a technically more intense mode of ecological exploitation in the periphery. Thus, the sustainable development movement has initiated a state led management of the Conservation Areas for extraction of genetic material for research purpose and ultimately for commodification; and communities become less able to adapt their local economies to local needs and conditions.

At the community level, the paper shows that commodification for sustainable development which has been associated with efforts to politically empower and economically advance some of the most disadvantaged groups of society, poor peasants, rural women and indigenous people, has become a process of enclosure of extended territories, including fauna, flora genetic material and communities. At the ecological level, the paper exposes corporate environmental NGOs influencing the transformation of tropical forests and societies in order to regulate forest access on behalf of industry. By analysing the social processes in the Conservation Areas of Costa Rica, this paper shows that organizing nature for research purposes raises questions of social justice and ethics, and environmental concerns.

Data used in this analysis was collected during the summers of 1998 and 1999 in the process of my research on the impact of the Canada/Costa Rica Debt-for-Nature In-

vestment. My doctoral thesis *An Environmental Feminist Analysis of Canada/Costa Rica Debt-for-Nature Investment: A Case Study of Intensifying Commodification* (2000) has shown that sustainable development management responds to debt and the environmental crises by extending its hegemony over community resources for the purposes of commodity production.

Commodification for Sustainable Development

What is sustainable development in the world-economy? The World Bank (WB) defines sustainable development as the management of the entire cycle of life (humankind and nature) with the intention of expanding 'wealth.' By expanding the measure of wealth the World Bank implies the inclusion of natural capital and human resources in national-asset accounting. Kirk Hamilton (1999), of the World Bank Environment Department, emphasizes the WB's concern with 'poverty reduction' around the world, particularly in Third World Countries, and its attempts to expand the concept of wealth and to develop a method to measure it. He states that one possible definition of sustainable development is the management of a nation's portfolio of assets. A nation's portfolio of assets includes built infrastructure, natural resources (minerals, energy, agricultural land, forest), human capital, and social capital. Thus, sustainable development requires not only macro-economic policies, that is, structural adjustment, but also the management of human resource development (Hamilton 1999). What matters for the World Bank vis-a-vis sustainable development is how natural capital is managed and whether the rents (profits) from the natural capital endowment are invested in repaying the debt.

In the current world economy non-market value found in nature and produced outside the market without wages is not recognized. Yet this wealth and work is what communities around the world have depended on for their subsistence. The process of 'sustainable development' that enhances market production and creates waged employment often at the expense of subsistence activity, leaves populations increasingly dependent on monetary relations for their survival without ensuring that people have access to adequate monetary income. The result is a state of generalized poverty without precedent.

This economic perspective put forth by the World Bank, supported by UNESCO, the IMF, industrialized countries, development agencies and many corporate environmental NGOs, reduces the value of humans and nature to one commensurable measure, that of energy flows in ecosystems expressed as a market cost. Reducing diverse senses of worthiness to the one dimension of market value, conventional economics has sidelined the issues of poverty and ecological destruction. The search for profit and

the rate of profit on real capital determines the dynamics and direction of social and ecological activity.

As capital confronts a crisis of accumulation on a world scale, it conducts restructuring in the core as well as in the periphery. The corporate group in charge of the new accumulation in the periphery is composed by transnational industry, third world elites as 'national' governments, and corporate environmental NGOs (Isla and Turner, forthcoming). These groups stress the importance of permanent growth and development based on the industrial world's experience. The new reorganization in the periphery has been known as sustainable development.

Sustainable Development in Costa Rica

The concept of sustainable development, linking the debt and the environmental crisis, emerged in *Our Common Future* (World Commission on Environment and Development-1997, also known as the Brundtland Report). The framework for sustainable development therefore integrated economic development and environmental management from the beginning. The Brundtland Report 'inspired' the USAID, which was acting as a Costa Rica's parallel state from 1984 to 1991 (Petch 1988; Sojo 1992) to organize a conference in 1989 under the name of Conservation Strategy for Sustainable Development, known as ECODES.. USAID collaborators included the environmental organizations operating in Costa Rica and the Ministry of Natural Resources, Energy and Mines (MIRENEM) – now Ministry of Environment and Energy - MINAE). At ECODES conference, deforestation was recognized as the heavy price imposed by development/modernization. MIRENEM (1990) had shown that Costa Rica, between 1940 and 1977, had one of the highest deforestation rates in the world, accounting for 50,000 hectares (ha.) of old-growth trees every year. Sustainable Development through the Conservation Areas system was proposed to address the deforestation problem. Deforestation as caused by:

- Industrial farming and monoculture expansion. The agricultural area to produce coffee, banana, sugar cane, and cattle ranching led to apply the highest rate of fertilizers use in Latin America (Ramirez and Maldonado, 1988: 56).
- Commercial logging, particularly the timber industry had enormous impacts. In the process of extraction, a large number of trees and plants, without market price, were destroyed (Ramirez and Maldonado, 1988).
- Land invasion and agricultural legislation promoted tree clearing as a mechanism to enable access to land property titles. The legislation which most affected deforestation included *Ley de Informaciones Posesorias No. 139* (Law of Private Possession), *Ley de Tierras y Colonizacion* (Law of Land and Colonization) No 2825, and the *Instituto de Desarrollo Agrario* (IDA) (Agrarian Development Institute) No 6735.

The Conservation Area model was introduced to manage the country's wildlife and biodiversity. But 'protection' of natural resources through central management is very expensive, because it requires acquisition of land, hiring of personnel for "protection and control" of the areas, and training of staff in fields such as administration and infrastructure. These are expenses that the Costa Rican government is unable to provide. Thus, Costa Rica's private and public conservation projects rely heavily on international aid and have received the majority of their funding from direct donations by international entities or from debt-for-nature investments.

In terms of land ownership, little-recognized problem is land concentration. Traditionally U.S. multinational corporations enclosed Costa Rica's land and converted it into cattle ranches and banana plantations. Parallel to this process, the local business community, which was supported by the state, enclosed land for use as coffee plantations. To support coffee production, the formation of a class of small and medium farmer (*campesino*) land property owners was crucial (Winson 1989). These land grabs by foreign and local businesses deeply divided Costa Rica in terms of land control and power. Excluding the owners of one hectare, 83.4 percent of the land owners with less than a 100 hectares control 1.12 percent of the national territory, while 0.71 percent of the owners with more than a 100 hectares own 70.3 percent of the country's territory (*El Estado de la Nacion,* 1996: 68).

Sustainable development aggravated these unequal relations by intensifying earlier destructive enclosure of the land to save representative samples of bio-diversity under *Sistema National de Conservacion* (SINAC). SINAC has divided the country into eleven Conservation Areas under the supervision of MINAE (Ministry of Environment and Energy). MINAE took the right to land ownership away from small and medium farms and placed it into the hands of the government in order to promote the race for biodiversity inventory and species prospecting. As competition for trade in biodiversity gains international momentum, competition related to biodiversity knowledge grows in the Conservation Areas (CA).

Local environments were already harmed by deforestation. Along with agrochemical residuals from the coffee, banana, sugar cane and cattle ranching, deforestation is the main source of water contamination and erosion (Ramirez and Maldonado, 1988).

Despite these problems, hunting and fishing have long been part of the subsistence economy in the jungle. Almost all farmers were also hunters and fishers. Game and fish allowed family subsistence during the rainy season or when family income was low. Among smallholder, natural resources (wild or cultivated) were considered their property. However, a significant number of community members traditionally hunted in their surrounding forest as well as in the forest reserves and national parks. They also fished in the numerous rivers that now are closed to them as part of the conservation area system.

What follow examines sustainable development in Costa Rica as an extension of the industrial control over the domains of nature and human nature through a process of 'land planning' that connects to the conditions and imperatives of the world-system. The politics of sustainable development have powerful implications for the welfare of local communities and ecologies.

Community Effects of Commodification for Sustainable Development

The Arenal Project Practice

In 1991, the *Arenal Project*, of the WWF-C, CIDA, and MINAE, elaborated the first step of a management plan, *El Plan General de Uso de la Tierra* (The General Land Use Plan) (hereafter referred to as the *Land Plan*). The *Land Plan* regulated land access and use in the Arenal-Tilaran Conservation Area (ACA). According to the Canadian Director, Claude Tremblay (interview, summer 1998), the *Land Plan* in ACA was based on the characteristics of the territory and its biophysical potentialities. It identified the limits of acceptable human intervention for the sustainability of the area. ACA-Tilaran was intended to establish a Model of Environmental Management that could be reproduced in other Conservation Areas and other parts of the world. "The model permits us to discuss and to look for harmony of local, regional, national and international interests" (Tremblay, 1999: 19).

The Arenal-Tilaran Conservation Area involves 250,561.5 hectares (ha.) of land. From this total, the *Land Plan* document recommended protecting of 116,690.2 ha. Of the 116,690.2 ha. of protected area, 76,707 ha. (37.54 percent of ACA) were selected for a research program and declared 'nucleus areas' (*area nuclei*). The selected research areas function on the basis of inter-institutional agreements (Tremblay and Malenfant, 1996). Architects of sustainable development argue that ACA's territory is one of the most biologically diverse area in Costa Rica. The Land Plan's biology section identified 4,283 species of flora and fauna in the nucleus area which represent 36% of the natural wealth of Costa Rica (ACA 1993).

As research centres are organized in the so-called nucleus areas, these areas are off-limits to rural communities unless they are part of the taxonomist program. Enclosed reserves of genetic material and forested people are put under pressure by the commercial interests of industry and corporate NGOs.

Since 1994, the Arenal-Tilaran Conservation Area has supported three research organizations projects:

1. INBio, the Costa Rican NGO, is involved in parataxonomy and chemical prospecting. It searches for new pharmaceutical and agricultural products from

plants, insects and other biological samples in three biological stations: San Luis de Monteverde; Cerro Chato; and Quebrada Guatuso.

2. ACA-MINAE, in partnership with INBio, are involved in two research projects: 1) Biodiversity Resources of the ACA Development Project, financed jointly by the World Bank and INBIO; and, 2) Development Knowledge and Sustainable Use of Costa Rica's Biodiversity, ECOMAPAS, financed by The Netherlands (M. Mora, 1998) in partnership with INBio and *Sistema Nacional de Areas de Conservacion (SINAC)*.

3. The World Wildlife Fund-Canada (WWF-C), a Canadian NGO, in partnership with the Asociación Conservacionista Monteverde (ACM), collects material and researches flora and fauna (PROACA, 1996). Since 1996, using its own *Land Plan*, the WWF-C is bio-prospecting in ten areas of the ACA territory. In the first phase, the areas included were: San Gerardo (Tilaran), La Tigra (San Carlos), Arenal Volcano (National Park), Alberto Manuel Brenes (Biologic Reserve) and Tenorio Volcano (National Park). In the second phase, after a detailed inventory of flora and monitoring of soil regeneration, the generation of products originating in the areas of biodiversity will be attempted. In the third phase, an additional five ACA nucleus areas will be added: San Bosco de San Carlos, Miravalles (Protected Zone), Cano Negro (National Sanctuary of Wildlife), Juan Castro Blanco (National Park), and Curena Curenita (Forestry Reserve).

The *Land Plan* (ACA 1993) of the *Arenal Project* affected the resources of 108 communities in the area, which were neither informed of nor included in the decision-making that changed their lives and livelihoods. The secretive approach of the *Land Plan* eliminated the communities' rights to use the land biomass included in the nucleus areas, and undermined local livelihoods. Land enclosure has transformed community members into criminal intruders. The newly declared private land in ACA's territory is patrolled by seven park guards that are organized in one Police Control Unit. They are trained in how to handle firearms and equipment and to counter land invasions. When the Police Control finds community members breaking regulations stipulated in the *Land Plan* (that is, not paying fees or intruding on designated research areas), the park guards confiscate anything the individual may have obtained on the land (eg., fish or game) and whatever tools were used, and then reports the offence to the office of the public prosecutor. One guard stated:

> "A year ago, three of us were patrolling Quebradon Patusi where many people used to hunt. We heard barking dogs and saw a *chavalo* (young man) walking behind the dogs. We walked in silence to corner him, but one of us tripped. The *chavalo*, scared to death, started to run, then swam, and then ran again, this time on a wall of rocks. To try to stop him, we shot at the air, but he never stopped, because he knew that he was breaking the law (Control Unit of MINAE, interview, Summer 1998)."

Community members' intimate knowledge of and connection with the land was ignored. This separation of people from nature has created a sense of disorder, alienation,

fragmentation, and uncertainty among the poor members of the community. Some of them still manage to live a traditional lifestyle and work in *quadrillas*. A *quadrilla* is a group of individuals working together for hunting purposes. In this job, no one works in isolation because of the risks of bites from poisonous snakes, broken legs, and rolling boulders ejected from the volcano. For the hunters from San Carlos, the only reason they are seen as enemies is because they do not have the money to pay the fees the new laws require. In this way, animal protein is removed from most community members diets. One hunter reported:

> "If I have money and pay a licence to hunt (*montear*), I can hunt without problem. Paying c/5.000 (US$20) I can kill moose (*dantas*), deer (*venado*), or whatever wildlife I want and no one would say a word. The licence only tells me what kind of gun I can use (28, 222 forming, 22), but it does not tell me how many I can kill. (Alas, interview, Summer 1999)[2]"

The amount of food provided by hunting and fishing was estimated, by the hunters of San Carlos, to account for almost half of their families' daily needs. But now, hunting and fishing for survival needs have made them criminals, even though, they argue, they are less harmful than outsiders who can pay the required fee. As traditional hunters, they know that a *tepezcuintle* (paca) bears offspring twice a year. They also know that it's reproduction rate naturally outstrips the rate of growth of the trees they depend on. Community members are resisting bans on the hunting of *tepezcuintle* and other animals.

> "If ACA-MINAE stops selling licences for hunting to the rich who can pay, I will stop hunting, because I will see that it is not just the poor who have to conserve wildlife. I can live happy if this inequality stops. If they permit hunting to the rich but bother the poor I cannot be happy. I can see rich hunters drinking in bars, while in their station wagons dogs bark and dead *tepezcuintles* hang in baskets. They are openly showing-off their hunting. But if I have a *tepezcuintle* in a bag, MINAE takes it from me, and if I do not confront them I also risk losing my dogs, because, I do not have a car and I am walking. That is the reason why we [the hunters] do not stop hunting. Why is it that those who have money can hunt and those who are poor must become 'conservationists.' As a poor man I believe that laws are only for the rich who can afford to pay, thus, I do not have to obey (Alas, interview, Summer 1999)."

Hunting is not the only prohibited activity for poor members of society, but fishing is as well:

> "We fish with *arbaleta* [spear] in *Embalse Arenal*. We believe that this is the only legal fishing, because I choose the fish I want. I won't fish a small fish, I will fish a big one. MINAE disagrees with our methods. MINAE prefers the use of fishing poles. With that instrument I cannot differentiate which fish is adult or young. Because we do not pay fees, fishing is also prohibited for us, thus, we must hide from the control unit. We need to be careful going in and out in order to avoid the guards. All this work means sacrifices, but we do it to live. This is the heaviest job in the world, because I

do not use oxygen tanks, I just use my lungs. This is a really hard job (Alas, interview, Summer 1999)."

Hunters and fishermen strongly defend their rights to the land and water resources on the grounds that they have being doing this forever without harm to the land.

"I am in my 40's and I have being hunting since I was 14 years old. Depending on the phase of the moon, we go to work, because *monteando* [hunting] is work for us. That is what provides a livelihood for my family. We hunt *tepezcuintles* and *sainos* and we know when and how. The best time to hunt is when there is no full moon, because *tepezcuintles* and *sainos* look for food in the dark. Our work is directed by the moon. (Alas, interview, Summer 1999)."

Confrontational situations between the *Unidad de Control* and the hunters are frequently reported. Alas said nothing has happened yet because

"we are more intelligent that they are. I meet MINAE's guard at least ten times a year. Our *encuentros* are irregular, sometimes we meet four times in a month but then we don't see each other for four months. They are trying to find us at fault, but when they invent something against us, we are three steps ahead. When they meet us and ask about the dogs, we answer, the dogs are mine, they go wherever I go. Any problem? However, one day when one of the guards tried to snatch away my dog, I told him that if he touched him I was going to cut off his hands. He knows that I can do it. (Alas, interview, Summer 1999)."

Deforestation is significant in the lives of everyone, particularly on poor hunters. In their view, deforestation threatens wildlife and water run-off, source of their livelihood.

INBio' Practices

In 1994, INBio was granted rights to state owned land to sell bio-diversity to industry. INBio established a partnership with the Ministry of Environment and Energy (MINAE) to collect samples for interested industries from the Conservation Areas. In the partnership agreement, INBio and MINAE assume that conservation areas are common goods in the state's hands. By the same token, local communities rights were disregarded. Since 1994, INBio's Inventory Division collects material from the Conservation Areas (CA) under MINAE administration. In exchange, INBio has taken responsibility for the support of the National System of Conservation (SINAC). INBio supports the Conservation Areas by looking for customers to purchase Conservation Area resources; by promoting the use of scientific knowledge in the management of the wildlands areas; by the generation of financial "opportunities"; and by the promotion of corporate ecology in the territory planning. The tenth clause of the agreement stipulates that in cases of bioprospecting research, INBio must contribute at least ten percent of the original budget to support the management and conservation of the Conservation Area (CA). Part of the tenth clause states that if the research results in successful discoveries, any

royalties awarded to INBio will be shared 50/50 between INBio and MINAE for the management and conservation of land administered by MINAE.

To organize the extraction, exploitation, and control of biodiversity from the conservation areas, INBio designed four divisions:

- The <u>Inventory Division</u> generates properly identified reference collections and field guides, provides electronic identification services that add knowledge of the organisms' natural history, and documents their distribution throughout the national territory.

- The <u>Information Dissemination Division</u> aims to disseminate information on diverse processes taking place in INBio with respect to the commercial possibilities of conserved wild lands, as well as training conservation area staff, producing hard copy field guides and other types of biodiversity literature, and holding national and international workshops. (Mateo, 1996).

- The <u>Information Management Division</u> develops software about the biodiversity; and,

- The <u>Biodiversity Prospecting Division</u> searches for new chemicals and genes. It focuses on systematic research on new sources of chemical compounds, genes and proteins produced by plants, insects and micro- and macro-organisms that may be of use to pharmaceutical, medical, and agricultural industries.

INBio's bioprospecting begins in the conservation areas with the biological samples brought by parataxonomists. It appropriates local knowledge about some of the attributes of the native plants and animals to initiate most of the prospecting work by hiring the daughters and sons in the rural communities as parataxonomists who initiate the collection. A MINAE worker stated:

> "A parataxonomist is a person (woman or man) necessarily from the rural area because there are many adverse factors, such as walking at night under heavy downpours to visit the hatch, with the added risk of falling branches and snake bites. As a rural person, the parataxonomist brings intimate knowledge of the eco-system. In the work process, she/he acquires information of the protected area and becomes an information generator (Anonymous interview, Summer 1998)."

Within these divisions, the only process that adds value is the work of the Biodiversity Prospecting Division, where nature's power and potential are appropriated. It is only when nature is modified in the laboratory that nature's productivity counts or has any value, in the sustainable development paradigm. As Mies and Shiva point out,

> "Experts and specialists are thus projected as the only legitimate seekers after and producers of knowledge. The transformation of creativity into passivity relocates productivity in disruptive, coercive and exploitative acts, and defines it as a source of value; and simultaneously defines all other values as non-value." (Mies and Shiva 1993: 24, 26).

Manipulation of the ecosystems for the exploitation of genes is thus initiated in IN-Bio's laboratory and then further developed through experiments in the installations of INBio's partners in the pharmaceutical, medical, and agricultural industries (Mateo 1996).

The Canada–Costa Rica debt-for-nature funds developed the production of extracts by the consolidation of the microbiology lab, and the extraction and fragmentation labs (INBio 1995). The only stage in which industry is interested takes place when the active extract is introduced into a feedback complex, which is called *fraccionamiento guiado por bioensayo* (guided division by laboratory testing). This process separates the extract from components not responsible for the desired activity. The active fragment is the third product, with a much higher and more complementary added value. The process is repeated many times until the active component is completely isolated. This active component is identified and promises to be interesting only if it contains structural or active novelties. This process is very expensive but it gives the product additional value. At this stage, there are many similar by-products derived from the original, natural product. They are mimetic products, derived from the biological activity but not equal to the natural, original product. Pharmaceutical companies are interested in mimetic products that can be patented. These are the products that generate economic benefits. It is thus the work of the Biodiversity Prospection Division of INBio to transform the original robbery, of the genetic material, into a property right for corporations, which claim ownership based on the 'improvements' they have made to the natural products.

INBio is a private institution that manages the samples of bio-diversity and enjoys jurisdiction over the inventory, prospecting, and commercialization of Costa Rican bio-diversity (Gudynas 1997). It receives donations because INBio's science is a response to the needs of a particular form of accumulation. Both the donors and INBio are interested in the commercial exploitation of bio-diversity, especially the bio-diversity of the rich rain forest. Yet, they do so under the guise of 'conservation.'

INBio's manipulation of the ecosystems to maximize the single component of genetic exploitation has undermined the integrity of nature and the rights of local communities to use their environment, and it has plundered local community members' means of livelihood. This type of reductionist science is at the root of the growing ecological crisis, because it entails a transformation of nature that destroys its organized processes, rhythms, and regenerative capacities (Mies and Shiva 1993). Reductionism permits knowledge of parts of a system to stand for knowledge of the whole. Fragmentation creates the possibilities of colonizing and controlling what is a free, self-generative, and communal source; and reduces complex ecosystems to a single component, and a single component to a single function. The single function becomes the single component for exploitation (Mies and Shiva 1993).

The new technology of bioprospecting has become instruments of poverty and underdevelopment. INBio vandalizes nature. INBio's science is based on the destruction

and subordination of nature as a living organism. Nature is considered dead, raw material. INBio's inventory division is a cemetery full of tons of inert plants, leaves, dead butterflies, pieces of wood, and micro-organisms, lying all over the floor, the walls, the shelves and rooms, waiting to be fully catalogued. For most of these samples, no technology yet exists that can bio-test all the "potential properties" of the thousands of substances involved in the dead species.

INBio's Inventory Division initiated its activities focusing on a limited number of taxa—plants and insects (1989), mollusks (1993) and fungi (1996). However, after five years, the output of this exercise was overwhelming and close to two million insect specimens are still waiting to be fully catalogued (Sancho, n.d.). In 1996, 428,000 entomological specimens were collected, increasing the reference collection to over 2.9 million insects at the close of the year. Of these, 2.4 million have been labelled, and 710,000 identified at the species level. Bryophyte specimens numbering more than 1,000 were added to the collection in 1995, while the taxonomy of plant species, estimated at 12,000 is almost completed, with 39 new species of plants described, of which 26 were new records for Costa Rica in 1996. The malacology collection now includes 90,000 specimens of which 25 percent have been classified to the family level, 47 percent to genes, and 28 percent to species level. At least eight are new species for the world and approximately 20 are new records for the country. Finally, a mycology department was opened in 1995 to inventory macro-fungi as the basis for exploring potentially useful bioactive substances. Currently, the collection numbers 1330, of which 11 percent have been identified to the family level, 48 percent to genus, and 37 percent to species level (Mateo, 1996).

INBio has not only a monopoly on nature but also on knowledge. Since the beginning of the 1990s, rural communities in Costa Rica have became familiar with scientists and their activities. They have witnessed the collection of and the intervention in nature and intrusions into their own lives. Meanwhile, they themselves, and their needs, have been ignored. They were not contacted, nor was there an attempt to engage in honest and frank communication. Information is managed in a restricted way. One MINAE official expressed:

> "When bio-diversity is treated as a commodity the very sacrificed people always will be the rural community. INBio's research program fails communities because it is only preoccupied in how many species we have and what to do with them. The knowledge acquired was not multiplied because the goal is to sell bio-diversity knowledge to the international market. The knowledge transfer failed the communities who have taken care of it for centuries." (Butterfly, Summer 1998).[3]

Biodiversity is a relational category, ecologically and culturally embedded. Local communities have worked as the keepers of nature for centuries. As such, their labour has no economic value, while 'scientific labour' is perceived to add value. Within the Canada/Costa Rica debt-for-nature agreement, INBio agreed to organize a conference

in 1998 between Indigenous People of Canada and Indigenous People of Costa Rica. Canadians told the Costa Ricans that they could help them to defend themselves and benefit from bio-diversity negotiations. The Talamanca Indigenous People answered: "We do not want to know about making business with bio-diversity, we are happy living like we are. What we want is just to keep and use the land, with the knowledge our ancestors handed down to us" (anonymous, interview, Summer 1998). Indigenous people in Costa Rica see bio-diversity as priceless and, therefore, non-negotiable. Bio-diversity is their source of medicine, their source of food, and particularly the source of their myths and traditions. Selling their bio-diversity is comparable to selling their culture, and more deeply, their soul.

INBio cheapened local community knowledge in order to appropriate it through local parataxonomists. INBio initiates its collection with local knowledge, through the parataxonomist, and it passes it on to the international and national business community. In INBio's conservation schemes, a parataxonomist's work does not add value. Their work is considered an extension of nature's work. Parataxonomists are considered non-specialists because they have no formal degree, although INBio uses the parataxonomist's knowledge to initiate every process. As of April 1997, INBio's Inventory Division had 26 Bio-diversity Offices in the various Conservation Areas, where some 32 parataxonomists were stationed. They work within a larger network of national and international taxonomy experts.

INBio devalued local communities as ecological authorities. 'Scientific' knowledge undermines customary knowledge on the grounds that living knowledge linked to sensuous knowledge and experience are unauthorized. In that way, the knowledge taken from local communities and Indigenous Peoples is not paid. However, biodiversity is not an exclusive product from nature. The activity of the Indigenous People and peasants has bred and improved traditional plants and medicines. Kloppenburg cites Norman Simmonds who has noted that change in genetics achieved by agriculturalists through the millennia has been probably more important than what has been reached by the systematic effort of science in the last hundred years (Kloppenburg and Gonzalez 1992). Third World local agriculturalists continue to produce genetic material of great value. Genes are selected, improved and developed by agriculturalists. These materials reflects the creation, inventive and genious of particular types of people. But their work is not recognized as labour, despite the fact that they are the providers and selectors of the biotechnology (Cabrera 1993).

INBio, therefore has a monopoly on nature, knowledge, *and* on profits. INBio has agreements with Bristol Myers Squibb Company, Recombinant Biocatalysts, Analyticom AG, Merck, INDENA (phyto-pharmaceutical company Milan, Italy), Givaudan-Roure Fragrances of New Jersey (to identify and collect interesting odours from forest organisms), British Technology Group, Strathclyde Institute for Drug Research (Scotland) and many others (Mateo, 1996; Gudynas, 1998). In INBio's first agreement (1991), Merck and Co. awarded INBio a US$1 million dollar research budget to carry out

a two-year, non-exclusive collaboration. Conservation Areas received ten percent of the original budget to support their conservation efforts while INBio used 90 percent for research, certain start-up costs, and the training of four Costa Rican scientists at Merck. INBio is not subject to public control and information, nor is it subject to parliamentary control. Its negotiations with respect to Costa Rican biodiversity are secret (Vargas 1992). INBio's director has explicitly stated that the agreement with Merck and Co. Enterprise is not a public document, according to Costa Rican legislation, and that therefore there is no reason for it to be approved by the Congress (Gamez qtd. in Gudyness, 1997). According to Gudyness, this agreement goes against international conventions such as WI, IUCN, PNUMA that claim that public access to information is fundamental in formulating environmental policies.

The potential for gene separation and manipulation reduces the organism to its genetic constituents. Patents and biotechnology contribute to a double theft: (1) they steal bio-diversity from Third World countries' producers; and (2) they steal safe and healthy food from every consumer of the world (Mies and Shiva 1993). Patents are a major means of establishing profits. "The granting of patent privileges over genetically engineered micro-organisms, plants, and animals represents the culmination of a five-hundred-year movement to enclose the planetary commons" (Rifkin, 1993: 70).

In sum, Costa Rica's Conservation Area (CA) system has nothing to do with conservation of the water system or protection of the vulnerable eco-system from deforestation. It has allowed to continue deforestation particularly for agriculture, cattle ranching, rural tourism, strip-mining. The official struggle against deforestation under Forestry Law No. 7575 (February 5, 1996) is only useful for the conservation of "small forests plots" for research purposes and global air market. Instead, corporation rights swallow the human rights of local communities.

Ecological Disturbances in Two Towns: La Fortuna and Z-Trece

In another paper I have examined the effects of integrating forested communities and forested women's households into the Conservation Areas strategy (Isla with Thompson, forthcoming). That work links enclosure for research in the Conservation Areas and unequal land access rights with the micro-enterprise programs. Micro-enterprises are advocated by the World Bank as poverty alleviation initiatives in indebted countries. The strategy of using biodiversity as part of micro-enterprise poverty alleviation has become a dynamic arena of struggle over power and development. The World Bank justifies these policies as providing cash to pay the country's foreign debt. The WWF-C supports them as ways to reduce the demand on biodiversity resources by

local communities. Both strategies have consequences for the welfare of forest animals, plants and people.

The ideology of sustainable development is contained within the limits of the market economy that sees the debt and environmental crises as separate from economic development, and proposes a solution to those crises by expanding the market system. This is not different to the past experience of Latin America where unequal exchange was established as the basis of surplus-extraction (Furtado, 1970; Galeano, 1973). Wallerstain (1985) argues that the surplus–extraction is through market mechanisms, therefore, more and more processes have to be commodified, oriented to production for a world market. These commodities move from the periphery to core and are produced by a variegated set of relations of production. Furthermore, since the debt crisis in the 1980s, International Monetary Fund (IMF), and World Bank (WB) Programs have integrated indebted countries into the global economy. As the implementation of these policies have proven insufficient to integrate and open up dependent economies, new and more subtle forms of management and control are, thus, put into operation. With the advent of sustainable development, eco-tourism has been classified as an export strategy, generating foreign exchange and investments. Eco-tourism is an extension of the commodification of modern life and an integral part of modern consumer culture. It sells the whole country including its biodiversity, culture, and identity. Eco-tourism involves the high volume movement of people over long distances, which can have a violent impact on vulnerable species and their habitats. Who are the beneficiaries? Those who have the economic and political power to instil a sense of materialism and consumerism in society, because they are also able to shape tourists' consciousness, values and tastes (Pleumaron 1999).

What follows is an example of how environmental corporations, by expanding the market system, can radically alter ownership claims and the regulation of forest access.

Commodification for Sustainable Development in Protected Areas: The Case of Arenal Volcano National Park

Every Conservation Area in Costa Rica has a godfather. Canada is the godfather of Arenal Conservation Area. (Director of the Arenal Volcano National Park, interview, Summer 1998).

After organizing research centres in the nucleus area, the major marketing achievement of the Arenal Project in the protected areas was the link of tourism with wildlife. The model of management established which commodities and communities have value. The main attraction of La Fortuna and Z-Trece is the Arenal Volcano National Park which is an active cone at an elevation of 1,633 metres. The volcano has two craters that erupt 24 hours a day, a spectacular show of nature.

Central to the changes in ACA-Tilaran, particularly in La Fortuna and Z-Trece, was the Arenal Project *Land Plan's* recommendation to change the Arenal volcano category.

The Arenal Volcano had been designated as Forestry Reserve in 1969 (Law 4380) with five protected hectares. This category was changed to Arenal Volcano National Park, in November 1994, with an area of 12,010 ha. (Decree No. 23774-MIRENEN). The development and expansion of the Arenal Volcano National Park was influential in the transformation of peoples livelihood.

Entire communities have been forcibly evicted. While the majority of the land around the volcano is not arable or adequate for cattle ranching, small farms had existed in the area. In 1994, this land was expropriated by MINAE to expand the National Park. Peasants who had organized their lives by clearing land for agricultural production and pasture around the Arenal Basin were thrown off the land. The land of some peasants was actually bought at low prices. However, only 54 percent of the landowners were paid, even though the Costa Rican Hydro Institute (ICE), which was officially in charge of the Arenal Basin, gave MINAE 200 million *colones* in bonds to pay for the expropriated land (Obregon 1999). MINAE and its police (Control Unit) expelled the families from the land. In Costa Rica's Supreme Court (Division IV of the judicial system) an injunction (*recurso de amparo*) reports heavy losses by campesinas/os who lived in the Basin area of ACA-Tilaran. They lost land, pasture, houses, dairies, and roads. Former property owners have become hut renters (*ranchos*) or slum inhabitants (*tugurios*). The personal effects of the *campesinas/os*, such as cars and small electrical appliances, were taken by the commercial banks when they could not afford to repay their loans acquired for economic development (Monestel Arce 1999). When in desperation some of them returned to their land to plant yucca, beans, corn and other subsistence foods, they were declared to have broken the law and some of them were thrown in jail (*Siete Dias de Teletica 1999*).

Following the expansion, the Arenal Volcano National Park's operation has internalized the market in three ways:

- by selling oxygen produced by the trees of the park—industrialized countries promote trading credits and compensation for the oxygen that the forested areas produce;
- by marketing biological diversity – there is a biologic station in Cerro Chato, located in the National Park, where an INBio parataxonomist is making an inventory of the park's species; and
- by collecting entrance fees—between January and July 1998, Arenal Volcano National Park collected 17,000,000 *colones* (CDN$95,000) (Director, interview, Summer 1988).

The marketing of Arenal Volcano National Park, as an eco-tourist centre, by the Arenal Project was done in association with some hotel and restaurant owners. The Arenal Project launched tourist promotion programs, hotels and internet advertisements that exploit the Arenal Volcano image on all printed materials. Thousands of tourists visit the Arenal Volcano National Park and its hot springs each year. In 1996, the daily number of tourists in La Fortuna was 500 in low season, and 1,500 to 2,000

during high season (Ulloa Gamboa, 1996a). Since 1992 an average of 39,190 Canadians visited Costa Rica. (ICT 1999).

Ecotourism excluded the original inhabitants. While recreational activities in natural settings used to be free for everyone, the *Land Plan* converted nature into expensive resort areas with limited social access. The protected areas only remain open to tourists, who can afford recreational activities. User fees were applied to land falling within the Protected Areas designated by the *Land Plan*. In the past, most families would spend their free hours walking in the countryside, climbing hills (*cerros*), swimming and fishing, or having picnics. Close to nature, families and neighbours were brought together.

In 1998, the Director of Arenal Volcano National Park explained the sustainable development work done by the Arenal Project:

> "In February 1995, the National Park began to charge fees. In the beginning, nobody wanted to pay fees. To make them pay fees, we closed the volcano's four entrances, leaving open and controlling one entrance. The entrance fees provided washroom, garbage collection and walking paths for tourists. When the area was not controlled, people used to take advantage of the resources of the area, resources they did not pay for. ACA made the people wake up to see that they have a resource that belongs to them and that these resources need conservation. ACA told the people that they should press for payment for the use of its resources." (Director, interview, Summer 1998).

To increase fees in the Arenal Volcano National Park, a look-out point was built, more walking paths were opened, and better water and electrical services were provided. A visitors' centre and administrator's house were also built.

The director also states: "Before the category changes, the Arenal volcano had already been sold as a product of the area, but to sell the Arenal Volcano National Park was a different thing. We received a donation from the Arenal Project of two million to sell the image" (Director, interview Summer 1998).

According to the director, the market success of the Arenal Volcano National Park could end because the daily fumes and lava activities of the active volcano, around which ecotourism is organized, have been progressively reducing. That preoccupation resulted, in the words of the director, in a proposition to expand eco-tourism to the Arenal basin. Thus, to do so, communities again were assaulted. The park management dug a ditch to stop community recreation use, and developed a camping trail, fishing programs, and tour for bird watchers.

La *Catarata de Rio Fortuna* (Rio Fortuna Waterfall), in the hands of the Association of La Fortuna, is another important area for eco-tourism lost by the community. A donation of c/.1,000,000 (CDN$ 5,600), from the *Arenal Project*, funded the building of a 70 metre-path that links the bottom of the waterfall with the visitor centre, which charges fees.

Water privatization was evidenced in 1997, when the Arenal Project paid a consultant to study "The Economic-Ecological Evaluation of the Hydro Resources in the

Arenal *Cuenca:* Water—A Permanent Source of Income." The aim of the study was to calculate the value of water. The director of the Arenal Volcano National park stated

> "For three years the Association of La Fortuna did not pay a cent to the water provider, namely the National Park. But now the Development Association has built a visitor centre and an agreement was reached between the National Park and the Association, which pays 50 *colones* (US$ 0.25) to the National Park for each visitor [the entrance fee is US $3 per visitor]." (Director, interview, Summer 1998).

Communities also lost the Tabacon river's hot spring. This spring is highly regarded as medicinal; it has been privatized by Tabacon Resort, which is an international private consortium with the involvement of some 'national' capital. Tabacon Resort has built eleven (11) swimming pools, using the hot spring water, at the very foot of the Arenal Volcano. From Tabacon restaurant, on clear nights, a cascade of red lava thrown by the volcano can be watched. An average of 300 tourists daily observe huge fireballs flying from the volcano that stops within 500 metres of the hotel. It is a very impressive and risky activity. Tourists frequently ask why the government issues licences to risky activities, such as this.

Sustainable development produces an irreparable loss of diversity in species. Tourism increased deforestation to build cabins and resort centres. Deforestation as a legal activity is fostered by government policy "You pay your fees, you fell the trees." The conversion of forests into resort centres endangers wildlife habitat by provoking mudslide, biotic impoverishment, and species forced migration. A Tabacon Resort's worker, who wishes to remain anonymous, says

> "Before building the swimming pools, we carried hundreds of frogs out of the area. After 5 years of activity, the frogs disappeared and the toucanos do not stand in the trees any longer. Massive use of chemicals to clean swimming pools, washrooms etc., left chemical residuals that force the animals to leave the surrounding areas."

As ecotourists want to have the experience of solitude, 'ecotourism' packages are manufactured to take them to distant/unspoiled areas. Plastic and paper garbage disposed by tourist resorts in isolated areas increase water contamination in distant frontiers in levels never imagined. As species' nests have been invaded by ecotourists, species' reduction is becoming another negative consequence.

To commodify nature for ecotourism entire communities have endured a radical change. The majority of the poor people in La Fortuna area used to work in agriculture. Agriculture was practised by *campesinas/os* who own small and medium-sized parcels of land. They were moved from agriculture to service provision. Tourism, linked to the Arenal Volcano and hot spring, produced changes not only in the production structure, but in employment.

Table 1 represents a picture of La Fortuna's changing productive structure. The statistics include only owners and workers that reported to *Caja Costarricense de Seguro Social, Sucursal* (Costa Rican Social Security office) La Fortuna in 1998.

Table 1:
Production Structure in La Fortuna-1998

Activity	Owners	Workers	Salaries in C	Average Salary
Cattle Ranching	78	218	10,134,166	46,487
Hotel/cabins	11	57	2,610,657	45,801
Comm/rest/tourism	40	183	9,037,272	49,384
Agriculture	13	42	1,602,636	38,158
Industry	6	36	1,538,496	42,736
Packing/factory	11	126	4,096,890	32,515
Construction	7	23	1,235,951	53,737
Other/services	24	49	2,172,121	44,329
Domestic/service	2	2	36,144	18,072
TOTAL	192	736	32,464,333	41,245

Source: *Presupuesto y Programacion Operativa. Ano 1999.* Sucursal La Fortuna. Caja Costarricense de Seguro Social, Direccion Regional Sucursales Huetar Norte

In 1998, only 13 of the medium-sized *finca* owners and 42 farmlands paid into the Costa Rican social security system. The commerce sector, which includes hotels, rental cabins, restaurants, and tourist attractions, became the number one activity in La Fortuna. This sector employed 240 workers in hotels and tourism-based industries, representing the largest number of workers in any one sector. The salaries paid in the tourism sector are also the highest in the area, US$ 250.00 per month. When agriculturalists were moved to eco-tourism, small agriculture collapsed. Small agricultural production is devalued; the average monthly salary in 1998 was US$152.00 (i.e., only 75 percent of the minimum wage in San Jose, which was US$206.00).

Since 1984, the defining role given to the market has deregulated traditional instruments that protected agriculture. Agricultural workers are the worst-paid workers in the country. Thus, the economic transformation taking place in the country decreased the importance of agriculture and further devalued production for family consumption. Agricultural production dropped from 3.1 percent, during the 1980s, to 2.9 percent between 1990 and 1997 (World Bank 1998).

With production reoriented toward international markets and eco-tourism, government policies have undermined the food security of rural peasant communities. As agricultural participation at the national level has decreased, while export of goods and services has increased, poverty in the rural area has risen from 24.6 percent in 1993, to 26.1 percent in 1994, to 27.6 percent in 1995, and 27.7 percent in 1996. Of this number, 11.2 percent live in extreme poverty, while 16.5 percent cannot satisfy their basic needs (*El Estado de la Nacion*, 1996: 219). Peasants are compelled to purchase their food stuffs (rice and beans imported mainly from the United States) at prices set according

to the vagaries of the international market. In 1990, Costa Rica produced 34,257 metric tons of beans, while in 2000, only produced 16,639 metric tons. Instead the country imported 27,000 metric tons (Barquero 2001). Grain growing has been reduced because there are fewer agricultural workers. According to the Consejo Nacional de Production (CNP), in 1994, 21,450 peasants produced beans while in 2000, their numbers were reduced to 9,475. Policies to import grain are justified on the grounds that it costs less than domestically produced grain, although campesinas/os families are made vulnerable to exchange rates and the caprice of corporate globalization. Even though more than 35 varieties of beans have been identified under cultivation in the Frijol Tapado[4] system in the southern part of Costa Rica, the variation in beans being grown has shrunk greatly (Jimenez 1998). In this way biodiversity is eroded, and vegetable protein consumption is reduced.

The Z-Trece community also changed. It is located at the foot of the Arenal Volcano. Z-Trece has an area of 470.55 ha. In this area, the so-called ecotourism boom has produced land concentration. The ecotourism advertisement attracted business men with fairly-deep pockets who set up tourist-resort centers. During the last five years in particular, many of the original owners sold their properties because the land price has risen, and local poor cannot afford the cost of living. Many original land owners have been reduced to living on a tiny portion of the land they once owned or were forced to move to San Jose to live in a shanty town.

Z-Trece was originally a *finca* whose branding iron was Z-13. The town was organized in 1983 as a shanty town. It was established in a way similar to many other Costa Rican small towns. Landless peasant invade *haciendas* (large *fincas*) and take a piece of land to build their homes and their livelihood. The government, through the *Instituto de Desarrollo Agrario* (IDA) (Institute for Agricultural Development), buys the conflicted land and divides it among the landless people. People who get the land have 15 years to pay the requested price to the government. In Z-Trece, IDA bought the land and divided it into 66 small holdings of 3.5 ha. By 2001 only 32 families were living in the area. From that number, 19 of them are small rural tourist entrepreneurs or workers, 4 families still work in agriculture, and only one of them produces its own vegetable. The three (3) other families are in the cattle ranching business while one family combines cattle ranching with tourism.

The process of sustainable development that enhances ecotourism creates low-waged employment at the expense of subsistence activity, and leaves populations increasingly dependent on monetary relations for their survival without ensuring people have enough cash income. The money these people receive cannot compensate for the loss of subsistence agriculture, or the loss of the few 'commons' they relied on to secured their livelihood. Food prices have gone up, and families not associated with tourism cannot afford to buy the basics any longer. "We pay for the products of this country with dollars, like tourists, but we do not earn dollars," they say.

The range of shops, lodges, and restaurants that displace local members renders meaningless local people's values, traditions and culture. The government overlooks these community anxieties, because the Arenal Volcano' ash mean foreign exchange and investments, as well as fame in the conservation industry. However, there are some positive aspects of eco-tourism, such as the improved landscape, electricity on the street, garbage collection, water reservoirs and frequency of transportation.

Conclusion

Commodifying nature for sustainable development, by using debt-for-nature investment integrates Costa Rica into the much broader world-system. It has linked the owners of transnational corporations (who have taken the political power in the industrial world), the third world capitalists (who have capital in the join-ventures), and the corporate environmentalists (who serve as managers).

My findings challenge the assumptions that sustainable development as generally understood will redress environmental problems (ecology) and solve the problems of debt (poverty). This paper has shown that, sustainable development suppresses the human rights of local communities and the rights of nature in favour of the rights of corporations. Vulnerable local nature and local people have become connected to the international markets and the world-economy on disadvantageous terms. Communities have had to surrender their safe local food system and their role as agricultural producers. Thus, local environments and communities are impoverished.

Sustainable development aggravated poverty and environmental destruction for the short term benefit of capital. It does not build on local knowledge and strengths. It is indigenous knowledge and experience that needs to be valued, supported and fostered if poverty and environmental destruction are to be tackled.

The market-oriented approach to conservation which has been chosen as a strategy by corporate environmental NGOs has three clear impacts:

1. external borders, between countries, are disappearing with the implementation of ecotourism as part of the International Financial Institutions (IMF-WB-WTO) policies;
2. internal boundaries, separating local people who share volcanoes, waterfall, rivers, hot springs, congo-monkey, and turtle-spawning havens, are built— through categories of management such as national parks, *humedales*, biological reserves, protected zones, forest reserves, and wildlife refuges.
3. customary claims of forest ownership and access to those forests are under ferocious attack from outside interests, with the collaboration of local elites.

In Costa Rica, these acts of colonization are called acts of sustainable development.

Footnotes

1. Debt-for-nature investments are financial mechanisms that offer repayment of loans held by creditors (commercial banks, governments) in return for natural resources. They are based on a negative assessment of the debt country, meaning that the debt must be considered unpayable, so the debt titles can be sold at a fraction of their value in the secondary market. Debt-for-nature investment was proposed by several environmental corporations as a way of capturing some benefits of debt-reduction efforts. For environmental organizations, the main objectives of this type of investment have been to identify and gain access to ecologically-sensitive areas for the purpose of protecting and negotiating them as sites for research and scientific data collection (Dawkins 1992).
2. "Alas" is a pseudonym for one of the hunters that belongs to the San Carlos *quadrilla* who wished to remain anonymous.
3. "Butterfly" is a pseudonym for an official from the Ministry of Environment and Energy (MINAE) who wished to remain anonymous.
4. Frijol Tapado is a system where beans are dropped in rows on top of the soil. The system permits the peasants to plant the seeds, cut down the weeds to cover the seeds, and wait three months until the plants have matured. During that period, the peasants can be working at a different job.

Bibliography

Area de Conservacion Arenal (ACA). (1993). *Plan General de Uso de la Tierra, Tomo I,II,III,IV.* Costa Rican Ministry of Natural Resources, Energy and Mines (MINAE)., with the support the Canadian International Development Agency (CIDA)., and the World Wildlife Fund-Canada (WWF-C).

Ballestero, Maureen (1999). "Comision para la Implementacion del Plan de Manejo de la Cuenca Embalse Arenal: Acciones para la Sostenibilidad de los Recursos." *ACA EN ACCION* Boletin No.9/ Publicacion Semestral/Enero.:12–13.

Boza, Mario (1993). "Conservation in Action: Past, Present and Future of the National Park System of Costa Rica." *Conservation Biology* 7 (2).: 239–247.

Cabrera, Jorge (1993) "Derechos de Propiedad Intelectual y Recursos Geneticos" in *Diversidad Biologica y Desarrollo Sostenible.* Fundacion AMBIO. Euroamericana de Ediciones (Costa Rica) S.A.

Caja Costarricense de Seguro Social, Direccion Regional Sucursales Huetar Norte (1998) Presupuesto y Programacion Operativa. Ano 1999. Sucursal Fortuna.

Dawkins, Kristin (1992). "Debt-for-Nature Swaps." *Debt Swaps, Development and Environment.* Editor Cuoto Soarez, Maria Clara. Rio de Janeiro: Instituto Brasileiro de Analises Sociales e Economicas (IBASE).: 31–46.

El Estado de la Nacion en Desarrollo Humano Sostenible (1996). Primera Edicion 1997. San Jose, Costa Rica.

Furtado, Celso (1970). *Economic Development in Latin America: A Survey from Colonial Times to the Cuban Revolution.* Cambridge, England: Cambridge University Press.

Galeano, Eduardo (1974). *Open Veins of Latin America. Five Centuries of the Pillage of a Continent.* New York: Montly Review Press, New York.

Gamez, Rodrigo (1991). "Biodiversity Conservation through Facilitation of its Sustainable Use: Costa Rica's National Biodiversity Institute." *Tree* 6 (2).: 377–378.

Gamez, Rodrigo, Alfio Piva, A. Sittenfeld, E. Leon, J. Jimenez and G. Mirabelli (1993). "Costa Rica's Conservation Program and National Biodiversity Institute (INBio)." *Biodiversity Prospecting.* Washington, D.C.: World Resources Institute.

Gudynas, Eduardo (1997). "La Naturaleza ante el doctor Fausto. Apropiacion o conservacion de la Bodiversidad." *Ciencias Ambientales* 13 (November).: 55–63.

Gudynas, Eduardo (1998). "Conservacion, Sustentabilidad ecologica y la Articulacion entre Comercio y Ambiente." *Ciencias Ambientales* 14 (June): 49–57.

Hamilton, Kirk (1999) "Expanding the Measure of Wealth: Views from the World Bank." Report of an April 23, 1999 Workshop on *Natural Capital: Views from Many Perspectives.* Editores: Adam Fenech, Roger Hansell, Ana Isla and Shirley Thompson. Toronto: December. Sponsored by: Institute for Environmental Studies, University of Toronto; Ecological Monitoring and Assessment Network (EMAN) Co-ordinating Office, Environment Canada and the World Bank.

Isla, Ana with Shirley Thompson (2001) "Environmental Economics Reality Check: A Case Study of the Abanico Medicinal Plant and Organic Agriculture Microenterprise Project" in *Environmental Monitoring and Assessment/Measuring Natural Capital* Guest Editor(s): Fenech, Hamilton, Hansell. Amsterdam: Kluwer Publishing.

Isla, Ana and Terisa Turner (2001) "Gendered Resistance to Corporate Environmentalism and Debt-for-Nature Swaps in Costa Rica" in *Just Ecological Integrity: The Ethics of Maintaining Planetary Life. Editors, Laura Westra and Peter Miller.*

INBio (1995) *"Biodiversidad y Desarrollo Socio-Economico,"* proposal presented to Canada–Costa Rica's *FIDEICOMMISSA.*

Instituto Costarricense de Turismo (ICT). (1999). Unpublished internal paper. San Jose: Costa Rican Tourism Institute.

Jimenez, Wilberth; Marco Zamora, Felix Angulo, Lucila Camacho, Rodolfo Quesada, Jorge Pleitez (1998). "Biodiversidad y Empresa Campesina: Simbiosis o Depredacion?."

Perspectivas Rurales 3. Mercados Alternativos y Pequenos Productores. 2 (1). (Marzo).: 60–74.

Kappelle, Maarten (1999). "Mapping and Monitoring Costa Rica's Biodiversity: The ECOMAPAS Project." Proyecto ECOMAPAS-INBio. Paper presented at Foro Mundial de Biodiversidad. San Jose, Costa Rica.

Kloppenburg, Jack and Tirso Gonzalez Vega (1992) "Prohibido Cazar! Expoliacion Cientifica, los Derechos Indigenas, y la Biodiversidad Universal." presented at Encuentro Internacional. Biotechnologia, Recursos Geneticos y el Futuro De la Agricultura en los Andes, Julio-Agosto.

McCullough, Robert (1995) *The Landcape of Community: A History of Communal Forests in New England.* Honower & London: University Press of New England

Matamoros, Alonso (1995) "Conservacion y Manejo de Recursos Naturales Renovables de Costa Rica. Documento de Trabajo. Instituto Nacional de Biodiversidad (INBio), Santo Domingo de heredia, Costa Rica.

Mateo, Nicolas (1996). "Wild Biodiversity: The Last Frontier? The Case of Costa Rica" *Globalization of Science: The Place of Agricultural Research.* Eds C. Bonte-Friedheim and K. Sheridan. The Hague: International Service for National Agricultural Research.

Memorandum of Understanding (MOU). (1995). Between the Government of Canada and the Government of the Republic of Costa Rica.

Merchant, Carolyn (1990) *The Death of Nature: Women, Ecology and the Scientific Revolution.* Harper & Row: San Francisco.

Ministerio de Recursos Naturales y Minas in Costa Rica (MIRENEM) (1990). "Plan de Accion Forestal para Costa Rica." Documento Base, San Jose.

Mies, Maria (1986). *Patriarchy and Accumulation on a World Scale. Women in the International Division of Labour.* London: Zed Books Ltd.

Mies, Maria and Vandana Shiva (1993). *Ecofeminism.* London and New Jersey: Zed Books.

Monestel Arce, Yehudi (1999). "Campesinos Precaristas en su Propia Tierra." *Eco Catolico* January 17: 11.

Mora, Maria Elena (1998). "Arenal, Corazon Energetico de Costa Rica." *ACA EN ACCION* Edicion Especial. Magazine published by Arenal Conservation Area, pp. :1–3.

Obregon, Carlos (1999). "Breve reseña cronológica que se impone." *Eco Católico* May 30.: 19.

Petch, Trevor (1988). "Costa Rica." *The Dance of the Millions. Latin America and the Debt Crisis.* Ed. Roddick. London: Latin America Bureau.: 191–215.

Pleumaron, Anita (1999). "The Rise and Fall of South-East Asian Tourism.? *Third World Resurgence* 103 (March).

Proyecto ACA (1996). "Apoyando Iniciativas Socio-productivas de Caracter Sostenible de Grupos Locales: Resumen: Enfoque Conceptual y Metodologico, Avances y Perspectivas, 1992–1995." Proyecto de Conservacion y Desarrollo Arena, Tilaran, Guanacaste.

Proyecto ACA (1996). "Lista de Verification (Checklist). Socioambiental General Aplicable a los Perfiles de Projectos Productivos y Demostrativos en el Proyecto de Conservaciion y Desarrollo Arenal." Comite de Credito del Projecto de Conservaciion y Desarrollo Arenal. Tilaran, Guanacaste.

PROACA 1996, *"Biodiversity-Programa de Investigation para el Uso Rational de la Biodiversity en el Area de Conservacion Arenal."* World Wildlife Fund-Canada (WWFBC) *and Asociacion Conservacionista Monteverde* (ACM).

Ramirez, Alonso and Tirso Maldonado (1988). *Desarrollo Socioeconomico y el Ambiente Natural de Costa Rica. Situacion Actual y Perspectivas.* San Jose, Fundacion Neotropica.

Rifkin, Jeremy (1993). *Biosphere Politics. A Cultural Odyssey from the Middle Ages to the New Age.* San Francisco: Harper San Francisco.

Sancho, Elvira (n.d.). "Costa Rica's Sustainable Development Model: From Forest to Society to Forest. Mimeograph.

Siete Dias de Teletica. Channel 7, January 1999.

Sojo, Carlos (1992). *La Mano Visible del Mercado.* Coordinadora Regional de Investigacion Economicas y Sociales (CRIES).

Tremblay, Claude and Daniel Malenfant (1996). "Estrategias Locales para Favorecer la Sostenibilidad de Acciones de Desarrollo El Caso del Proyecto de Conservacoon y Desarrollo Arenal Costa Rica." Paper presented at the *Congreso Mundial de Conservacion* (Global Conservation Conference). held in Montreal, Canada, 17–21 October.

Tremblay, Claude (1998). WWF'C official and Canadian director of the Arenal Project. Personal inverview.

Tremblay, Claude (1999). "Estrategia de Transferencia de Responsabilities y Traspaso de Recursos del Proyecto de Conservacion y Desarrollo Arenal: Algunas Reflexiones." ACA EN ACCION Boletin No.9/ Publicacion Semestral/Enero.:16–19.

Ulloa Gamboa, Carlos (1996a). "Diagnostico Socioambiental de la Unidad Territorial Priorizada, La Fortuna, San Carlos." The Arenal Conservation and Development Project, Phase II. MINAE-CIDA-WWF-C Agreement.

Ulloa Gamboa, Carlos (1996b). "Estrategia de Conservacion y Desarrollo Sostenible Unidad Territorial Priorizada La Fortuna." elaborado con la colaboracion de: Proyecto de Conservacion y Desarrollo Arenal, Organizaciones Comunales e Institutiones que trabajan en la Zona. December.

Vargas, Emilio (1992) El INBio y la Merck: ¿El fin del colonialismo farmacológico? AMBIEN-TICO. No. 3, August.

Wallerstein, Immanuel (1985). "Marx and Underdevelopment" *Rethinking Marxism. Essays for Harry Magdoff and Paul Sweezy.* Eds. Stephen Resnick and Richard Wolff. Autonomedia. Brooklyn, New York.

Winson, Anthony (1989). *Coffee and Democracy.* Toronto:Between the Lines Press.

World Bank Book (1998) *Global Development Finance.*

Women, Development, and the Market Economy

Ana Isla

L'inégalité des accords d'échange, des relations d'alde, des taux d'intérét et des politiques sociales de rajusiements imposés aux nations endettées contribue au transfert des richesses du Sud au Nord. L'auteure examine les aspects des structures économiques internationales quisont à la base de la crise humaine et écologique actuelle et que les féministes dans le monde entier essaient de contrer.

Environmental destruction cannot be understood outside the context of alternative economic frameworks. No reasoned

From *Canadian Women's Studies*, Vol. 13, No. 2 by Ana Isla.

argument can hide the fact that people in the South live in increasing poverty. This poverty is the product of current economic, social and political structures. It is providing a ground for intolerance, totalltarlanism, civil war, and environmental destruction, the violation of fundamental human rights, and the creation of refugees at local, regional, and international levels.

The International community has to address the need for alternative economic models in order to tackle the real causes of global poverty and violence, and environmental destruction. However, there is a widespread reluctance to undertake the profound questioning required. So, for instance, we find official documents suggesting that rapid population growth is the cause of poverty in the South and a threat the entire world. According to this argument, overpopulation is the first and final cause of environmental degradation.

Feminists with global awareness, on the other hand, are arguing that the very nature of international economic, social, and political relations are at the root of our current crisis, not the individual behaviour of hard-pressed peoples. We are seeking, not to sustain the present inherently exploitative economic model of 'development,' but to transform it. For Caribbean feminist Peggy Antrobus, current Executive Director of DAWN (Development Alternatives with Women for a New Era), an influential network of Third World feminist activist/theorists, the significant differences arising in Rio were not, as could have been expected, between Northern and Southern governments or even between governments and NOOS. In the final analysis, the major differences lay between those who believe that the environmental crisis can be solved by technological fixes (legislation, appropriate pricing for natural resources and expenditures for cleaning up pollution or preserving forests) and those who believe the situation requires alternative approaches to development which are people-centered, equitable, more ethical, and sustainable (DAWN).

The Economic System Today

Development as it is understood by the governments of the world today, in particular, the rich and powerful governments of the North which enforce this process, involves the extension of capitalist markets to all corners of the world and all areas of production. It measures as growth, not production for people's use, but production for exchange for profit in the market; that is, production for those who can afford to buy. Thus, the transfer of resources from production for local people's needs to production for sale (often abroad) is measured as 'progress,' regardless of the hardship that may result. At root, it is a process which opens all areas to investment and profit by local, national, and international interests with capital to invest. An almost inevitable consequence of this commodification and capitalization of production is the displacement and impoverishment of the majority of the people without the capital to invest or income to consume.

For instance, when land becomes valuable in market terms, the traditional rights of those farming it are often abrogated and they are forced off land they do not have the money to buy. When 'green revolutions' bring capital intensive, chemicalized, and highly technological forms of agricultural production, those without the capital to participate cannot compete and often lose their land to richer farmers or international agribusiness. The increase in agricultural production which this 'development' brings registers as growth, but leaves increasing numbers of impoverished people without a livelihood. The benefits are enjoyed by a small group of already wealthy farmers and transnational agribusiness. Far from decreasing poverty, these benefits widen the disparity between rich and poor.

This form of development is a windfall for international agribusiness which manufactures and markets the chemical fertilizers and tractors which the fewer, richer farmers now employ. At the same time the new agricultural practices degrade the fertility of the soil, intensify the effects of droughts, and contribute to desertification, pollute water resources, cause salinization, increase non-renewable energy dependence, destroy genetic resources, contaminate the food supply, and contribute to climatic change (see Shiva).

It should not be surprising that the official systems of economic accounting, institutionalized by these powers, enshrine the profit-centered values of this form of development and mask its destructive impact (Waring). Official economic measures of production count only production for the market and give no value to nature, women's work of reproduction, or other production work (largely in the South) that is not commodified. The contribution of both women's work and nature to peoples' well being (and their loss) remains invisible in these systems, and is not protected or supported in policy making.

International economic arrangements are such that the benefits of even this distorted form of 'development' accrue mainly to the North and involve a large drain of resources from South to North. Gross National Product (GNP) is the measure of the increase in income to a country's nationals. During the 1980s, records of the Gross National Products of Southern countries revealed that, even in these limited monetary terms, they had achieved no national growth. In response, and in order to hide this obvious failure of economic strategy, the United Nations, dominated by the industrialized nations of the North, began to use Gross Domestic Product (GDP) as the preferred measure of growth. The GDP measures production that generates income in a nation's economy, whether or not the resources and increased income are owned by or accrue to that country's residents. CDP, therefore measures profit made abroad from a country's resources. An increase in this product may well accompany a loss of control of a nation's resources and productive capacity and relative impoverishment of even a nation's elite. Neither the GNP not the GDP record the well being of the population, they record 'growth'. The difference is that the GDP claims income which is not enjoyed in the country as growth.

The kind of distortion involved in this narrow definition of production and value is illustrated by the widely used example of the Exxon Valdes oil spill. Because current forms of accounting do not recognize the value of nature or the costs of its destruction, and measure all market exchanges as value, the costs of the clean up register as a simple contribution to Gross National Production. In the terms of national income accounting, this devastating accident appears to have increased our wealth!

Feminists are questioning the world view that makes production for profit and the market the only measure of progress and well being. As the European Women's Caucus at Miami stated:

> We need to further empower ourselves and our knowledge by demystifying economic science: the language which puts monetary value to every human interaction, which "values" nuclear testing while ignoring women's unpaid work in the home; the language which speaks of free trade while putting severe restrictions on world trade. The language which does not count the essential work of families in the so-called "Informal sector"; the language which puts people's needs into impersonal statistics that ignore our specificities (27).

Although it is generally believed, in Canada, that countries of the North send aid and support to poverty stricken countries of the South, the reverse is in fact true. World Bank (WB) and International Monetary Fund (IMF) estimates show that non-industrialized countries are remitting over $50 billion more per year to the Northern countries than they receive in capital transfers. The resulting impoverishment of the South and overconsumption in the North are, together, fueling militarism and the environmental crisis (Bertell).

The Impact of Trade

The higher standard of living enjoyed by Northern countries would not have been possible without the explosion of global trade in terms highly unfavourable to the South. Although the days of the outright colonial destruction of the cotton industry in India or the imposition of the opium trade on an unwilling Chinese government are over, the North still uses its political, military, and economic power to control both market access and the terms of international trade. The level of Northern consumption to which this trade contributes is clearly unsustainable.

> The demands placed on the global ecosystems by the consumption habits of the rich are enormous. The industrialized nations, with just 25 percent of the world's population, consume 70 percent of its energy, 75 percent of its metals, 85 percent of its food (UNDP, 204).

And these demands are increasing: in the U.S., the average person in 1990 owned twice as many cars, drove two and half times as far, and used 21 times as much plastic, compared to 40 years earlier (Durning, 154).

Trends in Japan and Western Europe are similar. . . . (USD).

The impoverishment of the South also endangers the environment. Terms of trade (the value of a country's exports relative to the value of its imports), largely controlled by the industrialized nations, have always favoured industrial goods. That is, raw materials have always exchanged with industrial goods at unfavourable rates. However, in recent years these terms have been deteriorating, which means that Southern countries are paying continually higher prices for imports while receiving lower prices for exports. In 1951, the Index of Purchasing Power for primary commodities stood at 153. It declined to 100 by 1961, to 92 in 1971, to 91 in 1981 and to 73 in 1985. In other words, over this period of 34 years the purchasing power of the same amount of production fell by almost half. Other research has shown that in the last ten years, real prices for Southern goods have fallen by approximately 30 percent. This means, for instance, indonesia must export three times as much timber today to buy one tractor than it did in 1970.

This leaves the Southern nations in the position of having to increase the rates at which they exploit their natural resources to earn the same return. Southern residents and ecosystems are bearing the cost of economic activity which is transforming their entire culture, displacing the aboriginal peoples from their land, and destroying the environment upon which they depend for survival.

In addition to deteriorating terms of trade, Southern countries are faced with Northern imposed barriers to trade such as escalating tariffs, non-tariff barriers, and protectionism,[1] as well as subsidized competition. A recent study of the exports of six Southern nations found that exporters of raw materials capture only nine percent of the final price (profit margin). However, when they process the raw material in the country they capture 35 percent of the final price. However, Western European governments have used the General Agreement on Tariffs and Trade to challenge increased domestic processing as an unfair trade practice! And individual industrial countries generally place higher tariffs on processed than unprocessed materials to keep the jobs and profit involved in the processing in the North.

Textiles and Agriculture function under discriminatory rules that punish Southern producers. The U.S. floods world markets with subsidized products. During 1992 alone, export subsidies to agriculture in the U.S. were $1 billion, (*The Economist*) which resulted in depressed prices. This is costing Southern countries $40 billion per year.

Agricultural intensification promoted by price subsidies is also environmentally unsound, leading to problems of land degradation, and destruction of the water table. In the World Development Report (1986), the World Bank uses this example: "Sugar is a tropical crop, but Western Europe and North America subsidize domestic producers of beet sugar and restrict their import of cane sugar." This was estimated to cost Southern

countries $7.4 billion in 1983 in lost income. Beet sugar is not only an inefficient use of temperate land, but the processing of the beet is one of the most polluting of food processing activities.

Trade-Related Intellectual Property Rights

A major thrust of current national and international discussions and negotiations around trade is to strengthen private ownership rights and extend them into areas previously not available to control for profit. In the Trade Related Intellectual Property Rights (TRIPR) discussion, for instance, the United States is using the threat of blocking access to its market to force a number of countries into giving stronger protection for corporate patents and copyrights.

This will strengthen the rights of patent holders against the rights of communities and protect the profit of transnational corporations who are the patent holders. One example of the conflict of interest between communities and patent holders is the long fought war by International drug companies against any country that tries to produce cheaper forms of generic drugs for its population. This prohibition is costly for Canadians, and especially poor Canadians, but it is far more destructive when imposed on poor nations (Lexchin).

Since Northern countries monopolize patents and copyrights, approval of intellectual Property Rights at this round of the General Agreement on Tariffs and Trade [GATT] talks would entrench the current South-North financial flow more firmly.

This move would also enlrench technological control and profit in the North and exclude Southern countries even more effectively from ever following this development route. Both are outcomes resisted strongly, though largely ineffectively because of their lack of power, by Southern governments.

However, there are other, even more disturbing implications at the heart of these proposals that feminists are almost alone in naming and opposing (see article by Shiva in this issue). For the extension and enrichment of Intellectual Property Rights that is being sought would open whole new areas of activity to commodification and profit making, and expand the power of the international corporations and the dependence of communities into unheard of areas. At the GATT-TRIPR talks, for instance, the biotechnology industry is trying to win patent rights over plants, animals, genetic materials, and all life forms derived from the human body. Patents of seeds will cover not only the right to sell seeds, but plant parts and processes as well.

Feminists are insisting that this logic itself and all the arrangements that reflect it must be challenged. Curbs to its most destructive impacts are not enough. They are critical of the failure of Southern governments to resist the system outright. They view Southern attempts to gain more equal power and profit in the existing system as shortsighted and ultimately self-defeating.

International 'Aid'

Unfortunately, and contrary to most Canadians' understanding, the practice of 'aid' is a key component in the international system of Northern exploitation and control of the South. Both multilateral and bi-lateral aid[2] is administered on terms which greatly favour the interests of transnational corporations and the industrialized world. Most aid is in the form of loans not gifts, as the people in the North often presume. It often burdens recipients with high interest charges as well as principal repayment. The highest proportion of gift aid is in military 'aid.' It is generally tied to the purchase of military hardware and know-how from the donor nation. This 'aid' fuels local wars all over the globe, supports local dictatorships useful to international capitalism, and supports the arms industries of industrialized nations.

Much of billateral loan aid is also 'tied aid,' that is, it is tied to the purchase of goods and services from the donor country. For instance, a large-scale wheat project implemented by the Canadian International Development Agency [CIDA] in Tanzania required the use of Canadian form machinery. This type of aid has more to do with export promotion than with development needs. It often leaves Southern countries with inappropriate goods, a dependency on foreign imports, and huge external debt. The export interests in this aid means that is skewed toward costly, capital intensive, and often environmentally and humanly destructive projects. These are projects which provide markets for Northern goods and open up new areas for profit in the recipient country.

Aid also provides industrialized nations with a powerful lever in international negotiations. It is one among many economic forms of power the North is able to bring to bear in trade and other negotiations. This helps explain why the outcomes of international negotiations so invariably favour the North.

In addition, the project focus of aid serves to mystify the underlying causes of human and environmental damage. It emphasizes compartmentalized and piecemeal remedial solutions that obscure the general picture and mask the interconnection of the problems. It makes it difficult for development workers or recipient populations to obtain funds for other kinds of work such as supporting human rights, exploring gender oppression, studying the environmental effects of structural adjustment programs or the relationship between the ruling parties in Southern countries and the IMF and World Bank.

More recently, in keeping with the general global trend toward privatization, the aid discussion is taking on new dimensions. In the name of accountability, efficiency, and responsibility, some donors, including Canada and the World Bank, are considering tendering aid projects to private businesses who may in turn subcontract other firms to do the work. This will open another stage of the already profitable aid industry to potential profit.

Debt and Structural Adjustment

As a result of the current 'terms of trade', and the dependency on technology, markets and investments, Southern countries need to keep on borrowing money to cover their ongoing deficits. The growth in bank loans to Southern countries began in the late 1960s, led by CitiCorp (an American bank). In the 1970s, with the rise in oil prices, the traditional role of commercial banks was strengthened. Faced with cutbacks in economic activity in the North, banks could not find customers for their loans. Bank representatives could thus be found sitting on the doorsteps of Ministers of Finance all over the world offering money. The big funds went to those countries seen as having good economic prospects, a developing manufacturing base or a future as oil producers. Fierce competition between banks resulted, however, with offers of loans even to poor countries such as Peru, Bolivia, Philippines. The extension of loans to weaker countries has long been an important component of Northern expansionism.

The increase in interest rates in the 1980s was disastrous for the South and coincided with the deterioration in the terms of trade and a fall in a volume of export.

The World Commission on Environment and Development (WCED), better known as the Brundtland Commission, stated in its 1987 report that pressures on developing countries to earn foreign exchange (to repay the debt) was placing them in a position of undue reliance on increasing commodity export, thereby causing depletion of renewable natural resources.

This practice is mandated under the WN and IMP 'structural adjustments programs' (SAPS). SAPS are based on the concept that enlarged world trade will increase international well-being. Forcing many countries to simultaneously expand exports also helps to lower prices by increasing competition in the export of the same primary commodities.

Despite what most people in the North believe, Southern countries have paid back more than they borrowed, although in 1992 they still owed more than 1000 billion, due to the U.S. manipulation of exchange and interest rates.

In addition to SAPS, Northern business, supported by the IMP and WB, have been carrying out "debt-equity swaps," exchanging the banks' loans for ownership in all Southern assets. The new "swap," named Debt-for-nature conversion, implemented by some international development agencies, is helping creditors take control of debtor countries' natural resources. The debt crisis places the basic economy as well as greater sections of forested lands in Southern countries in the hands of transnational corporations. In addition to debt swaps, foreign aid is also a tool used to control Southern national policies, because aid (bilateral or multilateral), is given in the framework of structural adjustment programs (projects, technical assistance, etc.). Foreign donors assess the willingness of the recipients to engage in SAPS.

NAFTA *and the Enterprise of the Americas Initiative*

The liberalization of national economies[3] in Latin America and the Caribbean, through the implementation of SAPS, has been a prerequisite for the North American Free Trade Agreement (NAFTA). NAFTA can be seen as the extension of SAPS to Canada as well as the introduction of measures to protect U.S. monopoly profits through so-called "Intellectual Property Rights."

NAFTA and the Enterprise of the Americas Initiative[4] intend to reinforce the prevailing development model allowing transnational corporations to move freely in host countries without paying decent wages, protecting the health of workers, implementing safety measures, and paying fair taxes. Both initiatives are designed to limit the government's ability to provide long-term development, keeping the U.S. in control.

NAFTA and the Enterprise of the Americas Initiative can only accelerate environmental degradation. First, it will involve a high degree of specialization where goods and services would only be produced in the region which is selected for the transnational corporation. As economies became globalized, resources will shift from sector to sector or between countries, and put to more efficient use elsewhere. There may be no reason for new capital to replace what is has removed. Unemployment and poverty are inevitable.

Secondly, the initiatives will eliminate the government's power to regulate the import and export of resources, limit the ability of governments to reserve domestic production of goods for local consumption, and thereby weaken their ability to meet the needs of their own populations.

Thirdly, for aboriginal people or communities which have not previously been involved in the cash economy, it will mean a loss of self-sufficiency and traditional ways of life as they are forced to leave their lands, which may be valuable for agriculture or mineral resources. Large scale migration to urban-centres will be accelerated.

Last, but not least, increasing economic activity at a time when many of the world's ecosystems are already damaged will put the entire planet at risk.

Hidden Economic Agenda

The North defines the environment in extremely narrow ecological terms, like trees, the ozone layer and industrial pollution, excluding its economic, social, and cultural dimension. Consequently, it has drafted conventions on the climate, biodiversity and forests, measures aimed at controlling and managing the resources of the South. Its dependence on natural resources has led to the implementation of policies linking "development aid" to environmental conditionalities, reinforced by the "greening of trade" and the "greening of debt." In addition, the North has established a whole range

of institutional structures, such as the Global Environmental Facility under World Bank management, well known for its profanity in the South. Four items have been chosen as the first focus of this program, the ozone layer, international rivers, biodiversity, and green house gas emissions.

Southern governments, however, feel that environmental problems, as defined by Northern countries, are largely by-products of industrialization and irrelevant to their interests. They fear that environmental concerns in the North will slow down their development by imposing new preconditions for development projects, which would not be accompanied by new financial resources. Many are preoccupied that the concerns for environment and health will put new restrictions on their exports to the North and that multinational corporations will be driven by higher standards of living in the North to locate their dirtiest and most toxic facilities in the Southern "pollution havens."

Unfortunately, financially hard pressed Southern governments also recognize that there is money to be made by playing the environmental game, as it is narrowly defined by the North. They want to make sure that they are in on the distribution.

Footnotes

1. Escalating tariffs are import tariff rates which increase with the degree of processing of the goods. Non-tariff barriers are measures used to restrict imports. Voluntary Export Restraint (VER), for example, is an agreement for "voluntarily" reducing the volume or value of goods exported to a particular country usually under threat of some retaliatory action. Protectionism is a policy which advocates government economic protection for domestic producers through restrictions on foreign competitors.
2. Bilateral aid is given directly from one country to another. Multilateral aid is administered by international organizations. This reduces the pressure that can be wielded by a single donor nation, but actually increases the overall power of the North over the South.
3. Liberalization of local economies means liberalized access to foreign capital, but removes from national governments the power to manage their natural resources.
4. The Enterprise of the Americas (or Bush Plan) covers three areas of Latin American and Caribbean countries: trade, investment, and external debt. It involves expanding free trade, a U.S. commitment to reduce tariffs on exports from these countries, the establishment of an investment fund to promote privatization, a small reduction in the external debt, and increased loans to countries willing to implement SAPS as well as debt-for-nature swaps.

References

Bertell, Rosalie, *"No Immediate Danger": Prognosis for a Radioactive Earth*. Toronto: Women's Press, 1985.

DAWN Informs. 02/1993.

Duming, Alan. "Asking How Much Is Enough." *World Watch Institute: State of the World*. New York: W. W. Norton, 1991.

The Economist, June 27, 1992.

European Women's Caucus Statement. *Women's Action Agenda 21*. International Policy Action Committee, 1992.

IISD (International Institute for Sustainable Development), *Trade and Sustainable Development*. Winnipeg, 1992.

Lexchin, Joel, "Pharmaceutical Patents and Politics; Canada and Bill C22." Canadian Centre for Policy Alternatives. Ottawa, 1992.

Shiva, Vandana. *Staying Alive: Women, Ecology and Development*, London: Zed Books, 1989.

UNDP (United Nations Development Program). *Human Development Report*. New York: Oxford University Press, 1992.

Waring, Marilyn, *If Women Counted: A New Feminist Economics*. San Francisco: Harper and Row, 1988.

Stabilization/Structural Adjustment/Restructuring

Canadian Feminist Issues in a Global Framework

Ana Isla, Angela Miles, Sheila Molloy

Les auteures examinent les systèmes de marchés basés sur le profit qui requièrent la «modernisation» et le «développement» de l'économie du Sud. D'après les auteures, ces programmes de restructuration ne se portent garants ni de la croissance ni du bien-être des êtres humains et ils se cachent derrière un langage à double sens qui ne rend pas compte de la souffrance et de la destruction qu'ils causent. Les auteures tracent un parallèle avec les programmes de restructuration qui sont présentement mis sur pied dans le Nord.

*T*he official United Nations Platform for Action endorsed by governments in Beijing is stronger than the draft that

From *Canadian Woman Studies*, Vol. 16, No. 3 by Ana Isla, Angela Miles & Sheila Molloy.

went into the Conference, thanks to powerful and consensual lobbying by the world's women. Many of the commitments made in the Platform can be useful reference points for continued local lobbying around the world. However the document in general and its framing presumptions in particular remain deeply problematic for the feminist project of women's liberation and social justice in an ecologically sound and harmonious world.

Probably the most serious limitation of the Platform for Action is its implicit and explicit endorsement of existing global economic and political relationships. Certainly women's attempts to have the destructive nature of this system recognized in the Platform for Action were fiercely resisted and ultimately failed. The economically powerful nations of the world closed ranks and rode herd on others to insulate the formal government deliberations from this profound challenge. Equally noteworthy, however, was the broad consensus among those lobbying in Beijing that the current global system is flawed at its deepest level and in its deepest logic. The shared determination of women that this system must change is not reflected in the official Platform but it is none the less real and powerful.[1]

Women from the economic South have played a major role in developing feminist understanding of the deeply negative aspects of the global economy and the "growth" and "development" pursued as an unquestioned good in its name (see Anand; Antrobus; Bhasin; Dakar; D'Souza; ISIS; Oliviera and Coral; Sen and Grown; Shiva). But feminists from the economic North increasingly share this understanding and have contributed to it (see Boulding; Bunch and Carillo; Leghorn and Parker; Mies; Mies and Shiva; Moraga; Pietilä; and Waring). The consensus that shaped women's economic lobbying in Beijing has been built over decades of global dialogue grounded in autonomous feminist networks and organizing and fostered by opportunities for exchange and common action at regional and international gatherings.[2] The political work at Beijing and its Preparatory Committee Meetings followed and built on the work of feminists at a whole series of previous United Nations conferences including the World Women's Congresses in Mexico City 1975, Copenhagen 1980, and Nairobi 1985, and Conferences on Environment and Development (the Earth Summit) in Brazil 1992, Human Rights in Vienna 1993, Population in Cairo 1994, and Social Development in Copenhagen 1995.

Feminists at all these conferences, and through their activism and networking in between, have come to reject the profit based market system which 1) compels private ownership of all the earth's goods; 2) recognizes as value only what is sold for profit on the market; and therefore 3) fails, by definition, to acknowledge the value of nature and of women's work. Asian feminists at a regional meeting said of this system:

> Far from promoting broadly-based human development, this model has resulted in gross violations of human rights, continuing depletion of natural resources, increasing destitution of local communities, and violence against women. (Second Asian and Pacific Ministerial Conference on Women 31).

Feminists globally, are committed not only to resist the worst consequences of this system and its spread but to work towards totally different equal, cooperative, life sustaining, communal forms of social and economic organization. This involves recognizing the worth of women's work[3] and of nature and the importance of women's and other traditional knowledges, all of which are currently denied, devalued, marginalized, and rendered invisible. Feminists not only recognize the worth of these things but do so in terms of an alternative logic grounded in the value of life rather than profit.

Measuring value in terms of what contributes to the sustenance of human and non-human life reveals the absurdity, even criminality, of the current system which measures only production for the market and for profit (Waring). It makes it possible to see that what is called progress/ growth/ modernization/ development has been a centuries long process, in both the economic North and economic South, of often violent colonization of nature, women, workers, Indigenous peoples, and traditional cultures and communities.

"Modernization"/"development" has brought not only an enormous increase in production for profit, but also, and equally centrally, the relative and/or absolute deprivation of women, colonies, and marginal groups and communities. For expansion of the market and of production for exchange at the expense of production for use 1) removes the means of subsistence from individuals and communities; 2) institutionalizes mens' dependence on wages and women's dependence on men; 3) reduces all of human and non-human life to a commodity, valuable only in so far as it contributes to profit for a few; 4) fuels the concentration of wealth and power in fewer and fewer hands, ultimately a few non-accountable transnational corporations.

The intensification of this process of homogenization, control, and commodification is the real agenda of the "globalization" we hear so much about today. Everywhere, the exigencies of global competition and the global market are used to enforce policies which put absolute priority on unfettered transnational profit-making at the expense of people and the planet.

In both North and South the spectre of debt and deficit is used to impose these punitive and destructive policies. In Canada, and in the economic North generally, relentless fear mongering about the size of government deficits and their damaging consequences is used to sell policies of selective fiscal austerity which leave intact and even augment subsidies to transnational business while cutting the much less substantial social spending. Prosperity is misleadingly equated with "growth" of market production and transnational profit and any resources which do not serve this end directly are defined as dangerous and insupportable "costs."[4]

Countries of the economic South provide clear evidence that contrary to the dominant mythology, market forces are no guarantee of growth, welfare, and the development of human potential. Rather the reverse. For, due largely to the depredations of a global market dominated by the rich nations of the economic North, these

nations are deeply in debt to industrial countries and their financial institutions such as the International Monetary fund (IMF), World Bank (WB), commercial banks, insurance agencies. Unequal and deteriorating "terms of trade" and a huge jump in interest rates from 2.2 percent in the 1970s when the debts were incurred, to 16.6 percent in 1982 are the major causes of this debt. As a result of these factors countries which have repaid their debt many times over are still deeply in debt.

For instance, countries in Latin America and the Caribbean, Africa, and Asia which had received a total of US$458.1 billion in loans and paid back US$1.167 trillion in amortization and service charges as of 1988, still owe more than US$2 trillion (World Bank 192). The IMF estimates that since 1987 the economic North has been enriched by US$50 billion annually in net transfers from the South. In 1994 Latin America and the Caribbean alone sent US$73 billion to the North in interest and amortization payments; in 1995 the figure was US$87 billion (IMF).

Since 1982 most new borrowing has been used to service the debt. The money borrowed goes directly to creditors in the North even as the loans increase the indebtedness of the South. Nevertheless, their "debt" is used to impose on these countries policies which prioritize private (usually transnational) production for export and foreign currency earnings for debt repayment, over production for people's needs and protection of the environment (Isla 1993a).

It is true that the global competitive market imposes conditions that are hard, often impossible, for local economies and producers to resist and erodes nation states' power of economic management. Rising interest rates, for instance, are a large factor in the increase in the Canadian debt from US$276.69 billion in 1988 to US$592.9 billion in 1995. The fact that a large proportion of the Canadian debt is domestic rather than foreign (US$482.5 domestic compared to US$110.4 billion foreign debt in 1995) does not change this. Nor does it absolve Canada from the need to meet its IMF undertakings, because capital is international.

However, state power has not ceased to exist with the concentration of power in transnational capital. It is used to serve that concentration. The absolute dominance of the global market that restricts national options and is used to justify painful restructuring measures in the name of competitiveness, is itself the product of free trade and price liberalization policies dictated and implemented by the governments of wealthy nations (G-7) and their multilateral institutions (International Monetary Fund, World Bank, World Trade Organization) with the collaboration of some ruling groups in the economic South.

These policies shift resources from people to profit and redistribute income and property to the wealthy in the name of reducing debt/deficit and increasing efficiency and competitiveness.

They are called "stabilization" and "structural adjustment" when imposed by external bodies on the nations of the economic South and "restructuring" when imposed by national governments on their own populations in the economic North. Whatever

their name, they involve the privatization of public goods, tax cuts on business, cuts in social services, downsizing/layoffs by business, wage reductions.

The real anti-life and anti-women agenda of these policies is obscured by the powerful ideology that equates "growth" and "development" with human well-being, and "restructuring" with progress. The double speak that fosters these illusions is well illustrated in the World Bank's application of structural adjustment philosophy to health. In its *World Development Report 1993* the World Bank calls for governments to: foster an enabling environment for households to improve health; improve government spending in health; and promote diversity and competition in health services. David Werner provides an interpretation of this rhetoric:

> "Foster an enabling environment" means requiring disadvantaged families to pay for their own health, in other words fee-for-service and cost-recovery through user-financing that shifts the burden of health costs to the shoulders of the poor.
>
> "Improve government spending on health" means trimming government spending by reducing services from comprehensive coverage to a narrowly selective, cost-effective approach, or a new brand of selective primary health care.
>
> "Promote diversity and competition" means turning over to private doctors and businesses most of those government services that used to provide free or subsidized care to the poor. This implies privatization of most medical and health services, thus pricing many medical interventions beyond the reach of those in greatest need. (13–14)

This philosophy/agenda is being relentlessly imposed around the globe in every area of life. Free trade and price liberalization, cut backs in spending, privatization, and fiscal austerity are key conditionalities of IMF stabilization and World Bank structural adjustment policies (SAPS). They are also the hallmark of federal and provincial government policy in Canada today. The resulting suffering and destruction is much more acute in the South but it is increasingly felt in the North as well. This is the basis for feminists' shared understanding of the destructive consequences of the global economic system, and their concerted if largely unsuccessful efforts at the Beijing Conference to have this acknowledged in the Platform for Action.

It is not by chance that none of this economic truth is to be found in the UN Platform for Action. It is powerful knowledge and we need it all the more because it is absent from the United Nations Agenda. For the Platform for Action is essentially and insistently about integrating women into existing structures rather than transforming them.

Understanding this global system and its consequences exposes the inadequacy of this frame for feminist action. It uncovers the common agenda that drives policy in Canada in apparently disparate areas and illuminates the links between our struggles and the struggles of women around the world.[5] It reveals the connections, as well,

between our struggles in Canada against the North American Free Trade Agreement (NAFTA); against violence against women; against environmental destruction; against cut backs to welfare, education, health, child care, transportation, housing, women's services and groups; against militarism; against the destruction of the fishery and the family farm; for Indigenous communities and Native rights; for the rights of migrant workers and refugees; for recognition of women's unpaid work in the census and many more.

All these issues are global as well as local in their causes and their solutions. They are all necessarily part of a larger struggle to change the defining value of our global economic system from profit to the sustenance of human and non-human life.

Women from all the regions of the economic South have lived for decades with "stabilization" and "structural adjustment" policies that have destroyed the social fabric and ecological balance in their countries, undermined the health of their populations, and left millions in abject poverty, imposing special burdens on women (Isla 1993b). In Canadian federal and provincial governments' restructuring policies, women from these countries now living in Canada are seeing a re-run of a bad movie they've already been to. It is already clear that the consequences will be similar here, for Canadians across the country are beginning to experience and resist their socially and ecologically destructive impact.

The consequences are more extreme and have been felt over a longer period in the economic South and in depressed regions of Canada. But the parallels are indisputable and are illustrated in the accompanying sidebar. The columns list 1) the words that rationalize these policies in every region, 2) what these policies actually are, and 3) what the consequences are for women around the world. Women everywhere are clearly in the same life and death struggle. We need each other to change the world. Our success depends on our understanding this, and the future of humanity and the planet depends on our success.

References

Anand, Anita. "Rethinking Women and Development." *Women in Development: A Resource Guide for Organization and Action.* Rome and Geneva: ISIS International, 1983. 5–11.

Antrobus, Peggy. "Equality, Development, and Peace: A Second Look at the Goals of the UN Decade for Women." Address to the Associated Country Women of the World, Vancouver, BC, 18–29 June 1983.

Antrobus, Peggy. "Caribbean Women in Development: A Reassessment of Concepts, Perspectives, and Issues." *Bulletin of Eastern Caribbean Affairs* 2.2 (May/June (1985): 10–15.

Barlow, Maude. "Global Pillage: NAFTA has Become a Charter of Rights and Freedoms for Corporation. It's Time to Create a Moral Vision." *This Magazine* (March/April 1996): 8–11.

Bhasin, Kamla. "Alternative and Sustainable Development," *Convergence* 25.2 (1992): 26–35.

Boulding, Elise. "Integration into What? Reflections on Development Planning for Women." *Convergence* 13.1–2 (1980): 50–59.

Bunch, Charlotte and Roxanna Carillo. "Feminist Perspectives on Women in Development." *Persistent Inequalities.* Ed. Irene Tinker. New York: Oxford University Press, 1990. 70–82.

Council of Canadians. *Canadian Perspectives.* (Summer 1996): 6–9.

CUPE. *Believe It or Else.* . . . Ottawa: Canadian Union of Public Employees, 1996.

Dakar. "The Dakar Declaration on Another Development with Women." *Development Dialogue* 1.2 (1982): 11–16.

D'Souza, Corinne Kumar. "The South Wind." *Terra Femina.* Eds. Rosiska Darcy deOliviera and Thais Corral. Brazil: IDAC/REDEH, 1992. 24–53.

Goar, Carol. "Maverick Liberal Takes on Big Shots." *Toronto Star* 10 Dec. 1994: D4.

International Monetary Fund. *World Economic Perspectives.* Washington: IMF, 1996.

ISIS. *Women in Development: A Resource Guide for Organization and Action.* Rome and Geneva: ISIS International, 1983.

Isla, Ana. "The Debt Crisis in Latin America: An Example of Unsustainable Development." *Canadian Woman Studies* 13.3 (1993a): 65–68.

Isla, Ana. "Women, Development, and the Market Economy." *Canadian Woman Studies* 13.3 (1993b): 28–33.

Leghorn, Lisa and Katherine Parker. *Woman's Worth: Sexual Economics and the World of Women.* London: Routledge and Kegan Paul, 1981.

Mies, Maria. *Patriarchy and Accumulation on a World Scale: Women in the International Division of Labour.* London: Zed Books, 1986.

Mies, Maria. "The Global is the Local." *Terra Femina.* Eds. Rosiska Darcy De Oliviera and Thais Corral. Brazil: IDAC (Institute of Cultural Action) and REDEH (Network in Defence of Human Species), 1992. 54–68.

Mies, Maria, and Vandana Shiva. *Ecofeminism.* London: Zed Press, 1993.

Miles, Angela. *Integrative Feminisms: Building Global Visions 1960s–1990s.* New York: Routledge, 1996.

Nesbitt Research. *The Bank Analyzer.* Toronto: Nesbitt Thompson Inc., 1993.

Pietilä, Hilkka. "A New Picture of Human Economy: A Woman's Perspective." Paper presented at Fifth Interdisciplinary Congress on Women. San Jose, Costa Rica, 22–26 Feb. 1993.

Second Asian and Pacific Ministerial Conference on Women. "Our Concerns, NGO Statement on Issues." *Seizing the Alternative to Forge a Better Future.* Proceedings of the Lobby Training Seminar for Asian Women's NGOs at the Asia Pacific Ministerial Meeting for Women in Development. 1–14 June 1994. Jakarta, Indonesia, 1994.

Sen, Gita, and Caren Grown. *Development, Crises, and Alternative Visions: Third World Women's Perspectives.* New York: Monthly Review Press, 1987.

Shiva, Vandana. *Staying Alive: Women, Ecology, and Development.* London: Zed Books, 1989.

South Asian Workshop on Women and Development. *Pressing Against the Boundaries, Report of an FAO/FFHC/AD* Workshop. New Delhi: FAO, 1989.

Stienstra, Deborah. *Women's Movements and International Organizations.* Basingstoke, UK: MacMillan, 1995.

"Tax Critics Blast Corporate Dodge: Up to $60 Billion in Foreign Cash Moves Unreported." *Toronto Star* 10 May 1996: E1.

Waring, Marilyn. *If Women Counted: A New Feminist Economics.* San Francisco: Harper and Row, 1988.

Werner, David. "The Life and Death of Primary Health Care." *Third World Resurgence* 42/43 (1994): 13–14.

World Bank. *World Debt Tables, External Finance for Developing Countries.* Vol. 1. Washington: World Bank, 1996.

World Women's Congress for a Healthy Planet. *Official Report including Women's Action Agenda 21 and Findings of the Tribunals.* New York: Women's Environment and Development Organization (WEDO), 1991.

SECTION II

Theoretical Transformations

Black Women: Shaping Feminist Theory

bell hooks

\mathcal{F}eminism in the United States has never emerged from the women who are most victimized by sexist oppression; women who are daily beaten down, mentally, physically and spiritually—women who are powerless to change their condition in life. They are a silent majority. A mark of their victimization is that they accept their lot in life without visible question, without organized protest, without collective anger or rage. Betty Friedan's *The Feminine Mystique* is still heralded as having paved the way for contemporary feminist movement—it was written as if these women did not exist. Friedan's famous phrase, 'the problem that has no name', often quoted to describe the condition of women in this society, actually referred to the

plight of a select group of college-educated, middle- and upper-class, married white women—housewives bored with leisure, with the home, with children, with buying products, who wanted more out of life. [. . .] She made her plight and the plight of white women like herself synonymous with a condition affecting all American women. In so doing, she deflected attention away from her classism, her racism, her sexist attitudes towards the masses of American women. In the context of her book, Friedan makes clear that the women she saw as victimized by sexism were college-educated, white women who were compelled by sexist conditioning to remain in the home. [. . .] Specific problems and dilemmas of leisure-class white housewives were real concerns that merited consideration and change but they were not the pressing political concerns of masses of women. Masses of women were concerned about economic survival, ethnic and racial discrimination, etc. [. . .] It remains a useful discussion of the impact of sexist discrimination on a select group of women. Examined from a different perspective, it can also be seen as a case study of narcissism, insensitivity, sentimentality and self-indulgence which reaches its peak when Friedan, in a chapter titled 'Progressive Dehumanization', makes a comparison between the psychological effects of isolation on white housewives and the impact of confinement on the self-concept of prisoners in Nazi concentration camps.[1]

[. . .] Like Friedan before them, white women who dominate feminist discourse today rarely question whether or not their perspective on women's reality is true to the lived experiences of women as a collective group. Nor are they aware of the extent to which their perspectives reflect race and class biases, although there has been a greater awareness of biases in recent years. Racism abounds in the writings of white feminists, reinforcing white supremacy and negating the possibility that women will bond politically across ethnic and racial boundaries. Past feminist refusal to draw attention to and attack racial hierarchies suppressed the link between race and class. Yet class structure in American society has been shaped by the racial politic of white supremacy; it is only by analyzing racism and its function in capitalist society that a thorough understanding of class relationships can emerge. Class struggle is inextricably bound to the struggle to end racism.

[. . .] White women who dominate feminist discourse, who for the most part make and articulate feminist theory, have little or no understanding of white supremacy as a racial politic, of the psychological impact of class, of their political status within a racist, sexist, capitalist state. [. . .]

There is much evidence substantiating the reality that race and class identity creates differences in quality of life, social status and lifestyle that take precedence over the common experience women share—differences which are rarely transcended. [. . .]

A central tenet of modern feminist thought has been the assertion that 'all women are oppressed'. This assertion implies that women share a common lot, that factors like class, race, religion, sexual preference, etc. do not create a diversity of experience that determines the extent to which sexism will be an oppressive force in the lives of indi-

vidual women. Sexism as a system of domination is institutionalized but it has never determined in an absolute way the fate of all women in this society. *Being oppressed means the absence of choices.* It is the primary point of contact between the oppressed and the oppressor. Many women in this society do have choices (as inadequate as they are) therefore exploitation and discrimination are words that more accurately describe the lot of women collectively in the United States. [. . .] There are oppressed women in the United States, and it is both appropriate and necessary that we speak against such oppression. [. . .] However, feminist emphasis on 'common oppression' in the United States was less a strategy for politicization than an appropriation by conservative and liberal women of a radical political vocabulary that masked the extent to which they shaped the movement so that it addressed and promoted their class interests. [. . .]

Initially, radical participants in the women's movement demanded that women penetrate that isolation and create a space for contact. Anthologies like *Liberation Now, Women's Liberation: Blueprint for the Future, Class and Feminism, Radical Feminism* and *Sisterhood Is Powerful,* all published in the early 1970s, contain articles that attempted to address a wide audience of women, an audience that was not exclusively white, middle-class, college-educated, and adult (many have articles on teenagers). [. . .] Women who were not opposed to patriarchy, capitalism, classism or racism labeled themselves 'feminist'. Their expectations were varied. Privileged women wanted social equality with men of their class; some women wanted equal pay for equal work; others wanted an alternative lifestyle. Many of these legitimate concerns were easily co-opted by the ruling capitalist patriarchy. [. . .]

Feminists in the United States are aware of the contradictions. Carol Ehrlich makes the point in her essay, 'The Unhappy Marriage of Marxism and Feminism: Can It Be Saved?', that 'feminism seems more and more to have taken on a blind, safe, nonrevolutionary outlook' as 'feminist radicalism loses ground to bourgeois feminism', stressing that 'we cannot let this continue'.[2] [. . .]

It is no accident that feminist struggle has been so easily co-opted to serve the interests of conservative and liberal feminists since feminism in the United States has so far been a bourgeois ideology. [. . .] The ideology of 'competitive, atomistic liberal individualism' has permeated feminist thought to such an extent that it undermines the potential radicalism of feminist struggle. The usurpation of feminism by bourgeois women to support their class interests has been to a very grave extent justified by feminist theory as it has so far been conceived. (For example, the ideology of 'common oppression'.) Any movement to resist the co-optation of feminist struggle must begin by introducing a different feminist perspective—a new theory—one that is not informed by the ideology of liberal individualism.

The exclusionary practices of women who dominate feminist discourse have made it practically impossible for new and varied theories to emerge. Feminism has its party line and women who feel a need for a different strategy, a different foundation, often find themselves ostracized and silenced. [. . .] Non-white women who feel affirmed

within the current structure of feminist movement (even though they may form autonomous groups) seem to also feel that their definitions of the party line, whether on the issue of black feminism or on other issues, is the only legitimate discourse. Rather than encourage a diversity of voices, critical dialogue and controversy, they, like some white women, seek to stifle dissent. As activists and writers whose work is widely known, they act as if they are best able to judge whether other women's voices should be heard. [. . .]

We resist hegemonic dominance of feminist thought by insisting that it is a theory in the making, that we must necessarily criticize, question, re-examine and explore new possibilities. My persistent critique has been informed by my status as a member of an oppressed group, experience of sexist exploitation and discrimination, and the sense that prevailing feminist analysis has not been the force shaping my feminist consciousness. This is true for many women. There are white women who had never considered resisting male dominance until the feminist movement created an awareness that they could and should. My awareness of feminist struggle was stimulated by social circumstances. Growing up in a Southern, black, father-dominated, working class household, I experienced (as did my mother, my sisters and my brother) varying degrees of patriarchal tyranny and it made me angry—it made us all angry. Anger led me to question the politics of male dominance and enabled me to resist sexist socialization. Frequently, white feminists act as if black women did not know sexist oppression existed until they voiced feminist sentiment. [. .]

These black women observed white feminists focus on male tyranny and women's oppression as if it were a 'new' revelation and felt such a focus had little impact on their lives. To them it was just another indication of the privileged living conditions of middle- and upper-class white women that they would need a theory to inform them that they were 'oppressed'. The implication being that people who are truly oppressed know it even though they may not be engaged in organized resistance or are unable to articulate in written form the nature of their oppression. These black women saw nothing liberatory in party line analyses of women's oppression. Neither the fact that black women have not organized collectively in huge numbers around the issues of 'feminism' (many of us do not know or use the term) nor the fact that we have not had access to the machinery of power that would allow us to share our analyses or theories about gender with the American public negate its presence in our lives or place us in a position of dependency in relationship to those white and non-white feminists who address a larger audience.

The understanding I had by age thirteen of patriarchal politics created in me expectations of the feminist movement that were quite different from those of young, middle-class, white women. When I entered my first women's studies class at Stanford University in the early 1970s, white women were revelling in the joy of being together—to them it was an important, momentous occasion. I had not known a life where women had not been together, where women had not helped, protected and loved one another

deeply. I had not known white women who were ignorant of the impact of race and class on their social status and consciousness. (Southern white women often have a more realistic perspective on racism and classism than white women in other areas of the United States.) I did not feel sympathetic to white peers who maintained that I could not expect them to have knowledge of or understand the life experiences of black women. Despite my background (living in racially segregated communities) I knew about the lives of white women, and certainly no white women lived in our neighborhood, attended our schools or worked in our homes.

[. . .] Frequently, college-educated black women (even those from poor and working-class backgrounds) were dismissed as mere imitators. Our presence in movement activities did not count, as white women were convinced that 'real' blackness meant speaking the patois of poor black people being uneducated, streetwise and a variety of other stereotypes. If we dared to criticize the movement or to assume responsibility for reshaping feminist ideas and introducing new ideas, our voices were tuned out, dismissed, silenced. We could be heard only if our statements echoed the sentiments of the dominant discourse.

Attempts by white feminists to silence black women are rarely written about. [. . .] Often the white women who are busy publishing papers and books on 'unlearning racism' remain patronizing and condescending when they relate to black women. This is not surprising given that frequently their discourse is aimed solely in the direction of a white audience and the focus solely on changing attitudes rather than addressing racism in a historical and political context. They make us the 'objects' of their privileged discourse on race. As 'objects', we remain unequals, inferiors. Even though they may be sincerely concerned about racism, their methodology suggests they are not yet free of the type of paternalism endemic to white supremacist ideology. Some of these women place themselves in the position of 'authorities' who must mediate communication between racist white women (naturally they see themselves as having come to terms with their racism) and angry black women whom they believe are incapable of rational discourse. Of course, the system of racism, classism and educational elitism remain intact if they are to maintain their authoritative positions. [. . .]

Racist stereotypes of the strong, superhuman black woman are operative myths in the minds of many white women, allowing them to ignore the extent to which black women are likely to be victimized in this society and the role white women may play in the maintenance and perpetuation of that victimization. In Lillian Hellman's autobiographical work *Pentimento*, she writes, 'All my life, beginning at birth, I have taken orders from black women, wanting them and resenting them, being superstitious the few times I disobeyed.'[3] The black women Hellman describes worked in her household as family servants and their status was never that of an equal. Even as a child, she was always in the dominant position as they questioned, advised or guided her; they were free to exercise these rights because she or another white authority figure allowed it. Hellman places power in the hands of these black women rather than acknowledge her

own power over them; hence she mystifies the true nature of their relationship. By projecting onto black women a mythical power and strength, white women both promote a false image of themselves as powerless, passive victims and deflect attention away from their aggressiveness, their power (however limited in a white supremacist, male-dominated state), their willingness to dominate and control others. These unacknowledged aspects of the social status of many white women prevent them from transcending racism and limit the scope of their understanding of women's overall social status in the United States. [. . .]

As a group, black women are in an unusual position in this society, for not only are we collectively at the bottom of the occupational ladder, but our overall social status is lower than that of any other group. Occupying such a position, we bear the brunt of sexist, racist and classist oppression. At the same time, we are the group that has not been socialized to assume the role of exploiter/oppressor in that we are allowed no institutionalized 'other' that we can exploit or oppress. (Children do not represent an institutionalized other even though they may be oppressed by parents.) White women and black men have it both ways. They can act as oppressor or be oppressed. Black men may be victimized by racism, but sexism allows them to act as exploiters and oppressors of women. White women may be victimized by sexism, but racism enables them to act as exploiters and oppressors of black people. Both groups have led liberation movements that favor their interests and support the continued oppression of other groups. Black male sexism has undermined struggles to eradicate racism just as white female racism undermines feminist struggle. As long as these two groups or any group defines liberation as gaining social equality with ruling-class white men, they have a vested interest in the continued exploitation and oppression of others.

Black women with no institutionalized 'other' that we may discriminate against, exploit or oppress often have a lived experience that directly challenges the prevailing classist, sexist, racist social structure and its concomitant ideology. This lived experience may shape our consciousness in such a way that our world view differs from those who have a degree of privilege (however relative within the existing system). It is essential for continued feminist struggle that black women recognize the special vantage point our marginality gives us and make use of this perspective to criticize the dominant racist, classist, sexist hegemony as well as to envision and create a counter-hegemony. I am suggesting that we have a central role to play in the making of feminist theory and a contribution to offer that is unique and valuable. The formation of a liberatory feminist theory and praxis is a collective responsibility, one that must be shared. Though I criticize aspects of the feminist movement as we have known it so far, a critique which is sometimes harsh and unrelenting, I do so not in an attempt to diminish feminist struggle but to enrich, to share in the work of making a liberatory ideology and a liberatory movement.

Footnotes

1. Betty Friedan, *The Feminine Mystique* (New York: W. W. Norton Co., 1963).
2. Carol Ehrlich, 'The Unhappy Marriage of Marxism and Feminism: Can it be Saved?', in Lydia Sargent (ed.), *Women and Revolution* (Boston: South End Press, 1981).
3. Lillian Hellman, *Pentimento* (Boston, MA: Little Brown, 1973).

Colonization and Housewifization

Maria Mies

The Dialectics of 'Progress and Retrogression'

On the basis of the foregoing analysis, it is possible to formulate a tentative thesis which will guide my further discussion.

The historical development of the division of labour in general, and the sexual division of labour in particular, was/is not an *evolutionary* and peaceful process, based on the ever-progressing development of productive forces (mainly technology) and specialization, but a violent one by which first certain categories of men, later certain peoples, were able mainly by virtue of arms

From *Patriarchy and Capital Accumulation on a World Scale: Women in the International Division of Labour* by Maria Mies. Copyright © 1986 by Maria Mies. Reprinted by permission of Zed Books, Ltd.

and warfare to establish an exploitative relationship between themselves and women, and other peoples and classes.

Within such a predatory mode of production, which is intrinsically patriarchal, warfare and conquest become the most 'productive' modes of production. The quick accumulation of material wealth—not based on regular subsistence work in one's own community, but on looting and robbery—facilitates the faster development of technology in those societies which are based on conquest and warfare. This technological development, however, again is not oriented principally towards the satisfaction of subsistence needs of the community as a whole, but towards further warfare, conquest and accumulation. The development of arms and transport technology has been a driving force for technological innovation in all patriarchal societies, but particularly in the modern capitalist European one which has conquered and subjected the whole world since the fifteenth century. The concept of 'progress' which emerged in this particular patriarchal civilization is historically unthinkable without the one-sided development of the technology of warfare and conquest. All subsistence technology (for conservation and production of food, clothes and shelter, etc.) henceforth appears to be 'backward' in comparison to the 'wonders' of the modern technology of warfare and conquest (navigation, the compass, gunpowder, etc.).

The predatory patriarchal division of labour is based, from the outset, on a structural *separation* and *subordination* of human beings: men are separated from women, whom they have subordinated, the 'own' people are separated from the 'foreigners' or 'heathens'. Whereas in the old patriarchies this separation could never be total, in the modern 'western' patriarchy this separation has been extended to a separation between MAN and NATURE. In the old patriarchies (China, India, Arabia), men could not conceive of themselves as totally independent from Mother Earth. Even the conquered and subjected peoples, slaves, pariahs, etc., were still visibly present and were not thought of as lying totally *outside* the *oikos* or the 'economy' (the hierarchically structured social universe which was seen as a living organism (cf. Merchant, 1983)). And women, though they were exploited and subordinated, were crucially important as mothers of sons for all patriarchal societies. Therefore, I think it is correct when B. Ehrenreich and D. English call these pre-modern patriarchies gynocentric. Without the human mother and Mother Earth no patriarchy could exist (Ehrenreich/English, 1979: 7–8). With the rise of capitalism as a world-system, based on large-scale conquest and colonial plunder, and the emergence of the world-market (Wallerstein, 1974), it becomes possible to *externalize* or *exterritorialize* those whom the new patriarchs wanted to exploit. The colonies were no longer seen as part of the economy or society, they were lying outside 'civilized society'. In the same measure as European conquerers and invaders 'penetrated' those 'virgin lands', these lands and their inhabitants were 'naturalized', declared as wild, savage nature, waiting to be exploited and tamed by the male civilizers.

Similarly, the relationship between human beings and external nature or the earth was radically changed. As Carolyn Merchant has convincingly shown, the rise of modern science and technology was based on the violent attack and rape of Mother Earth—hitherto conceived as a living organism. Francis Bacon, the father of modern science, was one of those who advocated the same violent means to rob Mother Nature of her secrets—namely, torture and inquisition—as were used by Church and State to get at the secrets of the witches. The taboos against mining, digging holes in the womb of Mother Earth, were broken by force, because the new patriarchs wanted to get at the precious metals and other 'raw-materials' hidden in the 'womb of the earth'. The rise of modern science, a mechanistic and physical world-view, was based on the killing of nature as a living organism and its transformation into a huge reservoir of 'natural resources' or 'matter', which could be analysed and synthesized by Man into his new machines by which he could make himself independent of Mother Nature.

Only now, the dualism, or rather the polarization, between the patriarchs and nature, and between men and women could develop its full and permanent destructive potential. From now on science and technology became the main 'productive forces' through which men could 'emancipate' themselves from nature, as well as from women.

Carolyn Merchant has shown that the destruction of nature as a living organism—and the rise of modern science and technology, together with the rise of male scientists as the new high priests—had its close parallel in the violent attack on women during the witch hunt which raged through Europe for some four centuries.

Merchant does not extend her analysis to the relation of the New Men to their colonies. Yet an understanding of this relation is absolutely necessary, because we cannot understand the modern developments, including our present problems, unless we include all those who were 'defined into nature' by the modern capitalist patriarchs: Mother Earth, Women and Colonies.

The modern European patriarchs made themselves independent of their *European* Mother Earth, by conquering first the Americas, later Asia and Africa, and by extracting gold and silver from the mines of Bolivia, Mexico and Peru and other 'raw materials' and luxury items from the other lands. They 'emancipated' themselves, on the one hand, from their dependence on European women for the production of labourers by destroying the witches, as well as their knowledge of contraceptives and birth control. On the other hand, by subordinating grown African men and women into slavery, they thus acquired the necessary labour power for their plantations in America and the Caribbean.

Thus, the progress of European Big Men is based on the subordination and exploitation of their own women, on the exploitation and killing of Nature, on the exploitation and subordination of other peoples and their lands. Hence, the law of this

'progress' is always a contradictory and not an evolutionary one: progress for some means retrogression for the other side; 'evolution' for some means 'devolution' for others; 'humanization' for some means 'de-humanization' for others; development of productive forces for some means underdevelopment and retrogression for others. The rise of some means the fall of others. Wealth for some means poverty for others. The reason why there cannot be unilinear progress is the fact that, as was said earlier, the predatory patriarchal mode of production constitutes a non-reciprocal, exploitative relationship. Within such a relationship no general progress for all, no 'trickling down', no development for all is possible.

Engels had attributed this antagonistic relationship between progress and retrogression to the emergence of private property and the exploitation of one class by the other. Thus, he wrote in 1884:

> Since the exploitation of one class by another is the basis of civilization, its whole development moves in a continuous contradiction. Every advance in production is at the same time a retrogression in the condition of the exploited class, that is of the great majority. What is a boon for the one is necessarily a bane for the other; each new emancipation of one class always means a new oppression of another class (Engels, 1976: 333).

Engels speaks only of the relationship between exploiting and exploited classes, he does not include the relationship between men and women, that of colonial masters to their colonies or of Civilized Man in general to Nature. But these relationships constitute, in fact, the hidden foundation of civilized society. He hopes to change this necessarily polarized relationship by extending what is good for the ruling class to all classes: 'What is good for the ruling class should be good for the whole of the society with which the ruling class identifies itself' (Engels, 1976: 333).

But this is precisely the logical flaw in this strategy: in a contradictory and exploitative relationship, the privileges of the exploiters can never become the privileges of all. If the wealth of the metropoles is based on the exploitation of colonies, then the colonies cannot achieve wealth unless they also have colonies. If the emancipation of men is based on the subordination of women, then women cannot achieve 'equal rights' with men, which would necessarily include the right to exploit others.[1]

Hence, a feminist strategy for liberation cannot but aim at the total abolition of all these relationships of retrogressive progress. This means it must aim at an end of all *exploitation* of women by men, of nature by man, of colonies by colonizers, of one class by the other. As long as exploitation of one of these remains the precondition for the advance (development, evolution, progress, humanization, etc.) of one section of people, feminists cannot speak of liberation or 'socialism'.

Subordination of Women, Nature and Colonies: The Underground of Capitalist Patriarchy or Civilized Society

In the following, I shall try to trace the contradictory process, by which, in the course of the last four or five centuries women, nature and colonies were externalized, declared to be outside civilized society, pushed down, and thus made invisible as the under-water part of an iceberg is invisible, yet constitute the base of the whole.

Methodologically, I shall try as far as possible to undo the division of those poles of the exploitative relations which are usually analysed as separate entities. Our understanding of scholarly work or research follows exactly the same logic as that of the colonizers and scientists: they cut apart and separate parts which constitute a whole, isolate these parts, analyse them under laboratory conditions and synthesize them again in a new, man-made, artificial model.

I shall not follow this logic. I shall rather try to trace the 'underground connections' that link the processes by which nature was exploited and put under man's domination to the processes by which women in Europe were subordinated, and examine the processes by which these two were linked to the conquest and colonization of other lands and people. Hence, the historical emergence of European science and technology, and its mastery over nature have to be linked to the persecution of the European witches. And both the persecution of the witches and the rise of modern science have to be linked to the slave trade and the destruction of subsistence economies in the colonies.

This cannot be a comprehensive history of this whole period, desirable though this might be. I shall mainly highlight some important connections which were crucial for the construction of capitalist patriarchal production relations. One is the connection between the persecution of the witches in Europe and the rise of the new bourgeoisie and modern science, and the subordination of nature. This has already been dealt with by several researchers (Merchant, 1983; Heinsohn, Knieper, Steiger, 1979; Ehrenreich, English, 1979; Becker *et al*, 1977). The following analysis is based on their work.

The historical connections between these processes and the subordination and exploitation of colonial peoples in general, and of women in the colonies in particular, has not yet been adequately studied. Therefore, I shall deal with this history more extensively.

The Persecution of the Witches and the Rise of Modern Society Women's Productive Record at the End of the Middle Ages

Among the Germanic tribes who occupied Europe, the house-father (*pater famil-ias*) had power over everything and everybody in the house. This power, called *munt* (Old High German) (*mundium* = *manus* = hand), implied that he could sell, bill, etc., wife, children, slaves, etc. The *munt* of the man over the woman was established through marriage. The relationship was one of property rights over things, which was founded on occupation (kidnapping of women), or purchase (sale of women). According to Germanic law, the marriage was a sales-contract between the two families. The woman was only the object in this transaction. By acquiring the *munt*-power, the husband acquired the right over the wife's belongings, as she was his property. Women were lifelong under the *munt* of their men—husband, father, son. The origin of this *munt* was to exclude women from the use of arms. With the rise of the cities since the thirteenth century and the emergence of an urban bourgeoisie, the 'whole house'—the earlier Germanic form of the extended family and kinship—began to dissolve. The old *potestas patriae*, the power of the father over sons and daughters, ended when they left the house. Wives were put under the *munt* or guardianship of the husband. However, if unmarried women had property of their own, they were sometimes considered *mündig* (major) before the law. In Cologne, unmarried women who followed some craft were called *selbstmündig* in 1291 (Becker *et al*, 1977: 41). The laws prevailing in the cities, as well as some laws for the countryside, freed women in the crafts from the *munt* or dependence on a father or husband.

The reason for this liberalization of sexual bondage has to be seen in the need to allow women in the cities to carry on their crafts and businesses independently. This was due to several factors:

1. With the extension of trade and commerce the demand for manufactured goods, particularly clothes and other consumer goods, grew. These goods were almost exclusively produced in the household of craftsmen and women. With the growth of money-supply in the hands of the patricians, their consumption of luxury goods also grew. Costly clothes of velvet and silk, lace collars, girdles, etc., became the fashion. In many of these crafts women were predominant.

However, in Germany, married women were not allowed to carry out their business or any property transaction without the consent of their husband, who continued to be their guardian and master. However, craftswomen or businesswomen could appear before a court as witnesses or complainants, without a guardian. In some cities the businesswomen or market-women were given equal rights with the men. In Munich it was

stated that 'a woman who stands in the market, buys and sells, has all rights her husband has'. But she could not sell his property.

The independence of the medieval crafts- and market-women was not unlimited; it was a concession given to them because the rising bourgeoisie needed them. But within the family the husband retained his master role.

2. The second reason for this relative freedom for women in commerce and crafts was a shortage of men at the end of the Middle Ages. In Frankfurt the sex ratio was 1,100 women for 1,000 men, according to a thirteenth-century census; in Nuremberg (fifteenth century), the sex ratio was 1,000 men to 1,207 women. The number of men had diminished due to the crusades and constant warfare between the feudal states. Moreover, male mortality seems to have been higher than female mortality 'because of the men's intemperance in all sorts of revelries' (Bücher, quoted in Becker *et al*, 1977: 63).

Among the peasants in South Germany, only the eldest son was allowed to marry because otherwise the land would have been divided into holdings too small to be viable. Journeymen were not allowed to marry before they became masters. The serfs of the feudal lords could not marry without the consent of their lords. When the cities opened their doors, many serfs, men and women, ran away to the cities; 'city air makes men free' was the slogan. The poor people in the countryside had to send their daughters away to fend for themselves as maidservants because they could not feed them until they were married.

This all resulted in an increase in the number of unattached, single or widowed women who had to be economically active. The cities, in the twelfth and thirteenth centuries did not exclude women from any craft or business which they wanted to take up. This was necessary as, without their contribution, trade and commerce could not have been expanded. But the attitude towards the economically independent women was always contradictory. In the beginning the crafts' guilds were exclusively men's associations. It seems they had to admit some craftswomen later. In Germany this did not occur before the fourteenth century. Mainly weaver-women and spinsters and women engaged in other branches of textile manufacture were allowed to join guilds. Weaving had been in the hands of the men since the twelfth century, but women did a number of ancillary jobs, and later also female master weavers are mentioned for certain branches like veil-weaving, linen-weaving, silk-weaving, gold-weaving, etc., which were only done by women. In Cologne there were even female guilds from the fourteenth century.

Apart from the crafts, women were mainly engaged in *petty trade* in fruits, chicken, eggs, herrings, flowers, cheese, milk, salt, oil, feathers, jams, etc. Women were very successful as peddlers and hawkers, and constituted a certain challenge to male traders. But they did not engage in foreign trade though they advanced money to merchants who traded with the outside markets.

The silk-spinners of Cologne often were married to rich merchants who sold the precious products of their wives in far-off markets in Flanders, England, at the North Sea and the Baltic Sea, at the big fairs in Leipzig and Frankfurt (Becker *et al*, 1977: 66–67).

Only one merchant women is mentioned who herself travelled to England in the fifteenth century: Katherine Ysenmengerde from Danzig (Becker *et al*, 1977: 66–67).

In the fifteenth and sixteenth centuries, however, the old European order collapsed and 'there came to be a European world economy based on the capitalist mode of production' (Wallerstein, 1974: 67). This period is characterized by a tremendous expansion and penetration of the rising bourgeoisie into the 'New Worlds', and by pauperization, wars, epidemics and turbulence within the old core states.

According to Wallerstein this world economy included, by the end of the sixteenth century, north-west Europe, the Christian Mediterranean, Central Europe, the Baltic region, certain regions of America, New Spain, the Antilles, Peru, Chile and Brazil. Excluded at that time were India, the Far East, the Ottoman Empire, Russia and China.

Between 1535 and 1540, *Spain* achieved control over more than half the population of the Western Hemisphere. Between 1670–1680, the area under European control went up from about three million square kilometres to about seven million (Wallerstein, 1974: 68). The expansion made possible the large-scale accumulation of private capital 'which was used to finance the rationalization of agricultural production' (Wallerstein, 1974: 69). 'One of the most obvious characteristics of this sixteenth century European World Economy was a secular inflation, the so-called price revolution' (Wallerstein, 1974: 69). This inflation has been attributed, in one way or the other, to the influx of precious metals, bullion, from Hispano America. Its effect was mainly felt in the supply of foodgrains available at cheaper prices. 'In those countries where industry expanded, it was necessary to turn over a larger proportion of the land to the needs of horses'. Grain then had to be bought in the Baltic at higher prices. At the same time, wages remained stagnant in England and France because of institutional rigidities, and even a decline in real wages took place. This meant greater poverty for the masses.

According to Wallerstein, sixteenth-century Europe had several core areas: northern Europe (Netherlands, England, France) where trade flourished, and where land was used mainly for pastoral purposes, not for grain. Rural wage-labour became the dominant form of labour control. Grain was imported from Eastern Europe and the Baltics—the periphery—where 'secondary serfdom' or 'feudalism' emerged as the main labour control. In northern and central Europe this process led to great pauperization of peasants. There seems to have been population growth in the sixteenth century and the pressure on the towns grew. Wallerstein sees this population pressure as reason for out-migration. 'In Western Europe there was emigration to the towns and a growing vagabondage that was "endemic"' (Wallerstein, 1974: 117). There was not only the rural exodus due to eviction and the enclosure system (of the yeomen in England), 'there was also the vagabondage "caused by the decline of feudal bodies of retainers

and the disbanding of the swollen armies which had flocked to serve the kings against their vassals" ' (Marx, quoted by Wallerstein, 1974: 117).

These wanderers—before they were recruited as labourers into the new industries—lived from hand to mouth. They were the impoverished masses who flocked around the various prophets and heretic sects. Most of the radical and utopian ideas of the time are concerned with these poor masses. Many poor women were among these vagabonds. They earned their living as dancers, tricksters, singers and prostitutes. They flocked to the annual fairs, the church councils, etc. For the Diet of Frankfurt, 1394, 800 women came; for the Council of Constance and Basle, 1500 (Becker *et al*, 1977; 76). These women also followed the armies. They were not only prostitutes for the soldiers but they also had to dig trenches, nurse the sick and wounded, and sell commodities.

These women were not despised in the beginning, they formed part of medieval society. The bigger cities put them into special 'women's houses'. The church tried to control the increasing prostitution, but poverty drove too many poor women into the 'women's houses'. In many cities these prostitutes had their own associations. In Church processions and public feasts they had their own banners and place—even a patron saint, St Magdalene. This shows that up to the fourteenth century prostitution was not considered a bad thing. But at the end of the fourteenth century, the Statues of Meran rule that prostitutes should stay away from public feasts and dances where 'burgers women and other honorable women are'. They should have a yellow ribbon on their shoes so that everyone could distinguish them from the 'decent women' (Becker *et al*, 1977: 79).

The witch-hunt which raged through Europe from the twelfth to the seventeenth century was one of the mechanisms to control and subordinate women, the peasant and artisan, women who in their economic and sexual independence constituted a threat for the emerging bourgeois order.

Recent feminist literature on the witches and their persecution has brought to light that women were not passively giving up their economic and sexual independence, but that they resisted in many forms the onslaught of church, state and capital. One form of resistance were the many heterodox sects in which women either played a prominent role, or which in their ideology propagated freedom and equality for women and a condemnation of sexual repression, property and monogamy. Thus the 'Brethren of the Free Spirit', a sect which existed over several hundred years, established communal living, abolished marriage, and rejected the authority of the church. Many women, some of them extraordinary scholars, belonged to this sect. Several of them were burnt as heretics (Cohn, 1970).

It seems plausible that the whole fury of the witch-hunt was not just a result of the decaying old order in its confrontation with new capitalist forces, or even a manifestation of timeless male sadism, but a reaction of the new male-dominated classes against the *rebellion* of women. The poor women 'freed', that is, expropriated from their means

of subsistence and skills, fought back against their expropriators. Some argue that the witches had been an organized sect which met regularly at their 'witches' sabbath', where all poor people gathered and already practised the new free society without masters and serfs. When a woman denied being a witch and having anything to do with all the accusations, she was tortured and finally burnt at the stake. The witch trial, however, followed a meticulously thought-out legal procedure. In protestant countries one finds special secular witch-commissions and witch-commissars. The priests were in constant rapport with the courts and influenced the judges.

One prosecutor, Benedikt Carpzov, first a lawyer in Saxonia, later professor in Leipzig, signed 20,000 death sentences against witches. He was a faithful son of the protestant church (Dross, 1978: 204).

If someone denounced a woman as a witch, a commission was sent to that place to collect evidence. Everything was evidence: good weather or bad weather, if she worked hard or if she was lazy, diseases or healing powers. If under torture the witch named another person, this person was also immediately arrested.

The Subordination and Breaking of the Female Body: Torture

Here are the minutes of the torture of Katherine Lips from Betzlesdorf, 1672:

> After this the judgement was again read to her and she was admonished to speak the truth. But she continued to deny. She then undressed willingly. The hangman bound her hands and hung her up, let her down again. She cried: woe, woe. Again she was pulled up. Again she screamed, woe woe, lord in heaven help me. Her toes were bound . . . her legs were put into Spanish boots—first the left then the right leg was screwed . . . she cried, 'Lord Jesus come and help me . . .' She said she knew nothing, even if they killed her. They pulled her up higher. She became silent, then she said she was no witch. Then they again put the screws on her legs. She again screamed and cried . . . and became silent . . . she continued to say she knew nothing . . . She shouted her mother should come out of the grave and help her . . .
>
> They then led her outside the room and shaved her head to find the stigma. The master came back and said they had found the stigma. He had thrust a needle into it and she had not felt it. Also, no blood had come out. Again they bound her at hand and feet and pulled her up, again she screamed and shouted she knew nothing. They should put her on the floor and kill her, etc., etc., etc. . . . (quoted in Becker *et al*, 1977: 426ff).

In 1631 Friedrich von Spee dared to write an anonymous essay against the tortures and the witch-hunt. He exposed the sadistic character of the tortures and also the use the authorities, the church and the secular authorities made of the witch hysteria to

find a scapegoat for all problems and disturbances and the unrest of the poor people, and to divert the wrath of the people from them against some poor women.

> 31 October 1724: Torture of Enneke Fristenares from Coesfeld (Münster) After the accused had been asked in vain to confess, Dr Gogravius announced the order of torture . . . He asked her to tell the truth, because the painful interrogation would make her confess anyway and double the punishment . . . after this the first degree of torture was applied to her.

> Then the judge proceeded to the second degree of torture. She was led to the torture chamber, she was undressed, tied down and interrogated. She denied to have done anything . . . As she remained stubborn they proceeded to the third degree and her thumbs were put into screws. Because she screamed so horribly they put a block into her mouth and continued screwing her thumbs. Fifty minutes this went on, the screws were loosened and tightened alternately. But she pleaded her innocence. She also did not weep but only shouted, 'I am not guilty. O Jesus come and help me.' Then, 'Your Lordship, take me and kill me.' Then they proceeded to the fourth degree, the Spanish Boots . . . As she did not weep Dr Gogravius worried whether the accused might have been made insensitive against pain through sorcery. Therefore he again asked the executioner to undress her and find out whether there was anything suspicious about her body. Whereupon the executioner reported he had examined everything meticulously but had not found anything. Again he was ordered to apply the Spanish Boots. The accused however continued to assert her innocence and screamed 'O Jesus I haven't done it, I haven't done it, Your Lordship kill me. I am not guilty, I am not guilty!' . . .

> This order went on for 30 minutes without result.

> Then Dr Gogravius ordered the fifth degree:

> The accused was hung up and beaten with two rods—up to 30 strokes. She was so exhausted that she said she would confess, but with regard to the specific accusations she continued to deny that she had committed any of the crimes. The executioner had to pull her up till her arms were twisted out of their joints. For six minutes this torture lasted. Then she was beaten up again, and again her thumbs were put into screws and her legs into the Spanish Boots. But the accused continued to deny that she had anything to do with the devil.

> As Dr Gogravius came to the conclusion that the torture had been correctly applied, according to the rules, and after the executioner stated the accused would not survive further torturing Dr Gogravius ordered the accused to be taken down and unbound. He ordered the executioner to set her limbs in the right place and nurse her (quoted in Becker *et al*, 1977: 433–435, transl. M.M.).

Burning of Witches, Primitive Accumulation of Capital, and the Rise of Modern Science

The persecution and burning of the midwives as witches was directly connected with the emergence of modern society: the professionalization of medicine, the rise of *medicine* as a 'natural science', the rise of *science* and of *modern economy*. The torture chambers of the witch-hunters were the laboratories where the texture, the anatomy, the resistance of the human body—mainly the female body—was studied. One may say that modern medicine and the male hegemony over this vital field were established on the base of millions of crushed, maimed, torn, disfigured and finally burnt, female bodies.[2]

There was a calculated division of labour between Church and State in organizing the massacres and the terror against the witches. Whereas the church representatives identified witches, gave the theological justification and led the interrogations, the 'secular arm' of the state was used to carry out the tortures and finally execute the witches on the pyre.

The persecution of the witches was a manifestation of the rising modern society and not, as is usually believed, a remnant of the irrational 'dark' Middle Ages. This is most clearly shown by Jean Bodin, the French theoretician of the new mercantilist economic doctrine. Jean Bodin was the founder of the quantitative theory of money, of the modern concept of sovereignty and of mercantilist populationism. He was a staunch defender of modern rationalism, and was at the same time one of the most vocal proponents of state-ordained tortures and massacres of the witches. He held the view that, for the development of new wealth after the medieval agrarian crisis, the *modern state* had to be invested with absolute sovereignty. This state had, moreover, the duty to provide for enough workers for the new economy. In order to do so, he demanded a strong police which above all would fight against witches and midwives who, according to him, were responsible for so many abortions, the infertility of couples, or sexual intercourse without conception. Anyone who prevented the conception or the birth of children he considered as a murderer, who should be persecuted by the state. Bodin worked as a consultant of the French government in the persecution of the witches, and advocated torture and the pyre to eradicate the witches. His tract on witchcraft was one of the most brutal and sadistic of all pamphlets written against witches at that time. Like Institoris and Sprenger in Germany he singled out women for his attack. He set a ratio of 50 women to one man for the witch persecutions (Merchant, 1983: 138). This combination of modern rationality, the propagation of the new state and a direct violent attack on the witches we also find with another great master of the new era of European civilization, namely Francis Bacon (cf. Merchant, 1983: 164–177).

Similarly, there is a direct connection between the witch pogroms and the emergence of the professionalization of *law*. Before that period, the German law followed

old Germanic custom; it was people's law or customary law, but not a discipline to be studied. But now Roman law was introduced, most of the universities established a law faculty and several universities, like the university of Frankfurt, consisted in fact only of the law faculty. Some contemporaries complain about the universities:

> They are good for nothing and train only parasites who learn how to confuse the people, how to make good things bad and bad things good, who withhold what is rightful from the poor and give what is not his right to the rich (Jansen, 1903, quoted in Hammes, 1977: 243; transl. M.M.).

The reason why the sons of the rising urban class were flocking to the law faculties was the following: 'In our times jurisprudencia smiles at everybody, so that everyone wants to become a doctor in law. Most are attracted to this field of studies out of greed for money and ambition' (ibid.).

The witch trials provided employment and money for a host of lawyers, advocates, judges, councils, etc. They were able, through their complicated and learned interpretations of the authoritative texts, to prolong the trials so that the costs of the trial would go up. There was a close relationship between the worldly authorities, the church, the rulers of the small feudal states and the lawyers. The latter were responsible for an inflation of fees, and filled their coffers by squeezing money from the poor victims of the witch-hunt. The fleecing of the people was so rampant that even a man like the Elector of Trier (the Archbishop of Trier was one of the seven princes who elected the German Kaiser), Johann von Schoenburg, who had himself had several hundred people executed as witches and sorcerers, had to check the robbing of the widows and orphans by the learned jurists and all others connected with the witch trials. Some of the rulers set up accountants to check what the various officials had done with the money extracted and the fees they had demanded. Among the costs for a trial were the following:

– for the alcohol consumed by the soldiers who pursued a witch;

– for the visit the priest paid to the witch while in prison;

– for the maintenance of the private guard of the executioner.

(Hammes, 1977: 243–257).

According to Canon Law, the property of the witch was to be confiscated, irrespective of whether there were heirs or not. The bulk of the confiscated property, never less than 50 per cent, was appropriated by the government. In many cases, all that was left over after the deduction of the costs for the trial went to the state treasury. This confiscation was illegal, as the 'Constitutio Criminalis' of Emperor Charles V proclaims in 1532. But this law had only paper value.

The fact that the witch-hunt was such a lucrative source of money and wealth led in certain areas to the setting up of special commissions which had the task of de-

nouncing ever more people as witches and sorcerers. When the accused were found guilty, they and their families had to bear all the costs of the trial, beginning with the bills for alcohol and food for the witch commission (their *per diem*), and ending with the costs for the firewood for the stake. Another source of money was the sums paid by the richer families to the learned judges and lawyers in order to free one of their members from the persecution if she was accused as a witch. This is also a reason why we find more poor people among those who were executed.

Manfred Hammes has brought to light yet another dimension of the 'political economy' of the witch-hunt, namely, the raising of funds by the warring European princes to finance their wars, particularly the Thirty-Year War from 1618–1648. From 1618 onwards, the Law of Charles V, prohibiting the confiscation of property of witches and sorcerers, was virtually abandoned and witch-hunts were specifically organised or encouraged by some of the princes in order to be able to confiscate the property of their subjects.

Hammes gives us the example of the city of Cologne and the dispute that arose between the city fathers and the Elector Ferdinand of Bavaria—the ruler of the diocese. The city of Cologne, a rich centre of trading and industries, had remained neutral for a long time during the Thirty-Years War. (In the beginning of the seventeenth century, the city had seen a flourishing trade—mainly in silk and textiles.)[3] Nevertheless, the city had paid considerable sums into the war fund of the Emperor. This was made possible by an increase in taxes. When foreign armies were marauding and looting the villages, many rural people fled into the free and neutral city. The result was a scarcity of food supplies which led to tensions among the people and even to open riots. At the same time the witch trial against Catherine Hernot[4] started, which was followed by an intense witch-hunt. When the first judgements were pronounced, the Elector Ferdinand of Bavaria, who had to pay his armies, presented a bill to the city authorities. In this bill he claimed that all the property of executed witches should be confiscated and go to the exchequer. The city council tried with all means to prevent the implementation of this ordinance. They asked their lawyers to make an expert study of the law. But the Elector and his lawyers finally proclaimed that the bill was an emergency measure. Since the evil of witchcraft had assumed such dimensions in recent times, it would be politically unwise to follow the letter of the law (namely, Constitutio Criminalis of Charles V prohibiting confiscations) word by word. However, the lawyers of the city were not convinced and they suggested a compromise. They said it was fair and just that the persons who had been involved in the witch trial, the lawyers, executioners, etc., would get a fee as compensation 'for their hard work and the time they had spent on the trial'. The Elector, as he could not press money out of the urban witch-hunt, confiscated all the property of the witches executed in the rural areas of the diocese.

But not only the feudal class (particularly the smaller princes who could not compete with the rising bourgeoisie in the cities, or the bigger lords), but also the propertied

classes in the cities were using the confiscation of witch-property as a means for capital accumulation.

Thus, in Cologne itself in 1628, ten years after the beginning of the war, the city authorities had introduced the confiscation of witch-property. One of the legitimations forwarded by the lawyers of Cologne was that the witches had received a lot of money from the devil and that it was perfectly in order that this devil's money be confiscated by the authorities to enable them to eradicate the evil breed of sorcerers and witches. In fact, it seems that in some cases the cities and the princes used witch-pogroms and confiscations as a kind of development aid for their ruined economies. The city fathers of Mainz did not make much fuss about legal niceties and simply asked their officials to confiscate all property of the witches. In 1618, the Monastery of St Clare of Hochheim had donated them 2,000 guilders for the 'eradication of witches'.

There is a report of the Bailiff Geiss who wrote to his Lord of Lindheim asking him to allow him to start with the persecution because he needed money for the restoration of a bridge and the church. He noted that most of the people were disturbed about the spreading of the evil of witchcraft:

> If only your Lordship would be willing to start the burning, we would gladly provide the firewood and bear all other costs, and your Lordship would earn so much that the bridge and also the Church could be well repaired.

> Moreover, you would get so much that you could pay your servants a better salary in future, because one could confiscate whole houses and particularly the more well-to-do ones (quoted in Hammes, 1977: 254; transl. M.M.).

Apart from the big bloodsuckers—the religious authorities, the worldly governments, the feudal class, the urban authorities, the fraternity of jurists, the executioners—there grew up a whole army of smaller fry who made a living out of the burning witches. Begging monks wandered around and sold pictures of the saints which, if swallowed by the buyers, would prevent them from being afflicted by witchcraft. There were many self-appointed witch-commissars. Since the authorities paid fees for the discovery, the arrest and the interrogation of witches, they accumulated money by wandering from place to place instigating the poor people to see the cause of all their misery in the workings of the witches. Then, when everybody was in the grip of the mass psychosis, the commissar said he would come to eradicate the pest. First, the commissar would send his collector who would go from house to house to collect donations to prove that the peasants themselves had invited him. Then the commissar would come and organize two or three burnings at the stake. If someone was not ready to pay, he was suspected of being a sorcerer or a witch or a sympathizer of the witches. In some cases the villages paid a sum to the commissar in advance, so that he would not visit their village. This happened in the Eifel village of Rheinbach. But five years later the same commissar came back and, since the peasants were not ready to yield a

second time to this blackmail, he added more death sentences to the record of 800 he had already achieved.

The hope of financial gains can be seen as one of the main reasons why the witch hysteria spread and why hardly any people were acquitted. The witch-hunt was business. This is clearly spelt out by Friedrich von Spee who finally had the courage, in 1633, to write a book against this sordid practice. He notes:

– the lawyers, inquisitors, etc., use torture because they want to show that they are not superficial but responsible lawyers;

– they need many witches in order to prove that their job is necessary;

– they do not want to lose the remuneration the princes have promised for each witch.

To summarize we can quote Cornelius Loos who said the witch trials 'were a new alchemy which made gold out of human blood' (Hammes, 1977: 257). We could add, out of female blood. The capital accumulated in the process of the witch-hunt by the old ruling classes, as well as by the new rising bourgeois class is nowhere mentioned in the estimates and calculations of the economic historians of that epoch. The blood-money of the witch-hunt was used for the private enrichment of bankrupt princes, of lawyers, doctors, judges and professors, but also for such public affairs as financing wars, building up a bureaucracy, infrastructural measures, and finally the new absolute state. This blood-money fed the original process of capital accumulation, perhaps not to the same extent as the plunder and robbery of the colonies, but certainly to a much greater extent than is known today.

But the persecution and torture of witches was not only motivated by economic considerations. The interrogation of witches also provided the model for the development of the new scientific method of extracting secrets from Mother Nature. Carolyn Merchant has shown that Francis Bacon, the 'father' of modern science, the founder of the inductive method, used the same methods, the same ideology to examine nature which the witch-persecutioners used to extract the secrets from the witches, namely, torture, destruction, violence. He deliberately used the imagery of the witch-hunt to describe his new scientific method: he treated 'nature as a female to be tortured through mechanical inventions' (Merchant, 1983: 168), as the witches were tortured by new machines. He stated that the method by which nature's secrets might be discovered consisted in investigating the secrets of witchcraft by inquisition: 'For you have but to follow and as it were hound out nature in her wanderings, and you will be able when you like to lead and drive her afterward to the same place again . . .' (quoted by Merchant, 1983: 168). He strongly advocated the breaking of all taboos which, in medieval society, forbade the digging of holes into Mother Earth or violating her: 'Neither ought a man to make scruple of entering and penetrating into these holes and corners,

when the inquisition of truth is his whole object . . .' (Merchant, 1983: 168). He compared the inquisition of nature to both the interrogation of witches and to that of the courtroom witnesses:

> I mean (according to the practice in civil causes) in this great plea or suit granted by the divine favour and providence (whereby the human race seeks to recover its right over nature) to *examine nature herself* and the arts upon interrogatories . . . (Merchant, 1983: 169).

Nature would not yield her secrets unless forcibly violated by the new mechanical devices:

> For like as a man's disposition is never well known or proved till he be crossed, nor Proteus ever changed shapes till he was *straitened* and *held fast*, so nature exhibits herself more clearly under the *trials* and *vexations* of art (mechanical devices) than when left to herself (quoted by Merchant, 1983: 169).

According to Bacon, nature must be 'bound into service', made a 'slave', put 'in constraint', had to be 'dissected'; much as 'woman's womb had symbolically yielded to the forceps, so nature's womb harboured secrets that through technology could be wrested from her grasp for use in the improvement of the human condition' (Merchant, 1983: 169).

Bacon's scientific method, which is still the foundation of modern science, unified knowledge with material power. Many of the technological inventions were in fact related to warfare and conquest, like gunpowder, navigation, the magnet. These 'arts of war' were combined with knowledge—like printing. Violence, therefore, was the key word and key method by which the New Man established his domination over women and nature. These means of coercion 'do not, like the old, merely exert a gentle guidance over nature's course; they have the power to conquer and subdue her, to shake her to the foundations' (Merchant, 1983: 172).

Thus, concludes Carolyn Merchant:

> The interrogation of witches as symbol for the interrogation of nature, the courtroom as model for its inquisition, and torture through mechanical devices as a tool for the subjugation of disorder were fundamental to the scientific *method as power* (emphasis added) (Merchant, 1983: 172).

The class which benefited from this new scientific patriarchal dominance over women and nature was the rising protestant, capitalist class of merchants, mining industrialists, clothier capitalists. For this class, it was necessary that the old autonomy of women over their sexuality and reproductive capacities be destroyed, and that women be forcibly made to breed more workers. Similarly, nature had to be transformed into a vast reservoir of material resources to be exploited and turned into profit by this class.

Hence the church, the state, the new capitalist class and modern scientists collaborated in the violent subjugation of women and nature. The weak Victorian women of

the nineteenth century were the products of the terror methods by which this class had moulded and shaped 'female nature' according to its interests (Ehrenreich, English, 1979).

Colonization and Primitive Accumulation of Capital

The period referred to so far has been called the period of *primitive accumulation of capital*. Before the capitalist mode of production could establish and maintain itself as a process of extended reproduction of capital—driven by the motor of surplus value production—enough capital had to be accumulated to start this process. The capital was largely accumulated in the colonies between the sixteenth and seventeenth centuries. Most of this capital was not accumulated through 'honest' trade by merchant capitalists but largely by way of brigandage, piracy, forced and slave labour.

Portuguese, Spanish, Dutch, English merchants went out to break the Venetian monopoly of the spice trade with the East. Most of the Spanish-Portuguese discoveries were inspired by the motive to find an independent sea-route to the Orient. In Europe, the result was a price revolution or inflation due to 1. the technical invention of separating copper from silver; 2. the plundering of Cuzco and the use of slave labour. The cost of precious metal fell. This led to the ruination of the already exhausted feudal class and of the wage earning craftsmen. Mandel concludes:

> The fall in real wages—particularly marked by the substitution of cheap potatoes for bread as the basic food of the people—became one of the main sources of the primitive accumulation of industrial capital between the sixteenth and eighteenth century (Mandel, 1971: 107).

One could say that the *first phase of the Primitive Accumulation* was that of merchant and commercial capital ruthlessly plundering and exploiting the colonies' human and natural wealth. Thus, there had been 'a marked shortage of capital in England' about 1550:

> Within a few years, the pirate expeditions against the Spanish fleet, all of which were organised in the form of joint stock companies, changed the situation . . . Drake's first pirate undertaking in the years 1577–1580 was launched with a capital of £5,000 . . . it brought in about £600,000 profit, half of which went to the Queen. Beard estimates that the pirates introduced some £12 million into England during the reign of Elizabeth (Mandel, 1971: 108).

The story of the Spanish Conquistadores, who depopulated regions like Haiti, Cuba, Nicaragua completely, and exterminated about 15 million Indians is well known. Also, Vasco da Gama's second arrival in India in 1502–1503 was marked by the same trial of blood.

It was a kind of crusade . . . by merchants of pepper, cloves and cinnamon. It was punctuated by horrible atrocities; everything seemed permissible against the hated Moslems whom the Portuguese were surprised to meet again at the other end of the world . . . (quoted from Hauser in Mandel, 1971: 108).

Commercial expansion from the beginning was based on *monopoly*. The Dutch drove out the Portuguese, the English, the Dutch.

It is, therefore, not to be wondered that the Dutch merchants, whose profits depended on their monopoly of spices obtained through conquests in the Indonesian archipelago went over to mass destruction of cinnamon trees in the small islands of the Moluccas as soon as prices began to fall in Europe. The 'Hongi Voyages' to destroy these trees and massacre the population which for centuries had drawn their livelihood from growing them, set a sinister mark on the history of Dutch colonization, which had, indeed, begun in the same style. Admiral J.P. Coen did not shrink from the extermination of all the male inhabitants of the Banda islands (Mandel, 1971: 108).

The trading companies—the Oost-Indische Companie, the English East India Company and Hudson Bay Company and the French Compagnie des Indes Orientales—*all combined the spice trade with the slave trade:*

Between 1636 and 1645 the Dutch West India Company sold 23,000 Negroes for 6.7 million florins in all, or about 300 florins a head, whereas the goods given in exchange for each slave were worth no more than 50 florins. Between 1728 and 1760 ships sailing from Le Havre transported to the Antilles 203,000 slaves bought in Senegal, on the Gold Coast, at Loango, etc. The sale of these slaves brought in 203 million livres. From 1783 to 1793 the slavers of Liverpool sold 300,000 slaves for 15 million, which went into the foundation of industrial enterprises (Mandel, 1971: 110).

Mandel and others, who have analysed this period, do not say much about how the colonizing process affected women in the newly-established Portuguese, Dutch, English and French colonies in Africa, Asia and Latin and Central America. As the merchant capitalists depended mainly on brute force, outright robbery and looting, we can assume that the women were also victims of this process.

The recent work done by feminist scholars has shed more light on to these hidden sides of the 'civilizing process'. Rhoda Reddock's work on women and slavery in the Caribbean shows clearly that the colonizers used a diametrically opposed value system *vis-à-vis* the women of the subjugated peoples as that *vis-à-vis* their 'own' women. Slave women in the Caribbean for long periods were *not* allowed to marry or to have children; it was cheaper to import slaves than to pay for the reproduction of slave labour. At the same time, the bourgeois class domesticated its 'own' women into pure, monogamous breeders of their heirs, excluded them from work outside their house and from property.

The whole brutal onslaught on the peoples in Africa, Asia and America by European merchant capitalists was justified as a *civilizing mission* of the Christian nations.

Here we see the connection between the 'civilizing' process by which poor European women were persecuted and 'disciplined' during the witch-hunt, and the 'civilizing' of the 'barbarian' peoples in the colonies. Both are defined as uncontrolled, dangerous, savage 'nature', and both have to be subdued by force and torture to break their resistance to robbery, expropriation and exploitation.

Women Under Colonialism

As Rhoda Reddock (1984) has shown, the colonizers' attitude to slavery and slave women in the Caribbean was based clearly on capitalist cost-benefit calculations. This was particularly true with regard to the question whether slave women should be allowed to 'breed' more slaves or not. Throughout the centuries of the modern slave trade and slave economy (from 1655 to 1838), this question was answered not according to the principles of Christian ethics—supposedly applicable in the 'Motherlands'— but according to the accumulation considerations of the capitalist planters. Thus, during the first period, from 1655 to the beginnings of the eighteenth century, when most estates were smallholdings with few slaves, these planters still depended, following the peasant model of reproduction, on the natural reproduction of the slave population. The second period is characterized by the so-called sugar-revolution, the introduction of large-scale sugar production in big plantations. In this period, beginning around 1760 and lasting till about 1800 slave women were actively discouraged from bearing children or forming families. The planters, as good capitalists, held the view that 'it was cheaper to purchase than to breed'. This was the case in all sugar colonies whether they were under catholic (French) or protestant (British, Dutch) dominion. In fact, slave women who were found pregnant were cursed and ill-treated. Moreover, the backbreaking work in the sugar plantations did not allow the slave women to nurse small babies. The reason behind this anti-natalist policy of the planters are expressed in the statement of one Mr G.M. Hall on Cuban planters:

> During and after pregnancy the slave is useless for several months, and her nourishment should be more abundant and better chosen. This loss of work and added expense comes out of the master's pocket. It is he who has to pay for the often lengthy care of the newborn. This expense is so considerable that the negro born on the plantation costs more when he is in condition to work than another of the same age bought at the public market would have cost (G.M. Hall, quoted by Reddock, 1984: 16).

In the French colony of St Dominique the planters calculated that a slave woman's work over a period of 18 months was worth 600 Livres. The 18 months were the time calculated for pregnancy and breast feeding. During such a time the slave woman would be able to do only half her usual work. Thus, her master would lose 300 Livres. 'A fifteen month old slave was not worth this sum' (Hall, quoted by Reddock, 1984: 16).

The effect of this policy was, as many observers have found, that the 'fertility' of slave women was extremely low during this period and far into the nineteenth century (Reddock, 1984).

Towards the end of the eighteenth century, it became evident that Western Africa could no longer be counted upon as fertile hunting ground for slaves. Moreover, the British colonizers saw it as more profitable to incorporate Africa itself into their empire as a source of raw material and minerals. Therefore, the more 'progressive' sections of the British bourgeoisie advocated the abolition of the slave trade—which happened in 1807—and the encouragement of 'local breeding'. The colonial government foresaw a number of incentives in the slave codes of the late eighteenth and nineteenth centuries to encourage local breeding of slaves by slave women on the plantations. This sudden change of policy, however, seems to have had little effect on the slave women. As Rhoda Reddock points out, in the long years of slavery the slave women had internalized an anti-motherhood attitude as a form of resistance to the slave system; they continued a kind of birth strike till about the middle of the nineteenth century. When they became pregnant, they used bitter herbs to produce abortions or, when the children were born, 'many were allowed to die out of the women's natural dislike for bearing them to see them become slaves, destined to toil all their lives for their master's enrichment' (Moreno-Fraginals, 1976, quoted by Reddock, 1984: 17). Rhoda Reddock sees in this anti-motherhood attitude of the slave women an example of 'the way in which the ideology of the ruling classes could, for different though connected material reasons, become the accepted ideology of the oppressed' (Reddock, 1984: 17).

The colonial masters now reaped the fruits—or rather the failures—of treating African women as mere conditions of production for capital accumulation. The problem of labour shortage on the plantations in the Caribbean became so acute, due to the slave women's birth strike, that in Cuba virtual 'stud farms' were established and slave breeding became a regular business (Moreno Fraginals, quoted by Reddock, 1984: 18). Rhoda Reddock summarizes the changing policy of the colonizers regarding slave women's procreative capacities in the following manner:

> As long as Africa was incorporated in the capitalist world economy only as a producer of human labour, there was no need to produce labour locally. Through the use of cost-benefit analysis the planters had taken the most profitable line of action. When this was no longer profitable for them, they were surprised by the resistance shown by the slave women who . . . recognized clearly their position as the property of the plantation owners. The fact is, that for more than 100 years, the majority of slave women in the Caribbean were neither wives nor mothers and by exercising control over their reproductive capabilities were able to deeply affect the plantation economy (Reddock, 1984: 18).

These more than a hundred years that 'slave women in the Caribbean were neither wives nor mothers' were exactly the same period that women of the European bour-

geoisie were domesticated and ideologically manipulated into wifehood and mother-hood as their 'natural' vocation (Badinter, 1980). While one set of women was treated as pure labour force, a source of energy, the other set of women was treated as 'non-productive' breeders only.

It is, indeed, an irony of history that later in the nineteenth century the colonizers tried desperately to introduce the nuclear family and the monogamous marriage norm into the ex-slave population of the Caribbean. But both women and men saw no bene-fit for themselves in adopting these norms, and rejected marriage. Now their own double-faced policy boomeranged on the colonizers. In order to be able freely to ex-ploit the slaves, they had for centuries defined them outside humanity and Christian-ity. In this they were supported by the ethnologists who said that the negroes did not belong to the same 'species' as the Europeans (Caldecott, 1970: 67). Hence, slaves could not become Christians because, according to the Church of England, no Christ-ian could be a slave.

When, around 1780, the new Slave Codes began to encourage marriage among the slaves as a means to encourage local breeding of slaves, the slaves only ridiculed this 'high caste' thing and continued with their 'common law' unions. This meant that each woman could live with a man as long as she pleased; the same also applied to the man. Slave women saw the marriage tie as something that would subject them to the control of one man, who could even beat them. The men wanted more than one wife and there-fore rejected marriage. The missionaries and planters who tried to introduce the Eu-ropean middle-class model of the man-woman relationship were exasperated. A church historian, Caldecott, eventually found an explanation for this resistance to the benefits of civilization in the fact that negroes were not able to 'control their fancy' (their sexual desires), and therefore shrank from constancy: 'With them it is the women as much as the men who are thus constituted; there is in the Negro race a nearer ap-proach to equality between the sexes than is found in the European races . . .' (Calde-cott, quoted by Reddock, 1984: 47). 'Equality between the sexes', however, was seen as a sign of a primitive, backward race, a notion which was common among nineteenth-century colonizers and ethnologists.

That equality of men and women is a sign of backwardness and that it is part of the 'civilizing mission' of the British colonialialists to destroy the independence of colo-nized women, and to teach the colonized men the 'virtues' of sexism and militarism are also clearly spelt out by one Mr Fielding Hall in his book. *A People at School.*[5] Mr Hall was Political Officer in the British colonial administration in Burma between 1887–91. He gives a vivid account of the independence of Burmese women, of the equality be-tween the sexes, and of the peace-loving nature of the Burmese people which he as-cribes to Buddhism. But, instead of trying to preserve such a happy society, Mr Hall comes to the conclusion that Burma has to be brought by force on the road of progress: 'But today the laws are ours, the power, the authority. We govern for our own subjects

and we govern in our own way. Our whole presence here is against their desires.' He suggests the following measures to civilize the Burmese people:

1. The men must be taught to kill and to fight for the British colonialists: 'I can imagine nothing that could do the Burmese so much good as to have a regiment of their own to distinguish itself in our wars. It would open their eyes to new views of life' (*A People at School*, p. 264).
2. The women must surrender their liberty in the interests of man.

Considering equality of the sexes a sign of backwardness, this colonial administrator warned: 'It must never be forgotten that their civilization is relatively a thousand years behind ours.' To overcome this backwardness, the Burmese men should learn to kill, to make war and to oppress their women. In the words of Mr Hall: 'What the surgeon's knife is to the diseased body that is the soldier's sword to the diseased nations'. And again:

> . . . the gospel of progress, of knowledge, of happiness . . . is taught not by book and sermon but by spear and sword . . . To declare, as Buddhism does, that bravery is of no account; to say to them, as the women did, you are no better and no more than we are, and should have the same code of life; could anything be worse?

He also seeks the help of ethnologists to defend this ideology of Man the Hunter: 'Men and women are not sufficiently differentiated yet in Burma. It is the mark of a young race. Ethnologists tell us that. In the earliest peoples the difference was very slight. As a race grows older the difference increases.' Then Mr Hall describes how Burmese women are eventually 'brought down' to the status of the civilized, dependent housewife. Local home-industries, formerly in the hands of women, are destroyed by the import of commodities from England. Women are also pushed out of trade: 'In Rangoon the large English stores are undermining the Bazaars where the women used to earn an independent livelihood.'

After their loss of economic independence, Mr Hall considers it of utmost importance that the laws of marriage and inheritance be changed, so that Burma, too, may become a 'progressive' land where men rule. Woman has to understand that her independence stands in the way of progress:

> With her power of independence will disappear her free will and her influence. When she is dependent on her husband she can no longer dictate to him. When he feeds her, she is not longer able to make her voice as loud as his is. It is inevitable that she should retire . . . The nations who succeed are not feminine nations but the masculine. Woman's influence is good provided it does not go too far. Yet it has done so here. It has been bad for the man, bad too for the woman. It has never been good for women to be too independent, it has robbed them of many virtues. It improves a man to have to work for his wife and family, it makes a man of him. It is demoralising for both if the woman can keep herself and, if necessary, her husband too. (*A People at School*, p. 266).

That the African women brought to the Caribbean as slaves were not made slaves because they were 'backward' or less 'civilized' than the colonizers, but on the contrary were *made* 'savages' by slavery itself and those colonizers is now brought to light by historical research on women in Western Africa. George Brooks, for example, shows in his work on the *signares*–the women traders of eighteenth-century Senegal–that these women, particularly of the Wolof tribe, held a high position in the pre-colonial West African societies. Moreover, the first Portuguese and French merchants who came to Senegal in search of merchandise were totally dependent on the cooperation and goodwill of these powerful women, who entered into sexual and trade alliances with these European men. They not only were in possession of great wealth, accumulated through trade with the inferior parts of their regions, but had also developed such a cultured way of life, such a sense for beauty and gracefulness, that the European adventurers who first came into contact with them felt flabbergasted. Brooks quotes one Rev. John Lindsay, chaplain aboard a British ship, as having written:

> As to their women, and in particular the ladies (for so I must call many of those in Senegal), they are in a surprising degree handsome, have very fine features, are wonderfully tractable, remarkably polite both in conversation and manners; and in the point of keeping themselves neat and clean (of which we have generally strange ideas, formed to us by the beastly laziness of the slaves) they far surpass the Europeans in every respect. They bathe twice a day . . . and in this particular have a hearty contempt for all white people, who they imagine must be disagreeable, to our women especially. Nor can even their men from this very notion, be brought to look upon the prettiest of our women, but with the coldest indifference, some of whom there are here, officers' ladies, who dress very showy, and who, even in England would be thought handsome (Brooks, 1976: 24).

The European men—the Portuguese and French who came to West Africa first as merchants or soldiers—came usually alone, without wives or families. Their alliances with the 'ladies' or *signares* (from the Portuguese word *senhoras*) were so attractive to them that they married these women according to the Wolof style, and often simply adopted the African way of life. Their children, the Euroafricans, often rose to high positions in the colonial society, the daughters usually became *signares* again. Obviously, the Portuguese and the French colonizers did not yet have strong racist prejudices against sexual and marriage relationships with West African women, but found these alliances not only profitable, but also humanly satisfying.

With the advent of the British in West Africa, however, this easy-going, catholic attitude towards African women changed. The British soldiers, merchants and administrators no longer entered into marriage alliances with the *signares*, but turned African women into prostitutes. This, then, seems to be the point in history when racism proper enters the picture: the African woman is degraded and made a prostitute for the English colonizers, then theories of the racial superiority of the white male and the 'beastliness' of the African women are propagated. Obviously, British colonial

history is as discreet about these aspects as the Dutch. Yet Brooks says that the institution of 'signareship' did not take root in Gambia because it was

> stifled by the influx of new arrivals from Britain, few of whom, whether traders, government officials, or military officers—deviated from 'proper' British behaviour to live openly with Euroafrican or African women, whatever they might do clandestinely. British authors are discreet about such matters, but it can be discerned that in contrast to the family lives of traders and their *signares*, there developed . . . a rootless bachelor community of a type found elsewhere in British areas of West Africa. Open and unrepentant racism was one characteristic of this community; two others were reckless gambling and alcoholism (Brooks, 1976: 43).

These accounts corroborate not only Walter Rodney's general thesis that 'Europe underdeveloped Africa', but also our main argument that the colonial process, as it advanced, brought the women of the colonized people progressively down from a former high position of relative power and independence to that of 'beastly' and degraded 'nature'. This 'naturalization' of colonized women is the counterpart of the 'civilizing' of the European women.

The 'defining back into nature', or the 'naturalization' of African women who were brought as slaves to the Caribbean is perhaps the clearest evidence of the double-faced, hypocritical process of European colonization: while African women were treated as 'savages', the women of the white colonizers in their fatherlands 'rose' to the status of 'ladies'. These two processes did not happen side by side, are not simply historical parallels, but are intrinsically and causally linked within this patriarchal-capitalist mode of production. This creation of 'savage' and 'civilized' women, and the polarization between the two was, and still is, the organizing structural principle also in other parts of the world subjected by capitalist colonialism. There is not yet enough historical research into the effects of the colonizing process on women, but the little evidence we have corroborates this observation. It also explains the shifts in colonial policy towards women—following the fluctuations of the accumulation process—which Rhoda Reddock observed.

Thus, Annie Stoler (1982) has found that, at the other end of the globe in Sumatra in the early 20th century, the Dutch followed a similar double-faced policy regarding women:

> At certain junctures in estate expansion, for example, women ostensibly recruited from Java as estate coolies were in large part brought to Sumatra to service the domestic, including sexual, needs of unmarried male workers and management. Prostitution was not only sanctioned but encouraged . . . (Stoler, 1982: 90).

The driving motive for these planters, as was the case with the French or English in the Caribbean, was profit-making, and this motive, as Annie Stoler remarks, explains the fluctuations in Dutch colonial policy *vis-à-vis* women. In the colonial records, the 'issues of marriage contracts, sickness, prostitution, and labour unrest appear as they re-

late to profit; married workers during the first decade of the century were considered too costly and therefore marriage contracts were difficult to obtain' (Stoler, 1982: 97).

Obviously, to make women prostitutes was cheaper, but then, when almost half of the female workers in North Sumatra were racked with venereal disease, and had to be hospitalized at the company's expense, it became more profitable to encourage marriage among the estate workers. This was between the 1920s and 1930s. Whereas in the first phase, migrant women were good enough to do all hard labour on the plantations, now a process of housewifization took place to exclude resident women from wage-labour on the estates. Annie Stoler writes:

> At different economic and political junctures in plantation history, the planters contended that (1) permanent female workers were too costly to maintain, because of the time they took off for child-birth and menstruation, (2) women should not and could not do 'hard' labour, and (3) women were better suited to casual work (Stoler, 1982: 98).

That this introduction of the image of the 'weak woman' was a clear ideological move which served the economic purpose of lowering women's wages and creating a casual female labour force becomes evident from the statistics. Thus, in the Coolie Budget Report of 1903, it is stated that only one per cent of total available working-days were missed because of pregnancy (Stoler, 1982: 98).

Rhoda Reddock also, in the later parts of her study, gives ample evidence of this process—around the same time, in the British Crown Colony of Trinidad—of excluding women from wage-labour proper and of defining them as 'dependents' (Rhoda Reddock, 1984).

> Also, in the case of the Dutch colonizers, profit-making was the overall objective, and the contradictory values and policies regarding their own 'civilized' women back home and the 'savage' women in Sumatra constituted the best mechanism to ensure this. The fact that they used two diametrically opposed sets of values to the two sets of women obviously did not give them any pangs of conscience. Prostitution became a public issue only when it was no longer profitable to recruit women as prostitutes. Again here we have to stress that the emergence of the Dutch housewife, the stress on family and homemaking 'back home', was not just a temporal coincidence but was causally linked to the disruption of families and homes among estate workers in the Dutch colonies.

Women Under German Colonialism

Whereas the examples of British and Dutch colonial policy regarding women given above mainly focus on the colonial side of the picture, the following example, based on Martha Mamozai's study of the impact of German colonialism on women,

includes the effect of this process also on the German women 'back home'. This account will, therefore, help us to perceive more fully the double-faced process of colonization and housewifization.

Germany entered the race for the looting and distribution of the world rather late. The German Colonial Society was founded in 1884, and from then until the beginning of World War I—a direct result of the inter-imperialist scramble for hegemony among the European nations—the government of the German Reich encouraged the establishment of German colonies, particularly in Africa.

Mamozai's study shows that colonization did not affect men and women in the same way, but used the particular capitalist sexual division of labour to bring the labour power of Africans under the command of capital and the White Man. As usually happens with conquerors, invaders and colonizers, the Germans who first came to West Africa as planters around the 1880s came mostly as single men. As had happened with the Portuguese and French men in West Africa, they entered into sexual and matrimonial relations with African women. Many formed regular families with these women. After some time, it became evident that these marriages would eventually lead to a new generation of 'mixed blood' Euroafricans who, following the patriarchal and bourgeois family laws in Germany, would be Germans with full economic and political rights. There were heated debates about the 'colonial question' or the 'native question' in the German Reichstag which centered, on the one hand, on the question of 'mixed marriages' and 'bastards'—hence on the concern for the privileges of the white race—on the other, on the production, subjugation and disciplining of sufficient African labour power for the German estates and projects.

Governor Friedrich von Lindquist expressed the 'bastard-question in South West Africa' in the following manner:

> The considerable preponderance of the white male over the white female population is a sorry state of affairs, which, for the life and the future of the country will be of great significance. This has led to a considerable number of mixed relations, which is particularly regrettable because, apart from the ill-effects of the mixing of races, the white minority in South Africa can preserve its dominance over the coloureds only by keeping its race pure (quoted by Mamozai, 1982: 125; transl. M.M.).

Therefore, in 1905 a law was passed which prohibited marriages between European men and African women. In 1907, even those marriages which had been concluded prior to this law were declared null and void. Those who lived in such unions, including their 'bastards', lost the rights of citizens in 1908, including the voting right. The objective of this law was clearly the preservation of property rights in the hands of the white minority. Had the Afro-Germans had the rights of German citizens and voting rights, they could, in the course of time, have outnumbered the 'pure' whites in the elections. The laws, however, prohibiting marriages between European men and black women did not mean that the Reichstag wanted to put restrictions on the sexual free-

dom of the colonizing men. On the contrary, the German men were even advised by doctors to recruit African women as concubines or prostitutes. Thus, one Dr Max Bucher, representative of the German Reich wrote:

> Regarding the free intercourse with the daughters of the land—this has to be seen as advantageous rather than as damaging to health. Even under the dark skin the 'Eternal Female' is an excellent fetish against emotional deprivation which so easily occurs in the African loneliness. Apart from these psychological gains there are also practical advantages of personal security. To have an intimate black girl-friend means protection from many dangers (quoted by Mamozai, 1982: 129).

This means black women were good enough to service the white men as prostitutes and concubines, but they should not become proper 'wives' because this would, in the long run, have changed the property relations in Africa. This becomes very clear in a statement of one Dr Karl Oetker who was Health Officer during the construction of the railroad between Dar-es-Salaam and Morogoro:

> It should be a matter of course, but may be stressed again, that every European man who has intercourse with black females has to take care that such a union remains sterile in order to prevent a mixture of races, such a mixture would have the worst effect for our colonies, as this has been amply proved in the West Indies, Brasil and Madagaskar. Such relationships can and should only be considered as surrogates for marriage. Recognition and protection by the state, which marriages among whites enjoy, have to be withheld from such unions (quoted by Mamozai, 1982: 130).

Here the double-standard is very clear: marriage and family were goods to be protected for the whites, the 'Master Men' (Dominant Men). African families could be disrupted, men and women could be forced into labour gangs, women could be made prostitutes.

It is important not to look at this hypocritical colonial policy towards women only from a moralistic point of view. It is essential to understand that the rise and generalization of the 'decent' bourgeois marriage and family as protected institutions are *causally* linked to the disruption of clan and family relations of the 'natives'. The emergence of the masses of German families from 'proletarian misery', as one colonial officer put it, was directly linked to the exploitation of colonies and the subordination of colonial labour power. The development of Germany into a leading industrial nation was dependent, as many saw it in those years, on the possession of colonies. Thus, Paul von Hindenburg, the later Reichskanzler wrote: 'Without colonies no security regarding the acquisition of raw materials, without raw materials no industry, without industry no adequate standard of living and wealth. Therefore, Germans, do we need colonies' (quoted by Mamozai, 1983: 27; transl. M.M.).

The justification for this logic of exploitation was provided by the theory that the 'natives' had 'not yet' evolved to the level of the white master race, and that colonialism was the means to develop the slumbering forces of production in these regions and

thus make them contribute to the betterment of mankind. A colonial officer from South West Africa wrote:

> A right of the natives, which could only be realised at the expense of the develop-
> ment of the white race, does not exist. The idea is absurd that Bantus, Sudan-
> negroes, and Hottentots in Africa have the right to live and die as they please, even
> when by this uncounted people among the civilized peoples of Europe were forced
> to remain tied to a miserable proletarian existence instead of being able, by the full
> use of the productive capacities of our colonial possessions to rise to a richer level
> of existence themselves and also to help construct the whole body of human and na-
> tional welfare (quoted by Mamozai, 1983: 58; transl. M.M.).

The conviction that the white master men had the god-given mission to 'develop' the productive capacities in the colonies and thus bring the 'savages' into the orbit of civilization was also shared, as we shall see later, by the Social Democrats who likewise believed in the development of productive forces through colonialism.

The refusal of the 'native' women of South West Africa to produce children for the hated colonial masters was, therefore, seen as an attack on this policy of development of productive forces. After the rebellion of the Herero people had been brutally crushed by the German General von Trotha, the Herero women went on a virtual birth-strike. Like the slave women in the Caribbean, they refused to produce forced labour power for the planters and estate owners. Between 1892 and 1909, the Herero population decreased from 80,000 to a mere 19,962. For the German farmers this was a severe problem. One of them wrote:

> After the rebellion the native, particularly the Herero, often takes the stand not to
> produce children. He considers himself a prisoner, which he brings to your notice at
> every job which he does not like. He does not like to make new labour force for his
> oppressor, who has deprived him of his golden laziness . . . While the German farm-
> ers have been trying for years to remedy this sad state of affairs by offering a pre-
> mium for each child born on the farm, for instance, a she-goat. But mostly in vain. A
> section of today's native women has been engaged for too long in prostitution and
> are spoiled for motherhood. Another part does not want children and gets rid of
> them, when they are pregnant, through abortion. In such cases the authorities should
> interfere with all severity. Each case should be investigated thoroughly and severely
> punished by prison, and if that is not enough by putting the culprit in chains. (quoted
> by Mamozai, 1982: 52; transl. M.M.).

In a number of cases the farmers took the law into their own hands and brutally punished the recalcitrant women. In the Herero women's stand we see again, as in the case of the slave women, that African women were not just helpless victims in this colonizing process, but understood precisely their relative power within the colonial relations of production, and used that power accordingly. What has to be noted, however, with regard to the comments of the German farmer quoted above, is that although it was the

Herero *women* who went on a birth-strike, he refers only to *the Herero* (man). Even in their reporting, the colonizing men denied the subjected women all subjectivity and initiative. All 'natives' were 'savages', wild nature, but the most savage of all were the 'native' women.

White Women in Africa

Martha Mamozai also provides us with interesting material about the 'other side' of the colonizing process, namely, the impact the subordination of Africans, and African women in particular, had on the German women 'back home' and on those who had joined the colonial pioneers in Africa.

As was said before, one of the problems of the white colonialists was the reproduction of the white master race in the colonies itself. This could be achieved only if white women from the 'fatherland' were ready to go to the colonies and marry 'our boys down there', and produce white children. As most planters belonged to that band of 'adventurous bachelors', a special effort had to be made to mobilize women to go to the colonies as brides. The German advocates of white supremacy saw it as a special duty of German women to save the German men in the colonies from the evil influence of the 'Kaffir females' who in the long run would alienate these men from European culture and civilization.

The call was heard by Frau Adda von Liliencron, who founded the 'Women's League of the German Colonial Society'. This association had the objective of giving girls a special training in colonial housekeeping and sending them as brides to Africa. She recruited mainly girls from the peasant or working class, many of whom had worked as maidservants in the cities. In 1898 for the first time 25 single women were sent to South West Africa as a 'Christmas gift' for 'our boys down there'. Martha Mamozai reports how many of these women 'rose' to the level of the white memsahib, the bourgeois lady who saw it as her mission to teach the African women the virtues of civilization: cleanliness, punctuality, obedience and industriousness. It is amazing to observe how soon these women, who not long ago were still among the downtrodden themselves, shared the prejudices against the 'dirty and lazy natives' which were common in colonial society.

But not only did the few European women who went to the colonies as wives and 'breeders for race and nation' rise to the level of proper housewives on the subordination and subjection of the colonized women, so too did the women 'back home'; first those of the bourgeoisie, and later also the women of the proletariat, were gradually domesticated and civilized into proper housewives. For the same period which saw the expansion of colonialism and imperialism also saw the rise of the housewife in Europe and the USA. In the following I shall deal with this side of the story.

Housewifization

1st Stage: Luxuries for the 'Ladies'

The 'other side of the story' of both the violent subordination of European women during the witch persecution, and of African, Asian and Latin American women during the colonizing process is the creation of the women first of the accumulating classes in Europe, later also in the USA, as consumers and demonstrators of luxury and wealth, and at a later stage as housewives. Let us not forget that practically all the items which were stolen, looted or traded from the colonies were not items necessary for the daily subsistence of the masses, but luxury items. Initially these items were only consumed by the privileged few who had the money to buy them: spices from the Molluccan islands; precious textiles, silk, precious stones and muslin from India; sugar, cacao and spices from the Caribbean; precious metals from Hispano America. Werner Sombart, in his study on *Luxury and Capitalism* (1922), has advanced the thesis that the market for most of these rare colonial luxury goods had been created by a class of women who had risen as mistresses of the absolutist princes and kings of France and England in the seventeenth and eighteenth centuries. According to Sombart, the great cocottes and mistresses were the ones who created new fashions in women's dress, cosmetics, eating habits, and particularly in furnishing the homes of the gentlemen. Neither the war-mongering men of the aristocracy nor the men of the merchant class would have had, if left to themselves, the imagination, the sophistication and the culture to invent such luxuries, almost all centred around women as luxury creatures. It was this class of women, according to Sombart, who created the new luxury 'needs' which gave the decisive impetus to capitalism because, with their access to the money accumulated by the absolutist state, they created the market for early capitalism.

Sombart gives us a detailed account of the development of luxury consumption at the Italian, French and English courts of the sixteenth and seventeenth centuries. He clearly identifies a trend in luxury-spending, particularly during the reign of Louis XIV. Whereas the luxury expenses of the king of France were 2,995,000 Livres in 1542, these had steadily risen and were 28,813,955 in 1680. Sombart attributes this enormous display of luxury and splendour to the love of these feudal lords for their courtesans and mistresses. Thus, the king's fancy for La Vallière prompted Louis XIV to build Versailles. Sombart is also of the opinion that Mme de Pompadour, the representative of the culture of the *ancien régime*, had a bigger budget than any of the European queens ever had had. In 19 years of her reign she spent 36,327,268 Livres. Similarly Comtesse Dubarry, who reigned between 1769–1774, spent 12,481,803 Livres on luxury items (Sombart, 1922: 98–99).

Feminists will not agree with Sombart who attributes this development of luxury which first centred around the European courts and was later imitated by the *nouveaux riches* among the European bourgeoisie, to the great courtesans with their great vanity, their addiction for luxurious clothes, houses, furniture, food, cosmetics. Even if the men of these classes preferred to demonstrate their wealth by spending on their women and turning them into showpieces of their accumulated wealth, it would again

mean to make the women the villains of the piece. Would it not amount to saying that it was not the men—who wielded economic and political power—who were the historical 'subjects' (in the Marxist sense), but the women, as the real power behind the scenes who pulled the strings and set the tune according to which the mighty men danced? But, apart from this, Sombart's thesis that capitalism was born out of luxury consumption and not in order to satisfy growing subsistence needs of the masses has great relevance for our discussion of the relationship between colonization and house-wifization. He shows clearly that early merchant capitalism was based practically entirely on trade with luxury items from the colonies which were consumed by the European elites. The items which appear in a trading-list of the Levant trade include: *oriental medicines* (e.g., aloes, balm, ginger, camphor, cardamon, myrobalam, saffron, etc.); *spices* (pepper, cloves, sugar, cinnamon, nutmeg); *perfumes* (benzoin, musk, sandalwood, incense, amber); *dyes for textiles* (e.g., indigo, lac, purple, henna); *raw materials for textiles* (silk, Egyptian flax); *precious metals and jewellery and stones* (corals, pearls, ivory, porcelain, glass, gold and silver); *textiles* (silk, brocade, velvet, fine material of linen, muslin or wool).

In the eighteenth and nineteenth centuries many more items were added to this list, particularly items systematically produced in the new colonial plantations like sugar, coffee, cacao and tea. Sombart gives an account of the rising tea consumption in England. The average tea consumption of an English family was 6.5 pounds in 1906. This level of consumption could be afforded in:

1668 by	3 families
1710 by	2,000 families
1730 by	12,000 families
1760 by	40,000 families
1780 by	140,000 families

(Source: Sombart, 1922: 146)

What did this tremendous deployment of luxury among the European rich, based on the exploitation of the peoples of Africa, Asia and America, mean for the European women? Sombart identifies certain trends in the luxury production, which he, as we have seen, attributes to the passions of a certain class of women. They are the following:

1. *a tendency towards domesticity:* Whereas medieval luxury was public, now it became private. The display of luxury does not take place in the market place or during public festivals, but inside the secluded palaces and houses of the rich.
2. *a tendency towards objectification:* In the Middle Ages wealth was expressed in the number of vassals or men a prince could count upon. Now wealth is expressed in goods and material items, commodities bought by money. Adam Smith would say: 'one moves from "unproductive" to "productive" luxury, because the former personal luxury puts "unproductive" hands to work, whereas the objectified luxury puts "productive" hands to work' (in a capitalist sense,

that is, wage-workers in a capitalist enterprise) (Sombart, 1922: 119). Sombart is of the opinion that leisure class women had an interest in the development of objectified luxury (more items and commodities), because they had no use for more soldiers and vassals.

Similar trends can be observed with regard to sugar and coffee. For most people in Europe in the eighteenth century, sugar had not yet replaced honey. Sugar remained a typical luxury item for the European rich until far into the nineteenth century (Sombart, 1922: 147).

Foreign trade between Europe, America, Africa and the Orient was, until well into the nineteenth century, mainly trade in the above-mentioned luxury goods. Imports from East India to France in 1776 were to the value of 36,241,000 Francs, distributed as follows:

coffee	3,248,000 fr.
pepper and cinnamon	2,449,000 fr.
muslin	12,000,000 fr.
Indian linen	10,000,000 fr.
porcelain	200,000 fr.
silk	1,382,000 fr.
tea	3,399,000 fr.
saltpetre	3,380,000 fr.
Total	*36,241,000 fr.*

(Source: Sombart, 1922: 148)

Sombart also includes the profits made by the slave trade in the figures for luxury production and consumption.[6] The slave trade was totally organized along capitalist lines.

The development of wholesale and retail markets in England followed the same logic from the seventeenth to the nineteenth century. The first big urban shops which came up to replace the local markets were shops dealing with luxury goods.

3. *a tendency towards contraction of time:* Whereas formerly luxury consumption was restricted to certain seasons because the indigenous production of a surplus needed a long time, now luxuries could be consumed at any time during the year and also within the span of an individual life.

Sombart again attributes this tendency—in my opinion, wrongly—to the individualism and the impatience of leisure class women who demanded immediate satisfaction of their desires as a sign of the affection of their lovers.

Of the above tendencies, the tendency towards domestication and privatization certainly had a great impact on the construction of the new image of the 'good woman' in the centres of capitalism in the nineteenth and twentieth centuries, namely, woman as *mother* and *housewife*, and the family as her arena, the privatized arena of con-

sumption and 'love', excluded and sheltered from the arena of production and accumulation, where men reign. In the following, I shall trace how the ideal of the domesticated privatized woman, concerned with 'love' and consumption and dependent on a male 'breadwinner', was generalized, first in the bourgeois class proper, then among the so-called petty-bourgeosie, and finally in the working class or the proletariat.

2nd Stage: Housewife and Nuclear Family: The 'Colony' of the Little White Men

While the Big White Men—the 'Dominant Men' (Mamozai)—appropriated land, natural resources and people in Africa, Asia and Central and South America in order to be able to extract raw materials, products and labour power which they themselves had not produced, while they disrupted all social relations created by the local people, they began to build up in their fatherlands the patriarchal nuclear family, that is, the monogamous nuclear family as we know it today. This family, which was put under the specific protection of the state, consists of the forced combination of the principles of kinship and cohabitation, and the definition of the man as 'head' of this household and 'breadwinner' for the non-earning legal wife and their children. While in the eighteenth and early nineteenth centuries this marriage and family form were possible only among the propertied classes of the bourgeoisie—among peasants, artisans and workers women had always to share all work—this form was made the norm for all by a number of legal reforms pushed through by the state from the second half of the nineteenth century onwards. In Germany—as in other European countries—there existed a number of marriage restrictions for people without property. These were only abolished in the second half of the nineteenth century, when the state intervened to promote a pronatalist policy for the propertyless working class (Heinsohn and Knieper, 1976).

Recent family history has revealed that even the concept 'family' became popular only towards the end of the eighteenth century in Europe, particularly in France and England, and it was not before the middle of the nineteenth century that this concept was also adopted for the households of the workers and peasants because, contrary to general opinion, 'family' had a distinct class connotation. Only classes with property could afford to have a 'family'. Propertyless people—like farm servants or urban poor—were not supposed to have a 'family' (Flandrin, 1980; Heinsohn and Knieper, 1976). But 'family' in the sense in which we understand it today—that is, as a combination of co-residence and blood-relationship based on the patriarchal principle—was not even found among the aristocracy. The aristocratic 'family' did not imply co-residence of all family members. Co-residence, particularly of husband and wife and their offspring, became the crucial criterion of the family of the bourgeoisie. Hence our present concept of family is a bourgeois one (Flandrin, 1980; Luz Tangangeo, 1982).

It was the bourgeoisie which established the social and sexual division of labour, characteristic of capitalism. The bourgeoisie declared 'family' a private territory in contrast to the 'public' sphere of economic and political activity. The bourgeoisie first

withdrew 'their' women from this public sphere and shut them into their cosy 'homes' from where they could not interfere in the war-mongering, moneymaking and the politicking of the men. Even the French Revolution, though fought by thousands of women, ended by excluding women from politics. The bourgeoisie, particularly the puritan English bourgeoisie, created the ideology of romantic love as a compensation for and sublimation of the sexual and economic independence women had had before the rise of this class. Malthus, one of the important theoreticians of the rising bourgeoisie, saw clearly that capitalism needed a different type of woman. The poor should curb their sexual 'instincts', because otherwise they would breed too many poor for the scarce food supply. On the other hand, they should not use contraceptives, a method recommended by Condorcet in France, because that would make them lazy because he saw a close connection between sexual abstinence and readiness to work. Then Malthus paints a rosy picture of a decent bourgeois home in which 'love' does not express itself in sexual activity, but in which the domesticated wife sublimates the sexual 'instinct' in order to create a cosy home for the hard-working breadwinner who has to struggle for money in a competitive and hostile world 'outside' (Malthus, quoted in Heinsohn, Knieper and Steiger, 1979). As Heinsohn, Knieper and Steiger point out, capitalism did not, as Engels and Marx believed, destroy the family; on the contrary, with the help of the state and its police, it *created* the family first among the propertied classes, later in the working class, and with it the housewife as a social category. Also, from the accounts of the composition and condition of the early industrial proletariat, it appears that the family, as we understand it today, was much less the norm than is usually believed.

As we all know, women and children constituted the bulk of the early industrial proletariat. They were the cheapest and most manipulable labour force and could be exploited like no other worker. The capitalists understood well that a woman with children had to accept any wage if she wanted to survive. On the other hand, women were less of a problem for the capitalists than men. Their labour was also cheap because they were no longer organized, unlike the skilled men who had their associations as journeymen and a tradition of organizing from the guilds. Women had been thrown out of these organizations long ago, they had no new organizations and hence no bargaining power. For the capitalists it was, therefore, more profitable and less risky to employ women. With the rise of industrial capitalism and the decline of merchant capitalism (around 1830), the extreme exploitation of women's and child labour became a problem. Women whose health had been destroyed by overwork and appalling work conditions could not produce healthy children who could become strong workers and soldiers—as was realized after several wars later in the century.

Many of these women did not live in proper 'families', but were either unmarried, or had been deserted and lived, worked and moved around with children and young people in gangs (cf. Marx, *Capital*, vol. I). These women had no particular material interest in producing the next generation of miserable workers for the factories. But they

constituted a threat to bourgeois morality with its ideal of the domesticated woman. Therefore, it was also necessary to domesticate the proletarian woman. She had to be *made* to breed more workers.

Contrary to what Marx thought, the production of children could not be left to the 'instincts' of the proletariat, because, as Heinsohn and Knieper point out, the propertyless proletariat had no material interest in the production of children, as children were no insurance in old age, unlike the sons of the bourgeoisie. Therefore, the state had to interfere in the production of people and, through legislation, police measures and the ideological campaign of the churches, the sexual energies of the proletariat had to be channelled into the strait-jacket of the bourgeois family. The proletarian woman had to be housewifized too, in spite of the fact that she could not afford to sit at home and wait for the husband to feed her and her children. Heinsohn and Knieper (1976) analyse this process for nineteenth-century Germany. Their main thesis is that the 'family' had to be forced upon the proletariat by police measures, because otherwise the propertyless proletarians would not have produced enough children for the next generation of workers. One of the most important measures—after the criminalization of infanticide which had already taken place—was, therefore, the law which abolished the marriage prohibition for propertyless people. This law was passed by the North German League in 1868. Now proletarians were allowed to marry and have a 'family', like the bourgeois. But this was not enough. Sexuality had to be curbed in such a way that it took place within the confines of this family. Therefore, sexual intercourse before marriage and outside it was criminalized. The owners of the means of production were given the necessary police power to watch over the morality of their workers. After the Franco-Prussian War in 1870–71, a law was passed which made abortion a crime—a law against which the new women's movement fought, with only small success. The churches, in their cooperation with the state, worked on the souls of the people. What the secular state called a crime, the churches called a sin. The churches had a wider influence than the state because they reached more people, particularly in the countryside (Heinsohn and Knieper, 1976).

In this way the housewifization of women was also forced into the working class. According to Heinsohn and Knieper (1976) and others, the family had never existed among the propertyless farm servants or proletarians; it had to be created by force. This strategy worked because, by that time, women had lost most of their knowledge of contraception and because the state and church had drastically curbed women's autonomy over their bodies.

The housewifization of women, however, had not only the objective of ensuring that there were enough workers and soldiers for capital and the state. The creation of housework and the housewife as an agent of consumption became a very important strategy in the late nineteenth and early twentieth centuries. By that time not only had the household been discovered as an important market for a whole range of new gadgets and items, but also scientific home-management had become a new ideology for the

further domestication of women. Not only was the housewife called on to reduce the labour power costs, she was also mobilized to use her energies to create new needs. A virtual war for cleanliness and hygiene—a war against dirt, germs, bacteria, and so on—was started in order to create a market for the new products of the chemical industry. Scientific home-making was also advocated as a means of lowering the men's wage, because the wage would last longer if the housewife used it economically (Ehrenreich and English, 1975).

The process of housewifization of women, however, was not only pushed forward by the bourgeoisie and the state. The working-class movement in the nineteenth and twentieth centuries also made its contribution to this process. The organized working class welcomed the abolition of forced celibacy and marriage restrictions for propertyless workers. One of the demands of the German delegation to the 1863 Congress of the International Workingmen's Association was the 'freedom for workers to form a family'. Heinsohn and Knieper (1976) point out that the German working-class organizations, at that time headed by Lassalle, fought rather for the right to have a family than against the forced celibacy of propertyless people. Thus, the liberation from forced celibacy was historically achieved only by subsuming the whole propertyless class under bourgeois marriage and family laws. As bourgeois marriage and family were considered 'progressive', the accession of the working class to these standards was considered by most leaders of the working class as a progressive move. The struggles of the workers' movement for higher wages were often justified, particularly by the skilled workers who constituted the 'most advanced sections' of the working class, by the argument that the man's wage should be sufficient to maintain a family so that his wife could stay at home and look after children and household.

From 1830–1840 onwards—and practically until the end of the nineteenth century—the attitude of the German male workers, and of those organized in the Social Democratic Party, was characterized by what Thönnessen called 'proletarian anti-feminism' (Thönnessen, 1969: 14). Their proletarian anti-feminism was mainly concerned with the threat the entry of women into industrial production would pose to the men's wages and jobs. Repeatedly, at various congresses of the workers' associations and party congresses, a demand was raised to prohibit women's work in factories. The question of women's work in factories was also discussed at the 1866 Congress of the First International in Geneva. Marx, who had drafted the instructions for the delegates of the General Council to the Geneva Congress, had stated that the tendency of modern industry to draw women and children into production had to be seen as a progressive tendency. The French section and also some of the Germans, however, were strongly opposed to women's work outside the house. The German section had in fact submitted the following memorandum:

> Create conditions under which every grown-up man can take a wife, can found a
> family, secured by work, and under which none of the miserable creatures will exist
> any longer who, in isolation and despair, become victims, sin against themselves and

against nature and tar by prostitution and trade in human flesh the civilisation . . . To wives and mothers belongs the work in the family and the household. While the man is the representative of the serious public and family duties, the wife and mother should represent the comfort and the poetry of domestic life, she should bring grace and beauty to social manners and raise human enjoyment to a nobler and higher plane (Thönnessen, 1969: 19; transl. M.M.).

In this statement we find all the hypocrisy and bourgeois sentimentalism which Marx and Engels had castigated in the Communist Manifesto, this time, however, presented by male proletarians, who want to keep women in their 'proper' place. But neither did Karl Marx take a clear and unequivocal position regarding the question of women's work. Although in his instructions to the First International he had maintained that women's and children's work in factories be seen as a progressive tendency, he declared at the same time that night work, or work which would harm women's 'delicate physique' should be reduced. Of course, he also considered night work bad for men, but special protection should be given to women. The tendencies of 'proletarian antifeminism' were most pronounced among the faction of the German Social Democrats led by Lassalle. At a party congress of the *Allgemeiner Deutscher Arbeiter-Verein* (ADAV) in 1866, it was stated:

> The employment of women in the workshops and modern industry is one of the most outrageous abuses of our time. Outrageous, because the material conditions of the working class are not improved but deteriorated thereby. Due particularly to the destruction of the family, the working population ends up in such a miserable condition that they lose even the last trace of cultural and ideal values they had so far. Therefore, the tendency to further extend the labour market for women has to be condemned. Only the abolition of the rule of capital will remedy the situation, when the wage relation will be abolished through positive and organic institutions and every worker will get the full fruit of his labour (*Social Democrat*, no. 139, 29 November 1867, vol. 3, app. 1; quoted in Niggemann, 1981: 40; transl. M.M.).

But it was not only the 'reformists' in the Social Democratic Party who held the view that the proletarians needed a proper family, the radicals who followed Marx's revolutionary strategy had no other concept of women and the family. August Bebel and Clara Zetkin who belonged to this wing and who, until then, had been, with Engels, considered the most important contributors to a socialist theory of women's emancipation, advocated the maintenance of a proper family with a proper housewife and mother among the working class. Also Bebel wanted to reduce women's employment so that mothers would have more time for the education of their children. He regretted the destruction of the proletarian family:

> The wife of the worker who comes home in the evening, tired and exhausted, again has her hands full of work. She has to rush to attend to the most necessary tasks. The man goes to the pub and finds there the comfort he cannot find at home, he drinks, . . . perhaps he takes to the vice of gambling and loses thereby, even more than by

drinking. Meanwhile the wife is sitting at home, grumbling, she has to work like a brute . . . this is how disharmony begins. But if the woman is less responsible she too, after returning home tired, goes out to have her recreation and thus the household goes down the drain and the misery doubles (Bebel, 1964: 157–8; transl. M.M.).

Bebel did not conceive of a change in the sexual division of labour nor a sharing of household tasks by men. He saw woman mainly as a mother, and did not envisage a change in her role in the future.

This is also the main view held by Clara Zetkin. In spite of her struggles against 'proletarian anti-feminism', she saw the proletarian women as a wife and mother rather than as a worker. In 1896 she gave a speech at the party congress in Gotha where she formulated the following main points of her theory:

1. the struggle for women's emancipation is identical with the struggle of the proletariat against capitalism.
2. nevertheless, working women need special protection at their place of work.
3. improvements in the conditions of working women would enable them to participate more actively in the revolutionary struggle of the whole class.

Together with Marx and Engels, she was of the opinion that capitalism had created equality of exploitation between man and woman. Therefore, the proletarian women cannot fight against men, as bourgeois feminists might do, but must fight against the capitalist class together with men:

> Therefore the liberation struggle of the proletarian woman cannot be a struggle like that of the bourgeois woman against the man of her class; on the contrary, it is a struggle together with the man of her class against the class of capitalists. She need not fight against the men of her class in order to break down the barriers which limit free competition. Capital's need for exploitation and the development of the modern mode of production have done this for her. On the contrary, what is needed is to erect new barriers against the exploitation of the proletarian woman. What is needed is to give her back her rights as a wife, a mother, and to secure them. The final goal of her struggle is not free competition with man but the establishment of the political rule of the proletariat (quoted in Evans, 1978: 114; transl. M.M.).

What is striking in this statement is the emphasis on women's rights as mother and wife. She made this even more explicit later in the same speech:

> By no means should it be the task of the socialist agitation of women to alienate women from their duties as mothers and wives. On the contrary, one has to see to it that she can fulfill these tasks better than hitherto, in the interest of the proletariat. The better the conditions in the family, her effectiveness in the home, the better she will be able to fight. . . . So many mothers, so many wives who inspire their husbands and their children with class consciousness are doing as much as the women comrades whom we see in our meetings (quoted in Evans, 1979: 114–115; transl. M.M.).

These ideas found a very positive echo in the party, which had in any case, as we have seen, a rather bourgeois concept of women's role as mother and wife. This process of creating the bourgeois nuclear family in the working class and of the house-wifization of proletarian women also was not restricted to Germany, but can be traced in all industrialized and 'civilized' countries. It was pushed forward not only by the bourgeois class and state, but also by the 'most advanced sections' of the working class, namely the male skilled labour aristocracy in the European countries. Particularly for socialists, this process points to a basic contradiction, which has still not been solved, not even in socialist countries:

> *If entry into social production is seen as a precondition for women's emancipation or liberation, as all orthodox socialists believe, then it is a contradiction to uphold at the same time the concept of the man as breadwinner and head of the family, of woman as dependent housewife and mother, and of the nuclear family as 'progressive'.*

This contradition is, however, the result of a *de facto* class division between working-class men and women. I disagree with Heinsohn and Knieper (1976) when they say that the working class as a whole had no material interest in the creation of the nuclear family and the housewifization of women. Maybe working-class women had nothing to gain, but working-class men had.

Proletarian men do have a material interest in the domestication of their female class companions. This material interest consists, on the one hand, in the man's claim to monopolize available wage-work, on the other, in the claim to have control over all money income in the family. Since money has become the main source and embodiment of power under capitalism, proletarian men fight about money not only with the capitalists, but also with their wives. Their demand for a family wage is an expression of this struggle. Here the point is not whether a proper family wage was ever paid or not (cf. Land, 1980; Barrett and McIntosh, 1980), the point is that the ideological and theoretical consequence of this concept led to the *de facto* acceptance of the bourgeois concept of the family and of women by the proletariat.

Marx's analysis of the value of labour power is also based on this concept, namely, that the worker has a 'non-working' housewife (Mies, 1981). After this all female work is devalued, whether it is wage-work or housework.

The function of housework for the process of capital accumulation has been extensively discussed by feminists in recent years. I shall omit this aspect here. But I would like to point out that housewifization means the externalization, or ex-territorialization of costs which otherwise would have to be covered by the capitalists. This means women's labour is considered a natural resource, freely available like air and water.

Housewifization means at the same time the total atomization and disorganization of these hidden workers. This is not only the reason for the lack of women's political power, but also for their lack of bargaining power. As the housewife is linked to the

wage-earning breadwinner, to the 'free' proletarian as a non-free worker, the 'freedom' of the proletarian to sell his labour power is based on the non-freedom of the housewife. Proletarianization of men is based on the housewifization of women.

Thus, the Little White Man also got his 'colony', namely, the family and a domesticated housewife. This was a sign that, at last, the propertyless proletarian had risen to the 'civilized' status of a citizen, that he had become a full member of a 'culture-nation'. This rise, however, was paid for by the subordination and housewifization of the women of his class. The extension of bourgeois laws to the working class meant that in the family the propertyless man was also lord and master.

It is my thesis that these two processes of colonization and housewifization are closely and causally interlinked. Without the ongoing exploitation of external colonies—formerly as direct colonies, today within the new international division of labour—the establishment of the 'internal colony', that is, a nuclear family and a woman maintained by a male 'breadwinner', would not have been possible.

Footnotes

1. The same could be said about the colonial relationship. If colonies want to follow this model of development of the metropoles, they can achieve success only by exploiting some other colonies. This has, indeed, led to the creation of internal colonies in many of the ex-colonial states.
2. The number of witches killed ranges from several hundred thousand to ten million. It is significant that European historians have so far not taken the trouble to count the number of women and men burnt at the stake during these centuries, although these executions were bureaucratically registered. West German feminists estimate that the number of witches burnt equals that of the Jews killed in Nazi, Germany, namely six million. The historian Gerhard Schormann said that the killing of the witches was the 'largest mass killing of human beings by other human beings, not caused by warfare' (*Der Spiegel*, no. 43, 1984).
3. The silk spinners and weavers in Cologne were mainly the women of the rich silk merchants who traded their merchandise with England and the Netherlands.
4. Catherine Hernot had been the postmistress of Cologne. The post office had been a business of her family for many generations. When the family of Thurn and Taxis claimed the monopoly over all postal services, Catherine Hernot was accused of witchcraft and eventually burnt at the stake.
5. I found the astounding extracts from Mr Hall's book in a text entitled *Militarism versus Feminism*, published anonymously in London in 1915 by George Allen and Unwin Ltd. The authors, most probably British feminists, had written this most remarkable analysis of the historical antagonism between militarism and

feminism as a contribution to the Women's Movement, particularly the International Women's Peace Movement which tried, together with the International Suffrage Alliance, to bring European and American women together in an antiwar effort. Due to the war situation, the authors published their investigation anonymously. They do not give complete references of the books they quote. Thus Mr Fielding Hall's book, *A Nation at School*, is referred to only by its title and page numbers. The whole text, *Militarism versus Feminism*, is available at the Library of Congress, in Washington DC.

6. This is quite logical because the slaves produced luxury items like sugar, cacao, coffee.

Under Western Eyes

Feminist Scholarship and Colonial Discourses

Chandra Talpade Mohanty

*A*ny discussion of the intellectual and political construction of "third world feminisms" must address itself to two simultaneous projects: the internal critique of hegemonic "Western" feminisms, and the formulation of autonomous, geographically, historically, and culturally grounded feminist concerns and strategies. The first project is one of deconstructing and dismantling; the second, one of building and constructing. While these projects appear to be contradictory, the one working negatively and the other positively, unless these two tasks are addressed simultaneously, "third world" feminisms run the risk of

marginalization or ghettoization from both mainstream (right and left) and Western feminist discourses.

It is to the first project that I address myself. What I wish to analyze is specifically the production of the "third world woman" as a singular monolithic subject in some recent (Western) feminist texts. The definition of colonization I wish to invoke here is a predominantly *discursive* one, focusing on a certain mode of appropriation and codification of "scholarship" and "knowledge" about women in the third world by particular analytic categories employed in specific writings on the subject which take as their referent feminist interests as they have been articulated in the U.S. and Western Europe. If one of the tasks of formulating and understanding the locus of "third world feminisms" is delineating the way in which it resists and *works against* what I am referring to as "Western feminist discourse," an analysis of the discursive construction of "third world women" in Western feminism is an important first step.

Clearly Western feminist discourse and political practice is neither singular nor homogeneous in its goals, interests, or analyses. However, it is possible to trace a coherence of *effects* resulting from the implicit assumption of "the West" (in all its complexities and contradictions) as the primary referent in theory and praxis. My reference to "Western feminism" is by no means intended to imply that it is a monolith. Rather, I am attempting to draw attention to the similar effects of various textual strategies used by writers which codify Others as non-Western and hence themselves as (implicitly) Western. It is in this sense that I use the term *Western feminist.* Similar arguments can be made in terms of middle-class urban African or Asian scholars producing scholarship on or about their rural or working-class sisters which assumes their own middle-class cultures as the norm, and codifies working-class histories and cultures as Other. Thus, while this essay focuses specifically on what I refer to as "Western feminist" discourse on women in the third world, the critiques I offer also pertain to third world scholars writing about their own cultures, which employ identical analytic strategies.

It ought to be of some political significance, at least, that the term *colonization* has come to denote a variety of phenomena in recent feminist and left writings in general. From its analytic value as a category of exploitative economic exchange in both traditional and contemporary Marxisms (cf. particularly contemporary theorists such as Baran 1962, Amin 1977, and Gunder-Frank 1967) to its use by feminist women of color in the U.S. to describe the appropriation of their experiences and struggles by hegemonic white women's movements (cf. especially Moraga and Anzaldúa 1983, Smith 1983, Joseph and Lewis 1981, and Moraga 1984), colonization has been used to characterize everything from the most evident economic and political hierarchies to the production of a particular cultural discourse about what is called the "third world."[1] However sophisticated or problematical its use as an explanatory construct, colonization almost invariably implies a relation of structural domination, and a suppression—often violent—of the heterogeneity of the subject(s) in question.

My concern about such writings derives from my own implication and investment in contemporary debates in feminist theory, and the urgent political necessity (especially in the age of Reagan/Bush) of forming strategic coalitions across class, race, and national boundaries. The analytic principles discussed below serve to distort Western feminist political practices, and limit the possibility of coalitions among (usually white) Western feminists and working-class feminists and feminists of color around the world. These limitations are evident in the construction of the (implicitly consensual) priority of issues around which apparently *all* women are expected to organize. The necessary and integral connection between feminist scholarship and feminist political practice and organizing determines the significance and status of Western feminist writings on women in the third world, for feminist scholarship, like most other kinds of scholarship, is not the mere production of knowledge about a certain subject. It is a directly political and discursive *practice* in that it is purposeful and ideological. It is best seen as a mode of intervention into particular hegemonic discourses (for example, traditional anthropology, sociology, literary criticism, etc.); it is a political praxis which counters and resists the totalizing imperative of age-old "legitimate" and "scientific" bodies of knowledge. Thus, feminist scholarly practices (whether reading, writing, critical, or textual) are inscribed in relations of power—relations which they counter, resist, or even perhaps implicitly support. There can, of course, be no apolitical scholarship.

The relationship between "Woman"—a cultural and ideological composite Other constructed through diverse representational discourses (scientific, literary, juridical, linguistic, cinematic, etc.)—and "women"—real, material subjects of their collective histories—is one of the central questions the practice of feminist scholarship seeks to address. This connection between women as historical subjects and the representation of Woman produced by hegemonic discourses is not a relation of direct identity, or a relation of correspondence or simple implication.[2] It is an arbitrary relation set up by particular cultures. I would like to suggest that the feminist writings I analyze here discursively colonize the material and historical heterogeneities of the lives of women in the third world, thereby producing/re-presenting a composite, singular "third world woman"—an image which appears arbitrarily constructed, but nevertheless carries with it the authorizing signature of Western humanist discourse.[3]

I argue that assumptions of privilege and ethnocentric universality, on the one hand, and inadequate self-consciousness about the effect of Western scholarship on the "third world" in the context of a world system dominated by the West, on the other, characterize a sizable extent of Western feminist work on women in the third world. An analysis of "sexual difference" in the form of a cross-culturally singular, monolithic notion of patriarchy or male dominance leads to the construction of a similarly reductive and homogeneous notion of what I call the "third world difference"—that stable, ahistorical something that apparently oppresses most if not all the women in these countries. And it is in the production of this "third world difference" that Western feminisms appropriate and "colonize" the constitutive complexities which characterize the lives

of women in these countries. It is in this process of discursive homogenization and systematization of the oppression of women in the third world that power is exercised in much of recent Western feminist discourse, and this power needs to be defined and named.

In the context of the West's hegemonic position today, of what Anouar Abdel-Malek (1981) calls a struggle for "control over the orientation, regulation and decision of the process of world development on the basis of the advanced sector's monopoly of scientific knowledge and ideal creativity," Western feminist scholarship on the third world must be seen and examined precisely in terms of its inscription in these particular relations of power and struggle. There is, it should be evident, no universal patriarchal framework which this scholarship attempts to counter and resist—unless one posits an international male conspiracy or a monolithic, ahistorical power structure. There is, however, a particular world balance of power within which any analysis of culture, ideology, and socioeconomic conditions necessarily has to be situated. Abdel-Malek is useful here, again, in reminding us about the inherence of politics in the discourses of "culture":

> Contemporary imperialism is, in a real sense, a hegemonic imperialism, exercising to a maximum degree a rationalized violence taken to a higher level than ever before—through fire and sword, but also through the attempt to control hearts and minds. For its content is defined by the combined action of the military-industrial complex and the hegemonic cultural centers of the West, all of them founded on the advanced levels of development attained by monopoly and finance capital, and supported by the benefits of both the scientific and technological revolution and the second industrial revolution itself. (145–46).

Western feminist scholarship cannot avoid the challenge of situating itself and examining its role in such a global economic and political framework. To do any less would be to ignore the complex interconnections between first and third world economies and the profound effect of this on the lives of women in all countries. I do not question the descriptive and informative value of most Western feminist writings on women in the third world. I also do not question the existence of excellent work which does not fall into the analytic traps with which I am concerned. In fact I deal with an example of such work later on. In the context of an overwhelming silence about the experiences of women in these countries, as well as the need to forge international links between women's political struggles, such work is both pathbreaking and absolutely essential. However, it is both to the *explanatory potential* of particular analytic strategies employed by such writing, and to their *political effect* in the context of the hegemony of Western scholarship that I want to draw attention here. While feminist writing in the U.S. is still marginalized (except from the point of view of women of color addressing privileged white women), Western feminist writing on women in the third world must be considered in the context of the global hegemony of Western scholarship—i.e., the production, publication, distribution, and

consumption of information and ideas. Marginal or not, this writing has political effects and implications beyond the immediate feminist or disciplinary audience. One such significant effect of the dominant "representations" of Western feminism is its conflation with imperialism in the eyes of particular third world women.[4] Hence the urgent need to examine the *political* implications of our *analytic* strategies and principles.

My critique is directed at three basic analytic principles which are present in (Western) feminist discourse on women in the third world. Since I focus primarily on the Zed Press Women in the Third World series, my comments on Western feminist discourse are circumscribed by my analysis of the texts in this series.[5] This is a way of focusing my critique. However, even though I am dealing with feminists who identify themselves as culturally or geographically from the "West," as mentioned earlier, what I say about these presuppositions or implicit principles holds for anyone who uses these methods, whether third world women in the West, or third world women in the third world writing on these issues and publishing in the West. Thus, I am not making a culturalist argument about ethnocentrism; rather, I am trying to uncover how ethnocentric universalism is produced in certain analyses. As a matter of fact, my argument holds for any discourse that sets up its own authorial subjects as the implicit referent, i.e., the yardstick by which to encode and represent cultural Others. It is in this move that power is exercised in discourse.

The first analytic presupposition I focus on is involved in the strategic location of the category "women" vis-à-vis the context of analysis. The assumption of women as an already constituted, coherent group with identical interests and desires, regardless of class, ethnic or racial location, or contradictions, implies a notion of gender or sexual difference or even patriarchy which can be applied universally and cross-culturally. (The context of analysis can be anything from kinship structures and the organization of labor to media representations.) The second analytical presupposition is evident on the methodological level, in the uncritical way "proof" of universality and cross-cultural validity are provided. The third is a more specifically political presupposition underlying the methodologies and the analytic strategies, i.e., the model of power and struggle they imply and suggest. I argue that as a result of the two modes—or, rather, frames—of analysis described above, a homogeneous notion of the oppression of women as a group is assumed, which, in turn, produces the image of an "average third world woman." This average third world woman leads an essentially truncated life based on her feminine gender (read: sexually constrained) and her being "third world" (read: ignorant, poor, uneducated, tradition-bound, domestic, family-oriented, victimized, etc.). This, I suggest, is in contrast to the (implicit) self-representation of Western women as educated, as modern, as having control over their own bodies and sexualities, and the freedom to make their own decisions.

The distinction between Western feminist re-presentation of women in the third world and Western feminist self-presentation is a distinction of the same order as that made by some Marxists between the "maintenance" function of the housewife and the

of women in these countries. It is in this process of discursive homogenization and systematization of the oppression of women in the third world that power is exercised in much of recent Western feminist discourse, and this power needs to be defined and named.

In the context of the West's hegemonic position today, of what Anouar Abdel-Malek (1981) calls a struggle for "control over the orientation, regulation and decision of the process of world development on the basis of the advanced sector's monopoly of scientific knowledge and ideal creativity," Western feminist scholarship on the third world must be seen and examined precisely in terms of its inscription in these particular relations of power and struggle. There is, it should be evident, no universal patriarchal framework which this scholarship attempts to counter and resist—unless one posits an international male conspiracy or a monolithic, ahistorical power structure. There is, however, a particular world balance of power within which any analysis of culture, ideology, and socioeconomic conditions necessarily has to be situated. Abdel-Malek is useful here, again, in reminding us about the inherence of politics in the discourses of "culture":

> Contemporary imperialism is, in a real sense, a hegemonic imperialism, exercising to a maximum degree a rationalized violence taken to a higher level than ever before—through fire and sword, but also through the attempt to control hearts and minds. For its content is defined by the combined action of the military-industrial complex and the hegemonic cultural centers of the West, all of them founded on the advanced levels of development attained by monopoly and finance capital, and supported by the benefits of both the scientific and technological revolution and the second industrial revolution itself. (145–46).

Western feminist scholarship cannot avoid the challenge of situating itself and examining its role in such a global economic and political framework. To do any less would be to ignore the complex interconnections between first and third world economies and the profound effect of this on the lives of women in all countries. I do not question the descriptive and informative value of most Western feminist writings on women in the third world. I also do not question the existence of excellent work which does not fall into the analytic traps with which I am concerned. In fact I deal with an example of such work later on. In the context of an overwhelming silence about the experiences of women in these countries, as well as the need to forge international links between women's political struggles, such work is both pathbreaking and absolutely essential. However, it is both to the *explanatory potential* of particular analytic strategies employed by such writing, and to their *political effect* in the context of the hegemony of Western scholarship that I want to draw attention here. While feminist writing in the U.S. is still marginalized (except from the point of view of women of color addressing privileged white women), Western feminist writing on women in the third world must be considered in the context of the global hegemony of Western scholarship—i.e., the production, publication, distribution, and

consumption of information and ideas. Marginal or not, this writing has political effects and implications beyond the immediate feminist or disciplinary audience. One such significant effect of the dominant "representations" of Western feminism is its conflation with imperialism in the eyes of particular third world women.[4] Hence the urgent need to examine the *political* implications of our *analytic* strategies and principles.

My critique is directed at three basic analytic principles which are present in (Western) feminist discourse on women in the third world. Since I focus primarily on the Zed Press Women in the Third World series, my comments on Western feminist discourse are circumscribed by my analysis of the texts in this series.[5] This is a way of focusing my critique. However, even though I am dealing with feminists who identify themselves as culturally or geographically from the "West," as mentioned earlier, what I say about these presuppositions or implicit principles holds for anyone who uses these methods, whether third world women in the West, or third world women in the third world writing on these issues and publishing in the West. Thus, I am not making a culturalist argument about ethnocentrism; rather, I am trying to uncover how ethnocentric universalism is produced in certain analyses. As a matter of fact, my argument holds for any discourse that sets up its own authorial subjects as the implicit referent, i.e., the yardstick by which to encode and represent cultural Others. It is in this move that power is exercised in discourse.

The first analytic presupposition I focus on is involved in the strategic location of the category "women" vis-à-vis the context of analysis. The assumption of women as an already constituted, coherent group with identical interests and desires, regardless of class, ethnic or racial location, or contradictions, implies a notion of gender or sexual difference or even patriarchy which can be applied universally and cross-culturally. (The context of analysis can be anything from kinship structures and the organization of labor to media representations.) The second analytical presupposition is evident on the methodological level, in the uncritical way "proof" of universality and cross-cultural validity are provided. The third is a more specifically political presupposition underlying the methodologies and the analytic strategies, i.e., the model of power and struggle they imply and suggest. I argue that as a result of the two modes—or, rather, frames—of analysis described above, a homogeneous notion of the oppression of women as a group is assumed, which, in turn, produces the image of an "average third world woman." This average third world woman leads an essentially truncated life based on her feminine gender (read: sexually constrained) and her being "third world" (read: ignorant, poor, uneducated, tradition-bound, domestic, family-oriented, victimized, etc.). This, I suggest, is in contrast to the (implicit) self-representation of Western women as educated, as modern, as having control over their own bodies and sexualities, and the freedom to make their own decisions.

The distinction between Western feminist re-presentation of women in the third world and Western feminist self-presentation is a distinction of the same order as that made by some Marxists between the "maintenance" function of the housewife and the

real "productive" role of wage labor, or the characterization by developmentalists of the third world as being engaged in the lesser production of "raw materials" in contrast to the "real" productive activity of the first world. These distinctions are made on the basis of the privileging of a particular group as the norm or referent. Men involved in wage labor, first world producers, and, I suggest, Western feminists who sometimes cast third world women in terms of "ourselves undressed" (Michelle Rosaldo's [1980] term), all construct themselves as the normative referent in such a binary analytic.

"Women" as Category of Analysis, or: We Are All Sisters in Struggle

By women as a category of analysis, I am referring to the crucial assumption that all of us of the same gender, across classes and cultures, are somehow socially constituted as a homogeneous group identified prior to the process of analysis. This is an assumption which characterizes much feminist discourse. The homogeneity of women as a group is produced not on the basis of biological essentials but rather on the basis of secondary sociological and anthropological universals. Thus, for instance, in any given piece of feminist analysis, women are characterized as a singular group on the basis of a shared oppression. What binds women together is a sociological notion of the "sameness" of their oppression. It is at this point that an elision takes place between "women" as a discursively constructed group and "women" as material subjects of their own history.[6] Thus, the discursively consensual homogeneity of "women" as a group is mistaken for the historically specific material reality of groups of women. This results in an assumption of women as an always already constituted group, one which has been labeled "powerless," "exploited," "sexually harassed," etc., by feminist scientific, economic, legal, and sociological discourses. (Notice that this is quite similar to sexist discourse labeling women weak, emotional, having math anxiety, etc.) This focus is not on uncovering the material and ideological specificities that constitute a particular group of women as "powerless" in a particular context. It is, rather, on finding a variety of cases of "powerless" groups of women to prove the general point that women as a group are powerless.

In this section I focus on five specific ways in which "women" as a category of analysis is used in Western feminist discourse on women in the third world. Each of these examples illustrates the construction of "third world women" as a homogeneous "powerless" group often located as implicit *victims* of particular socioeconomic systems. I have chosen to deal with a variety of writers—from Fran Hosken, who writes primarily about female genital mutilation, to writers from the Women in International Development school, who write about the effect of development policies on third world women for both Western and third world audiences. The similarity of assumptions about "third world women" in all these texts forms the basis of my discussion.

This is not to equate all the texts that I analyze, nor is it to equalize their strengths and weaknesses. The authors I deal with write with varying degrees of care and complexity; however, the *effect* of their representation of third world women is a coherent one. In these texts women are defined as victims of male violence (Fran Hosken); victims of the colonial process (Maria Cutrufelli); victims of the Arab familial system (Juliette Minces); victims of the economic development process (Beverley Lindsay and the [liberal] WID School); and finally, victims of *the* Islamic code (Patricia Jeffery). This mode of defining women primarily in terms of their *object status* (the way in which they are affected or not affected by certain institutions and systems) is what characterizes this particular form of the use of "women" as a category of analysis. In the context of Western women writing/studying women in the third world, such objectification (however benevolently motivated) needs to be both named and challenged. As Valerie Amos and Pratibha Parmar argue quite eloquently, "Feminist theories which examine our cultural practices as 'feudal residues' or label us 'traditional,' also portray us as politically immature women who need to be versed and schooled in the ethos of Western feminism. They need to be continually challenged . . ." (1984, 7).

Women as Victims of Male Violence

Fran Hosken, in writing about the relationship between human rights and female genital mutilation in Africa and the Middle East, bases her whole discussion/condemnation of genital mutilation on one privileged premise: that the goal of this practice is "to mutilation the sexual pleasure and satisfaction of woman" (1981, 11). This, in turn, leads her to claim that woman's sexuality is controlled, as is her reproductive potential. According to Hosken, "male sexual politics" in Africa and around the world "share the same political goal: to assure female dependence and subservience by any and all means" (14). Physical violence against women (rape, sexual assault, excision, infibulation, etc.) is thus carried out "with an astonishing consensus among men in the world" (14). Here, women are defined consistently as the *victims* of male control—the "sexually oppressed."[7] Although it is true that the potential of male violence against women circumscribes and elucidates their social position to a certain extent, defining women as archetypal victims freezes them into "objects-who-defend-themselves," men into "subjects-who-perpetrate-violence," and (every) society into powerless (read: women) and powerful (read: men) groups of people. Male violence must be theorized and interpreted *within* specific societies, in order both to understand it better and to effectively organize to change it.[8] Sisterhood cannot be assumed on the basis of gender; it must be forged in concrete historical and political practice and analysis.

Women as Universal Dependents

Beverly Lindsay's conclusion to the book *Comparative Perspectives of Third World Women: The Impact of Race, Sex and Class* (1983: 298, 306) states: "dependency relationships, based upon race, sex and class, are being perpetuated through social, educational, and economic institutions. These are the linkages among Third World Women." Here, as in other places, Lindsay implies that third world women constitute an identifiable group purely on the basis of shared dependencies. If shared dependencies were all that was needed to bind us together as a group, third world women would always be seen as an apolitical group with no subject status. Instead, if anything, it is the *common context* of political struggle against class, race, gender, and imperialist hierarchies that may constitute third world women as a strategic group at this historical juncture. Lindsay also states that linguistic and cultural differences exist between Vietnamese and black American women, but "both groups are victims of race, sex, and class." Again black and Vietnamese women are characterized by their victim status.

Similarly, examine statements such as "My analysis will start by stating that all African women are politically and economically dependent" (Cutrufelli 1983, 13), "Nevertheless, either overtly or covertly, prostitution is still the main if not the only source of work for African women" (Cutrufelli 1983, 33). *All* African women are dependent. Prostitution is the only work option for African women as a *group*. Both statements are illustrative of generalizations sprinkled liberally through a recent Zed Press publication, *Women of Africa: Roots of Oppression*, by Maria Rosa Cutrufelli, who is described on the cover as an Italian writer, sociologist, Marxist, and feminist. In the 1980s, is it possible to imagine writing a book entitled *Women of Europe: Roots of Oppression?* I am not objecting to the use of universal groupings for descriptive purposes. Women from the continent of Africa can be descriptively characterized as "women of Africa." It is when "women of Africa" becomes a homogeneous sociological grouping characterized by common dependencies or powerlessness (or even strengths) that problems arise—we say too little and too much at the same time.

This is because descriptive gender differences are transformed into the division between men and women. Women are constituted as a group via dependency relationships vis-à-vis men, who are implicitly held responsible for these relationships. When "women of Africa" as a group (versus "men of Africa" as a group?) are seen as a group precisely because they are generally dependent and oppressed, the analysis of specific historical differences becomes impossible, because reality is always apparently structured by divisions—two mutually exclusive and jointly exhaustive groups, the victims and the oppressors. Here the sociological is substituted for the biological, in order, however, to create the same—a unity of women. Thus, it is not the descriptive potential of gender difference but the privileged positioning and explanatory potential of

gender difference as the *origin* of oppression that I question. In using "women of Africa" (as an already constituted group of oppressed peoples) as a category of analysis, Cutrufelli denies any historical specificity to the location of women as subordinate, powerful, marginal, central, or otherwise, vis-à-vis particular social and power networks. Women are taken as a unified "powerless" group prior to the analysis in question Thus, it is then merely a matter of specifying the context *after the fact.* "Women" are now placed in the context of the family, or in the workplace, or within religious networks, almost as if these systems existed outside the relations of women with other women, and women with men.

The problem with this analytic strategy, let me repeat, is that it assumes men and women are already constituted as sexual-political subjects prior to their entry into the arena of social relations. Only if we subscribe to this assumption is it possible to undertake analysis which looks at the "effects" of kinship structures, colonialism, organization of labor, etc., on women, who are defined in advance as a group. The crucial point that is forgotten is that women are produced through these very relations as well as being implicated in forming these relations. As Michelle Rosaldo argues, "woman's place in human social life is not in any direct sense a product of the things she does (or even less, a function of what, biologically, she is) but the meaning her activities acquire through concrete social interactions" (1980, 400). That women mother in a variety of societies is not as significant as the value attached to mothering in these societies. The distinction between the act of mothering and the status attached to it is a very important one—one that needs to be stated and analyzed contextually.

Married Women as Victims of the Colonial Process

In Lévi-Strauss's theory of kinship structure as a system of the exchange of women, what is significant is that exchange itself is not constitutive of the subordination of women; women are not subordinate because of the *fact* of exchange, but because of the *modes* of exchange instituted, and the values attached to these modes. However, in discussing the marriage ritual of the Bemba, a Zambian matrilocal, matrilineal people, Cutrufelli in *Women of Africa* focuses on the fact of the marital exchange of women before and after Western colonization, rather than the value attached to this exchange in this particular context. This leads to her definition of Bemba women as a coherent group affected in a particular way by colonization. Here again, Bemba women are constituted rather unilaterally as victims of the effects of Western colonization.

Cutrufelli cites the marriage ritual of the Bemba as a multistage event "whereby a young man becomes incorporated into his wife's family group as he takes up residence with them and gives his services in return for food and maintenance" (43). This ritual extends over many years, and the sexual relationship varies according to the degree of the girl's physical maturity. It is only after she undergoes an initiation ceremony at pu-

berty that intercourse is sanctioned, and the man acquires legal rights over her. This initiation ceremony is the more important act of the consecration of women's reproductive power, so that the abduction of an uninitiated girl is of no consequence, while heavy penalty is levied for the seduction of an initiated girl. Cutrufelli asserts that the effect of European colonization has changed the whole marriage system. Now the young man is entitled to take his wife away from her people in return for money. The implication is that Bemba women have now lost the protection of tribal laws. However, while it is possible to see how the structure of the traditional marriage contract (versus the postcolonial marriage contract) offered women a certain amount of control over their marital relations, only an analysis of the political significance of the actual practice which privileges an initiated girl over an uninitiated one, indicating a shift in female power relations as a result of this ceremony, can provide an accurate account of whether Bemba women were indeed protected by tribal laws *at all times.*

However, it is not possible to talk about Bemba women as a homogeneous group within the traditional marriage structure. Bemba women *before* the initiation are constituted within a different set of social relations compared to Bemba women *after* the initiation. To treat them as a unified group characterized by the fact of their "exchange" between male kin is to deny the sociohistorical and cultural specificities of their existence, and the differential *value* attached to their exchange before and after their initiation. It is to treat the initiation ceremony as a ritual with no political implications or effects. It is also to assume that in merely describing the *structure* of the marriage contract, the situation of women is exposed. Women as a group are positioned within a given structure, but there is no attempt made to trade the effect of the marriage practice in constituting women within an obviously changing network of power relations. Thus, women are assumed to be sexual-political subjects prior to entry into kinship structures.

Women and Familial Systems

Elizabeth Cowie (1978), in another context, points out the implications of this sort of analysis when she emphasizes the specifically political nature of kinship structures which must be analyzed as ideological practices which designate men and women as father, husband, wife, mother, sister, etc. Thus, Cowie suggests, women as women are not *located* within the family. Rather, it is *in* the family, as an effect of kinship structures, that women as women are *constructed*, defined within and by the group. Thus, for instance, when Juliette Minces (1980) cites *the* patriarchal family as the basis for "an almost identical vision of women" that Arab and Muslim societies have, she falls into this very trap (see especially p. 23). Not only is it problematical to speak of a vision of women shared by Arab and Muslim societies (i.e., over twenty different countries) without addressing the particular historical, material, and ideological power

structures that construct such images, but to speak of the patriarchal family or the tribal kinship structure as the origin of the socioeconomic status of women is to again assume that women are sexual-political subjects prior to their entry into the family. So while on the one hand women attain value or status within the family, the assumption of a singular patriarchal kinship system (common to all Arab and Muslim societies) is what apparently structures women as an oppressed group in these societies! This singular, coherent kinship system presumably influences another separate and given entity, "women." Thus, all women, regardless of class and cultural differences, are affected by this system. Not only are *all* Arab and Muslim women seen to constitute a homogeneous oppressed group, but there is no discussion of the specific *practices* within the family which constitute women as mothers, wives, sisters, etc. Arabs and Muslims, it appears, don't change at all. Their patriarchal family is carried over from the times of the prophet Mohammed. They exist, as it were, outside history.

Women and Religious Ideologies

A further example of the use of "women" as a category of analysis is found in cross-cultural analyses which subscribe to a certain economic reductionism in describing the relationship between the economy and factors such as politics and ideology. Here, in reducing the level of comparison to the economic relations between "developed and developing" countries, any specificity to the question of women is denied. Mina Modares (1981), in a careful analysis of women and Shi'ism in Iran, focuses on this very problem when she criticizes feminist writings which treat Islam as an ideology separate from and outside social relations and practices, rather than a discourse which includes rules for economic, social, and power relations within society. Patricia Jeffery's (1979) otherwise informative work on Pirzada women in purdah considers Islamic ideology a partial explanation for the status of women in that it provides a justification for the purdah. Here, Islamic ideology is reduced to a set of ideas whose internalization by Pirzada women contributes to the stability of the system. However, the primary explanation for purdah is located in the control that Pirzada men have over economic resources, and the personal security purdah gives to Pirzada women.

By taking a specific version of Islam as *the* Islam, Jeffery attributes a singularity and coherence to it. Modares notes, " 'Islamic Theology' then becomes imposed on a separate and given entity called 'women.' A further unification is reached: Women (meaning *all women*), regardless of their differing positions within societies, come to be affected or not affected by Islam. These conceptions provide the right ingredients for an unproblematic possibility of a cross-cultural study of women" (63). Marnia Lazreg makes a similar argument when she addresses the reductionism inherent in scholarship on women in the Middle East and North Africa:

A ritual is established whereby the writer appeals to religion as *the* cause of gender inequality just as it is made the source of underdevelopment in much of modernization theory. In an uncanny way, feminist discourse on women from the Middle East and North Africa mirrors that of theologians' own interpretation of women in Islam. . . .

The overall effect of this paradigm is to deprive women of self-presence, of being. Because women are subsumed under religion presented in fundamental terms, they are inevitably seen as evolving in nonhistorical time. They virtually have no history. Any analysis of change is therefore foreclosed. (1988, 87).

While Jeffery's analysis does not quite succumb to this kind of unitary notion of religion (Islam), it does collapse all ideological specificities into economic relations, and universalizes on the basis of this comparison.

Women and the Development Process

The best examples of universalization on the basis of economic reductionism can be found in the liberal "Women in Development" literature. Proponents of this school seek to examine the effect of development on third world women, sometimes from self-designated feminist perspectives. At the very least, there is an evident interest in and commitment to improving the lives of women in "developing" countries. Scholars such as Irene Tinker and Michelle Bo Bramsen (1972), Ester Boserup (1970), and Perdita Huston (1979) have all written about the effect of development policies on women in the third world.[9] All three women assume "development" is synonymous with "economic development" or "economic progress." As in the case of Minces's patriarchal family, Hosken's male sexual control, and Cutrufelli's Western colonization, development here becomes the all-time equalizer. Women are affected positively or negatively by economic development policies, and this is the basis for cross-cultural comparison.

For instance, Perdita Huston (1979) states that the purpose of her study is to describe the effect of the development process on the "family unit and its individual members" in Egypt, Kenya, Sudan, Tunisia, Sri Lanka, and Mexico. She states that the "problems" and "needs" expressed by rural and urban women in these countries all center around education and training, work and wages, access to health and other services, political participation, and legal rights. Huston relates all these "needs" to the lack of sensitive development policies which exclude women as a group or category. For her, the solution is simple: implement improved development policies which emphasize training for women fieldworkers, use women trainees, and women rural development officers, encourage women's cooperatives, etc. Here again, women are assumed to be a coherent group or category prior to their entry into "the development process." Huston assumes that all third world women have similar problems and

needs. Thus, they must have similar interests and goals. However, the interests of urban, middle-class, educated Egyptian housewives, to take only one instance, could surely not be seen as being the same as those of their uneducated, poor maids. Development policies do not affect both groups of women in the same way. Practices which characterize women's status and roles vary according to class. Women are constituted as women through the complex interaction between class, culture, religion, and other ideological institutions and frameworks. They are not "women"—a coherent group— solely on the basis of a particular economic system or policy. Such reductive cross-cultural comparisons result in the colonization of the specifics of daily existence and the complexities of political interests which women of different social classes and cultures represent and mobilize.

Thus, it is revealing that for Perdita Huston, women in the third world countries she writes about have "needs" and "problems," but few if any have "choices" or the freedom to act. This is an interesting representation of women in the third world, one which is significant in suggesting a latent self-presentation of Western women which bears looking at. She writes, "What surprised and moved me most as I listened to women in such very different cultural settings was the striking commonality—whether they were educated or illiterate, urban or rural—of their most basic values: the importance they assign to family, dignity, and service to others" (1979, 115). Would Huston consider such values unusual for women in the West?

What is problematical about this kind of use of "women" as a group, as a stable category of analysis, is that it assumes an ahistorical, universal unity between women based on a generalized notion of their subordination. Instead of analytically *demonstrating* the production of women as socioeconomic political groups within particular local contexts, this analytical move limits the definition of the female subject to gender identity, completely bypassing social class and ethnic identities. What characterizes women as a group is their gender (sociologically, not necessarily biologically, defined) over and above everything else, indicating a monolithic notion of sexual difference. Because women are thus constituted as a coherent group, sexual difference becomes coterminous with female subordination, and power is automatically defined in binary terms: people who have it (read: men), and people who do not (read: women). Men exploit, women are exploited. Such simplistic formulations are historically reductive; they are also ineffectual in designing strategies to combat oppressions. All they do is reinforce binary divisions between men and women.

What would an analysis which did not do this look like? Maria Mies's work illustrates the strength of Western feminist work on women in the third world which does not fall into the traps discussed above. Mies's study of the lace makers of Narsapur, India (1982), attempts to carefully analyze a substantial household industry in which "housewives" produce lace doilies for consumption in the world market. Through a detailed analysis of the structure of the lace industry, production and reproduction relations, the sexual division of labor, profits and exploitation, and the overall

consequences of defining women as "non-working housewives" and their work as "leisure-time activity." Mies demonstrates the levels of exploitation in this industry and the impact of this production system on the work and living conditions of the women involved in it. In addition, she is able to analyze the "ideology of the housewife," the notion of a woman sitting in the house, as providing the necessary subjective and socio-cultural element for the creation and maintenance of a production system that contributes to the increasing pauperization of women, and keeps them totally atomized and disorganized as workers. Mies's analysis shows the effect of a certain historically and culturally specific mode of patriarchal organization, an organization constructed on the basis of the definition of the lace makers as "non-working housewives" at familial, local, regional, statewide, and international levels. The intricacies and the effects of particular power networks not only are emphasized, but they form the basis of Mies's analysis of how this particular group of women is situated at the center of a hegemonic, exploitative world market.

This is a good example of what careful, politically focused, local analyses can accomplish. It illustrates how the category of women is constructed in a variety of political contexts that often exist simultaneously and overlaid on top of one another. There is no easy generalization in the direction of "women" in India, or "women in the third world"; nor is there a reduction of the political construction of the exploitation of the lace makers to cultural explanations about the passivity or obedience that might characterize these women and their situation. Finally, this mode of local, political analysis which generates theoretical categories from within the situation and context being analyzed, also suggests corresponding effective strategies for organizing against the exploitation faced by the lace makers. Narsapur women are not mere victims of the production process, because they resist, challenge, and subvert the process at various junctures. Here is one instance of how Mies delineates the connections between the housewife ideology, the self-consciousness of the lace makers, and their interrelationships as contributing to the latent resistances she perceives among the women:

> The persistence of the housewife ideology, the self-perception of the lace makers as petty commodity producers rather than as workers, is not only upheld by the structure of the industry as such but also by the deliberate propagation and reinforcement of reactionary patriarchal norms and institutions. Thus, most of the lace makers voiced the same opinion about the rules of *purdah* and seclusion in their communities which were also propagated by the lace exporters. In particular, the *Kapu* women said that they had never gone out of their houses, that women of their community could not do any other work than housework and lace work etc. but in spite of the fact that most of them still subscribed fully to the patriarchal norms of the *gosha* women, there were also contradictory elements in their consciousness. Thus, although they looked down with contempt upon women who were able to work outside the house—like the untouchable *Mala* and *Madiga* women or women of other lower castes, they could not ignore the fact that these women were earning more money precisely because they were *not* respectable housewives but workers. At one

discussion, they even admitted that it would be better if they could also go out and do coolie work. And when they were asked whether they would be ready to come out of their houses and work in one place in some sort of a factory, they said they would do that. This shows that the *purdah* and housewife ideology, although still fully internalized, already had some cracks, because it has been confronted with several contradictory realities. (157).

It is only by understanding the *contradictions* inherent in women's location within various structures that effective political action and challenges can be devised. Mies's study goes a long way toward offering such analysis. While there are now an increasing number of Western feminist writings in this tradition,[10] there is also, unfortunately, a large block of writing which succumbs to the cultural reductionism discussed earlier.

Methodological Universalisms, or: Women's Oppression Is a Global Phenomenon

Western feminist writings on women in the third world subscribe to a variety of methodologies to demonstrate the universal cross-cultural operation of male dominance and female exploitation. I summarize and critique three such methods below, moving from the simplest to the most complex.

First, proof of universalism is provided through the use of an arithmetic method. The argument goes like this: the greater the number of women who wear the veil, the more universal is the sexual segregation and control of women (Deardon 1975, 4–5). Similarly, a large number of different, fragmented examples from a variety of countries also apparently add up to a universal fact. For instance, Muslim women in Saudi Arabia, Iran, Pakistan, India, and Egypt all wear some sort of a veil. Hence, this indicates that the sexual control of women is a universal fact in those countries in which the women are veiled (Deardon 1975, 7, 10). Fran Hosken writes, "Rape, forced prostitution, polygamy, genital mutilation, pornography, the beating of girls and women, purdah (segregation of women) are all violations of basic human rights" (1981, 15). By equating purdah with rape, domestic violence, and forced prostitution, Hosken asserts its "sexual control" function as the primary explanation for purdah, whatever the context. Institutions of purdah are thus denied any cultural and historical specificity, and contradictions and potentially subversive aspects are totally ruled out.

In both these examples, the problem is not in asserting that the practice of wearing a veil is widespread. This assertion can be made on the basis of numbers. It is a descriptive generalization. However, it is the analytic leap from the practice of veiling to an assertion of its general significance in controlling women that must be questioned. While there may be a physical similarity in the veils worn by women in Saudi Arabia and Iran, the specific meaning attached to this practice varies according to the cultural and ideological context. In addition, the symbolic space occupied by the practice of

purdah may be similar in certain contexts, but this does not automatically indicate that the practices themselves have identical significance in the social realm. For example, as is well known, Iranian middle-class women veiled themselves during the 1979 revolution to indicate solidarity with their veiled working-class sisters, while in contemporary Iran, mandatory Islamic laws dictate that all Iranian women wear veils. While in both these instances, similar reasons might be offered for the veil (opposition to the Shah and Western cultural colonization in the first case, and the true Islamicization of Iran in the second), the concrete *meanings* attached to Iranian women wearing the veil are clearly different in both historical contexts. In the first case, wearing the veil is both an oppositional and a revolutionary gesture on the part of Iranian middle-class women; in the second case, it is a coercive, institutional mandate (see Tabari 1980 for detailed discussion). It is on the basis of such context-specific differentiated analysis that effective political strategies can be generated. To assume that the mere practice of veiling women in a number of Muslim countries indicates the universal oppression of women through sexual segregation not only is analytically reductive, but also proves quite useless when it comes to the elaboration of oppositional political strategy.

Second, concepts such as reproduction, the sexual division of labor, the family, marriage, household, patriarchy, etc., are often used without their specification in local cultural and historical contexts. Feminists use these concepts in providing explanations for women's subordination, apparently assuming their universal applicability. For instance, how is it possible to refer to "the" sexual division of labor when the *content* of this division changes radically from one environment to the next, and from one historical juncture to another? At its most abstract level, it is the fact of the differential assignation of tasks according to sex that is significant; however, this is quite different from the *meaning* or *value* that the content of this sexual division of labor assumes in different contexts. In most cases the assigning of tasks on the basis of sex has an ideological origin. There is no question that a claim such as "women are concentrated in service-oriented occupations in a large number of countries around the world" is descriptively valid. Descriptively, then, perhaps the existence of a similar sexual division of labor (where women work in service occupations such as nursing, social work, etc., and men in other kinds of occupations) in a variety of different countries can be asserted. However, the concept of the "sexual division of labor" is more than just a descriptive category. It indicates the differential *value* placed on "men's work" versus "women's work."

Often the mere existence of a sexual division of labor is taken to be proof of the oppression of women in various societies. This results from a confusion between and collapsing together of the descriptive and explanatory potential of the concept of the sexual division of labor. Superficially similar situations may have radically different, historically specific explanations, and cannot be treated as identical. For instance, the rise of female-headed households in middle-class America might be construed as a sign of great independence and feminist progress, whereby women are considered to have

chosen to be single parents, there are increasing numbers of lesbian mothers, etc. However, the recent increase in female-headed households in Latin America,[11] where women might be seen to have more decision-making power, is concentrated among the poorest strata, where life choices are the most constrained economically. A similar argument can be made for the rise of female-headed families among black and Chicana women in the U.S. The positive correlation between this and the level of poverty among women of color and white working-class women in the U.S. has now even acquired a name: the feminization of poverty. Thus, while it is possible to state that there is a rise in female-headed households in the U.S. and in Latin America, this rise cannot be discussed as a universal indicator of women's independence, nor can it be discussed as a universal indicator of women's impoverishment. The *meaning* of and *explanation* for the rise obviously vary according to the sociohistorical context.

Similarly, the existence of a sexual division of labor in most contexts cannot be sufficient explanation for the universal subjugation of women in the work force. That the sexual division of labor does indicate a devaluation of women's work must be shown through analysis of particular local contexts. In addition, devaluation of *women* must also be shown through careful analysis. In other words, the "sexual division of labor" and "women" are not commensurate analytical categories. Concepts such as the sexual division of labor can be useful only if they are generated through local, contextual analyses (see Eldhom, Harris, and Young 1977). If such concepts are assumed to be universally applicable, the resultant homogenization of class, race, religious, and daily material practices of women in the third world can create a false sense of the commonality of oppressions, interests, and struggles between and among women globally. Beyond sisterhood there are still racism, colonialism, and imperialism!

Finally, some writers confuse the use of gender as a superordinate category of organizing analysis with the universalistic proof and instantiation of this category. In other words, empirical studies of gender differences are confused with the analytical organization of cross-cultural work. Beverly Brown's (1983) review of the book *Nature, Culture and Gender* (Strathern and McCormack 1980) best illustrates this point. Brown suggests that nature:culture and female:male are superordinate categories which organize and locate lesser categories (such as wild/domestic and biology/technology) within their logic. These categories are universal in the sense that they organize the universe of a system of representations. This relation is totally independent of the universal substantiation of any particular category. Her critique hinges on the fact that rather than clarify the generalizability of nature:culture :: female:male as subordinate organization categories, *Nature, Culture and Gender* construes the universality of this equation to lie at the level of empirical truth, which can be investigated through fieldwork. Thus, the usefulness of the nature:culture :: female:male paradigm as a universal mode of the organization of representation within any particular sociohistorical system is lost. Here, methodological universalism is assumed on the basis of the reduction of the nature:culture :: female:male analytic categories to a demand for empirical proof of its

existence in different cultures. Discourses of representation are confused with material realities, and the distinction made earlier between "Woman" and "women" is lost. Feminist work which blurs this distinction (which is, interestingly enough, often present in certain Western feminists' self-representation) eventually ends up constructing monolithic images of "third world women" by ignoring the complex and mobile relationships between their historical materiality on the level of specific oppressions and political choices, on the one hand, and their general discursive representations, on the other.

To summarize: I have discussed three methodological moves identifiable in feminist (and other academic) cross-cultural work which seeks to uncover a universality in women's subordinate position in society. The next and final section pulls together the previous sections, attempting to outline the political effects of the analytical strategies in the context of Western feminist writing on women in the third world. These arguments are not against generalization as much as they are for careful, historically specific generalizations responsive to complex realities. Nor do these arguments deny the necessity of forming strategic political identities and affinities. Thus, while Indian women of different religions, castes, and classes might forge a political unity on the basis of organizing against police brutality toward women (see Kishwar and Vanita 1984), an *analysis* of police brutality must be contextual. Strategic coalitions which construct oppositional political identities for themselves are based on generalization and provisional unities, but the analysis of these group identities cannot be based on universalistic, ahistorical categories.

The Subject(s) of Power

This last section returns to an earlier point about the inherently political nature of feminist scholarship, and attempts to clarify my point about the possibility of detecting a colonialist move in the case of a hegemonic first-third world connection in scholarship. The nine texts in the Zed Press Women in the Third World series that I have discussed[12] focused on the following common areas in examining women's "status" within various societies: religion, family/kinship structures, the legal system, the sexual division of labor, education, and finally, political resistance. A large number of Western feminist writings on women in the third world focus on these themes. Of course the Zed texts have varying emphases. For instance, two of the studies, *Women of Palestine* (Downing 1982) and *Indian Women in Struggle* (Omvedt 1980), focus explicitly on female militance and political involvement, while *Women in Arab Society* (Minces 1980) deals with Arab women's legal, religious, and familial status. In addition, each text evidences a variety of methodologies and degrees of care in making generalizations. Interestingly enough, however, almost all the texts assume "women" as a category of analysis in the manner designated above.

Clearly this is an analytical strategy which is neither limited to these Zed Press publications nor symptomatic of Zed Press publications in general. However, each of the particular texts in question assumes "women" have a coherent group identity within the different cultures discussed, prior to their entry into social relations. Thus, Omvedt can talk about "Indian women" while referring to a particular group of women in the State of Maharashtra, Cutrufelli about "women of Africa," and Minces about "Arab women" as if these groups of women have some sort of obvious cultural coherence, distinct from men in these societies. The "status" or "position" of women is assumed to be self-evident, because women as an already constituted group are *placed* within religious, economic, familial, and legal structures. However, this focus whereby women are seen as a coherent group across contexts, regardless of class or ethnicity, structures the world in ultimately binary, dichotomous terms, where women are always seen in opposition to men, patriarchy is always necessarily male dominance, and the religious, legal, economic, and familial systems are implicitly assumed to be constructed by men. Thus, both men and women are always apparently constituted whole populations, and relations of dominance and exploitation are also posited in terms of whole peoples—wholes coming into exploitative relations. It is only when men and women are seen as different categories or groups possessing different *already constituted* categories of experience, cognition, and interests as *groups* that such a simplistic dichotomy is possible.

What does this imply about the structure and functioning of power relations? The setting up of the commonality of third world women's struggles across classes and cultures against a general notion of oppression (primarily the group in power—i.e., men) necessitates the assumption of what Michel Foucault (1980, 135–45) calls the "juridico-discursive" model of power, the principal features of which are "a negative relation" (limit and lack), an "insistence on the rule" (which forms a binary system), a "cycle of prohibition," the "logic of censorship," and a "uniformity" of the apparatus functioning at different levels. Feminist discourse on the third world which assumes a homogeneous category—or group—called women necessarily operates through the setting up of originary power divisions. Power relations are structured in terms of a unilateral and undifferentiated source of power and a cumulative reaction to power. Opposition is a generalized phenomenon created as a response to power—which, in turn, is possessed by certain groups of people.

The major problem with such a definition of power is that it locks all revolutionary struggles into binary structures—possessing power versus being powerless. Women are powerless, unified groups. If the struggle for a just society is seen in terms of the move from powerless to powerful for women as a *group*, and this is the implication in feminist discourse which structures sexual difference in terms of the division between the sexes, then the new society would be structurally identical to the existing organization of power relations, constituting itself as a simple *inversion* of what exists. If relations of domination and exploitation are defined in terms of binary divisions—groups

which dominate and groups which are dominated—surely the implication is that the accession to power of women as a group is sufficient to dismantle the existing organization of relations? But women as a group are not in some sense essentially superior or infallible. The crux of the problem lies in that initial assumption of women as a homogeneous group or category ("the oppressed"), a familiar assumption in Western radical and liberal feminisms.[13]

What happens when this assumption of "women as an oppressed group" is situated in the context of Western feminist writing about third world women? It is here that I locate the colonialist move. By contrasting the representation of women in the third world with what I referred to earlier as Western feminisms' self-presentation in the same context, we see how Western feminists alone become the true "subjects" of this counterhistory. Third world women, on the other hand, never rise above the debilitating generality of their "object" status.

While radical and liberal feminist assumptions of women as a sex class might elucidate (however inadequately) the autonomy of particular women's struggles in the West, the application of the notion of women as a homogeneous category to women in the third world colonizes and appropriates the pluralities of the simultaneous location of different groups of women in social class and ethnic frameworks; in doing so it ultimately robs them of their historical and political *agency*. Similarly, many Zed Press authors who ground themselves in the basic analytic strategies of traditional Marxism also implicitly create a "unity" of women by substituting "women's activity" for "labor" as the primary theoretical determinant of women's situation. Here again, women are constituted as a coherent group not on the basis of "natural" qualities or needs but on the basis of the sociological "unity" of their role in domestic production and wage labor (see Haraway 1985, esp. p. 76). In other words, Western feminist discourse, by assuming women as a coherent, already constituted group which is placed in kinship, legal, and other structures, defines third world women as subjects *outside* social relations, instead of looking at the way women are constituted *through* these very structures.

Legal, economic, religious, and familial structures are treated as phenomena to be judged by Western standards. It is here that ethnocentric universality comes into play. When these structures are defined as "underdeveloped" or "developing" and women are placed within them, an implicit image of the "average third world woman" is produced. This is the transformation of the (implicitly Western) "oppressed woman" into the "oppressed third world woman." While the category of "oppressed woman" is generated through an exclusive focus on gender difference, "the oppressed third world woman" category has an additional attribute—the "third world difference!" The "third world difference" includes a paternalistic attitude toward women in the third world.[14] Since discussions of the various themes I identified earlier (kinship, education, religion, etc.) are conducted in the context of the relative "underdevelopment" of the third world (which is nothing less than unjustifiably confusing development with the separate path taken by the West in its development, as well as ignoring the directionality of

the first-third world power relationship), third world women as a group or category are automatically and necessarily defined as religious (read "not progressive"), family-oriented (read "traditional"), legal minors (read "they-are-still-not-conscious-of-their-rights"), illiterate (read "ignorant"), domestic (read "backward"), and sometimes revolutionary (read "their-country-is-in-a-state-of-war; they-must-fight!") This is how the "third world difference" is produced.

When the category of "sexually oppressed women" is located within particular systems in the third world which are defined on a scale which is normed through Eurocentric assumptions, not only are third world women defined in a particular way prior to their entry into social relations, but since no connections are made between first and third world power shifts, the assumption is reinforced that the third world just has not evolved to the extent that the West has. This mode of feminist analysis, by homogenizing and systematizing the experiences of different groups of women in these countries, erases all marginal and resistant modes and experiences.[15] It is significant that none of the texts I reviewed in the Zed Press series focuses on lesbian politics or the politics of ethnic and religious marginal organizations in third world women's groups. Resistance can thus be defined only as cumulatively reactive, not as something inherent in the operation of power. If power, as Michel Foucault has argued recently, can really be understood only in the context of resistance,[16] this misconceptualization is both analytically and strategically problematical. It limits theoretical analysis as well as reinforces Western cultural imperialism. For in the context of a first/third world balance of power, feminist analyses which perpetrate and sustain the hegemony of the idea of the superiority of the West produce a corresponding set of universal images of the "third world woman," images such as the veiled woman, the powerful mother, the chaste virgin, the obedient wife, etc. These images exist in universal, ahistorical splendor, setting in motion a colonialist discourse which exercises a very specific power in defining, coding, and maintaining existing first/third world connections.

To conclude, then, let me suggest some disconcerting similarities between the typically authorizing signature of such Western feminist writings on women in the third world, and the authorizing signature of the project of humanism in general—humanism as a Western ideological and political project which involves the necessary recuperation of the "East" and "Woman" as Others. Many contemporary thinkers, including Foucault (1978, 1980), Derrida (1974), Kristeva (1980), Deleuze and Guattari (1977), and Said (1978), have written at length about the underlying anthropomorphism and ethnocentrism which constitute a hegemonic humanistic problematic that repeatedly confirms and legitimates (Western) Man's centrality. Feminist theorists such as Luce Irigaray (1981), Sarah Kofman (see Berg 1982), and Helene Cixous (1981) have also written about the recuperation and absence of woman/women within Western humanism. The focus of the work of all these thinkers can be stated simply as an uncovering of the political *interests* that underlie the binary logic of humanistic discourse and ideology whereby, as a valuable recent essay puts it, "the first (majority) term (Identity,

Universality, Culture, Disinterestedness, Truth, Sanity, Justice, etc.), which is, in fact, secondary and derivative (a construction), is privileged over and colonizes the second (minority) term (difference, temporality, anarchy, error, interestedness, insanity, deviance, etc.), which is in fact, primary and originative" (Spanos 1984). In other words, it is only insofar as "Woman/Women" and "the East" are defined as *Others,* or as peripheral, that (Western) Man/Humanism can represent him/itself as the center. It is not the center that determines the periphery, but the periphery that, in its boundedness, determines the center. Just as feminists such as Kristeva and Cixous deconstruct the latent anthropomorphism in Western discourse, I have suggested a parallel strategy in this essay in uncovering a latent ethnocentrism in particular feminist writings on women in the third world.[17]

As discussed earlier, a comparison between Western feminist self-presentation and Western feminist re-presentation of women in the third world yields significant results. Universal images of "the third world woman" (the veiled woman, chaste virgin, etc.), images constructed from adding the "third world difference" to "sexual difference," are predicated upon (and hence obviously bring into sharper focus) assumptions about Western women as secular, liberated, and having control over their own lives. This is not to suggest that Western women *are* secular, liberated, and in control of their own lives. I am referring to a *discursive* self-presentation, not necessarily to material reality. If this were a material reality, there would be no need for political movements in the West. Similarly, only from the vantage point of the West is it possible to define the "third world" as underdeveloped and economically dependent. Without the overdetermined discourse that creates the *third* world, there would be no (singular and privileged) first world. Without the "third world woman," the particular self-presentation of Western women mentioned above would be problematical. I am suggesting, then, that the one enables and sustains the other. This is not to say that the signature of Western feminist writings on the third world has the same authority as the project of Western humanism. However, in the context of the hegemony of the Western scholarly establishment in the production and dissemination of texts, and in the context of the legitimating imperative of humanistic and scientific discourse, the definition of "the third world woman" as a monolith might well tie into the larger economic and ideological praxis of "disinterested" scientific inquiry and pluralism which are the surface manifestations of a latent economic and cultural colonization of the "non-Western" world. It is time to move beyond the Marx who found it possible to say: They cannot represent themselves; they must be represented.

Footnotes

1. Terms such as *third* and *first world* are very problematical both in suggesting oversimplified similarities between and among countries labeled thus, and in

implicitly reinforcing existing economic, cultural, and ideological hierarchies which are conjured up in using such terminology. I use the term *"third world"* with full awareness of its problems, only because this is the terminology available to us at the moment. The use of quotation marks is meant to suggest a continuous questioning of the designation. Even when I do not use quotation marks, I mean to use the term critically.

2. I am indebted to Teresa de Lauretis for this particular formulation of the project of feminist theorizing. See especially her introduction in de Lauretis, *Alice Doesn't: Feminism, Semiotics, Cinema* (Bloomington: Indiana University Press, 1984); see also Sylvia Wynter, "The Politics of Domination," unpublished manuscript.

3. This argument is similar to Homi Bhabha's definition of colonial discourse as strategically creating a space for a subject people through the production of knowledges and the exercise of power. The full quote reads: "[colonial discourse is] an apparatus of power. . . . an apparatus that turns on the recognition and disavowal of racial/cultural/historical differences. Its predominant strategic function is the creation of a space for a subject people through the production of knowledges in terms of which surveillance is exercised and a complex form of pleasure/unpleasure is incited. It (i.e. colonial discourse) seeks authorization for its strategies by the production of knowledges by coloniser and colonised which are stereotypical but antithetically evaluated" (1983, 23).

4. A number of documents and reports on the UN International Conferences on Women, Mexico City, 1975, and Copenhagen, 1980, as well as the 1976 Wellesley Conference on Women and Development, attest to this. Nawal el Saadawi, Fatima Mernissi, and Mallica Vajarathon (1978) characterize this conference as "American-planned and organized," situating third world participants as passive audiences. They focus especially on the lack of self-consciousness of Western women's implication in the effects of imperialism and racism in their assumption of an "international sisterhood." A recent essay by Valerie Amos and Pratibha Parmar (1984) characterizes as "imperial" Euro-American feminism which seeks to establish itself as the only legitimate feminism.

5. The Zed Press Women in the Third World series is unique in its conception. I choose to focus on it because it is the only contemporary series I have found which assumes that "women in the third world" are a legitimate and separate subject of study and research. Since 1985, when this essay was first written, numerous new titles have appeared in the Women in the Third World series. Thus, I suspect that Zed has come to occupy a rather privileged position in the dissemination and construction of discourses by and about third world women. A number of the books in this series are excellent, especially those which deal directly with women's resistance struggles. In addition, Zed Press consistently publishes progressive feminist, antiracist, and antiimperialist texts. However, a

number of the texts written by feminist sociologists, anthropologists, and journalists are symptomatic of the kind of Western feminist work on women in the third world that concerns me. Thus, an analysis of a few of these particular works in this series can serve as a representative point of entry into the discourse I am attempting to locate and define. My focus on these texts is therefore an attempt at an internal critique: I simply expect and demand more from this series. Needless to say, progressive publishing houses also carry their own authorizing signatures.

6. Elsewhere I have discussed this particular point in detail in a critique of Robin Morgan's construction of "women's herstory" in her introduction to *Sisterhood Is Global: The International Women's Movement Anthology* (New York: Anchor Press/Doubleday, 1984). See my "Feminist Encounters: Locating the Politics of Experience," *Copyright* 1, "Fin de Siecle 2000," 30–44, especially 35–37.

7. Another example of this kind of analysis is Mary Daly's (1978) *Gyn/Ecology.* Daly's assumption in this text, that women as a group are sexually victimized, leads to her very problematic comparison between the attitudes toward women witches and healers in the West, Chinese footbinding, and the genital mutilation of women in Africa. According to Daly, women in Europe, China, and Africa constitute a homogeneous group as victims of male power. Not only does this label (sexual victims) eradicate the specific historical and material realities and contradictions which lead to and perpetuate practices such as witch hunting and genital mutilation, but it also obliterates the differences, complexities, and heterogeneities of the lives of, for example, women of different classes, religions, and nations in Africa. As Audre Lorde (1983) pointed out, women in Africa share a long tradition of healers and goddesses that perhaps binds them together more appropriately than their victim status. However, both Daly and Lorde fall prey to universalistic assumptions about "African women" (both negative and positive). What matters is the complex, historical range of power differences, commonalities, and resistances that exist among women in Africa which construct African women as "subjects" of their own politics.

8. See Eldhom, Harris, and Young (1977) for a good discussion of the necessity to theorize male violence within specific societal frameworks, rather than assume it as a universal fact.

9. These views can also be found in differing degrees in collections such as Wellesley Editorial Committee, ed., *Women and National Development: The Complexities of Change* (Chicago: University of Chicago Press, 1977), and *Signs*, Special Issue, "Development and the Sexual Division of Labor," 7, no. 2 (Winter 1981). For an excellent introduction of WID issues, see ISIS, *Women in Development: A Resource Guide for Organization and Action* (Philadelphia: New Society Publishers, 1984). For a politically focused discussion of feminism and development and the stakes for poor third world women, see Gita Sen and

Caren Grown, *Development Crises and Alternative Visions: Third World Women's Perspectives* (New York: Monthly Review Press, 1987).

10. See essays by Vanessa Maher, Diane Elson and Ruth Pearson, and Maila Stevens in Kate Young, Carol Walkowitz, and Roslyn McCullagh, eds., *Of Marriage and the Market: Women's Subordination in International Perspective* (London: CSE Books, 1981); and essays by Vivian Mota and Michelle Mattelart in June Nash and Helen I. Safa, eds., *Sex and Class in Latin America: Women's Perspectives on Politics, Economics and the Family in the Third World* (South Hadley, Mass.: Bergin and Garvey, 1980). For examples of excellent, self-conscious work by feminists writing about women in their own historical and geographical locations, see Marnia Lazreg (1988) on Algerian women, Gayatri Chakravorty Spivak's "A Literary Representation of the Subaltern: A Woman's Text from the Third World," in her *In Other Worlds: Essays in Cultural Politics* (New York: Methuen, 1987), 241–68, and Lata Mani's essay "Contentious Traditions: The Debate on SATI in Colonial India," *Cultural Critique* 7 (Fall 1987), 119–56.

11. Olivia Harris, "Latin American Women–An Overview," in Harris, ed., *Latin American Women* (London: Minority Rights Group Report no. 57, 1983), 4–7. Other MRG Reports include Ann Deardon (1975) and Rounaq Jahan (1980).

12. List of Zed Press publications: Patricia Jeffery, *Frogs in a Well: Indian Women in Purdah* (1979); Latin American and Caribbean Women's Collective, *Slaves of Slaves: The Challenge of Latin American Women* (1980); Gail Omvedt, *We Shall Smash This Prison: Indian Women in Struggle* (1980); Juliette Minces, *The House of Obedience: Women in Arab Society* (1980); Bobby Siu, *Women of China: Imperialism and Women's Resistance, 1900–1949* (1981); Ingela Bendt and James Downing, *We Shall Return: Women in Palestine* (1982); Maria Rosa Cutrufelli, *Women of Africa: Roots of Oppression* (1983); Maria Mies, *The Lace Makers of Narsapur: Indian Housewives Produce for the World Market* (1982); Miranda Davis, ed., *Third World/Second Sex: Women's Struggles and National Liberation* (1983).

13. For succinct discussions of Western radical and liberal feminisms, see Hester Eisenstein, *Contemporary Feminist Thought* (Boston: G. K. Hall & Co., 1983), and Zillah Eisenstein, *The Radical Future of Liberal Feminism* (New York: Longman, 1981).

14. Amos and Parmar describe the cultural stereotypes present in Euro-American feminist thought: "The image is of the passive Asian woman subject to oppressive practices within the Asian family with an emphasis on wanting to 'help' Asian women liberate themselves from their role. Or there is the strong, dominant Afro-Caribbean woman, who despite her 'strength' is exploited by the 'sexism' which is seen as being a strong feature in relationships between Afro-Caribbean men and women" (9). These images illustrate the extent to which *paternalism* is an essential element of feminist thinking which incorporates the

above stereotypes, a paternalism which can lead to the definition of priorities for women of color by Euro-American feminists.

15. I discuss the question of theorizing experience in my "Feminist Encounters" (1987) and in an essay coauthored with Biddy Martin, "Feminist Politics: What's Home Got to Do with It?" in Teresa de Lauretis, ed., *Feminist Studies/Critical Studies* (Bloomington: Indiana University Press, 1986), 191–212.

16. This is one of M. Foucault's (1978, 1980) central points in his reconceptualization of the strategies and workings of power networks.

17. For an argument which demands a *new* conception of humanism in work on third world women, see Marnia Lazreg (1988). While Lazreg's position might appear to be diametrically opposed to mine, I see it as a provocative and potentially positive extension of some of the implications that follow from my arguments. In criticizing the feminist rejection of humanism in the name of "essential Man," Lazreg points to what she calls an "essentialism of difference" within these very feminist projects. She asks: "To what extent can Western feminism dispense with an ethics of responsibility when writing about different women? The point is neither to subsume other women under one's own experience nor to uphold a separate truth for them. Rather, it is to allow them to *be* while recognizing that what they are is just as meaningful, valid, and comprehensible as what we are. . . . Indeed, when feminists essentially deny other women the humanity they claim for themselves, they dispense with any ethical constraint. They engage in the act of splitting the social universe into us and them, subject and objects" (99–100).

This essay by Lazreg and an essay by S. P. Mohanty (1989) entitled "Us and Them: On the Philosophical Bases of Political Criticism" suggest positive directions for self-conscious cross-cultural analyses, analyses which move beyond the deconstructive to a fundamentally productive mode in designating overlapping areas for cross-cultural comparison. The latter essay calls not for a "humanism" but for a reconsideration of the question of the "human" in a posthumanist context. It argues that (1) there is no necessary "incompatibility between the deconstruction of Western humanism" and such "a positive elaboration" of the human, and moreover that (2) such an elaboration is essential if contemporary political-critical discourse is to avoid the incoherences and weaknesses of a relativist position.

SECTION III

Redefining the Spaces of Women and Society

Alternative Visions, Strategies, and Methods

Gita Sen and Caren Grown

Much of what we have said so far has been drawn from women's experiences with development. While we have emphasized and drawn the links between macro policies and their less than benign effects on the poor, especially women, the picture is not entirely negative. Women drawing on their experiences have developed great capacities for internal resilience and resistance. Women have also had positive experiences of their own—of collective nonviolent resistance to nuclear weapons, military death squads, and forest contractors. Women have learned to shed traditional submissiveness and withstand family and community pressures, and have begun to work together to improve economic conditions for themselves and others. Women have organized to use traditional cultural forms to raise the consciousness of men and women about injustice and inequality.

The experience of working in grassroots organizations and women's groups over the last ten years has led us to several fundamental realizations. First, our consciousness and ethics now need to be crystallized into a clear *vision* of what we want society to be like, and what we want for women. This does not mean an attempt to impose a uniform ideology from the top. Rather, we feel that the debate around the real, hard issues of development, peace, and equality has only just begun, and we need to reflect together on what we have learned from the diverse richness of our experiences.

Second, we need the *strategies* that will get us from here to there, take us beyond the small and fragmented efforts of a decade in which women have begun to understand the enormity of the task we have set ourselves, and also the depths of our strength and potential. Thus, in this chapter we address ourselves first to women, but also to agencies and governments.

Third, we want to spell out the *methods* for actualizing our visions and strategies through the empowerment of individual women and their organizations. It has been a strong theme of the modern women's movement that objectives and methods, ends and means are closely bound together. Our own life experiences as women have shown us how easy it is to suppress and subjugate in the name of a "greater good" if this principle is forgotten. The mass movements for peace and justice have an ethical basis that can strengthen and empower us if it is clearly understood and affirmed. The women's movement too can have an ethic drawn from women's daily lives. At its deepest it is not an effort to play "catch up" with the competitive, aggressive "dog-eat-dog" spirit of the dominant system. It is, rather, an attempt to convert men and the system to the sense of responsibility, nurturance, openness, and rejection of hierarchy that are part of our vision.

Visions

Our understanding of feminism structures our visions for society and for women. We recognize that there can be diverse meanings of feminism, each responsive to the needs and issues of women in different regions, societies, and times. This is because of our understanding that feminism is a *political* movement, and as such expresses the concerns of women from different regions and backgrounds. Like all political movements, it can be diverse in its issues, immediate goals, and methods adopted. But beneath this diversity, feminism has as its unshakeable core a commitment to breaking down the structures of gender subordination and a vision for women as full and equal participants with men at all levels of societal life.

There has been considerable confusion and misunderstanding among women around this question. The recognition of the existence of gender subordination and the

need to break down its structures has often led to the wrong conclusion that it engenders monolithic and universal issues, strategies and methods, applicable to all women in all societies at all times. But a political movement that is potentially global in scope needs greater flexibility, openness, and sensitivity to issues and methods as defined by different groups of women for themselves. *Self-definition* is therefore a key ingredient to relevant political action.

A recognition of diversity in issues and methods allows women to work for change within existing structures or to work to transform those structures. It allows women to challenge and debate the connections between various immediate issues and the ultimate vision of gender equality in more fruitful ways than dogmatic assertions of the "true" meaning of feminism. It makes it possible to form alliances with other organizations, to assert the need for autonomy, or to work within existing organizations as appropriate. It enables women to link the struggle against gender subordination to those against national, racial, and class oppression where these issues are bound together, and depending on the politics and potential of other organizations.

In the light of this conception of feminism, the vision for society put forward here is a dual one. Since poor women are the central actors on our stage, both poverty and gender subordination must be transformed by our vision. Insofar as poverty is concerned, its structural roots lie in unequal access to resources, control over production, trade, finance, and money, and across nations, genders, regions, and classes. We are well aware that given the enormity of the present gulf between rich and poor, and the fact that it has tended to widen rather than to shrink, these structures are unlikely to change quickly. But we must have before us a vision of the kind of world we want.

We want a world where inequality based on class, gender, and race is absent from every country, and from the relationships among countries. We want a world where basic needs become basic rights and where poverty and all forms of violence are eliminated. Each person will have the opportunity to develop her or his full potential and creativity, and women's values of nurturance and solidarity will characterize human relationships. In such a world women's reproductive role will be redefined: child care will be shared by men, women, and society as a whole. We want a world where the massive resources now used in the production of the means of destruction will be diverted to areas where they will help to relieve oppression both inside and outside the home. This technological revolution will eliminate disease and hunger, and give women means for the safe control of their fertility. We want a world where all institutions are open to participatory democratic processes, where women share in determining priorities and making decisions.

Perhaps we have said nothing new; indeed, it has been said before. It is often stated, however, that the world lacks the resources to meet the needs of all the poor, and that poor countries must increase their productive potential before mass living standards can be improved. Both of these statements are, as we have argued, patently false. The massive and growing resource diversion toward militarization gives the lie to the first,

while the cited examples of countries which have grown rapidly without improving mass living conditions, and others which have done the reverse, prove that there is no simple congruence between economic growth and basic needs.

What is lacking is not resources, but political will. But in a world and in countries riven with differences of economic interest and political power, we cannot expect political will for systemic change to emerge voluntarily among those in power. It must be fostered by mass movements that give central focus to the "basic rights" of the poor, and demand a reorientation of policies, programmes, and projects toward that end. The opening of political processes to accommodate greater expression of opinions and dissent, as well as participation by poor people in the decisions that affect their lives at the macro and the micro levels, is crucial. In this regard, it is heartening that, despite the severity of the economic crisis (and in some instances through resistance to government programmes directed against the poor and middle classes), countries in Latin America and elsewhere have experienced a process of democratization of political processes. The power and potential of the women's movement must be tapped in expanding and safeguarding these gains.

The transformation of the structures of subordination that have been so inimical to women is the other part of our vision of a new era. Changes in laws, civil codes, systems of property rights, control over our bodies, labour codes, and the social and legal institutions that underwrite male control and privilege are essential if women are to attain justice in society. The consequences of the prevalent injustices and inequities in terms of women's health, work burden, access to employment and income, and even mortality rates are well documented. Only by sharpening the links between equality, development, and peace, can we show that the "basic rights" of the poor and the transformation of the institutions that subordinate women are inextricably linked. They can be achieved together through the self-empowerment of women.

Strategies

What do our experiences suggest about strategies for change? As we have seen, women's income and employment generation projects have suffered by being scattered, small, and peripheral to the main thrust of planning processes, programmes or projects. Different agencies (international and national) have financed a plethora of small projects in various sectors with little coordination nor concern for sustained financial viability, capacity to grow and expand, or replicability. Despite these drawbacks, the very smallness of projects has enabled women to understand how to cope with local power structures, how to articulate demands, and how to use organizational strength to counter gender biases and rigidities inside the home.

In moving beyond this initial project experience, we need to situate our goals and actions within the context of the larger vision we outlined. Improving women's oppor-

tunities requires long-term systematic strategies aimed at challenging prevailing structures and building accountability of governments to people for their decisions. Short-term, ameliorative approaches to improve women's employment opportunities are ineffective unless they are combined with long-term strategies to reestablish people's—especially women's—control over the economic decisions that shape their lives. Women's voices must enter the definition of development and the making of policy choices.

These are strategies that must be debated, first of all, within the women's movement and among grassroots women's organizations. Such discussions can help to genuinely incorporate the experiences and concerns of poor women, to discern and identify regional and local variations, and to articulate a consolidated body of analysis and programmes to ourselves, as well as to national governments and international agencies. Any effective strategy must integrate economic, political, legal, and cultural aspects. For the sake of simplicity, however, we have divided our discussion between these different spheres.

The *economic* sphere should distinguish between the long- and short-terms. In the *long run* we need strategies that will break down the structures of inequity between genders, classes and nations, which act as barriers to development processes responsive to the needs of people. Planned changes must reorient production processes in agriculture, industry, and services, so that meeting the needs of the poor becomes the principal focus of planning. In this context, recognition not just of poor women's work but of its *centrality* to such development processes is essential, as is the need to make poor women central to both planning and implementation.

Requisites for such a fundamental change in development orientation are national liberation from colonial and neocolonial domination, and national self-reliance, at least in basic requirements such as food and energy sources, health care and water provision, and education. This will in many instances involve a shift from export-led strategies in agriculture and industry, where such strategies have demonstrably been inimical to the basic needs of human survival. As we have argued, women's long-term interests are consistent with such a reorientation, even though women are the dominant workers in export industries and agriculture under present production structures.

Another important strategy needed to reorient development is a worldwide reduction in military expenditures and resource use. As we have shown, there are close links between growing military budgets and poverty in the industrial countries, on the one hand, and diversion of resources, depletion of minerals, suppression of dissent, armed conflict, and distortion of development priorities in the Third World, on the other. Of course, the interdependence between dictatorial regimes and external economic and geopolitical interests is close in most instances. But with growing liberalization of political processes, at least in some countries, there is considerable scope for building a popular climate against militarization. Women's organizations can play a crucial role in this.

On the international front, demilitarization strategies are linked to Third World priorities in another important way. The contribution of rising military expenditures to budget deficits, high interest rates in the U.S., and growing debt burdens in the Third World has already been noted. Therefore, a reduction in the U.S. military budget could potentially reduce the pressure on the balance of payments of debtor countries and hence the burdens imposed by structural adjustment on the poor and middle classes in these countries. As we noted, a very large share of these burdens falls on poor women, who lose incomes and access to services, and who have to make up for this loss through an increase in their own labour.

The control of multinationals is another long-term requirement. Large corporations have been instrumental in diverting resources from basic needs toward commercialization, exports, and militarization. The employment they create in the Third World tends to be small in volume and to consist of dead-end jobs. The technology they sell is often unsuited to the consumption needs of the majority, and to domestically available resources. The outflows of profits, interest, and royalities place considerable pressures on the balance of payments as well. Greater control over the activities of multinational corporations is therefore a critical ingredient for national self-reliance, which is in turn essential for equitable development.

In many countries the transformation of internal inequities is closely linked to the above strategies, since dominant internal classes and groups are often closely allied to external economic and political interests. In addition, needed changes in the rural areas must be predicated on genuine land reforms. The production organizations that emerge after such reforms will vary, depending on technology, cropping patterns, and the extent of landlessness that might persist even after reforms. We shall not elaborate on these here, beyond making the point that women must be given equal status during and after reforms, from the standpoint of equity and from the concerns of agricultural production and integrated fulfillment of such basic requirements as food, fuel, and water.

Proposing long-term strategies for major societal change may lead to cynicism because of the considerable chasm between the present situation and that projected in a vision. We face powerful interests internationally and nationally—dominant countries, internal ruling classes and groups, multinationals—opposed to our long-term vision and goals. *What are the strategic points of leverage* that women and other likeminded groups can identify and use in the struggle toward our vision of society? Since forces arrayed against us are by no means monolithic in their interests and aims, we must learn to use these differences strategically. A number of examples can be cited in this context.

On the question of food production in sub-Saharan Africa, for example, the Berg Report adopted by the World Bank, the Lagos Plan put forward by governments in the region, and the Reagan administration's proposals for agricultural production and aid are significantly at odds with one another.[169] While the Lagos Plan calls for greater self-

reliance on the food front, the Berg Report emphasizes accelerated export production supplemented by food aid. The Reagan government has cut back on aid to all but five countries in the region which it views as strategic to U.S. interests. In this case, women's interests appear to be more compatible with the Lagos Plan, provided that the role of women in food production and marketing can be made more central. Similarly, on the question of debt, women's interests are connected to those national interests opposed to IMF adjustment programmes. Government expenditures for basic needs must become an inviolable budgetary item. Here again women can bring in additional perspectives based on their experiences of providing collectively-managed services for food provision, child care, health, etc. We are not arguing that women should compensate for the loss of vital services by increasing their already heavy burdens (they are doing this individually in any case). But if provided with adequate funding, community control and participation by the poor can be a viable strategy toward raising people's consciousness through collective solutions to these problems. Vice versa, international agencies such as those in the United Nations system can also be used to exert greater pressure in the areas of basic needs, land reform, technology, and women's work and employment, as well as in national and international systems of data collection and planning.

Short run strategies must of necessity provide ways of responding to current crises, while building experience toward the longer vision. In the area of food production we advocate a shift toward policy packages that promote a more diversified agricultural base, leading to a safer long-term balance between export and food/subsistence crops. Women's expertise in food gathering and food production as well as in marketing and processing must be reinforced. Even as they have been moving into cash crop production or off-farm activities, most rural women have retained a toehold in this sector, especially in Africa. In the current crisis, policies should mobilize women's experience and skills. Toward this end governments should ease restrictions and pressures on women petty traders and vendors, while increasing the availability of credit for the the self-employed women in this group.

An additional challenge is in the area of poor women's employment and income earning in agro-related activities, many of which have been severely eroded by mechanization. The major agricultural research institutes at the national and international levels should be turning their attention to technologies that will reduce drudgery without reducing employment. Women's organizations have been active in the area of appropriate technology in food processing and storage, water provision, and fuel, and these experiences can be utilized. We also need to redress the relative exclusion of women agricultural labourers from farm labour unions, which helps perpetuate lower wages and greater seasonality in their employment. Where food-for-work or employment guarantee schemes have been launched in rural areas, they have in some cases been used to provide cheap labour to large farmers at government expense. Such schemes should be strictly used to create employment in, for example, tree planting for

local fuel, housing construction, water provision, and similar areas that will improve the basic needs of the local poor.

In the industrial sector, organization of workers in traditional industries (many of which tend to be female-dominated) is as necessary as in export industries and free trade zones. The problems of wage workers in this sector are somewhat different from those of self-employed women in the so-called "informal" sector. In petty trade and services women suffer particularly from police harassment, lack of credit, access to markets, and obstacles in obtaining licenses. Yet the informal sector is much larger than the "formal" in most countries, and more important, is more likely to be meeting the consumption requirements of the poor in urban and rural areas. Support for this sector and for women within it will pay off by helping them to meet the need for cheap basic goods and services in the current crisis.

It should be clear from our discussion that we do not expect the strategies suggested above to be implemented without sustained and systematic efforts by women's organizations and likeminded groups. Thus *political* mobilization, *legal* changes, *consciousness raising*, and *popular education* are core activities in the process we envisage. These have of course constituted a significant part of our efforts during the past years. Now we must draw together to consolidate and learn from our experiences and their diverse sucesses and failures. At the *global level*, a movement of women and the oppressed can mobilize support for the common goals of a more just and equitable international order, and for disarmament. A global network of likeminded women's organizations committed to these goals could exchange experiences and information, suggest action and provide support. We also need research programmes on those issues which can be best analyzed from a transnational or cross-cultural perspective for example, the links between gender subordination and global conservation measures, reform of the international monetary system and the IMF, and demilitarization.

In addition to global actions and programmes, involved non-governmental and women's organizations, politically active women's groups, and worker organizations can coordinate common action programmes at the *regional* and *sub-regional levels*. This is particularly important in supporting women in countries that are politically repressive or in which the state has attacked women's social and economic status. The initiation of projects on problems common to the region and the development of regional training and research insitutions can be useful steps in this direction. Such activities have grown in number and significance toward the latter part of the Decade.

In building movements at the *national level*, it is essential for us to develop a methodology for political action and political support to women's issues as they emerge, both on general questions and in a particular context. For this, coalitions and alliances (possibly cutting across different women's organizations and political affiliations) can help us to build a broad-based local and national movement. This too is essential in countries with repressive political climates. In some countries where class-based organizations are severely restricted, women's organizations may have

some flexibility for action; in others the reverse is true. A broad-based movement, including mixed organizations across gender and class, may offer the most viable route for fundamental change in many situations. A resource base of women activists can work toward the dissemination and acceptance of a common programme or ideology by other political and socially conscious organizations. Organizations of women and poor men to implement specific programmes and to work as pressure groups have already demonstrated their potential. Mobilization around specific laws and civil codes may also be required to complement these strategies. Here women's organizations can draw on the support of other socially conscious groups, and in return, provide support in struggles around civil liberties, political repression, and abuse.

The level of awareness about women's subordination has to be raised through popular culture, the media, and formal and informal education. Unfortunately, such activity is all too often seen as secondary or unrelated to the activities of politically-oriented organizations. But if we are ever to progress beyond peripheral projects and schemes for women, we need much more attention to consciousness-raising. Governments must be pressured to give us a greater voice in radio, T.V., film, and other mass media, and to generate more funding for such programmes. The role of women's studies in this process is important. We already know that research into our history, networking among scholars, and curriculum development are vital aids to raising our own consciousness, as well as that of men. But women's studies in the Third World cannot stay in the academy. Because large segments of our people are still illiterate or unused to the printed word (and this is even more true for women than for men), we need to concentrate on techniques for popular and mass education. This is where the methods learned in the "pedagogy of the oppressed" can be useful, and where local organizations can again play a crucial role. We must also educate lower-level planners and functionaries as well as activists, and make inroads into formal education. All this is essential if feminism and women's liberation are to be understood as relevant to the progress of all sections of the poor and oppressed in society.

Empowering Ourselves Through Organizations: Types and Methods

Because women's organizations are central to these strategies, a more thorough examination of methods for their empowerment is necessary. Not only must they strengthen their organizational capacity, but they must crystallize visions and perspectives that will move them beyond their present situation. The strategic role of these organizations and networks can be seen from two perspectives. Developing the political will for the major changes needed in most societies requires organizations that have the strength to push for those changes, and the mass potential of women's networks in

this area is great. Second, the particular perspective of poor women gives centrality to the fulfillment of basic survival needs as *the* priority issue; they are therefore the most committed, militant, and energetic actors once avenues for action emerge.

What methods for the empowerment of individual women and organizations can catalyze strategies and build movements for social change consonant with our vision? It is important to draw on existing organizational strengths while working out ways to overcome weaknesses and conflicts. Although many organizations suffer from class or other biases, we feel it is worthwhile to assess whether such biases can be overcome, and if not, whether there are particular issues or programmes on which organizations of poor women can work with other groups.

Empowerment of organizations, individuals and movements has certain requisites. These include resources (finance, knowledge, technology), skills training, and leadership formation on the one side; and democractic processes, dialogue, participation in policy and decision making, and techniques for conflict resolution on the other. Flexibility of membership requirements can also be helpful, especially to poor working women whose time commitments and work burdens are already severe. Within organizations, open and democratic processes are essential in empowering women to withstand the social and family pressures that result from their participation. Thus the long-term viability of the organization, and the growing autonomy and control by poor women over their lives, are linked through the organization's own internal processes of shared responsibility and decision making.

Since different types of organizations have different histories, weaknesses, and potential, we try below to spell out some of these differences in order to engender further debate. Our classification does not pretend to be exhaustive. Nor is it done from the usual viewpoint of donor agencies that wish to know which groups are the most suited to receive funding. It is done rather from the desire to build and strengthen our own movements and networks, that is, from the perspective of empowerment.

First, there are the major, traditional, service oriented women's organizations that are of long standing in many countries. While such organizations have sometimes been criticized for having a "welfarist" approach, they have performed valuable functions in the areas of women's education, health, and related services. In the Third World context, such organizations sometimes arose within a context of generalized social reform movements or nationalist struggles. At the time they often represented the only major avenue for raising issues concerning women. We need to learn more about their histories in the face of struggle, and how they were able to grow. Such organizations usually have significant resources and access to policy makers, formal structures of decision-making and power, membership drawn from different sectors of society, and systematic methods for transferring skills and building leadership.

They tend to have three major weaknesses. They often suffer from class biases in their membership and programmes so that their major efforts are directed at middle and upper class women, while poor women are treated in hierarchical and patronizing

ways. Their internal decision-making processes are usually top-down and allow little scope for participatory processes that empower all women, not a chosen few. And they often lack a clear perspective or even understanding of gender subordination or its links to other forms of social and economic oppression. Despite these flaws, we can learn a great deal from the ability of these organizations to raise women's issues in the public arena and marshal large-scale support for their agendas, often under adverse circumstances. Consciousness-raising in these organizations, especially those which direct their activities to poor women, can therefore have a worthwhile payoff.

A *second* major type of organization is that affiliated to a political party. The degree of importance of such organizations, their resource base, and their autonomy in raising issues for either debate or action varies considerably from country to country. Such organizations can raise issues related to organizing women workers within the context of parties that may already have considerable experience organizing peasants or male workers. Their problem is that they often find it difficult to address gender issues directly, even in this relatively familiar context, for fear of being labeled divisive to the struggles of workers or the poor. Thus, the question of autonomy is a key one for most such organizations. Some newer political parties, such as the Greens party in Germany, are more explicitly feminist both in orientation and internal structure.

A *third* type of potentially large organization is the worker-based organization.[172] This includes both formal trade unions of workers employed in the formal sector, and organizations of poor self-employed women, of which there are a growing number in the Third World. These two sub-types are themselves different in that the former contains examples of unions where women form the base, while most leadership positions are held by men; the latter groups have much better representation of poor women. The worker-based organization usually addresses issues of employment, incomes, working conditions, and availability of credit or marketing, and is more sensitive to such issues as childcare and the demands on women's time in the organization itself. Some of these organizations are explicitly aware of the character of women's subordination. But even those which do not overtly perceive themselves as feminist are conscious of the substantive issues of both gender and class as they affect poor women's lives. The experience and the potential of such organizations are encouraging, although their resource position may be weak, reflecting the poverty of their membership. Such organizations also tend to be very successful in empowering poor women in their own personal life situations.

A *fourth* type is the organizations that have mushroomed during the Decade as a result of the external flow of funds and interest. Many of these organizations have no previous organic history and little organizational or resource base independent of the project being implemented. Illustrations of this type of organization include the various handicraft or credit cooperatives set up by donor agencies. Some of these organizations match the structural weaknesses with a top-down approach, lack of understanding of the problems of poor women, and often class biases as well. Such organizations are

among the weakest of the different types of organizations considered here, though many of them have persisted through funding generated during the decade. Others, however, have been more successful in evolving participatory styles.

A *fifth* type of organization is the grassroots organization which may be related to a specific project. While similar in some respects to worker organizations, this category of groups does not engage directly in workplace issues. However, the problems they address are often economic in nature. Such groups may also focus on media, health, literacy, or violence. They often direct their work to poor and working women, provide various types of technical assistance to other groups, and engage in advocacy, legal struggles, and political action. Some of these groups are explicitly feminist in their orientation. Their weaknesses include an inadequate resource base and the fact that, in many instances, they tend to have a more middle-class, urban membership and perspective. But if their work with and among poor women can be strengthened, these groups have considerable potential.

The *sixth* organizational type is the research organizations that have been growing rapidly in the last few years. These include groups involved in participatory action (and policy) research, women's studies associations, and research networks. Such groups have considerable potential to influence public policy debates, evaluate the programmes of agencies and governments, inform and feed research into other types of women's organizations, and link research with action. These groups aim to eliminate the distinction between the researcher and the researched, so that research becomes a process of mutual education. They are also committed to using their findings to serve and empower the subjects of the research. Their flaw is that they sometimes exacerbate tensions between researchers and activists by using the results in individualistic ways without benefitting those researched. This, however, may sometimes be more a problem of the individual researchers than of the organizations to which they are linked, but the organizations themselves need to be aware of this problem. The challenge facing these groups is to develop structures and methods of accountability to both action organizations and the subjects of the research, perhaps through stronger policy linkages or direct services.

In addition to these six types of organizations, a large number of women's movements (encompassing individuals, organizations, and coalitions) have sprung up during the decade. These cover a multitude of issues and purposes but share a concern and identification with women's causes. Their overall strength derives from their flexibility and unity of purpose, while their weakness may stem from the lack of clear organizational structures (this can also be a source of strength in a repressive political situation). Such movements have come together around basic needs such as fuel and water, and in response to urban crises such as loss of services or inflation. They also focus on such issues as peace, opposition to violence against women, sex tourism and sexual exploitation, militarism and political represssion, racism, and fundamentalist religious forces opposed to women's rights. Many of these movements are large, mass-based,

non-violent in their methods, and extremely courageous in the actions undertaken. The tenacity and commitment of women in the peace encampments and in opposition to military dictatorships are well known. Such movements are dynamized by the issues, mass support, and energy of the activities of individuals, smaller groups, and coalitions that are involved in them. Between the organizations and the movements stand networks and coalitions, some of which are permanent and others more temporary. Their goals range from direct political action to exchanges of research and information.

The organizations described here have developed a range of methods for reaching marginalized women and have made significant contributions during the Decade. However, in order to move forward, it is necessary for us to experiment with creative approaches and to analyse the conflicts and issues that challenge our organizations. The first is that many (but not all) women's organizations have been wary of viewing large public policy issues as within their purview. Two distinct but related tendencies explain why groups have functioned outside this domain: on the one hand, feminism has concerned itself, among other things, with aspects of life that are only partially susceptible to institutional regulation. This is true not only in the domestic sphere but also (and this is particularly relevant in the Third World) in such spheres as the "informal" sector or clandestine economy. On the other hand, the marginalization of women's groups from public policy may also be due to the hitherto fragmentary character of our own vision, and our inability to articulate the links between development and equality.

The *second* problem arises in our search for non-hierarchical and non-formal organizational structures in a world increasingly formalized and hierarchical. In this context, we have not developed enduring and effective channels for acquiring representation. Frequently, a given organization does not clearly know who is a member. While this may be a useful tactic in confounding repressive regimes, it has made it difficult for us to establish clearly delineated relationships with complex and bureaucratized decision-making bodies and to successfully pressure them to implement policies in our interest.

A *third* set of problems occurs from women avoiding clear assignment of responsibilities or delegation of authority for fear of mirroring existing hierarchies or established power structures. Two difficulties derive from this stance. One is external: no one is authorized to speak for the women's movement, so that in trying to define public policies our voices are weakened. Another is internal: our groups are unstable largely because of inadequate resources, but also because of the total commitment (and resultant quick burnout) required of each person. If responsibilities are never defined, everyone is expected to do everything.

Why is it that many women have found it difficult to delegate organizational authority? Perhaps because our experience as women has shown that division of responsibility can be used as an instrument of subordination. Our mistrust must stimulate us, however, to devise innovative ways of sharing responsibilities so that we do not reinforce existing relationships of domination. And we must develop structures

which keep leaders accountable and responsive to the voices and needs of the membership at all levels of the organization.

A *fourth* difficulty arises when we try to build alliances. Women have had too long an experience of being used by governments, agencies, or organizations for purposes not in our interest or of our choosing. As a result we tend to look with suspicion upon any political force or body that is not of our own making. Even other women's groups in the same country sometimes come under attack. Especially given our vision of orienting ourselves to the mainstream of development activities and economic processes, we need to learn to ally ourselves more closely and effectively with other grassroots organizations without jeopardizing our autonomy or theirs. A process of dialogue and working on joint programmes is the only way to begin to build mutual respect for the strengths and capacities of each, and trust in each other's intentions.

A final issue is our ability and willingness to share power within our own organizations. Related to this is the question of our styles of conflict management and resolution. Such conflicts appear to come from two main sources: the first is genuine differences in strategies, issues, and evaluations of the organization's potential or internal biases; the second is that those with the dynamism, energy and genuine concern to start organizations are often afraid that others less well-motivated and more prone to personal aggrandizement will seize control over organizations built up with great effort. These fears are well-founded in some instances; they are compounded by the inflow of funds from international agencies that makes the takeover of organizations and their resources more tempting.

Experience tells us that there are two consistent ways of checking such tendencies. First, democratization of organizations and widening of their membership base is essential since it distributes power and diffuses hierarchy. Second, explicit assertion and commitment to an ethic that rejects personal aggrandizement, and a firm stance in that direction should be built into the organization from the beginning. We in the women's movement need to show by example that it is possible to bring these ethics to the centre of public life. Our own life experiences of powerlessness, cooperation, and nurturance can be enriching to our organizations, and to the world in which they function.

We do not claim to know all the answers to the problems, nor that there are unique solutions to them. In fact, we would assert that the solutions have to be worked out at the local level by the groups themselves. It is also important to recognize the cultural specificity of research methods and, especially, action. These depend on the social and cultural characteristics of regions and groups, though in general, women's groups appear more likely to be nonviolent and concerned about hierarchy and democratic processes. We need a great deal more self-understanding and dialogue about our own methods, problems, and successes in building organizations and managing power during the Decade, so that we can move ahead. Respect for the many voices of our movement, for their cross-fertilizing potential, for the power of dialogue, for the humility to learn from the experiences of others are crucial to our vision.

In many ways this book is the product of just such an ongoing process. Women from all over the globe and from many activities and professions have given unstintingly of their knowledge and experience through discussions, comments, criticisms, and suggestions. The process was always supportive even when it was critical or challenging. This speaks volumes for what we have learned is our most precious asset: the rich diversity of our experiences, understandings, and ideologies combined with a growing recognition that we cannot propose a social/political/economic programme for women alone, but that we need to develop one *for society from women's perspectives*. Thus, although the Decade that proclaimed so bravely "Development, Equality, Peace" has given so little of these to the majority of people, what we have learned in its course has already empowered us for the long haul ahead.

Footnotes

1 See *Development Dialogue* (1982), special issue, "Another Development with Women," for the proceedings of a symposium devoted to this theme, Jain, D. (1983), and Beneria and Sen (1981).

2 For similar perspectives on feminism, see the AAWORD Newsletter, *Feminism in Africa*, vol. II/III (1985), published by the Association of African Women for Research and Development; and *Bringing the Global Home, Feminism in the '80s—Book III* by Charlotte Bunch.

3 By now it should be clear that we use the term "Third World" as a positive self-affirmation based on our struggles against the multiple oppressions of nation, gender, class, and ethnicity.

4[a] See the "Report of the International Workshop on Feminist Ideology and Structures in the First Half of the Decade for Women," Bangkok, Thailand, June 1979, and "Report of the International Feminist Workshop" held at Stony Point, New York, April 1980.

4 We have the example of the U.S. where the gains made by the women's movement for equality in the 1970s left the core of the economic inequity untouched; in fact many of these gains were rolled back in the economic and political crunch of the 1980s, even though major changes in consciousness have occurred.

5 See El Saadawi (1980).

6 See Sen in RRPE (1984).

7 See Beneria (1982) and a number of the working papers and publications of the ILO's Rural Employment Programme as well as the Institute of Development Studies, Sussex.

8 See documents A/CONF.94/1–30 of the World Conference for the U.N. Decade for Women, 1980 and A/CONF.116/PC/21 of same, 1985, as well as Sivard (1985).

9 The writings emanating from the structuralist and dependency schools in Latin America, and from UNCTAD offer the best examples.

10 See Baran (1959) for a now classic statement of this argument.

11 See Chaudhuri (1982) and Palmer and Parsons (1977) for a few examples.

12 See Etienne and Leacock (1980) and Beneria and Sen (1981).

13 Boserup (1970) discusses the impact of colonialism in Chapter 3.

14 See Gonzalez (1984). The connections between gender subordination, racism, ethnic, and caste oppression in the Third World need to be studied more closely. There is a serious gap in research in this area.

People or Population: Towards a New Ecology of Reproduction

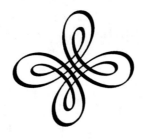

Maria Mies and Vandana Shiva

Population, Environment and People

Some years ago the continuing and increasing poverty in the countries of the South was attributed to the population explosion. Since the appearance of *The Limits to Growth*[1] population growth is seen increasingly as the main cause of environmental deterioration on a global scale. This assumed causal connection between the rising numbers of people and the destruction of the earth's ecological foundations was strongly emphasized in the political discourse around the June 1992 Earth

Summit (UNCED) in Rio de Janeiro. Arguments supporting this view were propagated worldwide by the media, and more and more outright cynical and inhuman population control policies were proposed, including coercive contraceptive technologies for women and denial of basic health care for children, for example in a proposal by Maurice King in 1990.[2]

That industrialization, technological progress and the affluent life-style of the developed nations have precipitated the acceleration of environmental degradation worldwide can no longer be ignored. The main threats are: 1) degradation of land (for example, desertification, salination, loss of arable land); 2) deforestation, mainly of tropical forests; 3) climate change, due to the destruction of the ozone layer; and 4) global warming, due mainly to increasing rates of carbon dioxide and other gaseous emissions. But instead of looking into the root causes of these threats which it is feared are approaching catastrophic threshholds, they are today almost universally attributed to a single cause: population growth. Not only the affluent North and dominant political and economic interests but UN organizations also subscribe to this view. Thus the United Nations Fund for Population Action (UNFPA), in its latest report, The State of World Population 1990 states:

> For any given type of technology, for any given level of consumption or waste, for any given level of poverty or inequality, the more people there are the greater the impact on the environment.[3]

In the affluent North there is a decline in the birth-rate, but this is balanced by immigrations; the culprits are seen as people living in the poor countries of the South. No less than 95 per cent of global population growth over the next thirty-five years will be in the developing countries of Africa, Asia and Latin America.

World population is growing at a rate of three people per second—or a quarter of a million people per day. This is faster than at any time in history. The most rapid growth is in developing countries. But will the earth's damaged environment be able to sustain such numbers in the 1990s and beyond? No account is taken of the exploitative and colonial world system, of the prevailing development paradigm or of the wasteful production and consumption patterns of the industrialized societies which are responsible for most of the environmental destruction, as, in fact, is admitted in the UNFPA report:

> By far the largest share of the resources used, and waste created, is currently the responsibility of the 'top billion' people, those in the industrialized countries. These are the countries overwhelmingly responsible for the damage to the ozone layer and acidification, as well as for roughly two-thirds of global warming.[4]

Despite these insights, however, the main policy to stem these threatening trends is to halt population growth. This means that it is not the rich, who have caused the problems, who must take action, but the poor, in the exploited countries of the South.

Arguments to support this Malthusian logic are usually based on statistical projections, which in turn are based on the assumption that the social and economic model of the industrialized North, the growth model, will eventually be followed by all people living in the South. Such arguments are always introduced by such phrases as: If present trends continue . . . If the pattern of the past is repeated . . . one example is the projection with regard to the growth of car production:

> As incomes grow, lifestyles and technologies will come to resemble those of Europe, North America or Japan . . . There will be an increase in car ownership. Since 1950 the human population has doubled, but the car population [sic] has increased seven times. The world car fleet is projected to grow from present 400 million to 700 million over the next twenty years—twice as fast as the human population.

After such a statement it might be expected that a reduction in the North's rate of car production would follow, but instead we read: 'If past trends continue, developing countries will be emitting 16.6 billion tonnes of carbon annually by 2025, over four times as much as the developed countries today.'[5]

The real threat, therefore, is considered to be that a growing world population would emulate the life-style of the average person in the North, with as many cars, TVs, refrigerators, and so on. While it is recognized that the generalization of this life-style would be catastrophic for nature, the North's industry, economy and its consumers and politicians know of no other way to support this life-style than that of the permanent proliferation of cars and so on. The 'car population' must grow, but in order to curb the environmental damage this causes, the South's human population (those who will not buy cars) must decrease. This is the industrial system's real dilemma. It does not want to abandon its growth therefore it lays the blame for the damage it causes on its victims: the South's poor, particularly the women who produce too many children. This becomes clear from a reading of UNFPA's 1990 report which targets these women as in need of family planning techniques and as mainly responsible for degrading the environment.

In patriarchal society women are responsible for the production and maintenance of everyday life, of subsistence, for water, fuel, food and fodder as well as for land preservation. But with more 'development' and more modernization propagated by the North they are pushed ever-closer to the margins of their life-sustaining systems. They are accused of destroying the forests in search of fuel, polluting and exhausting water sources in search of drinking water, and exhausting the land resources by producing too many additional mouths to feed.

All the methods proposed in the UNFPA Report to curb over-population are directed towards women. The responsibility of men, and their cult of machismo, for the large number of births is mentioned only en passant. It is stated that most women in the South want fewer children, but the men are not addressed when it comes to contraceptive methods. It seems to be feared that to directly attack and attempt to change

patriarchal culture would probably be interpreted as interference and the imposition of cultural imperialism by the North: if any UN organization attacked patriarchal culture in respect of sexual relations this would probably lead to political reactions. Instead, a policy of raising women's status is propounded.

This policy consists mainly of demanding the promotion of women's education, health, and income-earning capacities. Better-educated women, it is assumed, will practise family planning, as various examples show. But education is usually seen in isolation and its relations to class, to rural or urban backgrounds and other circumstances are ignored. Education alone has not solved the problem of poverty for many women, nor the problem of an insurance in old age, which is one reason why people in the South continue to have large families. In the absence of a social security system children are the only old-age insurance. The policy of family planning is always propagated by the argument that a small family is a happy family. But the UNFPA or other population control agencies have never asked whether in fact reducing the number of children in a family has made them happier or more prosperous. We can read only that the gap between the South's rich and poor is widening. As the world's political leaders dare not openly oppose the system based on permanent growth and demand drastically reduced consumption patterns in the North, the solution is increasingly seen in kind of lifeboat or triage philosophy. This philosophy is even promulgated by local family-planning workers in Bangladesh.

> You see, there are only nine cabins in the steamer launch which comes from Dhaka to Pathuakhali [a Bangladeshi village]. In the nine cabins only 18 people can travel. The ticket is expensive, so only the rich people travel in the cabins. The rest of the common passengers travel in the deck. The latrine facility is only provided for the cabin passengers. But sometimes cabin passengers allow them to use the latrine because they are afraid that if the poor deck passengers get angry then they might go down and make a hole in the launch. Then the launch will sink: they will die no doubt but the rich cabin passengers will not survive either. So, my dear sisters, do not give birth to more children as they cause a problem for the cabin passengers.[6]

The North's 'cabin passengers' fear of the South's population explosion is shared by the South's affluent middle-classes. Population control policy mobilizes these imperialist and class fears.

Discourses on population and poverty and on population and environment are permeated by several fundamental anomalies inherent in capitalist industrial society. These are the assumed contradictions between people and the environment, the individual and society, production and reproduction, and sexuality and procreation. For capitalist philosophy the basic economic unit is the isolated individual with his/her egotistic and aggressive self-interest, which is perceived as fundamentally antagonistic to that of other such self-interested individuals. Therefore, there is a conflict of interests between the individual and the community which, according to the Hobbesian concept of man and society, can only be solved by an all-powerful state. Adam Smith tried to

solve this dilemma by his famous 'invisible hand', which means allowing aggressive competition between these self-interested egotistic individuals for their economic gains, which eventually would result in optimal wealth for all.

Already underlying this concept of the human being and society is a statistical view or a 'political arithmetic', first developed by William Petty in 1690. Quantifying society, people and their relationship to nature (today one would say resources), became necessary for rising capitalism. Following Bacon, Petty saw a parallel between the 'body natural' and the 'body politic' and he tried to demonstrate that the wealth and power of the state depends on the number and character of its subjects.[7]

According to Barbara Duden, however, it was not before 1800 that statistics became the new language of all modern science, particularly economics, and that the term 'population' lost its tie to actual people.[8]

Meanwhile, actual living persons, real people, real communities, their history, culture and diversity have vanished behind the abstraction of aggregate numbers, expressed in population figures, growth rates, pressures and policies. The term population can refer, as Barbara Duden writes, as much to 'mosquitoes as to humans'.[9] This concept of population that transforms living people into mere numbers makes possible, as we have noted, even for a UN document to compare the growth of the 'car-population' with that of the 'human population'.

But not only did people disappear when populations were identified as mainly responsible for underdevelopment, poverty and environmental destruction, but other, different anomalies emerged with the new capitalist population policies, namely: in the relationship between the sexual and reproductive behaviour of individuals and the well-being of the community; and between production and reproduction. In capitalist patriarchy's liberal philosophy the sexual behaviour of individuals is assumed to be determined by natural laws expressed as biological drives, whereby, as in the case of economic self-interest, people simply follow their egotistic pleasure-seeking, careless of the well-being of others or the community, and of the consequences of sexual activity for women. It is assumed that eventually this individual sexual self-interest, unless checked by external forces, technologies, the state and new contraceptive devices, will result in 'overpopulation'.

The same liberal philosophy is applied to justify not only the separation between sexuality and procreation but also to conceptualize an individual's sexual and reproductive activity as a purely individual affair, rather than as the expression of a social relation, interconnected with other social, economic and cultural spheres and relations. This is why many women put emphases only on women's individual reproductive rights, without demanding changes in the overall political and economic structures of the present world (dis)order. They see only the individual woman and the need to protect her reproductive freedom or 'choice'.[10] The population controllers, however, see women only as aggregated uteruses and prospective perpetrators of over-population. Both views stem from the same philosophy and both are based on abstractions which ignore the real social

relations through which people—real men and women—interact with themselves, with each other and with nature as producers and reproducers. The separation between production and reproduction facilitated by capitalist patriarchy is such that producers conceive of themselves as separate from and superior to the nature around and within them, and women as reproducers experience themselves as passive and alienated from their own bodies, their procreative capacities and from any subjectivity.

Feminists in the North subscribe to the people and population anomaly by their demand for 'control over our own body' and safe contraceptives, without asking who controls the production of contraceptives, for what purposes and within which political and economic framework. Women of the South, however, experience this anomaly in the fact that they are increasingly reduced to numbers, targets, wombs, tubes and other reproductive parts by the population controllers.

The aim in this chapter is to show that these apparent anomalies are not only based on false assumptions but also on a viewpoint that blames the planet's ills on victims, mainly poor women.

Who Carries Whom?

Maurice King, in his analysis of the 'Demographic Trap',[11] assumes that local population pressure is the only pressure on ecosystems, that there is a straightforward carrying capacity calculus for human societies as there is for non-human communities.

Most ecosystems in the Third World, however, do not merely carry local populations; they also carry the North's demands for industrial raw material and consumption. This demand on Third World resources means that the threshold for the support of local populations is lowered. In other words, what would be a sustainable population size on the basis of local production, consumption and life-style patterns becomes non-sustainable due to external resource-exploitation. The theoretical and conceptual challenge is to find the roots of non-sustainable use not only in visible local demand but also in the invisible, non-local resource demand; otherwise, the search for sustainable population will become an ideological war declared against the victims of environmental degradation in the Third World, without removing the real pressures on the environment inflicted by global economic systems.

The 'carrying capacity' in the case of human societies is not simply a matter of local population size and local biological support systems. It is a more complex relationship of populations in the North to populations and ecosystems in the South. The South's ecosystems (E) carry a double burden: supplying commodities and raw materials to the global market (G); and supporting the survival of local communities (L).

Reducing L, and ignoring G, cannot protect E. Moreover, most analyses of the relationship between population and the environment ignore non-local demand for resources, as does Garett Hardin in his seminal essay, 'Tragedy of the Commons'. What he

failed to notice about the degradation of the commons is that it is accelerated when the commons are enclosed, that is, when they stop being commons and become privatized.

Enclosure of the Commons separates people from resources; people are displaced and resources exploited for private profit. In England, enclosure of the commons forced peasants off the land in order to pasture sheep. 'Enclosures make fat beasts and lean people', 'Sheep eat men' were some of the sayings that characterized the consequences of the enclosure. 'Carrying capacity' had been problematized because the land was no longer available to support people but sheep, largely to provide wool for Britain's emerging textile industry. The disenfranchised people were turned into a resource, worth only the market price of their labour power. Displacement from land makes a necessity of growth in numbers.

But not all these poor peasants and craftsmen, driven from their land and robbed of the commons, were absorbed by the rising industry as free wage labourers. Many had to migrate to the new colonies in America and Canada or, for petty thefts and the like, were deported to Australia. After the violent clearing of people from the Scottish Highlands to make room for sheep, many Highlanders were forced to migrate to Canada to work as lumber jacks or were recruited into the British army to fight in the new colonies.

Similar processes—privatization of the commons, eviction of the rural poor—took place in the other industrializing countries of Europe, and its pauperized masses were exported to the colonies. After the mid-19th century there was a wave of mass migration of poor Europeans to North America, and to other colonies, such as Brazil and South Africa. A wave of out-migration after World War II was not, however, confined to the poor. It was this out-migration of Europe's poor (and the ambitious) rather than advances in medicine, the rise of general living standards and the invention of new contraceptives, which led to a demographic decline in Europe. The consequences of colonization and development projects in the Third World have been the same as the enclosure of commons in Britain and Europe.

Population growth is not a cause of the environmental crisis but one aspect of it, and both are related to resource alienation and destruction of livelihoods, first by colonialism and then continued by Northern-imposed models of maldevelopment. Until 1600 India's population was between 100 and 125 million: in 1880 it remained stable. Then it began to rise: 130 million in 1845; 175 million in 1855; 194 million in 1867; 255 million in 1871. The beginning of the 'population explosion' dove-tailed neatly with the expansion of British rule in India, when the people's resources, rights and livelihoods were confiscated.

What is also ignored in this 'carrying capacity' discourse is the history of colonial intervention into people's reproductive behaviour. This intervention was initially motivated, as in Europe, by the need for more disposable labour, labour freed from subsistence activities and forced to work productively on plantations, farms, roads, in mines and so on for the benefit of foreign capital. This policy vacillated between a

largely anti-natalist regime for slaves in most of the Caribbean, who were cheaper to purchase than to breed,[12] and a pro-natalist approach later implemented in South Africa—when the white farmers needed more labour. After the Herero rebellion South African women were punished if they aborted or used contraceptives. This pro-natalist policy was supported throughout the colonial period by Christian missionaries who everywhere campaigned against indigenous institutions, family forms and methods and sexual practices which, women in particular, had used for centuries to regulate their procreative potential to maintain a balance with the ecological limits of their region that provided their livelihood.

The focus on population as the cause of environmental destruction is erroneous at two levels: 1) it blames the victims—mainly women; and 2) by failing to address economic insecurity and by denying rights to survival, the current policy prescriptions avoid the real problem. False perceptions lead to false solutions. As a result, environmental degradation, poverty creation, and population growth continue unabated, despite the billions of dollars spent on population control programmes.

It might then well be more fruitful to directly address the roots of the problem: the exploitative world market syste which *produces* poverty. Giving people rights and access to resources so that they can generate sustainable livelihoods is the only solution to environmental destruction and the population growth that accompanies it.

False Assumptions, False Conclusions

The discourse on the prime responsibility of the 'population explosion' for environmental destruction is also erroneous in so far as it is based on a number of patriarchal and eurocentric assumptions and theories which, in the light of careful socio-historical analysis, are untenable.

The first of these is the well-known Malthusian 'population law', according to which population grows geometrically, while food production proceeds arithmetically. This 'law' is based on what demographers have later called the concept of 'natural fertility'; that is, unchecked, uncontrolled human fertility, with no recourse to contraception or birth control, implying a purely unconscious, biological process.

Such a concept can only mean that, after a certain stage, there will be neither enough space nor food to 'carry' the people. The discourse on the ecological carrying capacity of earth is based on this Malthusian logic. But it is also based on what we have called the myth of catching-up development. This means population growth is seen not only as a biological and statistical process, but implies that all people worldwide, now and in future, will aspire to and eventually attain the level of consumption now prevailing in the North and in the rich classes of the South.

The Malthusian logic underpinning most demographic analyses and population policies of such UN organizations as the UNFPA, and of the World Bank, the Popula-

tion Council and other national and international agencies, is augmented by the concept of 'natural fertility' employed by some demographers in regard to pre-modern, pre-industrial, traditional societies. When these demographers characterize the reproductive behaviour of modern, industrial society in Europe, USA and Japan they apply the concept of 'controlled fertility behaviour'. They assume that 'natural fertility behaviour' prevailed in all pre-industrial societies before the end of the 18th century, meaning that contraception was unknown in these societies, in and outside Europe. 'Natural fertility' was assumed to always have been high and generally stable, checked only by biological factors: diseases; epidemics; wars; low standards of living; and institutional constraints such as sex taboos.

In Europe, however, after what the demographers have called the period of transition in the 18th and 19th centuries, natural fertility is said to have been replaced by controlled fertility; mid-19th century high fertility rates gave way to lower ones in the 20th century. Increased population in 19th-century Europe is usually attributed to industrial progress: better medicines; improved hygiene and standards of living; lower mortality rates. Similar modernization technology, particularly in the field of medicine, has supposedly led to the South's population explosion, because it said to have checked epidemics and diseases, the so-called 'natural' controls on population growth. But whereas this sudden population growth in Europe was supposedly checked by the invention of modern contraceptives, and by education, particularly of women, with gainful employment and more consumer goods bought by the masses, the same did not happen in the South. (The fact that Europe exported its poor to the colonies is usually disregarded.) Since the mid-1970s, feminists and other scholars have challenged the assumptions of overall natural fertility in pre-modern societies and convincingly demonstrated that women, in particular, knew and practised methods of contraception and birth control before the invention of the pill.

In her history of birth control in America, Linda Gordon showed that as early as 1877, it existed long before modern contraceptives were invented:

> There is a prevalent myth in our technological society that birth control technology came to us with modern medicine. This is far from the truth, as modern medicine did almost nothing until the last twenty years to improve on birth control devices that were literally more than a millenium old.[13]

From ancient times, women almost everywhere have known of methods and techniques of birth control; men, too, were aware of practices that precluded conception. As Wacjman argues, modern contraceptives were developed with a view to population control rather than motivated by a desire to further women's self-determination.[14] Feminist historians have provided ample evidence that the so-called witches, who for several centuries were persecuted and brutally murdered in Europe, were in fact the wise-women, well-versed in medicine and midwifery, who knew many methods whereby women were enabled to balance the number of their children. Since the Renaissance

and the rise of mercantile capitalism, however, more people were needed as labourers. Therefore, theoreticians of the modern absolutist state, for example, Jean Bodin in France or Francis Bacon in Britain, were among those who accused these 'wise-women' of witchcraft because their contraceptive knowledge was an obstacle to their pronatalist population policy. With the annihilation of these women went the disappearance of their birth-control and other knowledge.[15] According to Heinsohn and Steiger, it was the systematic destruction of these women and their knowledge together with the modern capitalist states' deliberate pro-natalist population policy, which led to rapid population growth in 19th-century Europe, and not advances in medicine, hygiene and nutrition.[16]

This critical historical research has been barely noticed by modern demographers and the population control establishment. They continue to cling to their theory of natural fertility for so-called pre-modern societies and project their interpretation of European history on to these. There is scant effort to study these societies' actual social history relating to sexuality and procreative behaviour.

To give one example: B. F. Mussalam has shown that the theory that pre-modern societies were ignorant of methods of contraception is false even for medieval Islam, a society which supposedly is more strongly traditional and patriarchal than European society. In a detailed socio-historical analysis, Mussalam shows that birth control, particularly the method of *coitus interruptus* was not only permitted by the Koran and Islamic law but also widely practised in Islamic society. In addition, techniques, mainly barrier methods, were employed by women. The concept of natural fertility cannot, therefore, be upheld, even for medieval Islamic society,[17] any more that it can be upheld for pre-industrial Europe or for other traditional societies in the South.

Many more social historical studies on sexual and generative behaviour in different cultures are needed. What has to be explained is how and why, in many societies, colonial intervention led to the knowledge of traditional birth control methods falling into disuse, or destroyed in order to produce more labourers for the Empire. And why, after World War II, were modern contraceptives developed by transnational pharmaceutical corporations in order to fight overpopulation in the South. Unlike traditional methods, modern contraceptive technology is totally controlled by scientists, the profit interests of pharmaceutical corporations, and the state. These technologies are based on a perception of women as an assemblage of reproductive components, uteruses, ovaries, tubes.

Women as Wombs and Targets

The process whereby people become populations is to be understood not only as a mere epistemological change. In practice it meant and means a direct and usually co-

ercive intervention into people's lives—particularly women's, because they have been identified as responsible for population growth.

Following the quantitative and divisive logic of modern reductionist science and capitalist patriarchy, population controllers and developmentalists both conceptualize people as separated from their resource base and women as separated from their reproductive organs. The population control establishment, including the producers of contraceptive devices, the multinational pharmaceutical corporations, are not concerned with real women, but only with the control of some of their reproductive parts: their wombs, tubes, their hormones and so on.

In the process of developing ever-more effective technical fixes to depopulate the South,[18] women's dignity and integrity, their health and that of their children are of little concern. This accounts for the fact that most of the contraceptives produced for and introduced into the South have, and continue to have negative side-effects on women. Moreover, hormonal contraceptives (Depo-provera, Net-OEN, and the latest Norplant or RU 486) increasingly take away from women control over reproduction processes and put it into the hands of doctors and the pharmaceutical industry. The latest in this process of alienating women from their reproductive capacities is the research into anti-fertility vaccines.[19] Apart from these, sterilization, mainly of women, is seen as the most efficient method of population control.

Since the early 1970s, population control policies have been criticized as racist, sexist, imperialist and anti the poor. These critics are equally concerned about the health of nations and their people and raise some uncomfortable questions for which there are no easy answers. Why are population policies and research into fertility control supported by certain countries' defence wings and why do they see population growth as 'a security threat,' evoking their intervention through subtle coercion of national governments and through them of their people, which almost invariably happens to be women? If stringent population policy is truly an anti-poverty measure, why have those Latin American countries who have had 80 per cent of their women sterilized become poorer and more deprived than before? If the intention was a qualitatively better life, then fewer poor street children should have been killed in Brazil to supply the richer countries with a thriving organ trade, especially as Brazil's birth rate declined by 50 per cent in two decades, a feat that the North took several centuries to achieve.

Development at Whose Cost?

Structural adjustment programmes forced on country after debt-ridden country in the South will serve only to increase disparities and indebtedness in the long term. Horrifying statistics bear evidence of rising infant and maternal mortality, an increase in the number of street children and uncontrolled urbanization. Throughout

history, African, Asian or Latin American countries have suffered a brutal plunder of their peoples and natural resources in order to further the North's economies. Today, while an increase in population is held responsible for environmental degradation, the Sarawak forests are being cleared and their peoples made homeless in their own land, in order that Japan can have its supply of disposable chopsticks; Indonesian forests are being felled to make toilet paper and tissues; and Amazon forests are burnt down to create cattle ranches to provide beefburgers. The plunder of such countries continues under unjustifiable world trade practices, loan servicing terms, and unrealistic interest rates on debts. As poverty increases and concomitantly, social insecurity, the poor and the illiterate will tend to look for security in numbers, and national governments will have to apply increasingly coercive measures in order to comply with the population control conditions linked to foreign aid.

In 1951, with its first Five Year Plan, India was the first country to formulate a National Population Policy. Typically 'top down', it was centrally planned, financed and monitored, to be applied at state and local levels. Guided, formulated and designed by external agencies it was to be implemented by India's government and its employees. It did not need the Planning Commission's midterm evaluation report to assess the population policy a failure, as it became evident through statistics that it had not met people's needs. After the failure of the coercive sterilization campaign during the Emergency (1975–77) the programme's title changed from 'family planning' to 'family welfare', but the strategies and approaches in respect of women remained unchanged. Women were seen as ignorant, illiterate and stupid beings who wanted only to produce children—curbing their fertility was obviously needed. For those involved in health-care, Indian population control policies were a double tragedy: first, because they failed to understand and cater to women's contraceptive needs; and second, because they marginalized and eclipsed all other health-care work.

The current population control policy in the South has been criticized not only by people concerned about the exploitative and imperialist world order, but also by health workers and feminists, particularly in the South. Thus, regarding India's population which treats women not as human beings but as 'tubes, wombs and targets', Mira Shiva draws attention to the total lack of accountability that characterized the drive for women to undergo tubectomies, for which financial incentives are on offer not only for those who accept sterilization 'but also for the family planning workers'. In a social context where little change was attempted in other areas, coercion was the one stick seen as a means to beat the population growth rate. The costs borne by women were all too apparent in a violation of their dignity and a denial of their right to unbiased information, to safe and effective contraceptive care and to follow-up services to make the whole process accountable to those involved. 'The deterioration of the health status of women in several regions and a [skewed] sex ratio call for intervention in several areas, contraceptive needs being only one among several components of human

welfare.' Mira Shiva, a health activist, writes about the side effects of the various contraceptive devices tried out on Indian women, all advertised as safe and 100 per cent effective:

> Lippes Loop was first introduced into India following a strong advertising blitz announcing it as the wonder contraceptive for women. Again, when Dalkon Shield was introduced in the '60s, it was pronounced 'safe' until litigation in the U.S., following the death of seven women users, brought to light the intrauterine infections that had developed in thousands of women users across the world. In India, the problem is inevitably compounded by the fact that due to a lack of access to their own medical records, no compensation is possible even when women develop serious complications. Even if access was possible, the almost non-existent follow up would have nullified any gains made through a control over their own medical records.

The method of female sterilization by means of the costly imported laparoscope was seen as a revolutionary step in the Indian family planning programme. Yet, Indian doctors' callous use of this technology, citing with pride the number of sterilizations performed within the hour, caused it to fall into grave disrepute.

Curiously, long-acting injectable contraceptives are considered safe and effective for anaemic, malnourished and underweight Third World women, while in the North, recognition of the hazards of hormonal doses have led to minimizing their use in the contraceptive pill. Western women who use a hormonal contraceptive, do so on the basis of an 'informed' choice, adequate nutritional status and with access to follow-up, diagnosis and treatment. The average Indian or Bangladeshi woman would be denied all these advantages, and the significant menstrual blood loss recognized as a side-effect of long-acting hormonal contraceptives would be especially damaging for an already severely anaemic woman. Also, no assurances or 'pep' talks by health workers can camouflage the fact that prolonged menstruation is as culturally unacceptable as amenorrhea or an absence of menses. And there are other questions: what effect would hormones have on the foetus if they were administered to a woman who was unaware of her pregnancy? It is widely recognized that introduced hormones can negatively influence the growth of the foetus (teratogenic effect), therefore can this effect be non-existent or insignificant in the case of long-acting hormonal contraceptives? Fears have been raised on this score by health, women's and consumer groups of target chasing once again dominating the programme without adequate warning of side effects being made available to users. In the West, Thalidomide and Diethylstilbaestrol were considered safe for pregnant women. There was no realization that infants would be born without limbs as an effect of the former: or that the long-term effects of the latter would result in the development of breast and cervical cancer, and that even the next generation was found to be affected as young adult daughters developed vaginal cancers, and sons abnormalities in their testes.[20]

Population Control and Coercion

The population-environment discourse gave rise to panic in some quarters and nullified any ethical, humanistic opposition to an open policy of coercive interventions into people's reproductive behaviour. Such interventions, of course, are not new—India, during the (1975–77) Emergency, and Bangladesh have been subjected to them. Farida Akhter from Bangladesh is one of the most outspoken critics of this 'coercive depopulation policy'. In numerous speeches and articles she has shown convincingly that population control programmes were devised to serve the commercial interests of the multinational pharmaceutical companies; forced on the Bangladeshi people as a pre-condition for aid and credit; and that, increasingly, coercion is applied in the implementation of these programmes. Additionally, in Bangladesh, sterilization is performed without prior examination of the women; even pregnant women are sterilized. But the government, which is responsible for enforcing these programmes, has no programme to treat the resultant health problems that women experience. In India and in Bangladesh, women are used as guinea-pigs to test new hormonal contraceptives: Norplant was administered to 1,000 women in Bangladesh, none of whom were told that they were participating in a test sponsored by the Bangladesh Fertility Research Programme.[21]

Farida Akhter has also pointed out the contradiction between this coercive policy vis-à-vis the South and the marketing rhetoric of 'free-choice', and 'reproductive freedom' in respect of new contraceptives and reproductive technologies in the North. She shows how the population control establishment increasingly co-opts the slogans of the North's Reproductive Rights Movement to legitimize depopulating strategies in the South. She also criticizes those feminists of the North who emphasize individualistic 'rights' and seemingly forget that reproduction as well as production is integral to social relations. To isolate the individual sexual and reproductive behaviour from the social fabric can only be harmful to women, in the South and the North.[22]

A New Ecology of Reproduction

Our critique of an anti-human, anti-woman, anti-poor, racist, imperialist and coercive population control policy, however, does not imply that no one, particularly women, should have access to birth control and contraceptive methods. From an ecofeminist perspective it is essential that women be asked what they themselves want. In target-oriented, coercive population control programmes, poor women's views on family size are not sought.

Most poor women of the South are the objects of two forces which try to control their sexuality and procreative activity: 1) the patriarchal institutions, ideologies,

norms, attitudes, which deny a woman's sovereignty over her own body: and 2) the international population control establishment, for whom the women are only potential breeders whose reproductive capacities must be controlled. But in neither the North nor the South do these population control agencies dare openly criticize patriarchal institutions and attitudes.

An ecofeminist perspective, however, is not to look at reproduction in isolation, but to see it in the light of men-women relations, the sexual division of labour, sexual relations, and the overall economic, political and social situation, all of which, at present, are influenced by patriarchal and capitalist ideology and practice. Therefore a primary demand is that women regain greater autonomy with regard to their sexuality and procreative capacities.

This implies first, that women must begin to overcome the alienation from, and learn again to be one with, their bodies. This alienation, brought about by capitalist, patriarchal reproduction relations and technologies has affected women in the North more than poor women in the South. Poor, rural women in the South may still be knowledgeable in respect of their bodily cycles and evidence of fertility and infertility, but women in the North have virtually lost this intimate knowledge and instead increasingly depend on medical experts to tell them what is happening in their bodies. A new ecology of reproduction would mean that women reappropriate this 'fertility awareness', as Mira Sadgopal calls it[23] and realize that traditional as well as modern sources can show them the way. Secondly, men too, must begin to be educated in women's fertility awareness and to respect it, which implies a new, creative interaction of the procreative potential of women and men.

It is essential to bear in mind that the sexual relationship must also be understood as an ecological one, embedded in overall production relations. Unless these relationships are freed from exploitation and dominance, the oppressors, as well as the oppressed, will face ruinous consequences. Liberating sexual relationships from patriarchal dominance and exploitation is not solely a matter of contraceptive technology, but demands a change in attitudes/life-style, institutions, and the everyday conduct of men and women. Clearly the introduction of new contraceptive devices has not resulted in the expected fundamental change in sexual relationships, even in the North. Social change cannot be facilitated by technological fixes; neither can production relations, or the earth, be freed from exploitation and dominance by technology alone.

If men and women begin to understand sexual intercourse as a caring and loving interaction with nature, their own and their partners, then they will also be able to find birth control methods which do not harm women. Such a loving and caring relationship would lead to a new understanding of sexuality—not as a selfish, aggressive 'drive' but as the human capacity for relatedness to ourselves, to each other and, by implication, the earth and all its inhabitants.

Development of this new sexual and reproductive ecology is essential if women are to be enabled to maintain their human dignity; it is even more important for men who,

in militaristic, patriarchal society are taught to identify their sexuality with aggression. This aggression, however, is directed not only against their sexual partners, but also against themselves. To conquer the 'enemy', 'nature', women, other people, they must first learn to conquer themselves, which means they must reject and destroy in themselves the caring, loving, nurturing characteristics that are generally attributed to women, and for which they are devalued.

This new understanding of non-patriarchal sexuality can develop only together with changes in the sexual division of labour, the economy and politics. Only when men begin seriously to share in caring for children, the old, the weak, and for nature, when they recognize that this life-preserving subsistence work is more important than work for cash, will they be able to develop a caring, responsible, erotic relationship to their partners, be they men or women.

Such relationships will enable the opposition between 'people' and 'population' to be resolved, thus: individuals' sexual and procreative activity need not be opposed to a community's need for a 'sustainable' number of children. We have shown that the concept of 'natural fertility' is a eurocentric, patriarchal myth propagated since the 18th century. Women, in particular, have always known methods and techniques of birth control and contraception. A new ecology of reproduction within the context of economic and political eco-regions will lead to new and/or rediscovered ways to ensure a balanced ratio of people to the environment, without coercive national or international intervention. From an ecofeminist perspective we demand the exclusion of state interference in the sphere of reproduction.

Footnotes

1. Meadows, et al, *The Limits to Growth*. Universe Books, New York, 1972.
2. King, Maurice: 'Health is a Sustainable State,' in *Lancet*, 15 September, 1990, abridged version in *Third World Resurgence*. No. 16, pp. 31–32.
3. Nafis Sadik (ed.) *The State of World Population* 1990. United Nations Population Fund (UNFPA), New York 1990, p. 10.
4. Ibid. pp. 1–2.
5. Ibid. p. 12.
6. Akhter, F., 'New Reasons to Depopulate the Third World,' in *Third World Resurgence*, No 16, pp. 21–23.
7. Duden, Barbara, 'Population,' in W. Sachs (ed), *Development Dictionary*. Zed Books, London 1992, p. 147.
8. Ibid.
9. Ibid., p. 148.

10. For a critique of this narrow and individualistic concept of 'reproductive rights' see F. Akhter. 'On the Question of Reproductive Right,' in Akhter, F. *Depopulating Bangladesh, Essays on the Politics of Fertility.* Narigrantha Prabartana, Dhaka, 1992, p. 33.
11. King, Maurice, *The Demographic Trap.*
12. Reddock, Rhoda, *A History of Women and Labour in Trinidad and Tobago.* Zed Books, London (forthcoming).
13. Gordon, Linda *Woman's Body, Woman's Right: A Social History of Birth Control in America.* Harmondsworth, Penguin, 1977 p. 25.
14. Wajcman, J. *Feminism Confronts Technology.* The Pennsylvania State University Press. Pennsylvania 1991, p. 76.
15. For a discussion of the witch-hunt and its impact on women see Mies, M. *Patriarchy and Accumulation on a World Scale: Women in the International Division of Labour.* Zed Books, London 1991.
16. Heinsohn G. and Steiger O. *Die Vernichtung der Weisen Frauen, Hexenverfolgung, Bevolkerungspolitik.* Marz-Verlag. Herbstein 1984.
17. Mussalam, B. F. *Sex and Society in Islam,* Cambridge University Press, Cambridge 1986.
18. Akhter, Farida, op. cit.
19. Dr Talwar in Bombay is one of the researchers who is working on the development of an anti-fertility vaccine. (See Video Documentary 'Something like a War' by Deepa Dhanraj and Abha Bhaiya.)
20. Vandana Shiva and Mira Shiva, 'Population and Environment: An Indian Perspective' in *Power, Population and the Environment: Women Speak.* WEED Foundation, Toronto 1992 (compiled by Gillian Philipps) pp. 43–51.
21. Akhter, F. op. cit. pp. 26–32.
22. Ibid., pp. 41–56.
23. Sadgopal, Mira, 'Fertility Awareness Education in the Context of Development Issues.' Paper presented at a Seminar on Women and Development, Pune University, 6 February 1992.

The Subsistence Economy

Veronika Bennholdt-Thomsen and Maria Mies

The History of the Subsistence Approach

My mother and the sow. Life has to go on.

For me, Maria Mies, the history of 'The Subsistence Perspective' started with my mother. The quest for the history of subsistence leads unavoidably to the recognition of the interconnectedness of one's own life history with the history of time. When I asked myself where to begin with this

retrospective, I remembered my mother and her sow. In honour of my mother, I would like to recount this story.

It was in February or March of the year 1945. The end of the war was approaching. My parents were peasants. Our village was close to the Western front in the Eifel. Five of my brothers were soldiers, somewhere in the East. Around this time the ragged and lice-ridden soldiers of the beaten German army returned from the West and were searching for a bit of warmth and something to eat from the peasants. Every evening, mother cooked a pot of milk soup and boiled a pot of potatoes in their jackets. Every night, soldiers sat around the table with us. People had given up hope. Most of the peasants butchered their cows and pigs; they did not bother to plough or to sow. Everybody was waiting for the end of the war without a thought beyond that end. At that time, my mother took the sow to the boar in the neighbouring village—pigs and the raising of piglets was women's work. It also was a source of revenue for them. The neighbours laughed at her and said she should slaughter the pig instead; did she not see that everything was coming to an end. My mother replied, 'Life goes on.' Perhaps she even said, 'Life has to go on!'

She took the sow to the boar. And at the end of May, after the war had ended, the sow had twelve piglets. Nobody had young pigs, calves, or foals. Since money had lost its value, mother traded her piglets for shoes, trousers, shirts and jackets for her five sons, who one after the other returned from the war. Life went on. But did it go on by itself? My mother didn't just sit down and say, 'Life will go on,' or, as a Christian peasant woman, 'The Lord will provide.' She knew that she had to act, that she had to cooperate with nature—so that life could continue. That is what she always said: life has to go on. That was her wish, her passion, which constituted her joy and her will for life.

My mother was not a feminist and she didn't know the word ecology, but she had recognised something which is today as urgently needed as daily bread, namely that we have to assume responsibility for life if we want it to continue. The increasing ecological catastrophies teach us that modern industrial society destroys, with its relentless pursuit of continuous growth of goods and money, the ability of nature to regenerate

(continued)

> herself, until she is totally exhausted. This applies to human life, particularly that of women and children, as well as to non-human nature. Women, women like my mother, have so far shouldered the responsibility in everyday life, particularly after wars and other catastrophies, that life should go on for their daughters, sons, husbands, and nature. They clean up after the wars that the men wage against nature and foreign peoples. The subsistence perspective, however, means for us feminists that we are concerned not only that life will continue after patriarchal wars, but that such wars should no longer occur.

How Did We Come to the Subsistence Perspective?

We, Veronika Bennholdt-Thomsen, Maria Mies and Claudia von Werlhof, became involved at the beginning of the seventies in the new women's movement. In our case, this happened against the background of many years' experience we had obtained in different countries of the South: in India, Costa Rica, San Salvador, Venezuela and Mexico. Thus from the very beginning we connected the 'women's question' with the 'Third World question'. In the process, we rediscovered Rosa Luxemburg's work on imperialism, and found there a plausible explanation of why capitalism requires, contrary to Marx's opinion, 'non-capitalistic classes', societies and milieux in order to start and maintain the 'extended reproduction of capital', that is to say, the accumulation of capital—the essence of capitalism (Luxemburg 1923: 15).

This simultaneous forceful conquering, acquisition and destruction of 'non-capitalistic economies'—the traditional subsistence economies—is not only the bloody pre-history of capitalism, of the 'original accumulation', as Marx supposed, but is still today the basic precondition for the ongoing accumulation of capital, what generally is called 'economic growth'. Rosa Luxemburg considered only the peasant–artisan and the natural or subsistence economies in the colonies as preconditions for capitalism. We, however, included in our analysis housework in the industrial core countries and the labour of peasants in the South and of marginalised people in the so-called informal sector—in the North as well as in the South (von Werlhof 1978).

The commonalities in such at first sight heterogeneous relations of production as the work of a middle-class housewife and mother in Germany and the work of a subsistence peasant woman in the Himalayas, or the work of a smallholder in Mexico, are as follows:

1. These producers are directly concerned with producing and maintaining food and life, and not with the acquisition of money in order to buy food to live.

2. These subsistence producers (men and women) do not live in a pre-capitalistic or non-capitalistic world—as Rosa Luxemburg still assumed; their work is exploited by capital not through wages but through their product, which is taken from them free of cost or very poorly paid for. Bennholdt-Thomsen calls this the subsumption of the market under capital (Bennholdt-Thomsen 1979). Many products of the Third World which today are displayed in the supermarkets of the North—such as orchids from Thailand, handicraft items from Mexico and India—stem from this kind of work. This means, in effect, that capitalism exploits more work and production relations than just wage labour relations. Capitalism is qualitatively different from what has so far been understood by Marxists as well as by liberals.

By including subsistence in the analysis of capitalism, it became possible to explain why in the highly developed industrial countries women's work is still of less value than that of men and why the hope of the Third World for 'catch-up development' is as little able to be fulfilled as the hope of women for equality.

During 1978 and 1979, we conducted empirical action research projects in order to find out if these early hypotheses would stand up to empirical tests. We did these on the peasant economy in Mexico (Bennholdt-Thomsen), among peasant women in India (Mies), and in Venezuela (von Werlhof). This research not only reinforced our assumption that women's subsistence work was the essential basis for the integration of these economies into the capitalist world market: we also discovered further dimensions of these relationships. Maria Mies discovered during her investigation of women in a home-based industry in India the process of *Hausfrauisierung* (housewifeisation), by which women's work under capitalism is universally made invisible and can for that reason be exploited limitlessly. This applies not only to 'housewives' in the narrow sense in the industrial countries but also to the work of the women who do home work, to farm labourers, peasants, small traders, and factory workers in the South (Mies 1982).

Several conferences on subsistence reproduction were held during the years 1978 and 1979 at the Centre for Development Studies at the University of Bielefeld. The conceptual framework for these conferences was largely provided by Veronika Bennholdt-Thomsen and Claudia von Werlhof. The approach, developed out of women's and Third World research, was now explicitly called 'the subsistence approach'. The theme of the conferences was subsistence reproduction in developing countries.

It became clear to us early on, after the analysis of peasant work in the Third World, that the exploitation of subsistence work, due to the latter's life-creating and life-maintaining character, is qualitatively different from that of wage labour. From this point of view the work of women and that of small peasants is conditioned by a similar logic. Their exploitation follows the example of the exploitation of nature as a resource which is allegedly free and inexhaustible. The means for the creation and maintenance of such an exploitative relationship is not the labour contract, as is the

case with the wage labourer, but violence, physical and structural violence. Natural resources are considered 'free goods' and are exploited and appropriated by the industrial system in the same way as life, created by women. This analysis was the key which opened up a new way of looking at not only the man–woman relationship but also the relations between humans and nature in the industrial system. There is not only a structural analogy between these two relationships but also a causal connection, the basis of which is the modern people–nature relationship. The division of labour by gender and between wage labour and house-work, public and private work, production and reproduction, was only possible through the *naturalisation* of one pole of this division of labour, namely of women. For that reason we have called nature, women, and the exploited countries of the Third World 'the colonies of the White Man'. Colonies are not subjected and exploited through agreement but by force. With this approach we linked the women's problem with the Third World problem as well as with the ecological movement, which had gained in significance during the seventies (Mies, Bennholdt-Thomsen and von Werlhof 1988).

At that time, the connection between the exploitation of women and the exploitation of nature became obvious to many women who were active in the anti-nuclear movement. It became impossible to ignore, particularly after Chernobyl (1986), not only that the total project of the modern industrial system—both in its capitalistic ans well as in its socialistic form—was based on the colonisation of nature, women, and de-developed peoples, but also that in this process nature herself—the basis of all life—was being destroyed (Gambaroff *et al.* 1986). The thesis of Rosa Luxemburg that the accumulation of capital not only exploits subsistence production but also destroys it, was again confirmed. In particular, the increasing concern with the ecological issue made it clear that the strategy of catch-up development is a dead-end street. According to this strategy, all societies would reproduce the economic path of the capitalist industrial countries, in order finally to achieve the production and consumption level that predominates in the rich countries. In the meantime it has become evident that such catch-up development is an economic and ecological impossibility for all people. This model cannot be generalised (Mies and Shiva 1993).

But this meant that the hope that further industrialisation could eliminate misery, hunger, social injustices, and also the exploitation of women, was definitely destroyed. Therefore it was necessary to search for a perspective of the liberation of nature, women, and the South that did not rest upon the continuation of the exploitative, colonising, industrial system and was not based on the strategy of 'catch-up development.'

In the early eighties it became evident that the industrial system continued to expand at the expense not only of the environment and the Third World; this particular expansion was driven by—among other factors—the new technology of microelectronics and the fundamental changes this brought about in the field of work which were leading to increasing unemployment. Unemployment particularly hit women. Because of that, in 1983 we organised a women's conference in Bielefeld with the theme

'The Future of Women's Work'. This conference was a reaction to a similarly titled congress held in Bielefeld the previous year, 'On the Future of Work', at which unpaid and poorly paid work performed by women was not even mentioned. Our subsistence approach was publicly presented for the first time during the 1983 conference, not only as a criticism of the dominant analyses of capitalism, but also as a necessary and possible perspective for women in the First as well as in the Third World and for all colonised peoples. Already we were predicting that the expanding 'housewifeisation' of work would also affect the men of the North.

Reception and Criticism

An indignant outcry arose when we emphasised that the subsistence perspective was, particularly for us in the industrialised countries and especially for us women, a perspective for the future, in contradistinction to the strategy of catch-up development. At the congress on 'Women and Ecology' held in Cologne in 1986—which had been organised by Green women—it suddenly became evident that women in the industrialised countries and middle-class women in the South are not only victims but also beneficiaries of the international exploitative system. It became clear that we have to relinquish this complicity if we want to dissociate ourselves from this system. We explained that we have to learn from the women and men in the Third World what a good life can be and that it is not totally dependent on international trade.

Several feminists rejected the suggestion not only that as well as recognising the connection between the exploitation of women, nature and the Third World and our consumer attitude in the First World, we should fight it through political action with the shopping bag, that is, with a movement against consumerism (Böttger 1987; Lenz 1988; Wichterich 1992). Later, when German feminists did occupy themselves at length with the subsistence approach and with ecofeminism, other criticisms came up. For some this approach was not sufficiently orthodox Marxist; for others, it contained too much of Marx, particularly in its concepts. Some so-called realists found it utopian, romanticising, ignorant of the ways of the world. Several dissertations were written, which reflect the split in the German women's movement between approval and rejection of industrial society as such, and therefore either lauded or tore apart the Bielefeld Approach, as it came to be called.

The following are some of the most commonly raised criticisms:

- The subsistence approach is not woman-friendly, because we women are again the first to be asked to forgo things. Women already have hardly any money (politicisation of consumption), (among others, Böttger 1987; Pinl 1993).
- You want us women to be the perpetual 'rubble women' (Trümmerfrauen)[1] of society (among others, Wichterich 1992).

- Your approach is moralistic. We are tired of such moralistic appeals. Morality has no place in the economy. At issue are interests. (Becker 1988; Klinger 1988; Schultz 1994; Wichterich 1992).

- What you say may be good for the Third World but not for us. We are used to a different standard of living. Why must women feel responsible for the whole world? (Klinger 1988).

- The subsistence approach reinforces the traditional female role, glorifies motherhood and childbearing. (Becker 1988; Pinl 1993).

- Your subsistence approach may be good for rich, middle-class women who can afford to buy organic food. What about the poor woman, the woman on social welfare or a student?

- We don't all want to go back to the farm in order to grow our own potatoes.

- Yours is almost 'blood and soil' ideology. (Ökolinx)[2]

- Your approach means regression (to the Stone Age, to the Middle Ages) but history does not go backwards.

- You are women Luddites!

- Something like that could be quite interesting for individuals and small groups, but it does not bother the capitalists. It does not lead to an overall change of the system. Your talk about limitation of consumption, for instance, remains a call to individuals and so far has remained powerless. (Pinl 1993, Wichterich 1992).

- And finally, this is not political. Subsistence has to be first politicised. A patchwork quilt of a thousand subsistence communes or eco-villages is not enough. Everybody would be totally occupied with securing their daily existence. (Spehr 1996).

We have the impression that many of our critics are scared by the fact that we do proceed logically from our criticism of capitalist patriarchy to an alternative perspective. On the contrary they passively expect that our problems will be solved through more regulation and equality politics within the framework of the existing welfare state, for instance through a guaranteed minimum income for all. They don't want to be continually reminded that others (nature, foreign women and men) will have to bear the costs for such a model. Most expect a solution of the ecological problems through an eco-tax. We will endeavour to find a reply to some of these questions in the following chapters.

Methodologically, we will adhere to the principles we had already formulated by the end of the seventies (Mies 1978; Bennhold-Thomsen 1979). That is to say, during the presentation of the subsistence perspective we will adhere to the 'view from below'. This is the only way that a subsistence perspective makes sense.

In the course of time this approach became well known in Germany among people who are beginning to search for a way out of the dead end of the industrial system. These are women and men of commune projects and the eco-village movement, anarchists,

women who so far have not considered themselves as feminists, but who are concerned about the future of life on earth and future generations, feminist theologians, people who are looking for a 'third way' between capitalism and socialism, eco-organisations in eastern Germany like the 'Grüne Liga', eco-educational institutions, community colleges, organic farmers, consumer–producer organisations, women and men in church organisations, the Third World movement, environmental, antigenetic engineering and anti-nuclear movements. In short, the subsistence approach which originated in the women's movement has by now gone far beyond these circles and is being discussed under different headings by many people.

The worldwide crises that began in the early nineties and involved also the rich countries of the North, and Germany where they caused a real panic, particularly after the euphoria over the collapse of socialism in Eastern Europe, certainly contributed to the broader and more positive reception of this approach. Suddenly it became clear to many people that the ground under the model called market economy is fragile and may crack at any time like a thin sheet of ice. Many say, 'It can't go on like this much longer'. Many are suddenly beginning to look for alternative ways, particularly in the face of the fact that our predictions of the early eighties are now confirmed and visible for all: namely that the time of full and protected employment is over, even in industrialised countries. We arrived at that conclusion from our study of the exploitation of women's work, of peasants, and of the Third World through capitalism. Today 'housewifeisation', that is, the flexibilisation of labour, has become reality for men also. More and more people are slowly realising that the old leftist union strategy, based upon the male 'normal wage labour relationship', no longer has a future when faced with global exploitation of 'housewifeised' flexibilised labour relations and the unimpeded advancing destruction of our natural basis for survival through the delusion of growth. But where is the alternative to this strategy? Where is a different vision?

The subsistence approach also had a broad impact in other countries. Some of our writings were first published in English. Several books were translated into English, Spanish, Japanese, Korean, Portuguese and French.

The Subsistence Perspective—A Path into the Open

In March 1987 Claudia von Werlhof, Irmgard Ehlers and Maria Mies organised a conference with the theme 'The Subsistence Perspective: A Path into the Open?' We invited to this conference women and men activists of the women's, peasants', Third World, and ecology movements in Germany, Asia and Latin America—people who agreed, in spite of all differences, that the current trend in development policy was a dead end, people who were looking for a way out, who fought against being 'developed' away from their subsistence basis into the 'modern age', like those presented by Helena Norberg-Hodge in the Ladakh project (Norberg-Hodge 1991).

Vandana Shiva spoke about the Chipko movement in the Himalayas where women in particular prevented so-called 'modern development' (in this case the cutting of their forests for among other things the production of sports equipment) by embracing the trees. Activists from Venezuela reported on their peasant movement and its struggle to reestablish subsistence farming. From Germany, women and men activists attended from the Socialist Self-Help Organisation in Cologne (SSK), an initiative that has existed since the student movement. This group has lived for years on the garbage of the rich society, and refuses to accept social handouts. Most of its members are people who haven't found a place in our society: escapees from psychiatric clinics, homeless youth, old people. Some members of the SSK suddenly realised during the conference that they had the same perspective as the people of the Ladakh project, the women in the Chipko movement and the peasants in Venezuela. This commonality was the concept of subsistence. One group of people did not want to be 'developed' into the modern industrial society; others wanted to get out of it.

What Is Subsistence?

The War Against Subsistence Since 1945

In the North and, since 1945, increasingly in the rest of the world, everything that is connected with the immediate creation and maintenance of life, and also everything that is not arranged through the production or consumption of commodities, has been devalued. This includes all activities whose object is self-provisioning, whether in the house, the garden, the workshop, on the land or in the stable. What doesn't cost or doesn't produce money is worthless. This devaluation of self-provisioning work cannot be understood, if measured only quantitatively. It indicates at the same time a degradation of and contempt for the person who still performs such work. 'Housework? what drudgery! Agricultural labour? Shame, peasants stink!' (See Chapter 3.)

This barrier of disgust, which today surrounds all unpaid, essential-for-life subsistence activities, has no relationship to the content of this work. Such activities are suddenly recognised as decent professions, not only for women but also for men, if they are carried out by industrialised waged labour, particularly if based on a labour contract. The present-day high esteem for wage labour obviously rests on the high evaluation of money and on its myth. Not the image of money as a simple medium of exchange or measure of value, but of the money that creates ever more money which then becomes the basis of life, security for life and the hope for progress, emancipation, culture and the 'good life'. *He/she who has no money, cannot live.* Most people in the industrial societies today believe this statement. The myth of money is connected with the myth of wage labour. *He/she who does not work for wages cannot live.*

If life depends, in a material and symbolic sense, on wage labour and the acquisition of money, a perspective that speaks of subsistence work as hope can only be regarded as romantic, as backward-looking, or even as the threat of death. How did this alienation between people and their work develop to the point that the most lifeless thing of all, money, is seen as the source of life and our own life-producing subsistence work is seen as the source of death?

Contempt for subsistence is not all that old. Most people of the industrialised countries, rural as well as urban, were in one way or another occupied with subsistence activities until after the Second World War. Small peasants were more or less self-sufficient and produced only in part for the market. Workers in the industrial cities often had small animals, a cow, a pig, a goat, chickens and a garden; women produced a variety of foodstuffs for their daily needs. Many consumer goods were not bought but traded, self-produced or bought second-hand. A well-functioning network of neighbourhood help existed as well as mutual aid, the values of the old peasant 'moral economy' which survived also in the cities.

On the one hand the subsistence orientation of wage labourers was necessary to supplement their low wages; on the other, it provided a piece of freedom, of self-determination and self-realisation, some joy, a piece of home in an alien and alienating industrial world. Subsistence work also maintained the community, even in the cities, because it relied on cooperation and mutual help.

According to Torry Dickinson, the subsistence orientation lasted until after the Second World War in the USA. Only after 1945 did the systematic and rigorous war against subsistence begin (Illich 1982). It was identical with the new paradigm of development. Under the New Deal, wage labourers in the north of the country received higher wages than they had ever before enjoyed. Subsequently, they abandoned their diverse subsistence activities because they were no longer worth their while. Simultaneously the consumer market expanded, now supplying cheaply what women and men had previously produced themselves.

> As the economy expanded, US-based business paid high wages to so-called skilled laborers, which served to further widen the domestic market. Between 1945 and 1970, development created images of a wage-labor monoculture, monolithic state and corporate power, insatiable consumerism, growing unions and secure wage pacts for men, with middle class housewives confined to private life. (Dickinson 1995 p. 168)

The consequence of this expansion of industrial production was a decline of subsistence:

> As large-scale production grew, traditional means of subsistence declined, particularly in urban areas. The cultivation of large vegetable gardens, raising chickens and goats, canning, and bread making occurred less frequently. Households purchased more food and non-food items and engaged less in 'producing' and transforming food for direct household consumption. (Dickinson 1995: 169)

Those of us older than fifty remember similar processes in Germany. We all learned to accept them as quasi-natural, necessary processes of 'development', 'progress', the 'development of productive forces', and 'modernisation'. We did not ask if it had to be that way (see Chapter 3). Only in the last few years, with the collapse of the wage labour monoculture due to high unemployment, have a few people in the North begun to realise that there could have been and could be a life before, during and after the wage labour system, and that this life would not be just disgusting, weary and burdensome. It is not a new, voluntaristic whim when we talk today of a subsistence perspective: it connects with a history which many of us still know. We want to free the subsistence orientation of the stigma that the discourse of progress has attached to it and that now sticks to it like pitch. We don't want to change the Pitch Mary of the fairytale totally into Gold Mary, but we do want to emphasise that it is us, the people, who create and maintain life, not money or capital. That is subsistence.

Ivan Illich stated as long ago as 1982 that the war against subsistence is the real war of capital, not the struggle against the unions and their wage demands. Only after people's capacity to subsist is destroyed, are they totally and unconditionally in the power of capital.

This war is a war not only to colonise subsistence work but also to colonise language, culture, food, education, thinking, images, symbols. Mono-labour, mono-language, mono-culture, mono-food, mono-thought, mono-medicine, mono-education are supposed to take the place of the manifold and diverse ways of subsistence. A subsistence perspective means resistance against mono-culturisation and putting an end to the war against subsistence.

The Concept of 'Subsistence'

We reflected a great deal about this concept. We know it is awkward, not easy and smooth. It demands explanation. But that is just right. Because we want to avoid it being immediately treated like small change, like so many of the new, meaningless, 'plastic' terms, which can so easily be coopted for totally opposite purposes. This has happened, for example, to the concept of 'sustainability'. We have decided to adhere to the term 'subsistence' for several reasons. Here are some of the most important ones.

● It expresses most inclusively all we expect of an alternative social orientation: freedom, happines, self-determination within the limits of necessity—not in some other world but here; furthermore persistence, stamina, willingness to resist, the view from below, a world of plenty. The concept of self-provisioning is, in our opinion, far too limiting because it refers only to the economical dimension. 'Subsistence' encompasses concepts like 'moral economy', a new way of life in all its dimensions: economy, culture, society, politics, language etcetera, dimensions which can no longer be separated from each other.

- For us, not only does the concept of 'subsistence' have a history, but it also expresses the historical connectedness that exists, through colonisation and development, between us in the industrial countries and the countries of the South. In both cases modern development happened and happens by means of war against subsistence. Today there comes to pass for the countries of the North what we have observed for years in the countries of the South.
- The term 'subsistence' is used in all modern languages and has the same meaning everywhere.
- Beyond the historical and geographic–political continuity, the concept expresses also the contradictory nature, the Janus face of this modern history, which is dependent on the perspective of the observer. For the men and women who profit from the war against subsistence, 'subsistence' spells backwardness, poverty, and drudgery. For the victims of this war it means security, the 'good life', freedom, autonomy, self-determination, preservation of the economic and ecological base, and cultural and biological diversity.
- The concept of 'subsistence' also expresses continuity with the nature within us and around us, and continuity between nature and history, the fact that dependence on the world of necessity is not to be seen as a misfortune and limitation, but as a good thing and a precondition for our happiness and freedom.
- The more the current crisis hits those who up to now have benefited from the war against subsistence, the more the attractiveness of the subsistence lifestyle will be rediscovered. The concept includes many things that are subsumed under headings such as regionalisation, local economy, self-sufficiency, new communes, alternative lifestyles, a caring economy, the living economy, the 'third way'.
- We adhere to the concept 'subsistence', because it offers a perspective, in particular for today.

We have emphasised for years not only that subsistence or production of life will not disappear as a result of modernisation, industrialisation and the consumer economy, but also that it is, on the contrary, the constant opposite as well as the basis of modern industrial society and of generalised commodity production. 'Without subsistence production, no commodity production: but without commodity production, definitely, subsistence production.' Until the beginning of the industrial age, subsistence production secured the life and survival of the people. If the people of the world had had to depend on generalised commodity production and universal wage labour, on the capitalist commodity market—which today is hailed as our saviour from poverty and underdevelopment—they would not have survived until today.

Inside the industrialised societies subsistence production is being continued, mainly in the form of unpaid housework. The reproduction of the workforce is guaranteed and kept cheap through unwaged housework. Therefore we defined subsistence production as follows:

Subsistence production or production of life includes all work that is expended in the creation, re-creation and maintenance of immediate life and which has no other purpose. Subsistence production therefore stands in contrast to commodity and surplus value production. For subsistence production the aim is 'life', for commodity production it is 'money', which 'produces' ever more money, or the accumulation of capital.

For this mode of production life is, so to speak, only a coincidental side-effect. It is typical of the capitalist industrial system that it declares everything that it wants to exploit free of charge to be part of nature, a natural resource. To this belongs the housework of women as well as the work of peasants in the Third World, but also the productivity of all of nature. (Mies 1983)

Originally we introduced the subsistence concept not only in order to be able to explain the exploitation of women's unpaid labour under capitalism, but also to find a way out of the dead end of industrial society with its ecologically unsustainable production and consumption patterns. Already twenty years ago, we saw that the utopia of scientific socialism, which presupposed the highest degree of development of the productive forces as the precondition for overcoming capitalism, was based on the same development model as capitalism (Ullrich 1979).

The concept of subsistence does not only have the negative connotations that are often attributed to it. On the contrary, as Erika Märke has shown, it means the 'attitude of independence', 'existence by one's own effort'. Märke enumerates three attributes of subsistence: (1) independence—in the sense of autonomy; (2) self-sufficiency in the sense of non-expansionism; (3) self-reliance, in the sense of cultural identity (Märke 1986: 138). This positive concept of subsistence is decisive for us when we speak of the need for a new social perspective.

We associate another image of the 'good life' with the concept of the 'subsistence perspective'. Recent developments and insights in the field of ecology have shown that the subsistence perspective is not only an approach to overcoming exploitation by capital, patriarchy and colonialism, the basic structures of the modern industrial system; it also constitutes a liberation of nature within us and around us from the self-destructive growth logic of capital.

The process of capital accumulation—the transformation of life (living work and nature) into commodities, money, and steadily increasing capital—is polarising and irreversible. In other words, money and capital can grow out of life, but no new life can grow out of capital and money. Life always has to be added to capital in order to make it palatable and bring it to life. Money that 'breeds' more money out of itself (as through interest) is a myth.

We call subsistence or life production that which has to be added to dead money/capital. If we truly want a future for ourselves and for nature of which we are part, life production has to be delinked from the production of capital. It has once again

to become the centre of our concerns. In other words, colonised and marginalised spheres of reality (nature, women, and children, etcetera) have to become the central focus of economic activity, and the earning of money has to become secondary and peripheral again.

The subsistence perspective is not only practically and theoretically necessary, it is also possible and it has already begun. It has started with those who do not want to be 'developed'. These are people who know they will have to pay the price for modernisation, but will never reap its benefits. They are the people of the Third World, women, indigenous peoples who fight for the continuation of their autonomous subsistence basis. In such movements this other concept of 'good life' is promoted which we describe as 'abundance', another synonym for subsistence.

But new reflections on a different concept of economy, other than the present dominating one, are also beginning in the industrial countries of the North. Not only are there thousands of initiatives for the founding of communes, eco-villages, self-governing enterprises, producer–consumer associations, self-help and communal projects in deindustrialised cities and regions. There are also systematic beginnings in the development of an economy other than that of global—and, we add, patriarchal—capitalism.

Naturally, not all these initiatives are to be equated with a broad and general rejection of the dominant capitalist production and consumption model or with a revolutionary movement. The old concept of revolution, that is, the mostly sudden, violent overthrow of state power and of social relations, does not fit our understanding of subsistence orientation. After so many failed or abrogated revolutions, we no longer have confidence in the power which comes out of the barrels of the guns of the international warriors.

The changes required for a subsistence approach do not presuppose a political avant-garde. Nor do they have to wait until the situation or the productive forces are 'ripe'. They can be started by every woman and every man here and now. But they do need a different perspective, a different vision.

Women in subsistence societies have no problem with the development of such a radically new perspective, but the women of the middle class, who consider the cage in which they are sitting a paradise, do have a problem. For that reason, we would now like to give voice to women of the South, who belong to the lowest level of the exploited, to express their analysis of the dominant economic system. Their vision of a different economy and society is far clearer than that of most feminist academicians in our countries.

Many women of the South no longer appreciate or accept the currently dominant economy. This was clearly expressed during a women's workshop in Rio de Janeiro in 1992. Women rubber tappers, fishers, nut gatherers, peasants, and coconut cutters, and women engaged in urban small trade conducted this workshop in connection with the UNCED conference in Rio de Janeiro. It had the theme 'With courage and competence: women in subsistence, in agriculture and gathering economies' (Viezzer 1992). In this

workshop women described their life and work. They analysed the economic and ecological consequences of the industrial model for themselves, for nature and for the future as well as for the women of the North.

After the women had listened to each other, they recognised what diversity and abundance nature was providing and what riches they themselves had created through their productive work. It was a wealth, however, of which the capitalist economy had totally robbed them. If they no longer exported this wealth to the rich countries and classes, if instead they traded among themselves, they would not only help and protect nature, but they all would be enabled to lead a full and happy life. At the end, after their stories, analyses, recommendations and role playing, they formulated the slogan '*Stop the capitalist economic model! Long live abundance!*'

Footnotes

1. After the Second World War the term 'Trümmerfrau' was used of the women who cleaned up the rubble in the ruins of the bombed German cities.
2. The expression 'blood and soil' (*Blut und Boden*) refers to a slogan of the national-socialists who considered race and land as the basis of the German people.

Globalisation and Subsistence

My Father, Professor Weizenbaum and the 'Black Hole'

Some years ago, the Trierer Initiative für angewandtes Denken (Initiative for Applied Thinking, Trier) organised a symposium to celebrate Karl Marx's 175th birthday (Marx was born in Trier). They invited several well-known professors and the keynote speaker was Josef Weizenbaum of the Massachusetts Institute of Technology (MIT). I, Maria Mies, was supposed to represent the 'feminist perspective' in this all-male circle. Josef Weizenbaum had converted from a computer specialist to one of the most prominent and radical critics of computers and particularly of artificial intelligence (AI). In his keynote he castigated the state of science in the USA. He not only refuted the common notion that computers had saved time, labour and money, he also said that computer science and technology had largely been financed by the US Defense Department. He stated, moreover, that today practically all research carried out in institutions like MIT is paid for by the Pentagon. He regretted that young scholars who were keen on their careers obviously had no problem with this state of affairs. Asked whether there was no opposition from students to this militarisation of science, Professor Weizenbaum said the curricula were such that students had no time for political activities.

He closed with the remark that the biggest problem of our time was no longer the threat of atomic annihilation but the population explosion. Scientists should devote all their efforts to curb population growth.

At the end of the symposium there was a panel discussion. The speakers had been asked to present their own perspectives on the future; and one by one these learned professors painted an absolutely bleak picture. I looked at the audience: all young people with worried faces. They had come on this Sunday morning to get some orientation from these famous speakers for their own future. But they only painted an apocalyptic

(continued)

picture of gloom and hopelessness. The gist of their presentations was that there was no alternative, that we could do nothing. I could not tolerate this pessimism any longer and said, 'Please, don't forget where we are. We are in Trier, in the midst of the ruins of what once was one of the capitals of the Roman empire. An empire whose collapse people then thought would mean the end of the world. But the world did not come to an end with the end of Rome. The plough of my father, a peasant in the Eifel, used to hit the stones of the Roman road that connected Trier with Cologne. On this road where the Roman legions had marched grass had grown, and now we grew our potatoes on that road.' I wanted to say that even the collapse of big empires does not mean the end of the world; rather, people then begin to understand what is important in life, namely our subsistence.

This was too much for Professor Weizenbaum. Angrily, he turned to me and said it was the utmost naïvety to believe that after the catastrophes that were imminent even a single blade of grass would still grow. It was irresponsible to think that life would simply go on. 'No, the only thing necessary now is to realise that there is just one big black hole in front of us. After that there is nothing, no hope.' After this he continued attacking me, the feminist: 'By the way, you women have not done anything to prevent those wars. You have not even organised a sex strike.'

That was enough for me. I replied that it was strange that he now blamed women for wars whereas the day before he had told us that the MIT was totally financed by the Pentagon and that one could do nothing against this militarisation of research. We women were fed up with this kind of male logic. We were also fed up to be the eternal *Trümmerfrauen*, ready to clean up the mess after each macho war and see to it that life goes on. After that, I stood up and went. I left the men sitting in front of their 'black holes' in their apocalyptic mood.

This episode taught me an important lesson, namely that there seems to be an interrelation between a mania for technological omnipotence and political impotence. Josef Weizenbaum is one of those prominent male scientists who, at the

end of their lives, are horrified when they look at themselves and their works, and when they realise that the God to whom they have devoted their whole life—scientific progress—is a Moloch who eats his children. Some of these men then convert from a Saul to a Paul. But they rarely give up the whole megalomania of the project of modern science. If they can't solve humanity's problems by almighty science and technology then at least the catastrophe has to be total and all-encompassing. Not even a single blade of grass is allowed to grow on the ruins of their deeds. When the big patriarchal project comes down with thunder and lightning then the whole world has to come to an end too. Its future and everything has to be sucked into an abyss of nothingness. Anyone who, in the face of such an apocalyptic scenario, still talks of life, potatoes, subsistence, hope, future, perspective, must be attacked as an enemy. Mania of omnipotence and of impotence are two sides of the same coin.

The image of my father behind the plough on the old Roman road stands for another philosophy, another logic. For most male—and also some female—scientists this subsistence logic is difficult to grasp. It is neither expressed in the slogan that 'life will go on by itself' (nature will regenerate herself, grass will grow by itself), nor by the attitude that we humans can control nature and repair all damage done by our master technology. The difference between a subsistence orientation and scientific omnipotence mania is the understanding that life neither simply regenerates itself, nor is it an invention of engineers; rather we, as natural beings, have to cooperate with nature if we want life to continue.

The 'Black Holes' of the Globalised Economy

After this episode, I discovered a number of 'black holes' in front of which people in the industrial world stand, feeling helpless and hopeless. Most of them are due to the globalisation of the economy. They have been visible since the beginning of the nineties. The phenomenon is particularly noticeable in Germany, where the euphoria after the breakdown of socialism in East Germany was soon followed by a deep sense of pessimism, in both the former East and the former West Germany. This was largely due to the dramatic rise of unemployment rates in the reunited Germany. They are the highest

since the Second World War. In January 1998 the official number of people unemployed was almost 5 million, a rate of 13 per cent (ÖTV Hintergrund, Info-Dienst für Vertrauensleute und Mandatsträger, June 1998, p. 14). The highest unemployment rate was observed in the former East Germany. In 1989 Chancellor Kohl had promised that East Germany would reach the economic standard of West Germany within three years, Since then the government has had to admit that this goal cannot be reached and that it will take at least twenty years to close the gap between West and East. Not only leading economists but also politicians say openly that the era of full employment is over for good, even in Germany. For young people, for women and for older people the prospect of finding secure long-term employment with sufficient income is drastically reduced. They must be happy if they find casual jobs, part-time employment or a job through the Employment Promotion Scheme (Arbeitsbeschaffungsmassnahmen—ABM).

Indeed, the black hole of decreasing waged work can be found in all the rich industrialised countries. It can be compared to Professor Weizenbaum's 'black hole': feelings of absolute impotence, hopelessness and lack of perspective had been preceded by fantasies of global power and omnipotence following the globalisation of the economy.

What Is 'Globalisation of the Economy'?

Although the globalisation of the economy is as old as capitalism, the modern use of this concept refers to the period that started around 1990. 'Globalisation' is part of neoliberal economic policy, which aims at abolishing protectionist rules, tariffs and regulations by means of which the free flow of goods, services and capital to all nooks and crannies of the world could be hampered by national governments. This policy has resulted in the integration of most national economies into one global market. This process has brought about a rapid qualitative change in the economy, in politics, in social life, a change that most people are not able to understand fully. Three phenomena made this rapid change possible: first, the long-term political strategy of those who wanted to replace post-1945 Keynesian economics by neoliberalism; second, the new communications technology; and third, the breakdown of socialism in Eastern Europe.

Tony Clarke and others have shown that the economic theory and policy followed from the end of the Second World War up to the end of the seventies in most industrialised countries did not disappear automatically but was systematically abolished by the think-tanks of the big transnational corporations (TNCs) (Clarke and Barlow 1997: 19ff.). Milton Friedman of the Chicago School of monetarists launched his attack on the Keynesian welfare state already in the 1970s. He advocated privatisation and the establishment of a 'free market place', unhampered by government intervention, regulation and protectionism. But this neoliberal theory was not put into practice until Pinochet's coup in Chile in 1973. Chile was the first country that carried out these economic 'reforms' under the conditions of a dictatorship. In the eighties Ms Thatcher in the UK and Mr Reagan in the USA followed the example of Chile. Then, with the beginning of the nineties,

neoliberal policy was universalised and stabilised by global treaties such as the General Agreement on Tariffs and Trade (GATT) which in 1995 was institutionalised in the World Trade Organisation (WTO). The latest effort to globalise and legitimise neoliberal dogma for all time is the Multilateral Agreement on Investment (MAI) (Clarke and Barlow 1997).

Through computer technology, the second promoter of globalisation, data can be transferred from one continent to another at the speed of light. Space and time fall into one. While employees of a TNC in Manhattan sleep, their colleagues in Hong Kong continue to work on the same task. Due to this speed of data transfer, the stock exchanges in New York or Frankfurt can realise profits by capitalising on differences between exchange rates that exist only for minutes. This example hints at two aspects of modern globalisation: (1) concentration of capital in fewer hands and the domination of TNCs, (2) the growing role of finance capital.

Today half the world's trade is carried out between financially interrelated TNCs, 90 per cent of which are based in the North, while the 100 mightiest among them dominate at all levels. Owing to the globalisation of the last few decades the national economies in particular of the seven most powerful nations—the G7 countries—have undergone definite changes. Visible transfers, that is, the trade in goods, have lost their importance *vis-à-vis* invisible transfers like banking, transport, insurances, tourism. Finance transactions play the most important role in this shift. In the USA, where this restructuring is most advanced, the proportion of the finance sector in GNP grew from 18 per cent in 1970 to 25 per cent in 1990. A large part of this increase comes from international finance transactions or speculations. Financial markets, which ought to be only the oil to lubricate world trade, have become independent markets. They can hardly be controlled by national authorities (Decornoy, *Le Monde Diplomatique*, 25 September 1996).

The breakdown of socialism has resulted in the G7 nations dividing the world up into their spheres of influence, where big capital can operate without any restrictions. This policy had started already after the Second World War when the World Bank and the International Monetary Fund (IMF) were created. Throughout their history, but particularly after 1989, the World Bank and the IMF have promoted the neoliberal policy of free trade and globalisation.

The end of East–West confrontation has led to a new trilateral structure of the world economy: the USA, the EU and Japan with their respective spheres of influence: Latin America, Africa and Asia. The core countries have only 12 per cent of the world's population, but 60 per cent of the world's production is concentrated in them and they control 51 per cent of military expenditure worldwide (SEF 1993/94).

It would be wrong, however, to believe, that economic globalisation is a new phenomenon. As Wallerstein (1974) pointed out, right from its beginning the capitalist economy has been a world system, based on colonialism and the marginalisation and exploitation of peripheral countries and agriculture. This colonial structure was and is the basis for what became known as 'free trade' in the eighteenth and nineteenth centuries. But this world structure was not only a historical phenomenon, without which

capitalism could not have established itself: due to its inner logic of permanent growth or accumulation capitalism *has to* strive towards universality and globalism. This means, as Marx observed, that this system is structurally condemned to encompass and transform all areas of the globe and of life. What is new today is simply the destruction of the illusion that the globalised economy would be the harbinger of universal equality, justice and welfare for everybody (Altvater and Mahnkopf 1996).

People in the South, who were the victims of this global system from its beginning, understood earlier than people in the North that the globalisation, deregulation and privatisation imposed on their governments by the World Bank and the IMF for the benefit of TNCs were a fraud. Therefore, in a number of countries in Asia and South America the new neoliberal regime was opposed by peasants, women and trade unions. In India large peasant movements fought against the GATT, against Trade Related Intellectual Property Rights (TRIPs), against TNCs like Pepsi-Cola, Kentucky Fried Chicken, Monsanto and Cargill who are keen to integrate Indian agriculture into the 'free' world market (Mies and Shiva 1993; Mies 1996c; Shiva 1996b).

One may ask why resistance against the neoliberal policy of globalisation was much stronger in the South than in the North. One reason is that the Northern welfare states are still, in spite of being under attack, in a position to provide a certain standard of social security to the unemployed and the growing number of the poor. Another reason is the illusions that are held about the nature of the 'market economy', namely, that in the long run it will create a 'level playing field' and that the wealth accumulated by the rich will eventually 'trickle down' to the poor. Those who have looked at this economic system from below, from the perspective of women, of children, of people in the colonised South and of nature, have developed a more comprehensive understanding of what capitalism really has been from its beginning. This understanding is corroborated today by the processes of globalisation worldwide. Before we take a closer look at the various 'black holes' in the globalised economy we want to present the main points of this analysis from below, as we developed it from the late 1970s on (Mies, Bennholdt-Thomsen and von Werlhof 1988).

Colonising Women, Nature and Foreign Peoples

It is usually assumed that progress is a linear, evolutionary process starting from a 'primitive', 'backward' stage and, driven by the development of science and technology, or in Marxist terms of 'productive forces', moving up and up in unlimited progression. In this Promethean project, however, the limits of this globe, of time, of space, of our human existence, are not respected. Within a limited world, aims like 'unlimited growth' can be realised only at the expense of others. Or: there cannot be progress of one part without regression of another part, there cannot be development of some without underdeveloping others. There cannot be wealth of some without impoverishing others.

Concepts like 'unlimited growth' or extended capital accumulation, therefore, necessarily imply that this growth (progress, development, wealth) is at the expense of some 'others', given the limits of our world. This means that 'progress', 'development', etcetera must be seen as polarising processes, following a dualistic worldview (Plumwood 1993).

Rosa Luxemburg has shown that capital accumulation presupposes the exploitation of ever more 'non-capitalist' milieux for the appropriation of more labour, more raw materials and more markets (Luxemburg 1923). We call these milieux colonies. Colonies were not only necessary to initiate the process of capital accumulation in what has been called the period of 'primitive accumulation' at the beginning of capitalism. They continue to be necessary even today to keep the growth mechanism going. Therefore we talk of the need for 'ongoing primitive accumulation and colonization' (Mies, Bennholdt-Thomsen and von Werlhof, 1988: 15–17).

Some Theses on Global Capitalism

1. There is no colonisation without violence. Whereas the relationship between the capitalist and the wage labourer is legally one of owners (the one of capital, the other of labour power) who enter a contract of exchange of equivalents, the relationship between colonisers and colonies is never based on a contract or an exchange of equivalents. It is enforced and stabilised by direct and structural violence. Hence, violence is still necessary to uphold a system of dominance oriented towards capital accumulation.

2. This violence is not gender-neutral; it is basically directed against women. It is usually been assumed that with modernisation, industrialisation and urbanisation patriarchy as a system of male dominance would disappear and make way for equality between men and women. Contrary to this assumption, it is our thesis that patriarchy not only has not disappeared in this process, which is identical with the spread of the modern capitalist world economy, but the ever-expanding process of capital accumulation is based on the maintenance or even re-creation of patriarchal or sexist man–woman relations, an asymmetric sexual division of labour within and outside the family, the definition of all women as dependent 'housewives' and the definition of all men as 'breadwinners'. This sexual division of labour is integrated with an international division of labour in which women are manipulated both as 'producer-housewives' and as 'consumer-housewives'.

3. With the global world system getting more and more into a crisis we can observe an increase of violence particularly against women, not only in the South but also in the North. As this violence is part and parcel of a political-economic system based on colonisation and limitless growth it cannot be overcome by a strategy aiming only at gender equality. Within a colonial context equality means catching up with the colonial masters, not doing away with colonialism. This is the reason why feminists cannot be satisfied with an 'equal opportunities' policy

but must strive to overcome all relationships of exploitation, oppression and colonisation necessary for the maintenance of global capitalist patriarchy (Plumwood 1993).

4. When in the late seventies we began to ask about the root causes of the ongoing oppression and exploitation of women, of the ongoing violence against women even in the rich, democratic, industrialised societies of the North, we rediscovered not only that patriarchy continued to exist as a social system but also that it is intrinsically linked to the capitalist system with its aim of ongoing growth of goods, services and capital. We realised that the secret of such ongoing economic growth was not, as is usually assumed, the intelligence of scientists and engineers who invent ever more labour-saving machines and thus make labour ever more 'productive' and by the same mechanism ever more redundant. Nor could permanent growth or accumulation be fully explained, as Marx had explained it, by the fact that the capitalists pay back to the workers only a share of the value they have produced by their work, namely only that share that is necessary to reproduce their labour power (Mies, Bennholdt-Thomsen and von Werlhof 1988).

We discovered that women's work to reproduce that labour power did not appear in the calculations either of the capitalists or of the state, or in Marx's theory. On the contrary, in all economic theories and models this life-producing and life-preserving subsistence work of women appears as a 'free good', a free resource like air, water, sunshine. It appears to flow naturally from women's bodies. 'Housewifeisation' of women is therefore the necessary complement to the proletarianisation of men. We visualised this capitalist patriarchal economy in the form of an iceberg.

We began to understand that the dominant theories about the functioning of our economy, including Marxism, were only concerned with the tip of the iceberg visible above the water, namely only capital and wage labour. The base of that iceberg under the water was invisible, namely women's unpaid housework, caring work, nurturing work, or, as we then called it, the production of life or subsistence production.

But as we had lived in Third World countries for a long time, we immediately saw that women's unpaid housework and caring work was not the only component of this invisible base of our economy; it also included the work of small peasants and artisans in still-existing subsistence economies in the South, the work of millions of small producers who produce for local needs. All work conceptualised as 'informal sector' work is part of the invisible economy (von Werlhof 1988: 168 ff.).

And finally we saw, that nature herself was considered to be a 'free good', to be appropriated and exploited with no or little costs for the sake of accumulation. Therefore we called all those parts of the submerged 'hidden economy' which are under the water in our iceberg metaphor—nature, women and colonised people and territories—the 'Colonies of the White Man'. 'White Man' stands here for the Western industrial system (Mies 1986b/1999; Mies, Bennholdt-Thomsen and von Werlhof 1988).

With regard to the growth paradigm it is our thesis that permanent economic growth or capital accumulation can only continue so long as such 'colonies' exist which can be exploited free of cost or at very little cost. These are the areas for the 'externalisation of costs'.

Patriarchy, Colonisation and Housewifeisation

In our feminist analysis of capitalism the concepts of patriarchy, housewifeisation and colonisation play a central role. They are also important concepts in our analysis of the globalised economy today. If we want to understand the functioning of this economy, we have to step back and take a brief look at the history of our societies. Let us look at the emergence of partriarchy first.

Patriarchy as a system of male dominance over women emerged some 5,000–6,000 years ago among certain tribes living in the central Asian steppes north of the Black Sea. According to the research of the late archaeologist Marija Gimbutas, the men of these tribes, whom she called the 'Kurgan people', were able to make warfare and conquest of other tribes and their territory the main source of their wealth. The secret of the success of these Kurgan tribes was not their superior intelligence or culture, or some kind of genetic superiority, but mainly their more efficient means of transport, namely tamed horses and camels, and their more efficient means of destruction, namely bows and arrows and spears and other long-distance weapons. The monopoly over these arms gave the men of the Kurgan tribes a power over foreign men, women and their territories that did not grow out of their own work but out of violence and coercion. It is the power over life and death. This monopoly over efficient means of destruction, however, changed not only the relationship between those tribes and other tribes, but also the relationship between humans and nature and also, in particular, the relationship between men and women. Whereas formerly men were dependent on the women of their own tribes and clans for sexuality and reproduction of the people, now they could steal and enslave the women of the conquered 'enemies'. Moreover, this relationship between the conquering men and the women who then became part of the loot also changed the relationship between these men and their 'own' women. It also changed the whole conceptualisation about the originator of human life. Whereas before it was clear that women were the beginning, the *arkhé*, of human life, this logic could now be turned upside down. A new logic could be created, namely that of 'He who kills is.' That means, he who is capable of killing determines who can stay alive. He 'gives' life to those whom he has not killed. From then onwards archaeologists find not only arms and bones of horses and of female slaves in the big tumuli where the 'leading men' are buried; we also find new myths of origin in which a male god–father or culture hero is the origin of all things, including women. 'He who kills is' has remained the core of all patriarchal logic until today (Mies 1986b/1999; Keller 1990). It is also the secret of the 'success' of European civilisation, including its modern industrial

phase, of colonialism, capitalism and the nuclear family. It is our thesis that patriarchal ideology and structures are necessary for the continuation of this system. But there are not only continuities, there are also differences and modifications of these structures and the patriarchal ideology.

Housewifeisation

One important difference between the 'old' patriarchies and the modern, industrial one is the new definition of the concept of labour and of the sexual division of labour. According to this new conceptualisation the man is the 'breadwinner' for 'his' family. He has to sell his labour power for a wage (a salary) with which he then is able to 'feed' a family: wife and children. The woman is defined as his housewife who has to do the unpaid work to reproduce his labour power and the future generation of wage workers. This new definition of the division of labour between men and women is not a result of some inborn male sadism but is, as was said before, a structural necessity for the process of extended capital accumulation.

The concept 'housewifeisation' was coined by Maria Mies on the basis of her research for *The Lacemakers of Narsapur: Indian Housewives Produce for the World Market* (1982). She found that poor rural women in South India were crocheting lace in a home-based industry based on the putting-out system, and this lace was then exported to Europe, Australia and the USA. These women earned a small fraction of what was considered the minimum wage for an agricultural labourer. Their exploitation was justified by the lace exporters—who meanwhile had become millionaires—by the argument that these women were 'housewives' who were anyhow sitting idly in their houses. By making lace they could use their time *productively.*

Housewifeisation, then, means not only the *wageless reproduction* of labour power but also the *cheapest kind of production work,* mainly done by women in homeworking or similar work relations.

The housewifeisation of women's labour is not eliminated when women do enter the wage labour market as full-time workers, or even when they are the only breadwinners of their family. The difference between male and female wages continues to exist. In Germany it is 30 percent. It is justified by the argument that women's earnings are only a supplement to the male breadwinner's wage.

Colonisation

The analysis of the process of housewifeisation would be incomplete if we did not look at it within the context of colonialism. In the first phase of globalisation, the processes of colonisation and housewifeisation did not only take place simultaneously; they were also logically connected. Without the conquest of colonies and their exploitation and plunder, European entrepreneurs would not have been able to start the

Industrial Revolution; scientists would not have found capitalists who would have been interested in their inventions, and the bourgeois class would not have had enough money to have 'non-working' housewives. Colonialism was/is the material precondition for the development of the productivity of human labour which made/makes the modern industrial expansion possible.

A typical colonial and housewifeised labour relation is the work relation in world market factories (WMFs), where Northern metropolitan enterprises produce with very low labour costs commodities for the world market, mainly for markets in Northern countries. The reason for these low labour costs in the South is not only the fact that these countries are generally poor and have a large pool of unemployed, but also the fact that by far the majority of workers in the WMFs and EPZs are young, unmarried women.[1] One of the main reasons for hiring young women is the housewife ideology and the skills they have already acquired for housework: they know how to sew and knit. They are supposed to have 'nimble fingers' and to be 'docile'. Moreover, when they get married and have children, many either leave the job or are fired. This is a result of the housewife ideology owing to which women's wage is seen only as a supplement to the man's wage. As most of these women come from impoverished rural or urban households, they accept appalling working conditions with a working day of up to twelve hours, inhuman work speeds, sexual harassment, practically coercive labour discipline, and safety and health risks that would not be permitted in Northern countries (Mies 1986b/1999, Elson 1994).

The Three Phases of Globalisation

As was said before, the globalisation of the economy is an intrinsic characteristic of capitalism. But this globalisation has not always been the same. We want to differentiate between three different phases of globalisation:

1. the colonial phase proper, which lasted till the end of the Second World War, when most colonies became politically independent but were made economically dependent by development colonialism;
2. the phase of the so-called new international division of labour which started around 1972–73. It is characterised by the relocation of whole branches of production like textiles, electronics, toys and shoes from the old industrial centres to so-called cheap labour countries like South Korea, Malaysia, the Philippines, Mexico and Taiwan;
3. the present phase. Its main features are the universalisation of the neoliberal dogma as the only possible economic theory, the elimination of all protectionist barriers to trade and investment, not only in the South but also in the East and North. The World Bank and IMF control national economies through structural

adjustment programmes (SAPs), by promoting free trade and free investment, deregulation, privatisation, globalisation and further commodity production and consumption.

In what follows we shall skip the first phase because we have written about it earlier (Mies 1986b/1999; Mies, Bennholdt-Thomsen and von Werlhof 1988). We shall concentrate on the second and third phases.

Globalisation Without a Human Face

The third phase of global restructuring began with the recession around 1990. It is characterised by an unprecedented penetration of all regions of the globe and all areas of life by the logic and practice of capital accumulation, epitomised as global 'free trade'. In this stage most of the changes brought about in the earlier stage of the restructuring of the world economy were continued, but there are quantitative and qualitative differences. Thus, the system of relocating manufacturing industries into low-wage countries has been vastly expanded and includes today not only practically all the poor countries of the world, but also all the erstwhile-socialist countries, including Eastern Europe, Russia and also China. The closing-down of labour-intensive, environmentally polluting plants and their relocation to cheap-labour countries has now affected more industrial branches in the rich countries, like the steel industry, coal mining, ship and car production etcetera. It has led to massive lay-offs of skilled workers, mainly male, in Europe and the USA. Moreover when, as a result of workers' protests, wages rise in one of the cheap labour countries, companies move to other countries which are even cheaper, for example from South Korea to Bangladesh (Elson 1994).

Until recently the women workers in these EPZs had hoped that through heroic struggles they would eventually at least reach minimum labour standards as they are prescribed by the ILO. But now they must realise that the TNCs for whom they had worked close down and move on to even 'cheaper' countries. From one day to the next they lose their jobs without any warning, compensation or alternative. Or, in Hong Kong, the companies hire even cheaper women workers as casual labour from mainland China.

In 1995 the Committee of Asian Women published a book with the title: *Silk and Steel*, in which the consequences of this new global restructuring for women in EPZs in South Korea, the Philippines, Hong Kong, Singapore, India and Bangladesh are analysed. From their data the authors conclude that sexist job discrimination has increased: for permanent jobs men are preferred, while women get casual and part-time jobs from which they can be fired at any time. Married women are practically excluded from the labour market, because 'the managers want to save the costs for maternity

leave and other benefits. They usually argue that married women have too many family obligations and hence could not concentrate on their work' (CAW 1995: 31).

But this does not mean that all married women are provided for by an earning 'breadwinner', and therefore need not themselves work directly for capital. The further relocation of EPZs to other, cheaper labour countries has resulted in an increased casualisation of jobs; permanent jobs are changed into part-time, insecure, unprotected jobs; full-time jobs are changed into casual jobs; factory work is put out into homeworking. Homeworking in particular is mainly done by married women who have lost their factory job. It allows them, as we know, to combine family obligations with 'productive' work for the global market. Many of the women who were suddenly fired now do casual work in some newly established service enterprise: 70 per cent of unemployed women found casual labour in this sector.

That means they work for a few hours at McDonald's, Spaghetti House, Maxim, in supermarkets, as sweepers, maidservants and also as sex-workers. In Hong Kong such sex workers have recently formed an association, a kind of trade union, to protect themselves against increasing exploitation and violence (*ZiTeng Newsletter*, October 1998, No. 7). This is the kind of work in the 'service sector' that economists and politicians praise as the new job machine to solve the problem of unemployment.

The analysis of the situation of women workers in many Asian countries corroborates what we wrote in 1988 about the tendency to further housewifeisation of labour under the impact of the crises brought about by global capital. *Silk and Steel* gives ample data about the deterioration of women's work and living conditions as a result of this strategy. The authors also show that in the economic crisis men often simply leave their families so that the women are left alone to provide for their children, parents and siblings.[2]

Housewifeisation of labour is the optimal strategy for capital it seems, to realise comparative advantage in a globalised economy, because women as mothers and caretakers are the cheapest and most exploitable of 'cheap labour'. For women this strategy is a catastrophe.

The process of restructuring the global economy in the direction of ever more export-led industrialisation, both in the South and the East, is driven by the big TNCs. More and more capital and power are concentrated in their hands. They continue their neoliberal strategy although it has resulted in financial and economic crises in Asia, Russia and South America.

This neocolonial structure of the global economy is upheld by a few global institutions like the World Bank and the IMF, by the GATT, and nowadays by the WTO, the MAI, and similar agreements.

GATT is an agreement by which trade barriers that countries have set up to protect certain areas of their economy and society have to be removed, thus obliging the countries to open their markets to goods from all over the world. This new free trade policy assumes that all trading partners are equal, and that by using the principle of

comparative advantage all trading partners will benefit. But in practice the weaker partners, above all Third World countries, will be forced to accept regulations that threaten their national sovereignty. They have to make their agricultural sector dependent on the TNCs and they have to abandon their policy of food self-sufficiency. They have to allow Northern firms to set up their 'dirty' industries in their territory. They have to open themselves up to Northern banks and insurance companies and above all, through the GATT clause on Trade Related Intellectual Property Rights (TRIPs), they have to allow foreign companies and scientists as patent holders to privatise, monopolise and commercialise their biological and cultural heritage and common property (see pages 39–40).

TRIPs are particularly dangerous for the Third World in combination with the development of biotechnology, gene and reproductive engineering. This technology is expected to change the world more than any technology before it. Biotechnological TNCs are trying to get monopoly control over all life forms, plants, animals, even human genes, particularly in the South. This will affect women in particular, who in many countries are responsible for the preservation of seeds (Mies and Shiva 1993; Akhter 1998).

But in the North also biotechnology—the genetic manipulation of plants, animals and eventually also of human beings—will have detrimental consequences. As most consumers in the North depend already now on the TNCs for their food, they will lose the freedom to choose food that is not manipulated. As biotechnology is seen as *the* growth industry, ethical considerations are more and more pushed aside. In these processes women and their capacity to generate new human life are of strategic importance. Reproductive technology is being expanded all over the globe. It opens the way for eugenic, racist and sexist manipulations, and treats women's bodies increasingly as reservoirs of biological raw material for scientific experiments and bioindustry (Mies and Shiva 1993; Mies 1996a).

Another consequence of globalisation is an increasing polarisation of the rich and the poor in the South. One reason for this is the structural adjustment programmes (SAPs) which are imposed on indebted Third World countries in order to bring their economies under the discipline of the 'free market'. These SAPs have had disastrous consequences, particularly for poor women. Whereas in the second phase of globalisation the poor could still hope that the state would eventually take care of them, this illusion is now no longer possible. The poor and particularly poor women are virtually left to fend for themselves, to survive or to die. They are in practice expendable, both as producers and consumers. That is the reason why poor women are the main target of population control.

On the other hand the new global restructuring has improved the situation of the elites in the Third World, so much so that their lifestyle is more or less similar to that of the middle classes in the North (Sklair 1994). In fact, in this phase the fastest-growing economies were some of the Newly Industrialising Countries in Asia (NICs) like Thailand, Indonesia and also China and India. Their middle classes are keen to buy

Western-produced consumer goods, and according to an analysis by Pam Woodall they helped 'to pull the rich world out of the recession of the early 1990s'. According to an OECD estimate, consumers in India, China and Indonesia will number 700 million people by the year 2010 (Woodall 1994: 13). But the author argues that the gap between these elite consumers and the poor in their countries will further widen.

A similar situation can also be observed in the North. Not only has the relocation of industries to 'cheap labour countries' led to increased unemployment, reduction in wage and poverty in the USA and Europe, but the strategies used to 'solve' this crisis are similar to those applied so far only in the Third World. This means deregulation and flexibilisation of labour—housewifeisation and informalisation of hitherto formal labour relations, an increase of homeworking, are the main methods. The creation of cheap labour sectors within a country, particularly for women, and the gradual dismantling of the welfare state follow the same pattern as SAPs in the Third World.

As a result of all these measures poverty has returned to the rich countries of the North, and its is mainly female poverty. Also in the North the polarisation between the poor and the rich is increasing. Global restructuring has not brought, as its spokespeople maintain, more wealth and happiness and development to all; on the contrary, the global capitalist economy can only grow so long as it maintains and re-creates inequality both within individual countries and in the world as a whole. This was clearly spelt out by Pam Woodall in the conservative *Economist*:

> The benefits of international trade come from allowing countries to exploit their comparative advantage, not from requiring them to be identical. And much of the Third World's comparative advantage lies, in one way or another, in the fact of its poverty, in particular, cheap labour and a greater tolerance of pollution. (Woodall 1994: 42)

The neoliberal free trade strategy promoted by the big TNCs has not only resulted in 'black holes' as far as the work situation is concerned, particularly for women in the EPZs and *maquiladoras* in Asia and Central and South America. It has also led to mass pauperisation of peasants everywhere in the South, to the taking over of vast areas of agricultural and food production by TNCs from the North, and to the destruction of policies of food self-sufficiency in the South and North. These so-called economic reforms have affected peasants and poor women in the South most dramatically. In order to understand whether the 'comparative advantages' of which the neoliberal dogma speaks are really creating a level playing field and really benefiting those at the bottom of the iceberg economy, it may be useful to look at some of the main features of the neoliberal strategy and their effects on women, children, farmers and nature.

GATT, the WTO, Regional Trade Blocks and Food Security

In 1986, in the so-called Uruguay Round,[3] neoliberal free trade policies were expanded to include the agricultural sectors of the nations that signed the General Agreement on Tariffs and Trade. Until then, agricultural trade had been exempted

from free trade policies in order to protect local farmers. The Uruguay Round talks lasted eight years, and were concluded in Marrakesh in 1994. Food and agricultural trade were thereby globalised and liberalised. This meant that the countries that had signed the GATT agreements had no longer the possibility of protecting local farmers or consumers by forbidding foreign corporations access to their markets. The main goal of agricultural production was no longer to provide the native population with food, but to produce trade goods for international export as needed by the market. Furthermore, the liberalising of agricultural and food trade meant that giant TNCs could invest in other countries without restrictions. As a result, for instance, Kentucky Fried Chicken, to name one company, could attempt to establish their fast-food chain all over India.

The GATT regulations contain a clause regarding Trade Related Intellectual Property Rights (TRIPs). Behind this abbreviation is mainly hidden the attempt of rich industrial nations and their TNCs to gain free access to the genetic diversity of the Southern tropical countries, and to the traditional knowledge of the local communities concerning plants, animals, the earth, and health. This knowledge will then be used to industrialise, to commercialise, to privatise and in the end to monopolise that genetic diversity (Shiva 1995b). This is made possible because the TRIPs under the auspices of GATT allow researchers and concerns to patent biologically or genetically manipulated plants and animals. The patenting of life forms was not possible until a short time ago.

The results for local farmers and small merchants were recently made clear by the Indian farmers' movement against GATT and against the patenting of products of the neem tree. These products had been used in India for thousands of years as natural disinfectants and pesticides, and the quality of neem products is common knowledge in India. Tony Larson, an American, acquired the patent for all neem products and sold it to the TNC W. R. Grace; he had discovered nothing new, but had made the ancient Indian knowledge his private property and then sold it. After this, Indians who wished to produce anything from neem had to pay licence fees to Larson and W. R. Grace. Vandana Shiva and Jeremy Rifkin fought successfully against this bio-piracy before the US Patent Office (*BIJA*, No. 15–16, 1996: 32). Similar processes are going on especially in the seed sector, where huge TNCs have expanded their global control to include seeds and biogenetic resources, and are supporting their commercial interests against the farming population with international laws.[4]

After the closing of the GATT talks, in January 1995 the complete set of regulations was transferred to the WTO, which now regulates world trade according to the free trade principles described above. At the same time, large trade blocks such as the EU, NAFTA, APEC (Asian–Pacific Economic Cooperation) and MERCOSUR (Mercado Comun del Cono Sur) have been or are in the process of being established. They are the result of competition in a global economy, competition for markets, investments, production and services. The FAO is trying expressly to achieve the goal of 'world food security' within this GATT/WTO framework. The analysers of the global free trade in

the agricultural sector expect profits in OECD nations to reach US$25 billion per year (FAO Technical Paper No. 7, 1996: 10).

Whether this gain in profits means a gain in food security is completely open to question. It is going on the wrong track to expect food security from those very institutions, interests and theories that have done so much to destroy food security for so many in the first place. We formulate the following thesis:

Universal food security is impossible in a global market economy that rests on worldwide liberalisation and deregulation of agricultural and food trade, and on the neoliberal dogma of comparative advantage, universal competition, profit maximisation and permanent growth.

Let us now take a look at the results these neoliberal trade doctrines have had up till now for the poor of the world. The poor, as is well known, are mostly women. The effects on women of globalisation in the South and in the North have been differently analysed and criticised. Not only is it the case that 70 per cent of the world's poor are women; neoliberal developments have led to an increase in female poverty in Germany as well (Bennholdt-Thomsen 1996b). What does this mean for food security?

The global doctrine of free trade is mainly based on David Ricardo's theory of comparative advantage. This theory states that goods should be produced where the natural conditions are most favourable and production costs are lowest. For example, the Portuguese should produce wine and not textiles, and the English should produce textiles and not wine. Both countries could then profit from trading these goods. Applied to agricultural and food production within the framework of GATT/WTO, this doctrine means that food should be produced where the wages are lowest, and where environmental protection laws are most lax. In addition, this means that the local farmers no longer provide for the needs of their own population, but instead produce for an external market where higher profits beckon.

To this end, for example in India, fertile ricelands along the east coast are bought or leased by international firms to make shrimp farms. The shrimps are exported to Europe, Japan and the USA, and can now be bought cheaply in our supermarkets. In order to set up the shrimp basins, salt water must be pumped onto the land, which spoils both the land and the drinking water.

The environmental, economic and social costs of this 'growth' are paid by the local communities, as proved by Vandana Shiva, above all by women. While shrimp exports appear in national and international growth statistics, the destruction of the local food and water resources remains unmentioned. Above all, the women of the local fishing and farming villages, who have lived from rice paddies and fishing for ages, have been robbed of their basis of sustenance. They are the ones who are most actively protesting against the shrimp farms. Vandana Shiva quotes Govindamma from the village of Kurru in Tamil Nadu: 'First they drove us from the coast, and we had to seek work in the country. Now they build these shrimp farms on the rice paddies. . . . There we have also lost our work. How shall we earn our living?' (Shiva 1995a).

The delta areas of India's east coast are especially suited for rice growing. Today, this basis for local self-sufficiency has been destroyed. The financial gains from shrimp export can never compensate: first, these gains are claimed by mainly private, foreign and domestic firms, and, second, the wages of the few people who find work in this industry are so low, that they can hardly guarantee food security as defined by the FAO. These cheap wages are part of the comparative advantage of the shrimp companies; without them they might have established their facilities on German or Japanese coasts. In addition, more jobs are destroyed than are created by these industries. Moreover, it is also known that these shrimp farms can only operate productively for a limited time, as the shellfish succumb to disease and new coastal areas must be sought. Child labour is part of the comparative advantage as well, as shown in the video 'The Violence of the Blue Revolution'.

The example of shrimp farming could be further supported by others, such as flower and strawberry production for export in West India, where land that had previously been available for local food production is now used for luxury goods for the already overfed consumers in the lands with higher purchasing power.

The doctrine of comparative advantage was developed at a time when the mobility of labour and capital was still limited by national borders. David Ricardo clearly stated that capital would seek absolute and not comparative advantage if it could move freely across all borders. Then, national governments and parliaments would no longer be able to obstruct the search for absolute and not comparative advantage. Today, this situation has been reached.

And the final costs are carried by nature, the poor, children and women. The search for absolute advantage in the agricultural and food sectors means that the survival of the farmers and food security for the impoverished countries of the South is sacrificed in the interest of capital growth. Vandana Shiva writes that in India the prices of rice and wheat have risen due to these export-oriented policies. Simultaneously, the poor farmers in poor regions were robbed of their own market by the import of cheap millet (Shiva 1995a).

That there are only winners in the global, liberalised market of agricultural production if there are losers somewhere else is confirmed by the following statement from a US agricultural politician: 'before the US can achieve its main economic objective, namely dramatic increases in grain sales [to Europe], they must firstly destroy the European food security policies that encourage domestic production' (quoted by Shiva 1995a). This statement expresses the true relationships in the global agrarian market. For certain countries and TNCs to realise their comparative or absolute advantages, local self-sufficiency elsewhere must be destroyed. The USA has been following the strategy of using wheat as a weapon since the early 1970s. That this is currently a conscious strategy of the TNCs as well is shown by the example of Pepsi and *Bikaneri bhujia* in India.

The **Bikaneri Bhujia** *Case*

Bikaneri bhujia is a traditional snack produced in cottage industries in Bikaner, Rajasthan, India, and currently provides 2,500,500 persons, mainly women, with an income. Pepsi, with its capital, is now mass-producing this snack and using this traditional name in its advertising, in order to underbid local producers and therefore destroy their market. Pepsi has introduced no new recipe to produce this snack. This US TNC, which after the economic liberalisation can now operate freely in India, has appropriated the common knowledge and the traditional method of food preparation of millions of simple women, and thereby destroyed their basis of living. These women, from town and country, educated and uneducated, married and widowed, gained an income from this cottage industry which was perfectly suited to the region which gave this snack its name. The moth lentil, used for preparing this snack, grows only in the deserts of Bikaner and Jodhpur. The cottage industry had a secure local market and supported not only the women but also the farmers in these desert regions, where not much else grows. A further ten thousand women are employed in the preparation of *papad*, a snack which is eaten together with the *Bikaneri bhujia*. And hundreds of thousands of street vendors live from the sales of these popular traditional snacks.

At the conference on 'Intellectual Property Rights, Community Rights, and Biodiversity' held in Delhi on 20 February 1996, it was reported that almost the entire population of Bikaner was involved in the production and distribution of *Bikaneri bhujia*. Now Pepsi has announced that it will remove this product from the cottage industry sector and relocate it in the high-tech sector. This will be a catastrophe for the people of Bikaner: Pepsi has stolen the traditional trademark name in order to destroy the market of the little people (*BIJA*, No. 15–16, 1996, pp. 29–30).

In India, in support of these policies, farmland necessary for the feeding of the local population is now planted with export food products, such as tomatoes for ketchup for Pepsi in place of rice in the Punjab, sunflowers instead of rice and millet in Karnataka, flowers, strawberries and fruits for export in Maharastra instead of basic foodstuffs. Corn is grown for animal feed, to be exported to Europe. The large food corporations turn the farmers into contract producers, who provide them with raw materials for the manufacture of 'novel food', which they then sell where there are social classes with the necessary purchasing power.

The results of these free trade policies are already being felt in India. The export of agricultural products, above all grain, has risen 71 per cent in recent years: from a value of 21.98 billion rupees in 1988–89 to 37.66 billion in 1992–93. Since the Indian government, according to the new economic policies, no longer has a right to influence the prices of basic foodstuffs, food prices rose 63 per cent in the same period of time, which led to an immediate drop in daily consumption from 510g. to 466g. per person (Shiva 1995a). In other countries of the South, the picture is similar.

On the basis of free trade, how can food security for all be guaranteed—for the economically weakest, the impoverished women and children? Regarding India, Vandana Shiva writes: 'When food is available solely at world market prices as required by the liberalizing of trade, hunger is the only certainty for the majority of the poor, who did not even have enough to eat before the economic reforms' (Shiva 1995a).

The Corn Farmers of Mindanao

A further example of how globalised free trade produces hunger is that of the corn farmers of Mindanao in the Philippines. These small peasants lived mainly by maize production, but the free trade policy of GATT/WTO drove them into poverty and starvation. When the USA began to export maize to the Philippines at a price far below the producer price of the corn farmers they could not compete and had to give up farming. The pauperised peasants then either moved to the slums of the cities, which are already overcrowded, or tried to find casual jobs on the plantations of food TNCs like Del Monte, which had bought up the peasants' land at a cutthroat price.

> Instead of growing food for themselves on their own land, those who are lucky to find casual jobs on the plantations now produce pineapples, bananas, vegetables for Western supermarkets on this land. And all this will be celebrated as a further victory of the theory of 'comparative advantages' and of free trade. After all, why should you grow your own food when you can buy it at a cheaper price? And cheaper than from the USA you can't get it these days. Since there are no trade barriers any longer the maize grown in the midwest of the United States can be sold for half of the corn market price in Mindanao. (Kevin Watkins, *Guardian Weekly*, 16 February 1997)

The irony is that agrarian trade in the USA is not really free. It is subsidised by the government to the extent of US$29,000 per farmer. 'Free trade' does not mean, as is always proclaimed by its propagandists, that a truly 'level playing field' is created, but that there are *winners* and *losers*. Winners are definitely the big agrarian and food TNCs. Losers are the small peasants, their women and children.

But what can we say about the consumers in the North? Do they not also belong to the group of winners? Weren't representatives of the G7 states right when at their summit in Lyons in autumn 1997 they stated that free trade would favour the consumers by making possible cheaper food prices? The international consumer associations welcomed GATT because of the lowering of all commodity prices. But consumers in Europe and the USA have hardly noticed the GATT negotiations. The majority do not ask why they can buy exotic fruits the whole year round for low prices and why T-shirts are getting cheaper every year. This kind of social ignorance regarding the real economy is part of the neoliberal strategy. It prevents people from beginning to question the food policy of GATT/WTO which sacrifices small peasants' existence and food security to boost TNC profits.

'Black Holes' for Women in the North

Although the countries of the North, particularly the G7 countries, have been the profiteers in the neoliberal globalisation process, the more this process goes on the more it becomes evident that poverty, hunger, social insecurity, misery and joblessness are found not only in the South but increasingly also in the North. In fact, in the USA as well as in Europe a process of social polarisation can be observed. This process has been most marked in eastern Germany where the reunification of Germany, first hailed as the beginning of a golden era, has led to a dramatic rise of joblessness. Two thirds of the jobless there are women. This happens in a country where women's waged employment was the highest in the world—90 per cent—and where women were represented in all the professions. Today the old patriarchal strategy is used to send women home to 'Küche und Kinder' (kitchen and children) without any alternative.

In consequence of neoliberal policies, expenses for kindergartens and social security have been cut; women are the main victims of these processes. This is true not only for the former East Germany but also for the former West Germany and all the OECD countries, where all the governments follow the same neoliberal dogma. These governments consider it their main task to protect the interests of the big TNCs and not to protect the people. They cut public spending in the fields of social security, health, education, childcare and women's equality in order to promote the privatisation of public assets and to deregulate labour laws. All this is done to enhance the big corporations' competitiveness in the global marketplace and to attract foreign investors. This policy is justified by the argument that it will create more jobs. It is clear by now that this strategy will not create new jobs. Each rationalisation and innovation has instead destroyed jobs and produced what is known as 'jobless growth'. This strategy, however, has not been given up anywhere.

It is believed that what has been artificially produced is superior and more productive than living human labour power. 'Increase in productivity'—either by substituting this labour power by high-tech machinery or by relocating production to 'cheap labour' countries—is one of the key mechanisms used by the corporations to counter global competition.

Divide and Rule

This neoliberal strategy is a disaster—not only for women in the South but also for women in the North. In Germany, for example, the proportion of social expenditure in GDP went down from 33 per cent in 1988 to 30 per cent in 1994. Of the women who work forty hours and more per week, 53 per cent do not have a sufficient income to cover their main costs of living—calculated to be DM1,800 (Möller 1991). In addition, women constitute the majority of workers in part-time and precarious jobs. The

economic situation of single mothers and women-headed households has deterio-rated since 1980, while the number of such households has increased by 1 million.

But this situation is not restricted to Germany. It can be found in the USA, in Canada, in the UK, and in most countries of the North. Of course, this feminisation of poverty, as it has been called, does not yet mean that many women are starving in these countries. What it is important to understand is that the present neoliberal glob-alisation process produces a new patriarchal subordination of women, both in the South and the North, not only by direct intervention or violence, but also simply by the fact that apparently value-free economic priorities, namely the commodification of everything and the maximisation of profit, are made the central goals of all soci-eties. These goals appear as quasi-natural laws of all economic activity. Such a view of an economy is fundamentally hostile to women, to life, to humans as social beings, and to nature.

In recent years we have been able to observe a depressing erosion of solidarity in our societies. As a result of the principle of divide and rule and of the hierarchically split patriarchal society, women are the main victims of this erosion. The breakdown of socialism is not the cause of this shift, as is often assumed; it only aggravated it. The lesson we have to learn today—a historic lesson we have avoided for at least two hun-dred years—is that the question of whether capitalism or socialism was the better sys-tem is simply the wrong question. If people had asked this question from a women's perspective they would have known the answer much earlier: none of the two is prefer-able to the other.

The Proletarian Is Dead, Long Live the Housewife!

'The Proletarian Is Dead, Long Live the Housewife!' is the title of an essay that Clau-dia von Werlhof published in German in 1983 (English translation in Mies, Bennholdt-Thomsen and von Werlhof 1988: 168). This was at a moment when for the first time the end of the proletariat and of the 'work society' had been declared (Gorz 1983). Werlhof criticised this discourse by explaining that perhaps the male skilled worker, well pro-tected by labour laws, trade unions and a labour contract, was no longer the optimal workforce for capital; instead the housewife was fitted exactly into the new capital strategy of that time, which demanded the flexibilisation of labour. This flexibilisation was propagated as the necessary consequence of the new work rationalisation brought about by the microelectronics and computer technology.

Whilst around 1983 the trade unions could still believe that flexibilisation was only a temporary strategy to tide capitalism over an economic slump, by now it is clear that this strategy has become the main method used to undermine the well-established and well-protected core labour standards in the industrialised countries. In the context of globalisation when corporations simply can move to other 'cheap labour countries', if trade unions in the core countries continue to stick to their traditional demands it

seems plausible, from the point of view of capital, to flexibilise labour further. The former German minister of economics Rexrodt openly suggested the establishment of a cheap labour sector within Germany. Otherwise German capital would continue to move out to 'cheap labour' countries, mainly in Eastern Europe and Asia or South America. The minister was even explicit about the type of workforce to be employed in this 'cheap labour sector': women, housewives. He praised women for their capacity to combine housework, and care for children and the old with productive work—perhaps as homeworkers at computers.

Flexibilisation of work, in fact, means housewifeisation of work. Already in 1983 Claudia von Werlhof wrote that not only women's but also men's work would be 'housewifeised'. Because in capital's strategy the white, male wage worker is not the image of the future for all workers. The dream of all capitalists is the universalisation of work relations similar to those of housewives:

> There is no cheaper, more productive, and more fruitful human labour and it can also be enforced without the whip. I believe that the restructuring of our economy will involve the effort to re-educate the men and force upon them, as far as possible, the feminine work capacity. For the (male) wage worker does too little and knows too little. He can do only what he is paid for and what has been agreed upon by contract (von Werlhof 1988: 129).

If we look at countries that have apparently solved their job problem these days—the USA, Denmark or the Netherlands—we can see the correctness of the above statement. The jobs that have been created in these countries are housewifeised jobs. They are badly paid, part-time, casual, without the protection of labour laws, non-unionised, short-term, atomised. There is a lot of homeworking, the exploitation of which is nowadays camouflaged by concepts like 'self-employment' or 'entrepreneurship'. The deregulation of labour markets and the emphasis on a strong service sector follow exactly this line. Much of what is included in this service sector is nothing but commodified housework.

The 'Black Hole' of Unemployment

As was said before, one of the attractions of globalisation for big corporations is the fact that they can save on labour costs. This together with continued rationalisation and capital concentration has destroyed millions of jobs in all industrialised countries at a rapid pace. Whereas the profits of these corporations have grown to fantastic heights, this growth does not lead to new jobs. 'Jobless growth' has become a normal phenomenon in the North. Even in Germany the official number of unemployed was 4.7 million in February 1997. This figure is higher than that of 1933, when it was less than 4.5 million (*Frankfurter Rundschau*, 3 February 1997).

Not only blue-collar workers are losing their jobs; highly qualified persons working in banking, insurance and industry are also becoming 'surplus' labour. For example,

the fact that well-qualified persons in places like Bangalore or Hyderabad in India are able to do the same work in the software industry as German or Dutch workers, but for a much lower wage, has led to massive closures or relocations of such industries in the North. Corporations like Siemens, Texas Instruments, Microsoft, Toshiba and Compac have relocated large parts of their software work. This has destroyed millions of jobs in the North. Martin and Schumann write that IBM, Digital Equipment and Siemens-Nixdorf eliminated more than 10,000 jobs by establishing daughter firms in Bangalore (Martin and Schumann 1996: 143). They estimate that of 200,000 jobs in the German software industry eventually only 2,000 will remain.

What is true for the computer and software sector is equally true for the service sector, for banking and insurance. The modernisation and globalisation of this sector—usually praised as the new job creator—will indeed destroy more jobs than it will create. Already the combined processes of globalisation, automation and rationalisation have abolished 40 million jobs in twenty-three OECD countries. The World Bank and other research institutions have come to the conclusion that 15 million people will lose their jobs in the EU. These numbers have to be added to the existing unemployment figures in the EU. After their analysis of the job situation in the OECD countries, Martin and Schumann are of the opinion that even in Germany the unemployment rate could rise from 9.7 per cent (in 1996) to 21 per cent (Martin and Schumann 1997: 146 ff.).

What is worse than the rising or stagnant figures of joblessness is the fact that politicians and economists have no idea how they should fill the 'black hole'. On the one hand they firmly believe in the neoliberal credo of globalisation, liberalisation, privatisation, rationalisation and competition, which destroys jobs, as they know; on the other they don't know how to create new jobs. So far they have no other solution to offer than the one that some twenty years ago we called the 'housewifeisation' of labour.

'Black Holes' of Financial Warfare

One of the reasons why governments are cutting down on their expenses for social security, public education, health and environmental projects are the 'black holes' in their financial budgets. These 'black holes' are partly a consequence of the fact that banks and corporations that operate transnationally hardly pay taxes in their 'home' countries. These corporations can avoid paying taxes by moving their base to tax paradises. But they benefit at the same time from any governmental subsidy for industry. Thus a corporation like BMW in 1988 paid DM 545 million as taxes to the German state. In 1992 it paid only 6 per cent of that sum. From 1980 onwards the tax income of the German state from corporation profits sank from 37 to 25 per cent. Big TNCs pay less and less into the state's coffers (Martin and Schumann 1997: 271–2). That means that normal taxpayers have to carry by far the greatest bulk of the tax burden.

Since 1980 the taxes paid by wage workers and employees in Germany have risen by 163 per cent, while those paid by corporations and owners of private assets have risen only 33 per cent.

The scandal of 'black holes' in state treasuries is not only that they are a redistribution from the bottom of the iceberg economy to its peak but also that the nation-states see no possibility of controlling the free capital transfers of globally operating banks, corporations and speculators. One of the pillars of democracy and national sovereignty is the state's sovereign right to collect taxes. For global capital this sovereignty no longer counts. Neoliberalism has finally 'liberated' capital from all obligations and restrictions that democratically elected governments had used so far to control capitalism. Those who had believed that it is possible to 'humanise' capitalism must now realise that the neoliberal globalised market economy cannot be tamed by national governments. Capitalism now shows its true inhuman face, a face it always had shown to the colonies.

Globalisation has not only caused big black holes in state treasuries. The sudden financial crises in 1997–98 in Asia, Russia and Latin America sent waves of panic also through the guardians and promoters of the neoliberal credo. The irony is that the breakdown of the finance systems in Asia and Russia is not due to the fact that they did not follow their neoliberal teachers in the World Bank, the IMF and the think-tanks of the USA. They all followed obediently the free trade dogmas which demanded that all government controls over the free flow of capital should be removed.

Michel Chossudovsky has shown that the financial crises in Asia as well as those in Russia and in other parts of the world did not just happen like natural disasters—that they are the outcome of 'financial warfare' based on the manipulations of market forces by powerful actors, including transnational banks, the IMF and speculators. According to Chossudovsky this financial and economic warfare will lead to a 'recolonisation' of the world.

> No need to recolonize lost territory or send in invading armies. In the late twentieth century, the outright 'conquest of nations', meaning the control over productive assets, labour, natural resources and institutions, can be carried out in an impersonal fashion from the corporate boardroom: commands are dispatched from a computer terminal, or a cell phone. The relevant data are instantly relayed to major financial markets—often resulting in immediate disruptions in the functioning of national economies. (Chossudovsky 1998: 6)

In this warfare the IMF plays an important role, because since the Mexican crisis in 1994–95 the IMF bail-out operations for destabilised economies have not really rescued these countries but have instead opened up key sectors of their economies to be privatised and sold off to the world's largest merchant banks.

> The world's largest money managers set countries on fire and are then called in as firemen (under the IMF 'rescue plan') to extinguish the blaze. They ultimately decide

which enterprises are to be closed down and which are to be auctioned off to foreign investors at bargain prices. (Chossudovsky 1998: 8)

While 'vulture foreign investors' gain from these induced crises, national economies collapse, unemployment rises overnight, governments are unable to pay wages, poverty and hunger return all of a sudden to countries that have followed the neoliberal path to prosperity.

The leaders of the world economy have no explanations for the sudden breakdown of the economies in Asia, Russia and Latin America. They are afraid that the financial crises there could develop into a full-fledged worldwide recession which could also include the USA and Europe. But instead of giving up their faith in the neoliberal paradigm they continue to preach the same dogmas of privatisation, liberalisation, deregulation. They are unable to draw lessons from the reality, namely that their theories have just created black holes all over the world.

The Great Confusion: From Theory to Religion

The chaos neoliberalism has caused in the real economy has its counterpart in the confusion found in the theoretical explanations of 'black holes' yawning everywhere, and in the solutions offered to fill them. Economists describe how globalisation affects different sectors of the economy. And according to their standpoint they evaluate this positively or negatively. But they usually do not explain *why* in the industrialised countries of the North, after more than twenty boom years following the Second World War, the Keynesian model came to an end; *why* successful welfare states like Sweden all of a sudden could no longer continue as before; *why* the women in Sweden, who worldwide so far had gained most from this welfare state and were considered a model for emancipatory politics, were now relegated to the 'normal' European patriarchy.

The confusion is particularly remarkable when one looks at the solution offered to fill the 'black holes' of unemployment. The following statements may serve as illustrations for this confusion:

> We still use the traditional concept of the full-time industrial labourer, although there are many people who are employed under labour relations which are different from these normal labour relations. These are not full-time wage labourers proper but have contracts on casual labour or are fake 'self-employed' who no longer work in a factory. I think we have to consider such new labour relations in our collective bargaining policy. (Walter Riester, IG Metall, *Frankfurter Rundschau*, 20 March 1997)

This statement made by a trade union leader shows that the trade unions have not yet started to develop a new labour concept which would include paid and unpaid labour—a task feminists had already done twenty years ago. Now, when flexibilisation

and housewifeisation of labour is the main strategy of the TNCs for lowering labour costs, the trade unions have no theoretical tools to explain this process.

But the confusion on the part of the big corporations and their spokesmen is no less remarkable. Helmut Maucher, the chief executive officer of Nestlé and president of the International Chamber of Commerce (ICC), expressed this theoretical confusion clearly:

> Indeed, you can't explain to a normal person why the stock exchange prices rise day after day and yet more and more people are thrown out of their jobs. Yet it remains true, on the other hand, that competitiveness is finally the safest method to create jobs—even if the road towards this goal may sometimes be rough. (Maucher, quoted by von Werlhof 1998: 166)

Even though the belief in the dogma of the miraculous capacity of competitiveness to create more jobs does not stand the test of reality, even though this gap between dogma and reality is admitted by a leading figure of international capital, he still prefers to uphold his faith rather than draw a lesson from the real economy.

This example shows that the neoliberal theory is a religious faith rather than a scientifically tested theory. One of the dogmas of this religion says, 'Without competitiveness no investment. Without investment no jobs' (von Werlhof 1998: 166). The knowledge that this dogma is false does not result in the giving up of this religion. The reason for the incapacity to draw a lesson from reality is the firm belief that There Is No Alternative (TINA) to neoliberal capitalism—a belief spread all over the world since 1989, the Fall-of-the-Wall year.

That neoliberalism is indeed a religion and that commonsense rationality has given way to confusion and faith can also be seen in statements made by analysts and leaders of international finance capital on the financial meltdown in Asia, Russia, Latin America and the sudden crisis of confidence of international investors that followed. One observer describes the situation thus:

> One had the impression of being at the funeral of globalisation. But the mourners could not decide to accept the evidence of this death. They could not show any clarity of mind because they were locked into an attitude of denial. The breaking down of globalisation caused an intellectual crisis in them which resembled a religious crisis. (William Pfaff, 'The Crunch has a Message for Europe's Central Bank' *International Herald Tribune*, 16 October 1998, quoted by Bernard Cassen in the German version of *Le Monde Diplomatique*, November 1998, p. 8)

After the crash on the New York Stock Exchange on 31 August 1998 and later after the collapse of the speculative hedge funds on 23 September, panic seized even the mightiest banker in the world, Alan Greenspan, chief of the Federal Reserve Bank of the USA. He is reported to have said: 'I've never seen anything like that' (Bernard Cassen, *Le Monde Diplomatique*, November 1998, p. 8).

Panic, confusion, irrationality, religious dogmatism seem to characterise the leaders of the globalised economy today. But not only the national and international leaders of this economy, but also most of the 'normal' citizens in the rich countries of the North suffer from the same TINA syndrome as those at the top. 'There is no alternative' is the sentence most often heard when one tries to criticise the logic and the results of neoliberal capitalism. One reason for the widespread confusion, pessimism and religious attitude expressed in the TINA syndrome is blind belief in the axioms and basic assumptions, on which the theoreticians of the capitalist economy have constructed their dogmas.

The Capitalist Creed

At the meeting of the international campaign against the Multilateral Agreement on Investments held on 17–20 October 1998 in Paris, the following eight Articles of Faith of the neoliberal religion were distributed. They contain the quintessence of neoliberalism as it was formulated in the early 1970s, becaming known as the 'Washington Consensus' (Clarke and Barlow 1997: 14–15).

The Eight Articles of Faith
1. There is no development without economic growth.
2. A growing national income automatically trickles down to benefit all members of society.
3. The integration of local and national economies in the world economy is a blessing to everybody.
4. The liberalisation of international trade enables every nation to make the best use of its comparative advantages in the international division of labour.
5. The liberalisation of international capital flows results in a better allocation of the means of production.
6. Technological innovation will compensate for the ecological flaws of the present production system.
7. Private property rights are not only the best system to deal with scarcity, but also suit human nature better than any other system.
8. The direct involvement of the nation-state in economic life always results in inefficiency and corruption.

We would like to add a few more to the above list of economic dogmas. They are the following:

a. Man is selfish. All economy is based on individual self-interest.
b. Nature is stingy. Economy has always to do with scarce resources.

c. Human needs are basically unlimited and insatiable.

d. A modern economy must permanently grow. Only 'productive work' is 'work'.

In what follows we criticise some of these dogmas from a subsistence perspective.

Man Is Selfish (Articles a and 7)

If the fathers of capitalist theory (Hobbes, Smith, Locke) had chosen a mother instead of a single bourgeois male as the smallest economic unit for their theoretical constructions they would not have been able to formulate the axiom of the selfish nature of human beings the way they did. They would have realised that human beings can be both selfish and altruistic, both aggressive and caring. They would have seen that human life is not just 'solitary, poor, nasty, brutish, and short' and that the law of history is not only the 'war . . . of every man against every man' (Hobbes); they would have been able to observe that people cooperate with each other, live in communities, can be peaceful and merciful and, in spite of hardships, enjoy and celebrate life.

Lieselotte Steinbrügge has shown that the Enlightenment philosophers of the eighteenth century were clearly aware of the difficulty the capitalist philosophy of the self-interested, competitive, rationally calculating, individualistic *homo oeconomicus* would create for society. What would happen, they asked, to mercy, peace, love, generosity etcetera?

They solved this difficulty by separating the public from the private sphere and creating two different kinds of ethics, one for the private, the other for the public sphere. The responsibility for 'private' values was then relegated to women, while men could pursue their 'war of all against all' in the public sphere of politics, militarism and economics (Steinbrügge 1987).

Resources Are Scarce (Articles b and 7)

The anthropology of the lonely, egotistic, male human warrior fits well into the cosmology based on a concept of nature as principally poor, stingy, with permanently scarce resources. As Carolyn Merchant has plausibly demonstrated, before the Renaissance nature was conceptualised as generous Mother Nature, a female organism with inexhaustible wealth and resources (Merchant 1980). But the theoreticians of capitalist patriarchy, above all Bacon, turned her into a stingy witch from whom 'rational man' has to extract her treasures by coercion and torture.

From the Renaissance onwards all precapitalist and pre-industrial peoples have been looked upon as poor (backward), always busy collecting or producing the basic requirements for survival: food, clothing, shelter. They supposedly have no time for the 'higher' things in life: culture and education. Concepts like 'natural man', 'primitives', 'Stone age people' express this valuation. In contrast to these 'primitives', capitalist industrial society appears to be the creator of all wealth, culture and surplus.

Marshall Sahlins has convincingly demonstrated that 'Stone-Age economies', both past and present ones, are the originally affluent societies. He defines an affluent society as one 'in which all the people's material wants are easily satisfied' (Sahlins 1974/1984: 1). 'Easily satisfied' can mean either that people 'desire little' or that they are readily able to 'produce more'. Capitalism has chosen the second path. This is the reason, according to Sahlins, why it had to introduce the concept of scarcity. This system is based on the assumption 'that man's wants are great, not to say infinite, whereas his means are limited, although improvable: thus the gap between means and ends can be narrowed by industrial productivity' (Sahlins 1974/1984: 2).

Industrial productivity then, is the means to create affluence. But in order to produce a wealth of goods, not only must the concept of scarcity be accepted as the most basic economic assumption, scarcity must be factually created in and by the very structures of the economy:

> The market-industrial system institutes scarcity, in a manner unparalleled and to a degree nowhere else approximated. Where production and distribution are arranged through the behaviour of prices, and all livelihoods depend on getting and spending, insufficiency of material means becomes the explicit, calculable starting point of all economic activity. The entrepreneur is confronted with alternative investments of a finite capital, the worker, (hopefully) with alternative choices of remunerative employ, and to the consumer . . . consumption is a double tragedy: what begins in inadequacy will end in deprivation . . . the market makes available a dazzling array of products: all these Good Things within a man's reach—but never all within his grasp. Worse, in this game of consumer free choice, every acquisition is simultaneously a deprivation, for every purchase of something is a forgoing of something else. (Sahlins 1974/1984: 4)

In the capitalist system, scarcity is structurally necessary and built into its functioning. In a system that is driven mainly by the motive of constant growth of money and because capital cannot say 'It is enough', there is no concept of sufficiency. Because of this it is necessary that people *believe* that nature does not provide enough and that the circle of work–money–commodities–consumption is the only way to escape scarcity, hunger or 'mere subsistence'.

According to Sahlins, 'mere subsistence' is one of the concepts by which the myth of scarcity was created and is constantly being upheld. It serves at the same time to devalue the subsistence economies of non-industrialised peoples and also creates totally erroneous impressions of the life of past and present 'Stone Age people'. This impression is in no way corroborated by empirical fact.

Among the Aborigines in Australia or the Bushmen of the Kalahari desert in Africa, men and women do not have to work more than six hours a day to get enough and diverse food, rich in calories. Sahlins quotes the findings of Lee's study on the Bushmen. They 'worked' only 2.5 days per week. The men worked as hunters, the women as gatherers. On an average their workday was six hours for both genders. In spite of that short

working day they consumed 2140 calories a day. What they did not consume they gave to their dogs (Sahlins 1974/1984: 20ff.).

Whatever one may think of the lifestyle of these 'Stone Age people' one thing is certain. They were not poor and they did not starve. On the contrary they were rich societies. They worked less than 'civilised' people, their food was healthier, richer in calories and diversity than the average for the 800 million people in the world whom the FAO defines as malnourished. According to the FAO, the average daily calorie intake of people living south of the Sahara is 1,300 calories (FAO 1996). This is much less than the calorie intake the pygmies of the Kalahari have obtained with much less work. At least so long as they were not colonised and subjected to modern 'development'.

In conclusion, we can say that hunger, malnutrition, scarcity and poverty are not caused by stingy nature or underdeveloped labour productivity. They are also not the result of unchecked population growth. They are the outcome of a mode of production that can never say, It is enough! Patriarchal capitalism is the father of scarcity, not mother nature.

But it is not only capitalist economics that is based on the axiom of universal and perennial scarcity. Marxism and socialism too have accepted the assumption of scarcity as the starting point for developing a new utopia.

Human Needs Are Infinite (Articles b and 1)

This article of faith stands in total contradiction to our daily experience in the 'real economy'. All our basic needs for food, clothing, shelter, warmth etcetera can be satisfied. They are not insatiable. Even so-called 'higher wants'—for instance for knowledge, culture, mobility, friendship, recognition, respect—love—are not infinite. They can be satisfied here and now. It is precisely one of the problems of the growth-oriented market economy that people's needs are so 'inflexible'. To solve this problem of finite needs in a finite world, capitalism had to transform needs into wants and addictions by producing ever more and ever more fashionable 'satisfiers' (Max-Neef *et al.* 1989). Only when thirst will no longer be quenched by water but only by Coca-Cola or wine or beer is it possible to extend the production of these and other beverages limitlessly. If such needs as thirst can be transformed into addictions and their satisfiers into pseudo-satisfiers, a limitless production of such commodified pseudo-satisfiers is possible. (Mies and Shiva 1993).

But even in spite of these strategies to stimulate consumption beyond the satisfaction of needs, one of the main problems of globalised capitalism is the limits to further expansion of markets. This problem is not only one of overproduction *vis-à-vis* the lack of purchasing power of masses of people in the South, it is also that the classes with purchasing power, the middle classes worldwide, already have most of the goods, both material and immaterial, which the market economy produces. In order to overcome this limit the corporations spend billions on advertising their products. Trainer

estimates that industry worldwide each year spends US$100,000 million on advertising. On the other hand they produce more and more throwaway articles or goods with in-built obsolescence.

In a subsistence society, on the other hand, all human needs would be really satisfied. This means that people would not have to turn to pseudo-satisfiers which at the same time stimulate further compensatory consumption because real needs are never satisfied. Pseudo-satisfiers and compensatory consumption lose their attraction if people and communities themselves produce what they need, and see in their own activity a connection between productive activity and consumption. These needs will not be infinite; they will be satisfied. True satisfaction always requires an element of self-activity. In a society where people are increasingly becoming mere consumers, without the satisfaction of producing (or doing anything meaningful), whole supermarkets full of goods and all the money in the world cannot buy true satisfaction. If people can see meaning in the work they do, the things they produce, if work is not only alienated wage labour, the supposed limitlessness of our needs will be drastically reduced.

The Economy Must Permanently Grow—Only 'Productive' Work Is Work (Articles d, 1 and 2)

This is the most prominent article of faith of (neoliberal) capitalism: without growth no development, without growth the whole economy will stagnate and collapse. Economists define growth as the increase of all goods and services produced and marketed in the course of one year in one country. The sum of this growth is measured in the GDP or GNP (gross domestic product, or gross national product). If, at the end of the business year, the GNP has not grown by at least 2 per cent it is said that the economy is in crisis. Joblessness grows and firms go bankrupt. Trainer has calculated what would happen by the year 2060 with a yearly growth rate of 2 per cent: we would have an output of goods and services eight times the one we have now. One does not need much imagination to understand what this would mean for the environment, for natural resources, for people in the South, for labour and for the relations between nations (Trainer 1996: 21).

But why and how was this indicator of growth, GNP/GDP, created in the first place? What does it measure, what not? Marilyn Waring has convincingly demonstrated that the bulk of the work done on this planet is *not* included in this indicator, namely the work of housewives and mothers, the work of subsistence peasants and artisans, most of the work in the informal sector, particularly in the South, and, of course, the self-generating activity of mother nature. All this production and work does not *count*. On the other hand all destructive work—like wars, environmental and other accidents, oil spills, arms production, trade and so on—is included in GDP, because it 'creates' more wage labour, more demand and economic growth. The oil spill of the *Exxon Valdez*

along the Canadian Pacific coast some years ago has resulted in the biggest rise so far in Canada's GNP—because it required an enormous amount of work to undo the damage caused by this catastrophe.

'Destructive production' is not only a secondary component of GNP. Marilyn Waring found out that it was invented during the Second World War by the British economists Gilbert, Stone and Keynes. They had been given the task of finding out whether the war was economically viable. And they came to the conclusion that the war was good for the British economy. A war economy, contrary to what people thought, would have a positive impact on the national growth rate. After the war the indicator they had developed to measure this growth was adopted by the UN in the United Nations System of National Accounting (UNSNA). It was then used worldwide to measure the economic performance of all nations (Waring 1989).

This, however, does not yet answer the question of why the capitalist economy has to grow permanently. In order to find an answer to this question it is useful to remember the main goal of all capitalist production and consumption. In non-capitalist subsistence (Sahlins 1974/1984, Trainer 1996) *use-values* are produced for the satisfaction of limited human needs. When they are exchanged in the market, use-value is exchanged for use-value, for example, potatoes against apples. Marx called this the 'simple circulation of goods'. His formula is C–M–C:

$$\text{Commodity} \rightarrow \text{Money} \rightarrow \text{Commodity}$$

$$c \quad \rightarrow \quad m \quad \rightarrow \quad c$$

But the capitalist production process has a different beginning and aim. It starts with money and its aim is more money. This is achieved by using human labour to produce *exchange-values*. Exchange-values have no other purpose than to be exchanged in the market for a higher price than their production costs. The formula for this extended circulation is M–C–M':

$$\text{Money} \rightarrow \text{Commodity} \rightarrow \text{Money}'$$

$$m \quad \rightarrow \quad c \quad \rightarrow \quad m'$$

In the next production round the increased money (money') is again invested with the aim of again producing *more* money (money''). And thus ad infinitum. Use-value production and exchange-value production realise two different economic goals: the one life, the other money. The aim of use-value production—we also call it subsistence production—is fulfilled with the satisfaction of limited, concrete needs. It makes no sense to work longer once one has produced the things—or services—one needs for a good life. Exchange-value production, on the other hand, is by its very logic unlimited. Its aim is extended accumulation of ever more money, or abstract wealth. The formula for this extended, unlimited accumulation is:

$$\text{Money} \rightarrow \infty$$

In this logic lies the basic clue for the understanding of the capitalist growth mania, not in insatiable human greed, as some think.

The contrast between use-value and exchange-value production explains why, in spite of growing GNP, in spite of extended accumulation and in spite of rising standards of living the quality of life has deteriorated at the same time, even in rich countries. Daly and Cobb have shown that from 1950 to 1990 the GNP per capita in the USA doubled, but that in the same period the quality of life measured by twenty indicators like environment, loss of topsoil, etcetera, deteriorated (Daly and Cobb 1989: 420). In conclusion we can say that today there is a contradiction between standard of living and quality of life. The more the standard of living rises the more the quality of life goes down (Trainer 1996: 28).

A subsistence perspective, on the other hand, insists on the priority of use-value production. It is based on the recognition that, on a limited planet, limitless growth of money and commodities can only be destructive. To avoid this we must strive for a cyclic economy. It cannot be based on global free trade and investment. A subsistence perspective can be realised economically only in smaller, regionally limited, decentralised areas. Only in such regional or local economies can production and consumption be integrated in such a way that the interests of the producers and the consumers are not antagonistic.

The subsistence perspective also means a radical critique of the existing concepts of labour and labour productivity. In contrast to exchange-value production, only that work will be called productive that really produces, maintains and enhances life, not the work that simply contributes to money 'giving birth' to ever more money. Life will no longer be only a side-effect of extended accumulation; instead it will be the main goal of work. This life will be the outcome of mutual, respectful, loving, caring relations between human beings, between humans and nature, between old and young, women and men.

Such subsistence work need not be remunerated by a wage, it can also be exchanged directly. This necessary, life-producing work will get a new value, a value not based on money—if men and women share this work equally and if subsistence work has a higher prestige in society than wage labour. In this sense the subsistence economy would be like the old *oikonomia* (household economy) of the Greeks, but without slavery and patriarchy: It would have more prestige than *chrematistics*, the mere making of money for the sake of money, an activity that was despised in Ancient Greece. But such a change presupposes a change in the hierarchical, sexual and colonial division of labour.

It also presupposes the giving up of the belief that there is 'no life without wage labour', and instead the development of a new concept of labour and a new valuation of wageless labour. We have already talked about this unpaid labour in the context of the analysis of housework. In a subsistence society where this unpaid work is shared by men and women equally and where it is given a central place in society, the loss of

wage labour would not be a tragedy. It would not lead to exclusion, depression and loss of perspective. This is because people would not depend solely on wage labour but also on non-wage-labour; and non-wage labour would be more important than wage labour (see Chapter 7).

This, however, cannot happen unless communities have been able to reclaim and recover control over their most important common resources: land, water, forests, biodiversity, knowledge. In such a society the present contradiction between the conservation of a healthy environment and the compulsion to destroy this environment in order to create jobs would no longer exist. At last places of work would be places of life.

Increases in Productivity Are Desirable and Infinite. Technological Progress Will Compensate for All Ecological Damage Done (Article 6)

The articles of faith that an economy has always to grow and that our needs are infinite correspond with the dogma that productivity growth has no limits. Productivity is defined as output per worker per unit time. This productivity can be enhanced by science and technology. A worker who works at a robot in a car factory can produce more than a worker in an old-fashioned workshop. An increase in productivity means that less human labour is needed for the same output. Rationalisation therefore means the substitution of human labour by labour-saving technology. Computer technology has enhanced labour productivity in an unprecedented way in recent years and economists calculate that it will continue to grow 2 per cent per year (Trainer 1996: 23).

Productivity growth has the appearance of a natural law. One labour-saving technology makes an earlier labour-saving technology obsolete. Like extended accumulation, the process of science, technology and productivity is conceived as an infinite upward curve. It is assumed that it will continue to grow until hardly any human labour is needed to produce the necessary requirements. According to this assumption the ratio between human labour and technology, the organic composition of labour, as Marx called it, will tend to decline more and more, until it reaches a point where machines/technology do 100 per cent of the work and human beings 0 per cent—where dead labour dominates living labour.

If, however, we look at the real economy we see that this article of faith of permanently rising productivity is a Eurocentric, male myth. We see that the impressive labour productivity at the top of the iceberg economy has its dark underside in millions and millions of workers, many of them women, who continue to do labour-intensive necessary 'shit work' to keep the whole production and reproduction process going. The history of the emergence of computer technology, for example, reveals that hundreds of thousands of women worked in Silicon Valley and in Southeast Asia under most brutal conditions and for a small percentage of the wages Western male workers demanded to produce the first chips. If all these women in the global computer factory

had had to be treated and paid like male skilled workers in Germany, we would not have had a 'computer revolution'.

What we want to point out is that 'increases in productivity' cannot only be understood as simply the new inventions of scientists and engineers. These inventions need the cheapest labour to turn them into mass consumer articles. The superexploitation of Asian women in particular has to be seen as one of the factors when one talks of the computer revolution and the growth of productivity.

The result of assumptions that there is no limit to increases of labour productivity is not only the 'dark underside' of progress, namely poverty and violence, but also the fact of the making redundant of the workers themselves by this progress. It is often argued that progress of technology is good and necessary because it frees people from hard and monotonous work and enables them to produce more in a shorter time. But this argument ignores that science and technology are not being used by capitalists to make work lighter and more agreeable for workers but to save labour costs, to have better control over the labour process and to beat competitors by means of higher labour productivity.

The often-heard critique that a subsistence orientation is 'anti-technology' misses the main point, namely that the logic of a certain production system is *inbuilt* into its science and technology. They are not system-neutral. In a subsistence perspective, science and technology will have to follow a subsistence logic and not an accumulation logic. There will be technology, no doubt, but it will be a different technology (Mies and Shiva 1993).

It is a fallacy that technology as such increases productivity, saves labour and is able to undo the damages created by technology. We also have to remember that much of the environmental destruction caused by the combination of technology and economic growth mania cannot be undone, cannot be repaired. This is the case with nuclear contamination, gene-manipulated organisms, the ozone hole, the desertification of whole areas, the destruction of biodiversity. Modern technology and capitalist greed are only able to produce big black holes. They are not capable of filling them again.

The Need for an Alternative Perspective

We have carried our analysis of the existing capitalist–patriarchal world system to its logical conclusion not to end on a pessimistic note and to leave everybody depressed but rather to destroy the illusion that we can continue to eat our cake and have it too. If we still want to uphold our claim for a humane society and economy for all on a limited earth, then we have no alternative but to reject the whole destructive paradigm and search for an alternative.

And we think this is possible now—for two reasons: first, more and more people in the world rebel against the commodification and monopolisation of life; second, even the guardians of this system are at their wits' ends. To fill the 'black holes' neoliberal capitalism has created, they simply suggest more of the same.

But criticising neoliberalism, the IMF, the World Bank, the GATT, the MAI and TNCs will not help us to get out of the dead end into which this system has landed us. A mere demand to restore the *status quo ante*, to reconsolidate the welfare state through Keynesian economic policies and more public spending, will also not do. We need a much more fundamental change if we want to establish an economy and society in which women and children are the centre and in which nature is not destroyed for short-sighted monetary gains.

There is no ready-made blueprint of such a society or economy at present, and there is no country in this world where we could find such a new social vision in practice. But if one looks around one finds a surprisingly large number of individuals, groups, organisations, networks and grassroots movements where people are asking themselves the same questions we are asking here. And most of these individuals and groups begin to ask: What would an economy look like in which nature mattered, in which women mattered, in which children mattered, in which people mattered—an economy that would not be based on colonizing and exploiting others? It is perhaps no coincidence that such questions are often asked by women, and that such initiatives are often started by women—not always women who have studied economics, but always women who are concerned about the well-being of women, children and nature. They are scattered all over the globe, both in the North and in the South. Some are more involved in practical survival struggles, others in the women's and ecology movements; others in the peace movement, others are doing more theoretical work. What unites them all is the fundamental critique of the dominant economic paradigm and the endeavour to find new ways into the open.[5] And they mostly begin with the same search for an alternative economics.

Is Sustainable Development an Alternative?

The iceberg paradigm of capitalist economy, with its pyramid of colonisation and its destructive consequences, leads us to formulate a few theses about 'sustainable development':

- 'Catch-up development' is not possible for all people. Historical ([ex]-colonies, [ex]colonisers and actual differences between various types of workers in terms of gender, race, ethnicity and age are used to set one against the other in an antagonistic relationship. Thus, wage workers in the North who lose their jobs as a result of the globalisation of the economy tend to consider 'cheap labour' in the South and the East as their enemy. This in turn exacerbates racism and sexism and further diminishes the possibility of equality for all.

- 'Catch-up development' is not even desirable for the comparatively few on top of the iceberg economy.
- To preserve the foundations of life on earth, equality, justice and solidarity, new models of society and economy are needed that can lead towards true sustainability, or subsistence, as we prefer to call it.

We try to avoid the concept of of 'sustainability' because it is flawed right from the beginning. 'Sustainable development' is defined as development 'to meet the needs and aspirations of the present without compromising the ability to meet those of the future. Far from requiring the cessation of economic growth it recognises that the problems of poverty and underdevelopment cannot be solved unless we have a new era of growth in which developing countries play a large role and reap large benefits' (World Commission on Environment and Development 1987: 40).

In the meantime the original intention of integrating environment and development in one term has been totally perverted. Today the concept of 'sustainability' is most frequently used by TNCs to legitimise their neoliberal growth mania. They speak only of 'sustainable growth'. We want to stress, however, that true sustainability and permanent growth or capital accumulation are a contradiction in terms. For a new vision of an alternative paradigm we therefore prefer the concept subsistence.

Main Features of a New Subsistence Paradigm

1. How Would Work Change?

- There would be change in the sexual division of labour: Men would do as much unpaid work as women.
- Instead of wage work, independent self-determined socially and materially useful work would be at the centre of the economy.
- Subsistence production would have priority over commodity production.
- Today, subsistence production subsidises the market (money) economy. This must be reversed, liberating (decolonising) subsistence production so that wage labour and the market (money) economy subsidise the larger social productivity, the production of life.

2. What Are the Characteristics of Subsistence Technology?

- It must be regained as a tool to enhance life, nurture, care, share; not to dominate nature but to cooperate with nature. Technology should value the knowledge available among people.
- Technology should be such, that its effects could be 'healed' and repaired.

3. What Are the 'Moral' Features of a Subsistence Economy?

- The economy respects the limits of nature.
- The economy is just one subsystem of the society, not the reverse. This calls for changes in economic relations based on cost-benefit calculations and competition.
- The economy must serve the core-life system.
- It is a decentralised, regional economy.
- The goal of a subsistence economy is to support the subsistence society in the production and regeneration of life on the planet as a whole.

4. How Would Trade and Markets Be Different?

- Local and regional markets would serve local needs.
- The primary function of local markets would be to satisfy the subsistence needs of all.
- Local markets would also preserve the diversity of products and resist cultural homogenisation.
- Long-distance trade would not be used for meeting subsistence needs.
- Trade would not destroy biodiversity.

5. Changes in the Concept of Need and Sufficiency

- A new concept of the satisfaction of needs must be based on direct satisfaction of all human needs and not the permanent accumulation of capital and material surpluses by fewer and fewer people.
- A subsistence economy requires new and reciprocal relations between rural and urban areas, between producers and consumers, between cultures, countries and regions.
- The principle of self-reliance with regard to food security is fundamental to a subsistence economy.
- The important concept and practice of the commons can be reclaimed to resist the injustice linked to privatisation and the commercialisation of nature.
- Money would be a means of circulation but cease to be a means of accumulation.

Footnotes

1. EPZs, Export Processing Zones, are so-called because their production is not for a home market but for consumers in the North. At the border between the USA

and Mexico they are called *maquiladoras*. The TNCs chose Third World countries as sites for their relocated global factories because of the great differences of labour costs. In 1994 a production worker in Germany earned US$25 per hour, a worker in the USA US$16 in Poland US$1.40, in Mexico US$2.40, in India, China and Indonesia US$0.50 (Woodall 1994: p. 42).

2. The book *Silk and Steel* was written in 1995, before the present financial crisis in Asia had broken out. From all we know this crisis has only exacerbated the tendences described above. The situation of women has dramatically deteriorated in all the countries of Asia. Due to the practical breakdown of the economies there are not only mass lay-offs of male and female workers, but also increasing direct violence against women (Mies and von Werlhof 1998).

3. This round of negotiations is so named because it started in Uruguay.

4. The FAO conference on biogenetic resources took place in Leipzig from 17 to 23 June 1996, and was thought of as a preparation for the World Food Summit in Rome. At this conference, US interests took a stand against the resistance of primarily Southern environmental protectionists and farmers, who represent the right of the local farmers and communities to retain legal rights concerning their diversity of plant types and seeds, and who do not wish these rights given over to TNCs.

5. The most recent example of such movements is the one against GM food and genetically manipulated organisms. It started among Indian farmers but was taken up by consumers in the UK, the USA and several countries in continental Europe. It led to a questioning of the whole globalised economic system, particularly in the UK where the 'From Global to Local' campaign is explicit about its new economic goals.

Women and Biodiversity as Capital Accumulation: An Eco-Feminist View

Ana Isla[1]

Introduction

*T*his paper develops the eco-feminist premise that sustainable development and women in development programs are instruments of neo-colonization of women's work, and of nature in the Third World. To achieve these aims, the centres of power in the industrial world have mobilized an array of institutions and discourses strongly linked with the

expropriations of biodiversity and rural women's labour power in the rainforests of countries indebted to first world businesses, agencies, organizations and governments. A case study of a gender in development crusade that promotes micro-enterprise for gender equity connects these processes. As biodiversity and women's non-wave labour comprise the support system that local communities rely upon for survival, micro-enterprise for women's equality has become a war on subsistence. Thus the unstated aim of expending industrialization and restructuring capital accumulation worldwide underlies the stated concern for environmental conservation and women's equality.

The theories of modernization and economic growth that dominated the economic development discourse in the beginning of the 1950s remain dominant today in theories of sustainable development and women in development. The discourse of economic development promised elimination of poverty in the Third World through different kinds of investment alleged to promote economic growth (Rostow 1960). Poverty was understood as absence of western consumption patterns, cash incomes and industrialization (Mics and Shiva 1993). The discourse of sustainable development assures that globalization of the economy will rescue poor countries from their poverty, even in the most remote areas of the world (Pearce and Warford 1993), yet poverty is once again made the excuse for now results on local commons in those countries.

This paper takes up a case study connecting two aspects of development: sustainable development and women in development in Costa Rica. Sustainable development, as proposed by the Report of the United Nations' World Commission on the Environment and Development (UNWCED) in *Our Common Future* (1987; also known as the Brondtland Report) emphasized the need for continued economic development (or, rather, economic growth) to save the planet. The Report's hopes for the future are contingent on decisive political action in managing environmental resources. The kind of sustainable development the report foresees must occur in the tropics of Third World countries as they host the greatest number and diversity of species.

Many disciplines and policy-making bodies are involved in redesigning the rain forest commons. The World Bank (WB) argues that, because economic rationale has become supra-territorial, environmental issues must also be considered at an international level. Using the rationale of neo-conservative economic thought, the WB asserts that the ecology must be embedded in the economic system. This requires a fully monetized world—by including nature in all its forms in the market as natural capital. In this regard, Kirk Hamilton (2001) of the WB has developed what he calls "genuine" saving measures which "broeden the usual national accounts definitions of assets to include human capital, minerals, energy, forest resources and the stock of atmospheric CO_2" (Hamilton 2001).

The Global Resource Managers (GRMs) use geography and the Geographic Information Systems (GIS) to facilitate their managing decisions. The WB has been financing

the GRMs, through the Global Environmental Facility (GEF), since the Earth Summit of 1992. I will henceforth refer to the GRMs as Corporate Environmental Non-Governmental Organizations (CENGOs); i.e. the large environmental organizations are performing the role of management. They are a special category of functionaries, subordinated to the ruling class, in which the managers are involved in the process of corporate globalization, economic restructuring and colonial practices. In the past, the main objectives of the corporate environmental organizations have been to identify and gain access to ecologically sensitive areas for use as sites for research and scientific data collection (Dawkins 1992). The growth framework has revived colonization, as local-commons (land, water, biodiversity, rivers, lakes, oceans, atmosphere, forest, mountains) at the NATIONAL, regional, and municipal levels are handled by global actors and local concerns are no longer existent. Michael Goldman (1998) reflects that "As long as the commons is perceived as only existing within a particular mode of knowing, called development, with its unacknowledged structures of dominance, this community [the CENGOs] will continue to serve the institution of development, whose *rairon d'être* is restructuring Third World capacities and social-natural relations to accommodate trans-national capital expansion"(47).

Since the debt crisis, in 1982, the indebted countries can no longer deliver services and policies due to the dismantling of the State; consequently CENGOs are managing the societies and environments of these countries. According to Gold man, CENGOs "have replaced the barefoot peasants as the "experts" on the commons; now, within the new discourse, it is their knowledge, rules and sciences and definitions that have become paramount for explaining ecological degradation and sustainability" (35). CENGOs are more concerned with the expansionary demands of the North's industrial base than with the health of the ecology. They will make sure that industry gets what it needs, because industrial expansionist projects require more raw materials extracted from the earth, rivers, forests, and aquifers, as well as cheap labour. Coincidentally, the decision-makers in the WB and the CENGOs are mostly male (although, increasingly, some women are co-opted), while, and upper middle class.

The appropriated lands are designed along the lines of national parks in North America, from which people are excluded and denied any role in sustaining the ecosystems (Hecht and Cockbum 1990). These expropriated lands are linked to transnational and political networks in order to forge local and global "stake-holders" in the era of sustainable development and corporate globalization. Thus new outside actors and new interests have become central in local communities, which are dispossessed through this process. For this purpose, proponents of the model have portrayed *campesinaslos* and indigenous peasant populations as the prime enemies of the rainforest in order to legitimise the latter's exclusion (Hecht and Cockburn 1990). The views of these disciplines and decision-makers form the guiding policies for sustainable development (Goldman 1998) and women in development (Isla 2000).

The definition of biodiversity as natural capital also has powerful effects on the sexual division of labour, as the market system is introduced in rural areas and women's traditional knowledge becomes devalued. This paper shows that sustainable development and women in development are connected. Sustainable development has defined biodiversity as "natural capital" while women in development has delineated women as "human capital." Since capital has converted the sensuous world into an abstraction for the purpose of profit, nature and women come to express alienated ways of being. On the one hand, nature is understood as a source for biotechnology/bio-piracy, mining, ecotourism, and oxygen generation carbon sink (Isla 2000, 2003, forthcoming). On the other hand, rural women get loans to develop biodiversity-related micro-enterprises which have become the main instrument of the Sustainable Development model for gender equity and environment. The double enclosure or expropriation of biodiversity and of women's productivity have become a war on subsistence.

This article addresses the commodification of rural women's labour power through the use of debt swaps: financial mechanisms to exchange debt for ownership in national industries, bank assets, and nature. Debt-for-nature swaps were proposed by several corporate environmental groups as a way of capturing some benefits of debt-reduction efforts. The case in this article involves the use by the World Wildlife Fund-Canada (WWF-C) of debt-for-nature funds provided by the Canada/Costa Rica debt-for-nature swap (MOU 1995) to organize micro-enterprises all over Costa Rica. In the Arenal Conservation Area, the WWF-C organized the Abanico Medicinal Plant and Organic Agriculture micro-enterprise (*The Abanico Project*,) in collaboration with Andar de Costa Rice (a Costa Rican NGO using Dutch funds), as part of a "Women in Development" (WID) program whose aim was gender equity. Although WID and Gender and Development (GAD) are often distinguished in the literature, they share the elements criticized in this paper; they are therefore treated together as WID/GAD (WGID).

In implementing the WGID agenda, the WB is interested in expanding human capital. The WGID framework criticizes the failure of economic development to recognise the productive role of women. Boserup argued in 1970 that the division of labour between women and men has created a wide gap in productivity and income, lowering the position of women in relation to that of men. "The gap between productivity and earnings of men and women is further widened because those few women who are employed in modern industry are mostly doing unskilled jobs" (117). She called for the education and integration of women into development projects as a way of legitirizing the claims of women to an equal share of the benefits of development. Since the debt crisis, WGID supporters have also criticized the unequal gender outcomes of the stabilization and structural adjustment programs implemented by the International Monetary Fund (IMF) and the WB. They point out that women generally suffer more

than men from the restructuring of education and health care, from the elimination of state social programs, from the removal of subsidies in the food system, and from high inflation. They propose that macro-economic policy be "engendered" in order to curtail differential outcomes for women (Bakker 1994).

Feminists cootradict those views and argue that, theoretically, WGID embraces the standard predictions of neoclassical economic discourse based upon a model which assumes that markets are perfectly competitive, with no market participant able to influence the price of any input or output. Consequently, WGID's economic discourse, demanding a strong state to remove the constraints that prevent women from reaching their full development and to channel resources to women, is futile and flawed as well as contradictory since the IMF-WB, WTO and other international corporate regimes forbid national governments from violating the laws of the market. During the sustainable development era, rural women's labour itself has becomes a commodity, that is, a source of surplus value. This transformation is spearheaded by the Women/Gender in Development (WGID) program that promotes the inclusion of women in the international market via micro-enterprise. Foreign currency earning is sought by the establishment of micro-enterprise as a way of introducing to the market innovative products based on biodiversity. In the rain forest, women and their products (medicinal plants) are becoming the basis for capital accumulation. The WGID components are often incorporated into these micro-enterprises an income generation activity for women's equality.

This paper also evidences the feminist argument (Shiva 1999, Pietila cited in Miles 2002, Mies 1999, Waring 1988 and Miles 2002) that the market does not *create* goods and services; these already exist in household work, local communities and ecologies. They are marketed to benefit some groups in the society while the communities from whom their wealth is removed become impoverished. Consequently, sustainable development and women in development are macro-economic instruments for control of the nature commons of the Third World and household work.

Data used in this analysis were collected during the summers of 1998 and 1999 in the process of my research examining the impact of the Canada/Costa Rica Debt-for-Nature Investment, and during 2001 in the process of my post-doctoral research, "Women's resistance to loss of community livelihood in the Arenal Conservation Area, Costa Rica." Information on Abanico Project was a Feminist Participatory Action Research project. By that time, women were already in economic crisis; hence they proposed to research the following question: Why are we working so hard and why can we not improve our quality of life? After three months of intensive data collection, the research confirmed the women's experience. Despite the fact that they have experienced some increased status and agency in the community in term of assumed responsibilities, the members of the Abanico Project have suffered serious negative consequences from their involvement with the project.

Women in Development—Women as Human Capital

a. Distinguishing Nature and Women's Generative Power

Medicinal plants form the common knowledge of rural women. Through centuries of interaction rural women have created a rich and elaborate culture—a culture of the medicinal plants whose biological value is intrinsically linked to social, ethical, and cultural values. The social and cultural significance of the medicinal plants used to remain unrecognized, because it was linked to women's work—something seen as non-work and non-knowledge despite the fact that women's work and knowledge has been central to biodiversity conservation and utilization. Medicinal plants were traditionally produced for a family's consumption, that is, they had no exchange value but only use value. Crucial to medicinal plants was the rainforest commons. Rural women were the keepers of medicinal plants and knowledge; as such they prepared *cocimientos*, which are combinations of plants used for healing purposes. Most rural women grew medicinal plants surrounding their homes as part of the intercropping system. In Abanico, as part of our research, women identified more than 60 wild medicinal plants and herbs. They also have the knowledge to make *cocimientos*. Having grown medicinal plants for centuries, women have acquired skills and the knowledge of seeds, and soil preparation.

With the advent of sustainable development in the 1990s, medicinal plants and organic agriculture (a productive system that uses regional components and avoids the use of agro-chemicals and growth regulators) have been mainstreamed as social and ecologically sound. In an ideological sense, many of the development programs are based on the assumption that indigenous people and peasants are culturally backward. Their ecological management systems, such as intercropping and agro-forestry, are seen as obstacles to modernization (Nygen 1995: 124). Medicinal plants have become a source of income for many women who become organized in micro-enterprises. According to the Northern consumers' preference, organic production is a growing market from which, supposedly, economic growth in rural areas will benefit. Organized into micro-enterprises, medicinal plants become commodities and the women become commodity producers. In this process, medicinal plants and women lose generative power. Medicinal plants, as a commodity, are located in an entirely different world, the commodity world, where profit is the only value.

In the process of commodification, medicinal plants lose their social, ethical, cultural, and even biological power and become mainly an economic value. When plants are domesticated and planted in monoculture crops, they are deprived of species association, and the destruction of their inherent properties starts. The deprivation of wild surroundings and different exposures of sunlight cause changes to their chemical properties. A plant in its natural ecosystem is inter-acting with other plants and its obiotic resources (soil, water, light); therefore, the plant conserves its properties as a natural defence. Its genetic strength is more active and dynamic against its predators

(Alvarado 1998). Therefore, producing medicinal plants as monoculture crops does not mean sustainability but genetic erosion, and it decreases the medicinal plant's fertility. When medicinal plants and organic agriculture are put together for the market, they shift from being a source of women's power (as it was women who provided *cocimientas*) to being a source of women's exploitation. Land enclosure and the disintegration of the ecosystem that supported the means of survival of local communities have thus also had powerful effect on the sexual division of labour, shifting women from subsistence production to the growth of cash crops for sale in the international market.

b. The Abanico Project

Andar de Costa Rica, a Costa Rica NGO using funds from the Costa Rica/Holland debt-for-nature swap, is directed by a middle-class woman. Andar defines the *Abanico Project* as a *campesina* small family-business development alternative within the globalization frame that will foster community economic welfare and gender equality in a sustainable environment (Asociación Andar 1996). According to Andar, the women's project must be supported by the whole family. As women's programs have no government resources, NGOs are using debt-for-nature swaps as a credit source to initiate income-generating activities in the women's sector.

Andar do Costa Rica in conjunction with Grupo Ecologico de Mujeres de Abanico (GEMA) (a group of local women established for the project) organized individual micro-enterprise projects for the cultivation of medicinal plants and organic agriculture. This was done on the women's family farmes, because rural women in Costa Rica are landless. GEMA's group project is made up of nine local women, 28—50 years old, of whom seven are married and two are single. They live and till their plots on their husbands' and parents' farms, respectively. The land holdings of the women's families vary from two hectares to ten hectares. The amount of land used by women on their own projects varies from 500 sq. metres to 1,500 sq. metres. Members of GEMA grow their "organic crops" on these small plots situated in the middle of the agro-chemical-based farms of their fathers, husbands, or in-laws.

In 1998, *the Abanico Medicinal Plant and Organic Agriculture (Abanico Project)* and the author participated in a Ferninist Participatory Action Research (FPAR) project. Despite the fact that they have experienced some increased status and agency in the community in term of assumed responsibilities, the members of the Abanico Project have suffered serious negative consequences from their involvement with the project (Isla 2000).

In the productive realm, four causes of their poverty were identified:

1. Each stage of the Abanico Project was built on loans from NGOs. A credit from the Arenal Project, directed by the WWF-C, using the Canada/Costa Rica debt-for-nature swap, provided a loan of CDN $4,480 (700,000 colones) at an interest rate of 20 percent to begin the micro-enterprise. In addition, Andar de Costa Rica lent to the group CDN $6,400 (1,000,000 colones) to buy an old

house, which is expected to be a processing plant as well as a site to sell the products, at an interest rate of 33%.

2. To develop a micro-enterprise, families had to transfer an important part of their land from food production to the production of medicinal plants. Yet the financial return to women is so small that it cannot help even one family member survive. Data show that women involved in the project earned in 1998 an hourly average of US $ 0.11, well below the Costa Rican minimum agricultural wage of US $ 0.97 per hour.

3. The women's working time expanded, lessening their personal availability for activities important to the community and their families. On average, they spent nine hours a day weeding, seeding, or harvesting. Their work is time-and labour-intensive. The most time-consuming task is the weeding, which is done with anachetes rather than herbicide. The typical day on the plot starts around 5:30 A.M. with cutting, selecting and cleaning the leaves. From 8:30 to 9:00, they spread the leaves in the solar drier, before it becomes too hot to work inside. When they are not cutting plants or weeds, they are preparing natural pesticides using gavilana, garlic and onions; applying fruit fertilizers using gusyaba, papaya, camote; and preparing seed beds. The women work nine hours in the medicinal plant plots, many more hours at home, cleaning, cooking, washing, ironing, caring for the elders and rearing children, and doing community work. They were active members of the Abanico Development Association Board of Directors, the church, the school, and Andar's credit committee. In 1999, on Friday afternoons these women spent additional working time preparing food to sell in *la feria* (local market) in order to pay their debts to the NGOs. Every week, two members of the group were in charge of preparing cold food such as larnales (rice and yocca with slices of meet) the night before and collecting supplies for a vegetable soup which was prepared in the local market. This activity was short-lived, because of difficulties in getting to the market location. Women's working time has increased with the closing of the health centre and the elimination of one teacher in the elementary school as a result of the structural adjustment programs, imposed by the IMF and WB policies. Their increased workload can lead to the inter-generational transference of poverty; household duties are passed to daughters, decreasing their education possibilities.

4. In the face of daily inflation and devaluation caused by the IMF and WB policies, wages are inadequate. Indeed, the legally prescribed maximum working day in those micro-enterprises has disappeared. Working for less than the minimum wage, these women will eventually collapse, exhausted by a never-ending competitive spiral of reducing real wages.

In the commercial realm, since the aim of micro-enterprises is to earn income by producing commodities for export, their products must be geared to the international market. These projects can only be developed within the NGOs' dependent structures.

Consequently, as an income-generating project, the work of the members and their families' is not only cheapened but also controlled because they are isolated and unorganized. This process is part of what Maris Mies (1986 1999) has called the "housewifization of labour," whereby women's autonomous subsistence work is eliminated in favour of poorly-paid exploitation in the capitalist market. The "housewifization" is facilitated by the fact that women in micro-enterprise are not seen as workers. Their work in the micro-enterprises is seen as the prolongation of women's work at home. Micro-enterprise is thus the first step in introducing rural women's labour into the market as human capital and making them produce for the world-market, not for their own subsistence.

Medicinal plant micro-enterprise leads to inequality, hunger, and environmental degradation among its participants. Instead of producing for their family and their communities, the micro-enterprise model makes women produce luxury items for the rich while the producers—women and their medicinal plants—are damaged. Hence, it has forged a gendered class struggle.

c. Resisting Housewifization

Aware of their situation, the group of women growers went to Consejo Nacional de Producion (CNP), a government agency, in charge of non-traditional production. As the cultivation of medicinal plants is non-traditional production, a type of economic value that CNP promotes, the group's research also drew its attention. As a result, CNP held a meeting in 1999 with all women's groups around the country working with Andar in medicinal plants and organic agriculture. The groups included: Las Malinches de Pocosi; Las MUSA (Mujeres Unidas de Sarapiqui); ASMUCA Group; *Grupo de Giras "Alfonso Quiroz de Acosta"*; GEMA *(Grupo Ecologico de Mujeres del Abanico)* from Abanico; and ARAO (Regional Association of Organic Agriculture) who worked with Andar.

The space provided by CNP permitted these women to reflect on their situation. The participatory research process empowered the Abanico group. Its members spoke about their low earnings, high levels of interest, long working hours in micro-entrepreneurial, housework and community work, and refuted the notion that women's work is "complementary" to men's. During this meeting, the Abanico women broke their relationship with Andar.

Women's resistance to Andar's exploitation brought the CNP into the picture of the *Abanico Project.* In 2000, CNP measured the land that women use in the micro-enterprise, made a direct approach to industry-Manzate (industry producing tea), and secured a contract. Manzate promised to buy the total production of *tilo* the group produced. With the assured buyer the group pulled out all the other medicinal plants except *tilo*. A monoculture production was thus initiated. In 2000, an area of 52,317 m^3 produced medicinal plants; *tilo* represented 80.02% of the land. In this year, the group sold *tilo* to Manzale according to a contract arranged by CNP. But in April 2001

the group received a letter from the enterprise invalidating the initial agreement and reducing its purchase to 800 kg every two months.

With the reduction in the sales of *tilo* on which the group had counted, it entered a new cycle of crisis among the members. Members complained that the new arrangement imposed by Manzate forced them to take care of the plants longer (dry medicinal plants must be sold immediately, otherwise they lose mass), extending their unpaid work or colonizing other people's work in order to reduce production costs. For instance, Juanilema (a medicinal-plant name used here as a pseudonym for one of the women involved) employed two Nicaraguan men to help her to maintain the *tilo* production. She explained that the only reason that she could afford salaried workers is because she barely pays them and they bring their families to work weeding the field. To cope with the new arrangements, the group assigned an amount of *tilo* that each member was allowed to sell every two months. The selling amount was based on the level of indebtedness of each member. This created difficulties, because the arrangement allowed one beneficiary, Juanilams, who has more land and more debt, to grow more *tilo*. Consequently, this plan brought about disputes.

The trouble created by the reduction in the sales also produced disputes among the members and created distance and antagonism. Members who are sisters, mothers or friends were not speaking to each other when I returned in 2001. A dispute, which included violence, broke out among the members of a family involved in this group. Two were accused of cheating. According to the association, one of them had stated in May that she had no *tilo* to sell, so the members could allocate 50 more kilograms. But, when Manzate's collectors collected the herbs, she added her 50 kilograms without informing the others; consequently, members who had increased their amount in that particular month were left with their additional parcel. This member was accused of handing over other members' *tilo*. This dispute produced a serious conflict between sisters first, sisters and mother second, and the whole organization later.

In July 2001, the group and I had several conversations. On one occasion we focused on exchange value and the use value of the medicinal plant. The conversation on the exchange value of the medicinal plants was lense. Most members were not talking to the two accused members. To break the tension, one of them brought up the dispute and asked for forgiveness. She explained as follows the discouraging times the group was experiencing because of the sales reduction:

To decide how many kg each member could sell has produced a crisis in the group. Many of us are not talking to each other, although we are sharing the same misfortune. Because we have in common the need to make the economic situation of our families better, we need to find support anywhere and we accepted the CNP initiative to discuss our problems with a psychologist. Our betterment will help our children and our community.

The group was scheduled to have group-psychological therapy. CNP-San Jose proposed a psychologist to mediate the crisis because, in the words of one official, "the

group was not tough enough to survive the globalization project." CNP does not recognize that women's economic lag is not a result of their "femininity'" but the reality of women's working conditions (performing triple work shifts and having no land of their own) and the market mechanism (liberalization of interest rates and the dismantling of the agriculture and food system). Instead of seeing the problems in how society is structured, CNP's message is that women need to fix their psyches to be able to participate in and profit from the globalized market. Pushing women to discuss their "personal problems" with a psychologist shows the tendency to see women as pathologized and in need of a fix. Yet it was the economics of the medicinal plants that produced grievances among the members. As Jualinama said:

> At the begining, Manzate told us to sow more and more. We removed whatever plants we had in order to now *tilo*. But when we all had been reduced to planting *tilo*, the enterprise told us "I will buy 500 kg every two months." Yerba Buena (pseudonym) said: "I believe that Manzate has new sources of supply. When we were few in the market, we had a good arrangement, then we were promoted on TV and radio as great medicinal plant sellers. Now there are many women organized around medicinal plants. We were crushed by our promotion."

In the case of medicinal plants, the expansion of the micro-enterprise as a poverty-alleviation program of WGID is organizing women's groups all over the world to produce for the international market, and they are producing the same products for the same consumers. The WGID program complements the stabilization and structural adjustment programs, designed by the IMF and the WB and forcibly imposed on indebted countries in order to reduce labour costs and commodity prices. Only corporate NGOs and industry profit from this arrangement; the former receive high interest rates for the loans while the latter receive, almost for free, products that will sell in the international market.

During our conversations, the women recalled the income they had earned. During July and August 2001, Juanilama who sold 160 kg (more than anyone in the group) and received US$393, while other members sold less than 50 kg and received US$ 98. The minimum wage in San Jose, the capital city in 2001, was US$240 monthly; with the exception of one member, these women were not earning half of the animal wage. Comparing their income with the labour-time spent on the production and maintenance of the medicinal plant (nine hours daily), it can readily be seen that the micro-enterprise that supposedly was going to alleviate poverty was making subsistence producers destitute. Moreover, because they were producing for the international market, the biomass of their land has not been used for their family needs. Instead the production of medicinal plants produced privation and hunger. Juanilama wished to plant food for her family, but she cannot afford to do that due to her debts with the NGOs. She stated, "I want to plant what I can eat. If I do not sell the product at least, I can eat. But I cannot eat medicinal plants." Menta remarked: "I am discouraged from producing *tilo*.

Right now I am thinking about leaving the medicinal plant production to produce what I use in my daily life, because this job does not even pay my own labour."

Reflecting on what they have learned in working in a micro-enterprise, they observed that while they were working the farms of their fathers and husbands, the land fed their families and built relationships among themselves. With the micro-enterprise their families are hungry because the market does not return their investments; consequently their friend and family relationships languish.

When the focus group turned to the medicinal plants as use value, it became the embodiment of relationships. Naming the benefits those medicinal plants brought to their lives became the connection among them and turned into a great conversation that permitted lively exchange and great communication. Members who had not spoken previously entered the conversation. It brought memories of family members, grandmothers and mothers, times of sickness and happiness, scents and pleasures. Furthermore, they recognized how their individual lives had been enriched because of their regular use. As Yierba Buena said: "Menta (pseudonym) has been turned into the medicine-plant-doctor in the town. She has medicinal plants not only to sell them, but to alleviate and cure the ailments of the members of this community."

Laughing, Menta recounted her experience:

> I turned the medicinal plant into a health issue because I was always sick. I had daily headaches. To cure myself I initiated experiments with my own health following the knowledge of the ancestors and it worked. Since then, people call me to ask for my advice when they or their children are sick. I get satisfaction when people feel well. For my wisdom sometimes I get paid. I would like to know more about natural medicine. (Laughing) My husband believes that the medicinal plants are making me crazy because now I want to be a nurse; he says that soon I may want to be a doctor.

They all laughed, and one by one they started to relate their accomplishments with medicinal plants. Most of them are again using medicinal plants on a daily basis in their households, with their children and ill family members. Speaking about their mothers' and elders' knowledge of medicinal plants, they realize that they have a whole knowledge system that has been made invisible. These women know that every plant is infused with properties and they use them as real doctors.

When asked what their hopes for the group were, Yerba Buena reflected that they might be living on illusions or in self-destruction. But they just learned about an offer from CNP that sparked again their hope in sustainable development. She said,

> Finally, we are going to use the old house, bought with ANDAR's loan, paying 33% of interest, as a processing plant to make tea, soap and shampoo. CNP (Consejo Nacional de Produccion) has negotiated a donation from Foode-Cooperation (cooperacion funds from Holland) to help the group build a feedback centre, and learn marketing technics.

They now are again hanging their dreams on what Wallerstein and Mies have called "catch-up with development." Development "is upheld by the promise that eventually women and all the colonized people at the bottom of the social pyramid will reach the level of those on the top" (Mies 1999). They do not know that this catch-up development is a myth (Mies and Shiva 1993, De Rivero 2001), that there is a connection between the wealth of one pole and the poverty and regression of the other pole.

Conclusion

Until the end of the 1980s, the biological diversity of the rainforest had no exchange value by itself, but use value and exchange value to the populations whose survival depended on the ecosystems where they live. Then poverty in the rainforest was defined as a lack of cash incomes, industrialization, consumerism. As a result sustainable development and women and development programs ignored the benefits that nature provides in its natural state to local population and produced a crisis of survival, social injustice and destruction among the rainforest ecosystems and dwellers.

Sustainable development and Women/Gender in development programs that promote women's equality by including women in the international market are damaging to women. As a result women are becoming indebted, extending their working time, transferring their biomass and food production to the production of medicinal plants, and working for less than the minimum wage. In sum, the micro-enterprise Abanlco Project has shown that sustainable development and women/gender in development programs connect vulnerable local nature and local women to the international markets and the world-economy for capital accumulation.

Footnote

1. Ana Isla is an Assistant Professor at Brock University.

Bibliography

Area de Conservacion Areasi (ACA). 1993. *Plan General de Uso de la Tierro, Tomo I, II, III, IV.* (Costs Rican Ministry of Natural Resources, Energy and Mines [MINAE], with the support the Canadian International Development Agency [CIDA], and the World Wildlife Fund-Canada [WWF-C]).

Alvarado, Cafso. 1998. MINAE biologist. Personal interview. Summer 1998.

Association ANDAR. 1996. "*Resumter Electro. La Education Participatives y el Enforces de genero para fortelecer las capacided de organization de Mujres y Hambres Campeslxes de is Region Huetar Norte.*" Unpublished paper. San José.

Bakker, Imbells. 1994. "Introduction: Regendering Macro-economic Policy Reform in the Era of Global Restructuring and Adjustment" in *The Strategle Silence. Gender and Economic Policy.* Edited by Isabella Bakker. (Zed Books in association with The North-South Institute) pp. 1–29.

Boserup, Ester. 1970. *Women's Roles in Economic Development.* (New York: St. Martin's Press).

DeRivero, Oswaldo. 2001. *The Myth of Development. The Non-viable Economics of the 21st Century.* (Zed Books, London and New York).

Goldman, Michael. 1998. "Inventing the Commons: Theories and Practices of the Commons' Professional" in *Privatizing Nature. Political Struggles for the Global Commons.* Edited by Michael Goldman. (Rutgers University Press. New Brunswick, New Jersey).

Hamilton, Kirk. 2001. "Genuine Savings, population growth and sustaining economic welfare." Paper presented at the Natural Capital, Poverty and Development Conference, 5–8 September.

Hecht, Susana and Alexander Cockburn. 1990. *The Fate of the Forest, Developers, destroyers and defenders of the Amazon.* (Penguia Books, England).

Isla, Ana. 2000. An Environmental Feminist Analysis of Canada/Costs Rica Debt-for-nature Investment: A Case Study of Intensifying Commodification. Doctoral dissertation, OISE/university of Toronto.

Isla, Ana. 2003. "Debt Crisis and Debt-for-Nature Investment at the Periphery: The Costa Rican Case" In *Emerging Issues in the 21st Century World-System.* Volume 1, Crises and Resistance in the 21st Century World-System. (Praeger, Westport, Connectict, London. Edited by Wilma A. Dunaway).

Isla, Ana. Forthcoming. "Land Management and Ecotourism: A Flawed Approach to Conservation in Costa Rica," in *Natural Capital, Poverty and Development. Eds: Adam Fenech, Roger Hansell and Kirk Hamilton. Amsterdam: Klvwer Publishing.*

Jimenez, Welberth, Marco Zamora, Felix Angulo, Lucila Camacho, Rodolfo Quesada, Jorge Pleitez. 1998. "Biodiversided y Empreso Campasina: Simbiosla o Depreciation?" *Perspections Rurales 3. Mercandos Alternatively Pequences Productive.* 2(i). (Marzo), pp. 60–74.

Mies, Maria. 1986. *Patriarely and Accumulation an a World Scale. Women in the International Division of Labour.* (London: Zed Books Ltd.).

Mies, Maria and Vandana Shiva. 1993. *Ecofeminism.* London and New Jersey: Zed Books.

Mies, Maria and Veranika Bennholdt-Thomsen. 1999. *The Substance Perspective. Beyond the Globalized Economy.* (Zed Books, London and New York, Spinifex Press, Australia).

Miles, Angela. 2002. "Women's Work, Nature and Colonial Exploitation: Feminist Struggles for Alternative to Corporate Globalizations" in *Canadian Journal of Development Studies.* Vol XXII, 2001, Special Issue. Eds. Terisa Tumes and Leigh Brownhill.

Memorandum of Understanding (MOU). 1995. Between the Government of Canada and the Government of the Republic of Costa Rica.

Pearce, W. David and Jereny J. Warford. 1993. *World Without End: Economics, environment and sustainable development.* Published for the World Bank by Oxford University Press. New York. NY.

Rostow, W. 1960. *The Stages of Economic Growth: A Non-Communist Manifesto.* (New York: Cambridge University Press).

Shiva, Vandana. 1999. *Biopiracy. The Plunder of Nature and Knowledge.* (Between the Lines. Toronto).

Tremblay, Claude and Daniel Maleafant. 1996. "*Estrategias Locales para Favorecer la Sostanibilidad de Acclones de Desarrallo El Caso del Proyecio de Conservation y Desarrollo Arenal Costa Rica.*" Paper presented at the *Congreso Murdial de Conservacion* (Global Conservation Conference) held in Montreal, Canada 17–21 October.

Waring, Marilyn. 1988. *If Woman Counted. A New Feminist Economics.* (San Francisco: Harper and Row).

World Commission of Environment and Development. 1987. *Our Common Future.* (Oxford, Toronto: Oxford University Press). Also known as the Brundtland Report.

36 Steps toward a Gift Economy

Genevieve Vaughan

To Change Society We Must Think in a Different Way

We must realize that:

1. Market exchange is not natural, real or necessary. It is an invention of patriarchy. The "illusion" that some religions find life to be, is created by the disalignment of our behavior and our constructions of reality, with the deeper logic of nature. Women appear more "natural" because they are in alignment with this logic while patriarchy is an aberration and an illusion. The disalignment and refusal to practice and value the deeper logic create the unhappines and the many problems of society.

2. The market actually creates negative relations which foment isolation, competition, war and domination.
3. Exchange—giving in order to receive an equivalent of what has been given—is artificial and is derived from a more fundamental behavior which has a logic of its own. This more fundamental behavior is gift-giving, giving directly to satisfy needs.
4. Giftgiving creates positive relations, through direct need satisfaction which creates bonding, communication and community.
5. Exchange and giftgiving constitute two ways of thinking and behaving that coexist but the giftgiving way remains largely unconscious. Many problems derive from the co-existence and interaction of these two logics and behaviors.
6. The logics of exchange and giftgiving constitute two paradigms or world views which compete with and complement each other. Exchange conceals giftgiving, competes with it and takes advantage of its gifts. Gift giving gives in to exchange and gives value to it. Giftgiving also often misrecognizes itself as valueless.
7. One of the ways giftgiving is hidden in a society based on market exchange is by recognizing it only in mothering, charity, and forms of symbolic gift-exchange. Other areas of life are seen as biologically based and governed by abstract rules. For example our society likes to look at the basis of language as biological, a hard wiring of our brains. Instead giftgiving can be seen as the basis of language at many levels, as the creation of human relations through the giving and receiving of verbal gifts, the mothering tongue. By restoring giftgiving to the many areas of life in which it has been unrecognized or concealed, we can begin to bring the gift paradigm to consciousness. Giftgiving underlies the synonymity of "meaning in language" and the "meaning of life".
8. Life beyond the areas of mothering and charity also seems to be governed by the ways of the "manhood agenda". Nevertheless giftgiving can be restored to our thinking about those broader areas. For example profit itself can be seen as a gift from the poor to the rich because it is constituted of surplus value, that part of the value of work not covered by the worker's salary. Women's free labor in the home, which would add some 40% to the GNP of the US (more in some other countries) can be seen as a gift of those practicing a gift economy to those practicing an exchange economy and to the whole system based on exchange.
9. Mothering and other types of free gift work are made difficult or even sacrificial by scarcity which is necessary for the functioning of the market. The scarcity is artificially created by the appropriation of the gifts of the many by the few, the gifts of poor countries by wealthy countries, the gifts of nature, the past and the future by the few for their profit in the present. The values of mothering are seen as unrealistic and or devalued by misogyny. They are seen as the cause of suffering while women's assertion of their suffering and the lack of satisfaction of their needs is seen as victimism. Rather the scarcity necessary for the market

and the discounting of the gift paradigm cause the suffering of women (and of children and men)

10. The exchange economy has values of objectification and fetishism and has always had a problem in distinguishing what is social from what is biological. This depends on its distress as a product of masculation which interprets a social "manhood" agenda as biologically fixed.

Why Has This Happened?

11. Masculation: All humans are born dependent so someone must care for them unilaterally from their earliest childhood. Women have been assigned this role by society due to the social interpretation of their biological capacities as opposed to men's. Until they learn language baby boys identify with their mothers and participate with them in giving and receiving. When they learn that they are in a category which is the opposite of their nurturing mothers they have to find—or create—an identity the basis of which is NOT being like their nurturing mothers—that is not gift giving. What they find is the manhood agenda: independence (as opposed to the interdependence of giving and receiving) competition (as opposed to cooperation) domination (as opposed to communication at the same level) stoicism (as opposed to emotion). This false masculated agenda has been taken as the human agenda instead of mothering. It has been projected into our institutions and deeply influences the way we construct reality.

12. Emotions are the maps towards gift giving. Manhood requires dominating the emotions. So does the market.

13. Hitting, which also bridges the gap between people (though negatively) and is a way of creating relations (of dominance), is the masculated replacement for giftgiving. Hitting replaces giftgiving at many levels from violence in the family to war.

14. Gift relations create community, masculated males want the independence which seems to be given by the market. Exchange separates people by putting them in adversarial positions. Exchange is ego oriented and gives value to the ego. Giftgiving gives value to the other. The market supplies a post masculated way to do gift giving. It allows the head of the family to support the family with a salary, and to own and provide the means of giving, the means of production of gifts. Similarly capitalists own the means of production of commodities and the means of exchange—money. This makes giftgiving dependent on exchange and giftgivers dependent on exchangers.

What to Do

15. Restore the mother image as the human image and giftgiving as the human way. See patriarchal religion as a projection of masculation, attempt to make women conscious of the gift ways they are already practicing and integrate giftgiving back into our expectations for the male gender identity. Mother Earth is not just a metaphor. Nature actually functions according to the gift way, not the exchange way. There is a spectrum of giftgiving from the least to the most intentional. If we project our understanding as MOTHERED children back onto this spectrum we can recognize gifts of nature. If we project the non-nurturing perspective of exchange we will see nature as objectified. Our understanding of nature as alive or dead really depends on whether we project the giftgiving way onto "her" or not. And very much the same for ourselves. The point of view of the ego created by exchange is very limited. Taking the point of view of the other, or of many others as having a need which we might satisfy, expands our perspective. We can consciously create and value gift based egos rather than exchange egos by standing at a meta level, realizing we are living in a market based society, working for a shift in the paradigm through social change and vice versa for social change through a shift in the paradigm, while at the same time maintaining our "selves" and our bodies as viable in an exchange based world. This may mean participating in the exchange economy while at the same time doing giftgiving at an individual level and at the level of social change and validating the gift way at a meta level. For example someone would have a job in the market (hopefully in a non polluting and non exploitative business). They would give money, time and creative imagination to social change activities while validating the gift paradigm and their own gift giving both socially, intellectually, spiritually and in their individual relations. They would critique the exchange economy. They would also create models of viable gift projects which validate the gift paradigm.

16. Create and believe in a women's culture with the economic base of gift giving now still burdened by the exchange economy, patriarchy and its values, but liberateable. It is important to do this within the oppressor cultures because this is where the values of patriarchy and the market are validated and produce harm.

Suggestions

17. Stand at a meta level.
 Look at the big picture.
 Restore the idea of gift giving where it has been eliminated or seen as victimism.

See all levels of needs—which have been hidden under other descriptions, need for social change, need for truth, needs of the market, created needs caused by scarcity.

Practice gift gaze to see needs instead of exchange gaze to reap profit.

Realize that we cannot make this change alone.

Promote a paradigm shift.

Promote decision making according to the values of gift giving while realizing that we are living in a society based on exchange.

Act in accord with gift values while not self destructing.

Criticize patriarchal exchange, the market and globalization.

18. In our personal lives empower ourselves with gift values, gratitude, community, turning towards the earth, spirituality. Pay attention to needs. Validate empathy. Learn to receive and give with dignity and sensitivity. Validate those values not only by doing gift giving practically, but consciously.

19. Do projects that promote the gift paradigm—with the full consciousness that we are not "there" yet. These include projects that also interrupt and unmask patriarchy like projects on environmental issues, globalization, racism, nuclear armaments, militarization and the death penalty.

Propose gift giving and its values as an alternative to patriarchy and as a standpoint from which to understand, criticize and dismantle it. Propose that patriarchy dismantle itself. (We have seen this in examples of unilateral disarmament, as happened in the USSR under Gorbachev). This can be non violent, lasting, and can have the advantage of the self knowledge of the powerful. (If it is true that power never gives up without a struggle, which I do not believe anyway, let that struggle take place inside the conscience of the powerful.) (If everyone, male and female, has values based on gift giving, if we are homo donans, then the powerful as well as the weak function according to gift giving. The problem is that the values and agenda of masculation and exchange have taken over as their way of interpreting the world and acting in it. Now not only do the wealthy and powerful believe in the value of domination, the poor and disempowered also believe in it so that the only way to survive and help others survive in our society seems to be to become powerful replacing those who are at the top in the system. (This applies to women, ethnic groups, religions and nations). However the system itself is an expression of patriarchy and the values of masculation. We can change the system by stepping down and stepping back from it together. Only by recognizing it for what it is, a sort of torture wheel for all, can we give it up and start over on the basis of nurturing for all. The nurturing values are already there we only have to uncover, not reinvent them.

Understand What Is Going On

20. Suspect and refuse reasoning and motivations based on exchange such as retribution, an eye for an eye, self interest, even the value given to equality over qualitative difference. Realize that they resonate with exchange and may appear more "just" for that reason. Lies are based on self interest while the truth satisfies the need of the other like a gift.

21. Address the false reflections about gift giving AND about the market itself, reflections which come from the market. Actually the critique of essentialism is based on exchange and market values. At an economic level there is no "common property" or "essence" among property owners except their relation of considering their property-and work-as having the "property" of exchange value. Both exchange and gift giving are processes which not only distribute goods but generate human relations and identities. The kind of identity fostered by exchange is atomistic, "self sufficient", and individualistic, denying connection (and denying the gifts it receives). It has no "essence" but a common lack of connection and it asserts this as a value. Thus the critique of essentialism comes from an exchange paradigm position.

22. The separation of "family" and "business", of the private and the economic spheres, has focussed gift giving within the family. Recognizing gift giving or mothering only in the mother child interaction, considering it inferior and as the biologically defined task of women, (as opposed to the variety of market and property—defined individualistic values and identities) leads us to abstract from this limited area a "common quality" of altruism as opposed to the apparent variety of qualities coming from the market and the values of the manhood agenda which have been incarnated into the market—independence, egotism, competition, domination, accumulation.

This reasoning has three defects:

1. Altruism is logically and psychologically different from egotism because (especially in abundance) it informs and diversifies the self as well as the other. In fact the variety of individuals and groups actually arises from the different kinds of nurturing they receive and give as children and, behind a wall of individual and collective denial, as adults (for example in the unacknowledged free labor of others)

2. Restricting the area of instances from which to abstract a "common quality" regarding mothering (giftgiving) to the mother-child interaction is much too limited. Mothering takes place in many other areas of life—practically everything BUT the market exchange-though unrecognized.

3. Mothering (giftgiving) is not a state but a creative process.

Abstracting from a state or series of states is different from abstracting from a process or different instances or levels of a process. Abstracting from states we may find an essence, attempting to abstract from a process at different levels

and instances of a process gives us a common logic or series of interconnected behaviors. If mothering is a process which takes place at different levels, abstracting its commonalities does not give us an essence. It gives us the logic of the gift.

23. The point is to liberate gift giving from the burden of the market and patriarchy by seeing humanity as homo donans, the giving being, not just homo sapiens. We have to be given to, and to creatively receive, in order to know.
Lay the blame where it belongs.

24. It is the market process that creates the monolithic economic "essence": exchange value. This essence is important as a model in our Patriarchal Capitalistic society and distorts the way we look at everything. Religion and philosophy deal with essences which reflect, or perhaps are even based upon or projections of this economic "essence". Actually giftgiving and receiving create a variety of qualitatively different identities and values (of which exchange value is only one among many—based on that singular quality which is quantity). Thus the desire for variety, creativity and meaning in connection can actually be satisfied by giftgiving and receiving while it is satisfied only apparently by the market, and at the expense of connection. Thus both essentialism and the critique of essentialism come from market based reasoning.

25. The exchange paradigm in consonance with its values of competition, competes with the gift paradigm. This competition is made necessary also by the very creativity and viability of giftgiving, the need of the market for free gifts, and the need of patriarchy for the assertion of "manhood" and its values as superior, whether transposed into the market or lived by actual males. Giftgiving, for its part, in consonance with its values, unfortunately gives to the market and to males, and gives way to exchange value and the manhood agenda.

Recognize the Importance of Logical Paradoxes

26. Unlike exchange, the gift process is not constructed around self reflection. At least in market society where giftgiving and exchange coexist, the process of self reflection has been taken over by self reflecting exchange and identified with it. Thus Derrida says the gift should not be recognized because if the person who is doing it self-reflects, she is rewarded for giving and the gift is transformed into an exchange. If giftgiving cannot be recognized it becomes difficult to consciously generalize it. What is basically a logical paradox becomes a practical paradox and is seen as a moral problem. That is, the issue is transferred to another plane on which the gift giver is accused and held responsible for "actually" exchanging. (It seems people can always "give" their suspicion). The giver is accused of a lie when actually exchange has the structure of the lie and is the norm. On the other hand, if giftgiving were generalized and made the norm there would be no particular ego reward for doing it.

27. Recognize that things we think of as properties or qualities are often relational. Like giftgiving the market is seen as a state or collection of states with the common quality of exchange value incarnated in money. Those states are actually parts of a process of abstraction of the common quality. That abstraction process IS the market process or mechanism. Thus essentialism is a pale reflection of the misinterpreted market process which is a process of the extraction of the "essence" of exchange value. Another reflection of the common quality of exchange value is "power", the masculine form of this "essence". Although power is seen as a quality or property it is actually relational and involves the dominance of one in polarity with the many who give way and give to the one.

28. Do projects of giftgiving with the full consciousness that a generalization of giftgiving to the system at large is necessary: volunteerism, charity, community activities, parenting, teaching, spirituality etc. are not just ends in themselves but must be generalized towards the gift paradigm in order to make a better world for all. Support large scale projects of government with this generalization in mind. Gifts from rich to poor countries should not contain hidden exchanges.

29. Remain conscious that the exchange paradigm seeks to discount giftgiving in innumerable ways.

30. Appreciate and learn from gift aspects of indigenous cultures.

31. Educate all children to be nurturing like their mothers. And educate mothers to validate giftgiving and to see its extensions in society at large. Refute the idea that there is a biologically non mothering "superior" gender. Encourage boys to be emotional like girls, so they can empathize and recognize needs more easily. Encourage the leveling of the roles as is already happening. See those roles as having gift aspects and emphasize those.

32. See giftgiving in all the different aspects of life so that our alignment with them can be recognized when and if it happens. These include: both internal and external psychological giftgiving; perception as reception of experiential data; giftgiving in nature; the consideration of language and messages as gifts, of mathematics and logic as having aspects of giftgiving, the consideration of biological giftgiving and giving on an atomic level.

33. Use the idea of a gift economy to bridge the differences in the women's movement so that it can unite across its diversity behind common goals and values to dismantle patriarchy. Link the different aspects of the women's movement on the basis of this common economic way having a superstructure of gift values.

 Use the idea of the gift economy to unite the women's movement with the mixed progressive movements under the banner and leadership of women and women's (giftgiving) values.

34. Let men (and women) see that the manhood agenda as understood in patriarchy and capitalism is a mistaken identity that is robbing them (and races, and nations) of their humanity, and that has been projected in the larger society causing devastation. Understand the psychology of patriarchy.
Let councils of women create teaching modules for men by which they can wean themselves from masculation and its values and begin practicing and validating giftgiving and its values. Have individual women personal trainers for giftgiving, training both women and men.

35. Link other mixed movements on this basis of mothering:

These are, for example, movements for peace and the environment (look at the profound implications of the image of Mother Earth)
Anti-racism, look at the different places given to giftgiving in different cultural groups even just within the US.
Anti-death penalty: mercy movement.
Anti-domestic violence.
Spirituality based on female images of God.
Anti-fundamentalism.
Economic justice, to the extent that capitalism is criticized but not to the extent that it promotes assimilation into capitalism, or at least only with the understanding that the way to peace for all is not through monetization. Economic justice is an illusion because capitalism needs free gifts therefore it cannot function for everybody.

Envision What To Do in the Future

36. Do anthropological studies of cultures doing giftgiving in order to find the different ways the gift economy has been practiced and the effects it has had. Enlist the help of surviving members of those cultures.
Create and validate a new popular psychological understanding of "human nature" as a social product and nurturing rather than as aggressive and competitive.
Do collective studies of how to's such as: how to assess needs, provide abundance, give and receive respectfully, how much technology to use, how to organize agriculture, distribution, education. Evaluate the use of alternative currencies to step down from the market.
Consider structuring society according to age-based work marked by rituals and organizing age-based ongoing education according to this structure.
Validate abundance for the many and work to create it.
Create small scale pilot projects to work out possible problems in practicing the gift economy and serve as models as well as educating the educators.
(Large scale experiments like Soviet Communism involve too many people and can have devastating effects)

Let these experiments include the creation of small local governments and gift initiatives.

Do large scale cooperative work to solve the problems created by capitalist patriarchy such as poverty, disease and environmental devastation.

Create a culture of kindness in which oppression is not validated and impulses towards domination and exploitation are interrupted habitually by all.

Eliminate patriarchal hierarchies

Give leadership to councils of women elders.

A)

Women must lead this transition not because men don't also do gift giving and have those values but because men have been taught that they are something other, that they have a manhood agenda of dominance and competition, and our institutions and economy have been built on that lie.

Women have also been taught and believe the lie that men are something else and that women not only are not adequate to be male but are supposed to be the "complement" of the artificial manhood agenda. In fact our society is built on this social lie, the lie of the father, and his father before him.

Women must lead also because we have been doing more free work for centuries than men, paying attention to needs in the family and in society. Otherwise children and society would not have survived. We must lead, informed by the values of the gift economy which we have been practicing so that gift giving can be restored as the way to peace and abundance for all.

B)

Patriarchy is a societal disease. Gift giving is healthy because it creates alignment with nature. (We can understand free will in these terms: we can choose exchange or giftgiving; both are products of socialization but one aligns with nature while the other distorts, dominates and exploits it) Perhaps illness happens because a gift giving body or mind finds itself out of alignment with an exchange based society.